On the Producti

Also by Simon O'Sullivan

ART ENCOUNTERS DELEUZE AND GUATTARI: Thought Beyond Representation

DELEUZE, GUATTARI AND THE PRODUCTION OF THE NEW
(*co-edited with Stephen Zepke*)

DELEUZE AND CONTEMPORARY ART
(*co-edited with Stephen Zepke*)

On the Production of Subjectivity

Five Diagrams of the Finite-Infinite Relation

Simon O'Sullivan
Goldsmiths, University of London, UK

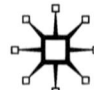

© Simon O'Sullivan 2012

All rights reserved. No reproduction, copy or transmission of this publication may be made without written permission.

No portion of this publication may be reproduced, copied or transmitted save with written permission or in accordance with the provisions of the Copyright, Designs and Patents Act 1988, or under the terms of any licence permitting limited copying issued by the Copyright Licensing Agency, Saffron House, 6–10 Kirby Street, London EC1N 8TS.

Any person who does any unauthorized act in relation to this publication may be liable to criminal prosecution and civil claims for damages.

The author has asserted his right to be identified as the author of this work in accordance with the Copyright, Designs and Patents Act 1988.

First published in hardcover 2012
Paperback edition published 2014 by
PALGRAVE MACMILLAN

Palgrave Macmillan in the UK is an imprint of Macmillan Publishers Limited, registered in England, company number 785998, of Houndmills, Basingstoke, Hampshire RG21 6XS.

Palgrave Macmillan in the US is a division of St Martin's Press LLC,
175 Fifth Avenue, New York, NY 10010.

Palgrave Macmillan is the global academic imprint of the above companies and has companies and representatives throughout the world.

Palgrave® and Macmillan® are registered trademarks in the United States, the United Kingdom, Europe and other countries.

ISBN 978–0–230–24980–6 hardback
ISBN 978–1–137–43028–1 paperback

This book is printed on paper suitable for recycling and made from fully managed and sustained forest sources. Logging, pulping and manufacturing processes are expected to conform to the environmental regulations of the country of origin.

A catalogue record for this book is available from the British Library.

A catalog record for this book is available from the Library of Congress.

Typeset by MPS Limited, Chennai, India.

Transferred to Digital Printing in 2014

For Hannah, Luke and Kit

Contents

List of Figures	viii
Acknowledgements	xi
Abbreviations	xiv
Introduction: Contemporary Conditions and Diagrammatic Trajectory	1
1 From Joy to the Gap: The Accessing of the Infinite by the Finite (Spinoza, Nietzsche, Bergson)	13
2 The Care of the Self versus the Ethics of Desire: Two Diagrams of the Production of Subjectivity (and of the Subject's Relation to Truth) (Foucault versus Lacan)	59
3 The Aesthetic Paradigm: From the Folding of the Finite–Infinite Relation to Schizoanalytic Metamodelization (to Biopolitics) (Guattari)	89
4 The Strange Temporality of the Subject: Life In-between the Infinite and the Finite (Deleuze contra Badiou)	125
5 Desiring-Machines, Chaoids, Probe-heads: Towards a Speculative Production of Subjectivity (Deleuze and Guattari)	169
Conclusion: Composite Diagram and Relations of Adjacency	203
Notes	223
Bibliography	287
Index	293

List of Figures

Figures

1.1	The first kind of knowledge	18
1.2	The second kind of knowledge	21
1.3	Spinoza's topology of expression: 1 Essences; 2 Relations; 3 Bodies; 4 Expression; 5 Effectuation	25
1.4	Spinoza's ethics: 1 First kind of knowledge; 2 Second kind of knowledge; 3 Third kind of knowledge; 4 Joy/understanding; 5 Joy/intuition	26
1.5	Spinoza's body without organs (with essence/autopoietic nuclei at centre)	26
1.6	Nietzsche's eternal return (through different 'levels' of intensity)	36
1.7	Bergson's plane of matter (with 'I' at centre)	43
1.8	The line of matter and the line of memory	44
1.9	Bergson's cone of memory (from 'On the Survival of Images', *Matter and Memory*)	46
1.10	Bergson's cone of memory with 'levels' (from 'On the Survival of Images', *Matter and Memory*)	50
1.11	'Shining points'/fractal ecology in cone	52
1.12	Cone of the mystic: 1: Static religion (habit/ritual), 2: Dynamic religion (introspection/intuition), 3: The mystic	54
1.13	Return path/circuit of the mystic/militant	56
1.14	Deleuze's diagram of the viniculum (from 'The Two Floors', *The Fold*)	228
2.1	Deleuze–Foucault's fold of subjectivation (from 'Foldings, or the Inside of Thought', *Foucault*)	74
2.2	Bergson's cone of memory (from 'On the Survival of Images', *Matter and Memory*)	75
2.3	Deleuze–Foucault–Bergson composite diagram (fold as cone)	76

2.4	Lacan's *Ethics* diagrammed as torus: 1 Ethical masters/boundaries; 2 The path of the subject/hero; 3 *das Ding*	77
2.5	Deleuze–Foucault–Bergson–Lacan composite diagram (fold/cone-torus)	79
2.6	Möbius strip	246
2.7	Klein bottle	246
3.1	Guattari's three assemblages: 1 Territorialized assemblage (pre-capitalist) (trans-individual); immanence/animist; polysemic/collective; 2 Deterritorialized assemblage (capitalist) (individual); transcendent over-coding; standardization/reduction; 3 Processual assemblage (post-capitalist) (post-individual); 'folding-in' of transcendence/autopoietic nuclei; autonomous/singular	96
3.2	The double cone Bergson–Guattari composite diagram	102
3.3	The double cone (with actual–virtual ecologies)	102
3.4	Guattari's diagram of 'The assemblage of the four ontological functions' (from 'Schizoanalytic Metamodelisation', *Chaosmosis*)	104
3.5	Diagram of *kairos*: 1 Past; 2 Present; 3 Future; 4 *Kairos*	120
3.6	Deleuze's diagram of the actual–virtual/real–possible (from 'The Two Floors', *The Fold*)	253
3.7	Guattari's diagram from 'The Place of the Signifier in the Institution', *The Guattari Reader*	253
4.1	Two diagrams of the subject: Lacan versus Badiou	127
4.2	First passive synthesis: habit (contraction-horizontal). Proper name: Hume	142
4.3	Second passive synthesis: memory (contraction-vertical). Proper name: Bergson	142
4.4	Third passive synthesis: aion (static). Proper name: Nietzsche	143
4.5	Diagram of Badiou's production of the subject: 1: Situation/world; 2: Elements/count; 3: Event site; 4: The subject; 5: Path of the militant/re-count; 6: The event; 7: Inconsistent multiplicity	161
4.6	Venn diagram: U: Universal set (inconsistent multiplicity), A: a set (situation/world), ∅: Empty set (void)	270
4.7	Passage through history of the Idea	271

x *List of Figures*

5.1	Connective synthesis (+)/disjunctive synthesis (⊕)	173
5.2	Diagram of desiring-production 1 ('soaring ascents and plunging falls'): 1 Desiring machine/disjunctive synthesis (the 'gap'); 2 The body without organs; 3 Attraction; 4 Repulsion; 5 The eternal return; 6 Different intensive states	174
5.3	Diagram of desiring-production 2 ('a succession of irregular loops'): 1 The celibate machine; 2 Disjunctive synthesis/recording process; 3 The body without organs/recording surface; 4 The subject	178
5.4	Desiring-production as spiral cone/flat spiral	181
5.5	The body without organs crisscrossed with lines of desire (1: Disjunctive synthesis)	181
5.6	The three forms of thought: 1 Chaos; 2 Planes of thought (art, science, philosophy); 3 The brain	187
5.7	Deleuze/Guattari-Lacan sinthome	276
6.1	Five diagrams of the finite–infinite relation	204

Acknowledgements

Parts of this book were given as invited papers or at conferences at Kingston University ('Rhythm and Event' conference); Goldsmiths College ('Beyond Spinoza' conference); Copenhagen Business School ('The Fourth International Deleuze Studies Conference: Creation, Crisis, Critique'); Trondheim Academy of Fine Art; Douglas Hynde Gallery, Dublin; Royal Academy of Arts Schools, London; The National College of Art and Design, Dublin; Cardiff University ('The First International Deleuze Studies Conference: One or Several Deleuzes?'); University of South Carolina ('Gilles Deleuze: Text and Images' conference); and the Danish Academy of Fine Arts, Copenhagen. I want to thank everyone who either hosted me and/or responded to work in progress. Perhaps more importantly, and certainly more intensively, I want to thank those MA Contemporary Art Theory students at Goldsmiths who took my seminar on *Thinking the Sensuous: Ethics, Aesthetics and the Production of Subjectivity* between the years 2006 and 2010, and those whose final dissertations I supervised. More or less all of the ideas in this book were presented and argued over in that seminar (alongside numerous drawings of diagrams). No doubt many of those participating will recognize some of their own thinking in what follows, but for specific contributions to my own understanding I would like especially to thank (in chronological order as it were): Sophie Springer, Manuela Zechner, Amy Visram, Abigail McDonald, Andrew Osborne, Laura Cashman, Emma Cocker, Leon Cooley, Oliver Fuke, Alice Rekab, Aimee Selby, Assunta Ruocco, Jacopo Nouvalari, Charlotte Bint, Charlie Johns, María del Carmen Molina Barea, Hessel de Ronde, Sifa Mustafa and Emily Sharp. A further crucible for testing my ideas, but also for reaping new ones, has been the PhD seminar that I have partially run in the Department of Visual Cultures for nearly the same amount of time. Thanks to those students who presented their own research and suggested such an interesting selection of texts to be read, some of which find themselves in the present volume. Those PhD students who have worked with me over the above timescale have contributed most directly to my thinking and I welcome the opportunity to acknowledge them here: Bridget Crone, Nicole Osborne, Christian Töpfner and Jon K. Shaw (who deserves a special mention as he co-taught the above seminar in 2011–12 while I completed this book. I am also indebted to Jon for his careful and astute

proof-reading, and for the preparation of the index). I would also like to thank my colleagues and other students, undergraduate and postgraduate, in the Department of Visual Cultures at Goldsmiths for making the latter a fertile and supportive place to both research and teach.

Stephen Zepke, in his usual rigorous and challenging manner, read a draft of the book and made numerous important comments and suggestions. Only he will be attuned to those passages that he has contributed to directly, but they are many, and certainly his careful reading has strengthened the book's argument even if I was not able to follow all the leads. Dan O'Sullivan also read parts of a draft and provided many helpful stylistic suggestions. David Burrows has accompanied me on more or less all the journeys of this book – both in our conversations, but also in our art practice together. I want to thank him for both.

Besides Stephen and David, there are many others whose own work and/or friendship has had an effect – often tangentially – on the writing of this book, and indeed on the production of my own subjectivity. In no particular order they are: Nick Thoburn, Felicity Colman, Gary Genosko, John Mullarkey, Ola Ståhl, John Cussans, John Russell, Darren Ambrose, Samudradaka, Janell Watson, Neil Chapman, Colin Gardner, Scott Wilson, Matt Fuller, Michael Goddard, Johnny Golding, Robert Garnett, Edgar Schmitz, James Hellings, Simon Harvey, Sara Ahmed, Ole Hagen, Anna Weaver, Joseph Collins, Thomas Mannion, John Cowcot, John Lynch, Ruth Blacksell, Kasja Thelin, Marcel Swiboda and Michael O'Rourke.

Others that I know less well (or, in some cases, not at all), but whose own writings or talks have directly or indirectly inspired the present work, or contributed to my understanding of especially Deleuze and Guattari, again in no particular order, are: Christian Kerslake, Jeffrey Bell, Peter Hallward, Dan Smith, James Williams, Éric Alliez, Ray Brassier, Reza Negarestani, Robin Mckay, Mark Fisher, Gabriel Catren, Nicola Masciandaro, Brian Massumi, Keith Ansell-Pearson, Todd May, John Rajchman, Nick Land, Franco Berardi, Eugene Holland, Ian Buchanan, Clare Colebrook, Alberto Toscano, Henry Somers-Hall, Levi R. Bryant, Jason Read, John Protevi and Philip Goodchild.

Thanks to Priyanka Gibbons at Palgrave Macmillan for being an exemplary editor. Special thanks to Jean Mathee and her inspiring seminar on Lacan's *The Ethics of Psychoanalysis* that informs my own understanding of the Lacanian subject in Chapter 2. The first part of this book was written, as with my last, at the Padmaloka retreat centre. Some of the later parts were completed while at Vajrasana retreat centre. I want to thank both for providing such excellent conditions for writing.

Some of the material in this volume has been previously published in journals. Versions of Chapters 2 and 3 as 'Lacan's Ethics and Foucault's Care of the Self: Two Diagrams of the Production of Subjectivity (and of the Subject's Relation to Truth)', *Parrhesia*, no. 10, 2010, 51–73, and 'Guattari's Aesthetic Paradigm: from the Folding of the Finite/Infinite Relation to Schizoanalytic Metamodelisation', *Deleuze Studies*, vol. 4, no. 2, 2010, 256–86; an earlier version of the first part of Chapter 4 as 'The Strange Temporality of the Subject: Badiou and Deleuze Between the Finite and the Infinite', *Subjectivity*, no. 27, 2009, 155–71; and an earlier version of the last part of Chapter 5 as 'Pragmatics for Future Subjectivities (*Probe-heads!* Or how to Live in the Face of Fear)', *Journal of Cultural Research*, vol. 10, no. 4, 2006, 309–22. I want to thank the editors of these journals for publishing the essays and for giving permission, where relevant, for their use here; and the anonymous readers who, in each case, provided valuable and informative feedback.

SIMON O'SULLIVAN

Abbreviations

AO Deleuze, G. and F. Guattari, *Anti-Oedipus: Capitalism and Schizophrenia*, trans. R. Hurley, M. Seem and H. R. Lane, London: Athlone Press, 1984.

ATP Deleuze, G. and F. Guattari, *A Thousand Plateaus*, trans. B. Massumi, London: Athlone Press, 1988.

B Deleuze, G., *Bergsonism*, trans. H. Tomlinson and B. Habberjam, New York: Zone Books, 1988.

BE Badiou, A., *Being and Event*, trans. O. Feltham, London: Continuum, 2005.

C Guattari, F., *Chaosmosis: An Ethico-Aesthetic Paradigm*, trans. P. Bains and J. Pefanis, Sydney: Power Publications, 1995.

DR Deleuze, G., *Difference and Repetition*, trans. P. Patton, New York: Columbia University Press, 1995.

E Spinoza, B., *Ethics*, trans. A. Boyle, London: Everyman, 1989.

EP Lacan, J., *The Ethics of Psychoanalysis 1959–1960: The Seminar of Jacques Lacan, Book VII*, trans. D. Potter, ed. J.-A. Miller, London: Routledge, 1992.

EST Foucault, M., *Ethics: Subjectivity and Truth (Essential Works of Foucault, 1954–1984, Volume One)*, trans. R. Hurley, ed. P. Rabinow, London: Penguin, 2000.

GS Nietzsche, F., *The Gay Science*, trans. J. Nauckhoff, Cambridge: Cambridge University Press, 2001.

H Foucault, M., *The Hermeneutics of the Subject: Lectures at the Collège de France 1981–82*, trans. G. Burchell, ed. F. Gros, Basingstoke: Palgrave Macmillan, 2005.

I Deleuze, G., *Pure Immanence: Essays on A Life*, trans. A. Boyman, New York: Zone Books, 2001.

LW Badiou, A., *Logics of Worlds*, trans. A. Toscano, London: Continuum, 2009.

MM Bergson, H., *Matter and Memory*, trans. N. M. Paul and W. S. Palmer, New York: Zone Books, 1991.

TR Negri, A., *Time for Revolution*, trans. M. Mandarini, London: Continuum, 2003.

TS Bergson, H., *The Two Sources of Morality and Religion*, trans. R. A. Audra and C. Brereton with W. Horstall-Carter, New York: Doubleday Anchor Books, 1935.

WP Deleuze, G. and F. Guattari, *What is Philosophy?*, trans. H. Tomlinson and G. Burchell, London: Verso, 1994.

Introduction: Contemporary Conditions and Diagrammatic Trajectory

> 'The only acceptable finality of human activity is the production of a subjectivity that is auto-enriching its relation to the world in a continuous fashion.'
> (Guattari, *Chaosmosis*, 1995)

I.1 Contemporary conditions

At the same time as a turn to the object, there has, in some recent continental philosophy, been a concomitant turn to, and renewal of interest in, the question of the subject.[1] A return to philosophy as a speculative realm of enquiry (that is, to metaphysics), and a return to philosophy as a way of life. In fact, this is not necessarily a subject that is opposed to the object. It is not a subject that is barred from what Quentin Meillassoux calls the *'great outdoors'* (Meillassoux 2008b, p. 7). Rather, it is a subject that is itself part of that object, a finitude that is woven from the very fabric of the infinite. This is to suggest a continuum of sorts between the finite and infinite, and also to foreground the heterogeneity of forms (and times) that such a subject might take. In fact, it is to foreground *subjectivity* over and above a subject, when the latter is understood as a single homogenized entity. It is also to emphasize the processual nature of this subjectivity as always a work in progress: an ethical and aesthetic programme aimed at producing a certain autonomy contra the dominant technologies and logics of subjection of our present moment. We might say then that this subjectivity is both pragmatic *and* speculative in the sense that its production must be carried out in our contemporary world, but that it is not reducible to those lifestyle options that are typically on offer. The present book is

concerned with the production of what we might call future-orientated diagrams of this different kind of subjectivity.

The genesis of what follows, however, does not lie in this more recent turn of (philosophical) events, but in an insight arrived at towards the end of writing my previous book, *Art Encounters Deleuze and Guattari*. At that time I came to realize that questions about the production of subjectivity were central to debates around contemporary art and politics (and also that art practice itself was a key technology in the production of subjectivity). Following Félix Guattari, it was apparent that the subject, that is to say I myself, was the site and locus of a kind of battle against the homogenizing powers of capitalism, and especially its reduction and standardization of heterogeneity. This was a point arrived at theoretically, but it was also a lived experience. A lived problem we might say.

Back then I had yet to read Alain Badiou on the subject, beyond a few minor works, and so it was very much Guattari that operated as my compass (and, subsequently, provided the title for the present book).[2] In many ways this sets the tone of what follows as a kind of confrontation between Guattari and Badiou, whom I subsequently encountered, although only if this is thought of as part of a larger confrontation between Spinoza–Bergson–Deleuze and a framework marked by Kant and Lacan. In fact, Spinoza and Bergson are a constant presence throughout my book (hence the time taken to introduce aspects of their philosophy in Chapter 1). It is my contention that both philosophers offer powerful frameworks for thinking contemporary subjectivity outside its typical understanding and habitual instantiations. I do attend in Chapter 4 to perhaps the chief philosophical *contretemps* of the present, between Badiou and Gilles Deleuze (and, in one very long footnote to this chapter, survey some of the secondary material that has been written on it), but it is Guattari who, I think, marks the real difference with Badiou. This is the case not only in content, but also in intention and style inasmuch as both Badiou and Deleuze are philosophers, whereas Guattari, although he may be claimed by that discipline, cannot be limited to it (indeed, it seems to me that Guattari, insofar as he was also an activist and analyst, might be better characterized, in Badiou's terms, as specifically a non-philosopher).

That said, Deleuze is certainly the more conceptually thorough of the two collaborators, and it is his take on ontology and on the three passive syntheses that, to some extent, grounds Guattari's own project (both of them presenting what we might call 'creaturely' accounts of lived life). It must also be said, however, that Deleuze's own philosophical

project is less concerned with subjectivity *per se* than with a certain 'larval' or pre-subjective state. We might compare this with Badiou for whom, as we shall see, the subject is precisely non-creaturely and certainly non-larval. This difference between Deleuze and Badiou has been commented on and is exemplified by the simple opposition: animal versus matheme.

Guattari's solo writings on the production of subjectivity were then instrumental in setting the intention of the present book which might be seen as a contribution to the 'aesthetic paradigm' that Guattari's writings inaugurate. In fact, *both* Badiou and Guattari foreground art as also an increasingly key technology of politics today insofar as it offers a model for subjectivity beyond the impasses in which the latter can find itself within late capitalism. For Guattari it is the idea of a kind of aesthetic event – 'mutant nuclei' – around which a different subjectivity might cohere, that is so suggestive for recent expanded art practices and for what we might call 'bottom up' political organization. For Badiou the idea of an event of art, which involves the coming in to form of that which hitherto was formless, is similarly suggestive for art theory, but also for a certain kind of aesthetic militancy. As we shall see, for Guattari, the event is very much of the world and common, whereas for Badiou it is extra-ontological and rare. Two technologies of the subject are attendant on this: production versus fidelity.

In fact, although in what follows I am often critical of Badiou as someone who, despite his own words, keeps the finite–infinite gap open, I do see many resonances between Badiou and Guattari, especially in terms of this attunement to the aesthetic. There are also profound resonances between Badiou and another thinker influenced by Deleuze and Guattari, but from whom Badiou is often keen to distance himself – Antonio Negri. For both Badiou and Negri, as we shall see, a re-theorization of the body, as the site of the finite–infinite relation (however this is thought), is crucial to a reinvigorated materialist project.

The other key motivating factor for this book was Michel Foucault's late work on ancient philosophy and especially his ideas about the 'Care of the Self'. Pierre Hadot's thesis on 'philosophy as a way of life', although I only attend to it in a few footnotes in what follows, was also instrumental in focusing my intention.[3] In many ways I see Guattari as 'updating' the technologies that Foucault (and Hadot) had excavated from the Ancients, especially in the attention he pays to capitalism's production of an increasingly homogenized time of the subject. Foucault and Guattari might both thus be said to be involved in mapping out an ethico-aesthetics of the subject: ethics naming here an

enquiry, *pace* Spinoza, into what a body, and thus what thought itself, is capable; and aesthetics naming an account of the forms of experience, but also the will to experiment and go beyond those very forms. In both Foucault and Guattari it is this turn to ethics and aesthetics that marks especially their later writings, and that works as a parallel to their interest in politics.

Indeed, although not always explicit in what follows, the urgency of what sometimes is a quite technical/abstract discussion is, as Negri has remarked, that there has been a total subsumption of society by Capital. It has now colonized lived time itself. In relation to this I am very much in agreement with Franco Berardi's analysis of semio-capitalism as that which increasingly stymies any real life. It is in this sense that the writing of this book was motivated by a desire to think alternative models for the production of subjectivity beyond those proffered by neo-liberalism which, despite its claims, increasingly produces an alienated, atomized and homogenized individual. Indeed, at a moment when time as well as space has been colonized, these alternative diagrams of the subject – and of the finite–infinite relation – become crucial and in and of themselves politically charged.

In many ways, and to give all this a further personal slant, the different chapters of the book are a record of my own attempt to work through what different thinkers might offer in aid of my desire to reconnect with life and specifically a form of life that might be lived against the dominant injunctions and regulative speeds of the market (thinkers that, as it were, offer a different thinking of time and of temporality).[4] Certainly my initial interest in Henri Bergson, and what I call the 'gap' (between stimulus and response) was precisely in a certain hesitancy and stillness: the deployment of slowness against the sometimes alienating speed of contemporary living. Likewise, with Nietzsche the initial interest was in the eternal return understood as that which names a different kind of temporality of life (a non-human temporality perhaps?).

A further early insight was that the question of subjectivity was also one of a subject's connection to an outside, however this may be conceptualized. At the beginning of my project I figured this very much as an outside to any particular institution that a given individual might be part of. I had in mind Guattari's thoughts about the 'writing machine' and about Kerouac's connections to the mountains, to yoga, to a life outside the literary institution.[5] In the course of writing this book it became clear to me that I was actually interested in a 'larger' outside – and that my understanding of subjectivity was part of a larger issue,

as I mentioned above, to do with the relation of a finite being to the infinite. This finite–infinite relationship is perhaps one of the oldest philosophical questions, and might also be seen as *the* theological question (it is, after all, the question of our own mortality). In fact, it might be said that what I am attempting to locate in this book is a specifically non-theological solution to the problem of our finitude. To complicate things further, it occurred to me that this relation was also capitalism's terrain of operation insofar as it now exploits our very potential, or capacity for, production. Indeed, the infinite as a 'resource' of the finite subject constitutes, it seems to me, perhaps the key site of political contestation in the contemporary Western world.

Having said this, it is important for me to point out at the outset that my book does not attend to the realm of politics *per se*, nor does it discuss the specifics of our late capitalist condition beyond the brief section on Italian autonomist thinkers at the end of Chapter 3, and certain marginal comments and footnotes throughout.[6] What is implicit, however, in what follows is a view of late capitalism that sees it as morphing from a transcendent enunciator to an immanent operator, and the resultant ideas of the production of subjectivity that this implies and invites. Thus, for example, in Chapter 1, there are certain suggestions as to how a subject might be produced 'outside' capitalism (albeit with various reservations, qualifications and caveats that appear in the footnotes). However, the kind of subjectivity implied in the final chapter is one that is produced, following *Anti-Oedipus*, by a desiring-process that is immanent to capitalism. In a sense this move tracks the more philosophical movement of my book – from diagramming a topology of sorts (for example, Bergson's actual/virtual dyad, or Spinoza's three kinds of knowledge, both in Chapter 1) to something more horizontal, with Chapter 3 operating as the passage between the two (the latter chapter thus also evidencing a certain tension between the two accounts of capitalism).

It goes without saying that what is offered here is a selective and to a certain extent idiosyncratic choice of thinkers. When deciding on my resources I was particularly interested in those thinkers who specifically seemed to posit a bridging, or continuum, between the finite and the infinite. Indeed, in its selection, as it were, of certain conceptual personae, my book identifies a kind of counter tradition to a post-Kantian philosophy that maintains the gap between phenomena and noumena, subject and object – again, a gap between the finite and the infinite.[7] This is not to say that thinkers such as Deleuze and Foucault do not follow Kant in some respects. Both, after all, are interested in the transcendental

conditions of experience – an interest they directly inherit from Kant as the founder of transcendental philosophy (although both wish to shift these conditions from possible to real experience). Nevertheless my book is marked by a desire to untie the subject from a certain bind that is given its most rigorous and exhaustive account in Kant's philosophy (although the latter does not explicitly appear in the book).[8]

A fundamental idea of this book follows from the above, namely, that any subject comes after, or is secondary to, a given process that is primary. It is this positioning of the object *and then* the subject that seems crucial to the thinkers collected here. It is also in this sense that the subject at stake in this book is not the Cartesian one, or what I occasionally call the subject-as-is, but something altogether stranger (indeed, it is really these states 'beyond', or outside of, typical subjectivity (a pre and post subjectivity if you like) that interests me). Again, this is especially apparent in my final chapter.

Related to all this is my interest in affirmation over negation. This is in part the subject matter of Chapter 1, so I will only say here that I affirm affirmation over negation for two reasons. The first, a 'molar' reason, is that negation can become trapped by the very thing which is negated. Or, put differently, negative critique (when this is not instigated by creativity/affirmation) can produce just more of the same – a mirror image of the thing critiqued insofar as it must use the same terms, operate on the same terrain as its object. Critique can operate as a trap for thought in this sense. It seems to me that the production of subjectivity cannot but be an affirmative project if it is to escape this logic of doubling (or what, as we shall see, Deleuze calls a logic of the possible). Second, a more 'molecular' reason: affirmation is both the character of an ethical life when this is truly lived, and the character of all life in general. If, with the first of these, I have in mind Spinoza's *Ethics* (and the progression in a certain kind of knowledge about the world) as discussed in Chapter 1, then with the second, which I engage with in Chapter 4, I am thinking of Deleuze's idea of a passive synthesis of life (that is also a joyful auto-affection). The notion of affirmation seems to me to be implicit in what I have already said about a continuum between the finite and the infinite, just as the positing of a gap lends itself to the production of a melancholy subject.

In relation to this idea of affirmation, feeling – or affect – becomes an important register of subjectivity, giving as it does a privileged access to this non-subjective infinite understood as a non-discursive and asignifying ground. Indeed, we might say that it is a subjectivity of intensity, a 'felt sense', rather than a subject *per se* that is named here. We might also

identify here a strategy of speeding up – of accelerating intensity – as a line of flight away from typical subjectivity. Speed constitutes a paradoxical parallel to the hesitancy and slowness I mentioned above. This, it seems to me, is what is at stake in Deleuze and Guattari's *Anti-Oedipus*, which I look at in the first part of Chapter 5. In a situation in which it is sometimes difficult, conceptually, to tell the difference between subjection (that can appear to offer self-determination) and subjectivation (our own processual self-production), or simply between those practices that control versus those that free (we might call this the creativity of capital versus creativity against capital), affect also becomes a kind of test. Simply put: does what we do in our lives produce sadness or joy? Are we rendered impotent and paralysed, or active and generative? It is in this sense that the battleground of subjectivity, it seems to me, *is* affect.

Although only mentioned briefly in the main body of the present book (though there are a few footnotes that follow up the idea) there is also, arising from the various ontological diagrams and theories of the subject, a philosophy of history as a lived archive. Indeed, for many of the thinkers deployed here, but perhaps most explicitly Badiou and Negri (the latter of whom I look at only briefly at the end of Chapter 3), history is to be tested in a present that is in and of itself *generative*. It is this that both Badiou and Negri take from Marx. In *Anti-Oedipus*, as we shall see, this is pushed to an extreme in the exploration of a subject that is in and of itself historical – insofar as it is composed of 'past' intensive states. We might say, in this sense, that the production of subjectivity is future orientated but also looks back to previous moments, reactivates previous events.

A further important interest – only fully grasped by myself towards the end of writing this book – is about retroactive causality and the subject assuming responsibility for itself. This is the avowed 'goal' of Lacanian psychoanalysis, as we shall see in Chapter 2, but it is also, it seems to me, the end point of Spinoza's ethical programme – as well as being an important factor in the notion of the subject in Deleuze and Guattari's *Anti-Oedipus*. It is also a definition – at least of sorts – of Nietzsche's eternal return. As far as this goes I firmly believe there is a larger project involved in looking at the later writings of Lacan – on the RSI knots and on the sinthome – and bringing them into encounter with Deleuze and Guattari's *Anti-Oedipus* around this idea of the self-production of an 'individual'. As Lacan remarks in his own *Ethics*, the important thing for analysis is to know how 'one eats the book' (and what transpires after), but also whether one might write the book itself – or, in Deleuze

and Guattari's case, how one might inhabit and/or scramble existing codings, but also produce autonomous ones. In relation to this there arises also the difference between assuming a name and becoming imperceptible. I will be looking a little at this issue in Chapter 4, again in relation to Badiou and Deleuze. Suffice to say here that a holding of these two together (the name *and* imperceptibility) – and thinking their relation – might be an interesting avenue for future enquiry.

I.2 Diagrammatic trajectory

Although instigated by my interest and previous work on Deleuze and Guattari, in this book I was especially keen to look at other writers on subjectivity, to engage with different thinkers (and not to have, as they say, just one guru – albeit a collaboration). As it turns out the book, although about a selection of different thinkers – or really the bringing into encounter of different thinkers – actually returns to Deleuze and Guattari and, in fact, often approaches the others through a Deleuzian optic (this is especially the case with Spinoza, Nietzsche and Bergson who were, of course, Deleuze's self-claimed precursors). In many ways all this makes my book a work of commentary more than anything else, when commentary is understood as that which attends closely to, but also occasionally departs from, an original.

Each particular chapter lays out what I call a diagram for subjectivity, or of the finite–infinite relation. More often than not this is a composite diagram that involves components from different thinkers. Indeed, this was my desire in writing the book, not to be partisan, but to take parts from different systems depending on their 'usefulness', particularly in relation to what I have written above about the deployment of a different kind of time of and for the subject. In this sense I might be accused of neglecting important differences between the resources I utilize in favour of a more synthetic programme. It is certainly the case that on more than one occasion the encounters are indeed forced, and that I make claims that the different philosophers involved would perhaps dispute. The book then offers a series of polemical readings and reflections, a 'cross section' of the work of different thinkers; each of the latter contributes a part towards what we might call the overall diagram, but the book unfolds with a particular logic and intention that is its own.

The diagram itself is becoming an increasingly popular 'tool' in philosophical work, and, of course, has always played a key role in Lacanian psychoanalysis.[9] I will say more about this formalism in the book itself, but we might note here that the diagram, for myself at any rate, is an

especially useful method for exploring the relations between thinkers, and indeed, for demonstrating surprising compatibilities and odd couplings that might in themselves produce further thought. In this sense the diagrams are an example of what Guattari calls 'metamodelization', involving as they do a combinatory and synthetic logic. As others have pointed out, the diagram is not merely a signifying form, nor, indeed, a form of representation.[10] It does not necessarily need to be interpreted, but 'communicates' more formally. I would like to think that the diagrams in my book could be extracted from the accompanying textual account and still give a sense of the book's trajectory and argument (in fact, in the first part of my Conclusion I do just this). Indeed, some of the diagrammatic experiments that follow lack an extensive discursive explication and explanation, but, I hope, this is also their suggestive strength. As far as this goes it seems to me that the diagram can operate as a kind of short-circuiting of the discursive, or put differently (and following Lacan) as something that does not necessarily need to be fully explained in order that it 'works'.

At certain points in what follows (especially in the first section of my final chapter) the diagram often leads the synthesis rather than merely illustrating a synthesis already made (it begins as an illustration ... then spirals out ...). It operates at a different speed to the discursive, and certainly in a more experimental manner. Diagrams are like fictions in this sense. They produce thought. I mean this in two senses: (1) as I have just mentioned, they often run ahead of the discursive work like a forward hurled probe (after which discursive work might follow); and (2) they operate as a map for thinking life more broadly, for spotting passageways, openings and lines of flight. As far as this goes diagrams are a picturing of things from the outside as it were (a view from nowhere as the saying goes). However, insofar as we are always, ourselves, in the middle of things as Deleuze and Guattari would have it, the diagrammatic perspective is a fiction, albeit, to borrow a phrase from Badiou (who is actually writing about Lacan's notion of the infinite here) this is an 'operating fiction'. A kind of 'speculative fiction' perhaps? Might we even say that the diagram is a kind of 'conceptual art', although somewhat distinct from Deleuze and Guattari's understanding of the latter?[11]

I intended the chapters to work as stand alone 'case studies', but they are also in sequence, each one building on the work of the previous. They are also, to a certain extent, written in different styles or tones. This is partly because they track my own attempts to get to grips with my subject matter, and, as such, they increase in complexity and,

I think, philosophical engagement as they progress (although the very last section of the final chapter was the first to be written). The sometimes quite lengthy footnotes are often evidence of a back stitching of later conclusions in to previous chapters. This difference in style is also, however, because it seemed to me that the different thinkers and texts I look at demanded different kinds of writing, not least because I wanted to extract different things from them and thus approach them with a wider or more narrow focus in order to 'see' at the appropriate detail. So, for example, in Chapter 1, the material on Spinoza is fairly introductory and indeed, free from quotes. This is because I am dealing with a whole book and was keen here to give an overview of the three kinds of knowledge (and, indeed, draw a diagram of the latter) that did not get bogged down in Spinoza's own complex and geometric system (and, indeed, his somewhat dry exposition). On the other hand, in the same chapter, I only look at a part of a book by Bergson in order to extract a particular diagram, thus I provide a closer reading – and there are many more quotes. Or, to take Chapter 3 as another example, it seemed to me that Guattari's thought needed to be addressed on a detailed and more abstract level, and on the terrain of the technical language and neologisms that he invents, insofar as this is what specifically characterises his thinking, hence, again, the closer reading and commentary.

To provide a brief synopsis of the chapters: Chapter 1 begins with a reading of Spinoza's *Ethics* paying particular attention to the account of the three kinds of knowledge found therein. The third kind of knowledge, especially, is irreducible to our more typical 'knowledge-economy' and further, involves a stepping 'outside' of what might be called the habitual time of the subject. The chapter goes on to examine some of Nietzsche's aphorisms collected in Book Five of *The Gay Science*, again, understood as a resource for the production of an affirmative and creative subjectivity. The final and longer section of the chapter explores a further temporal anomaly, namely the gap between stimulus and response addressed by Bergson in *Matter and Memory*. In terms of my own book's trajectory then, Spinoza and Nietzsche offer, albeit in different ways, the idea that it is possible for a finite subject to prepare for, and have an experience of, the infinite, while Bergson's addition to my own assemblage is the gap, or hesitancy, that allows access to this infinite, understood as a realm of pure potentiality.

Chapter 2 involves an examination of the later writings and teachings of Michel Foucault on the 'Care of the Self'. Again, it is the notion of there being a certain special kind of knowledge, what Foucault terms 'truth', that is explored. Such truth is only accessible to the subject in a

very particular condition (one that has been produced through practice), hence, as Foucault argues, the importance, for the Stoics and others, of certain pragmatic technologies of the self (we might say technologies of transformation). The chapter begins, however, with a Lacanian ethics (through a reading of *The Ethics of Psychoanalysis*), in many ways as a foil and corrective to the above; a move, we might say, from the *care* of the self to a *suspicion* of the self. Time is again an important issue here. Indeed, it is Lacan's rethinking of the time of the subject – its always retroactive formation – that links him back to Spinoza since both attend to the necessity, in an ethical life or via analysis, of understanding the causes of one's self but also of becoming a cause of one's self. Lacan provides a crucial thinking of the subject as non-identical to the ego and also as that which is 'to-come' and yet, paradoxically, must be *assumed*.

Guattari's solo writings, and especially his last major work *Chaosmosis: Towards an Ethico-Aesthetic Paradigm*, offer perhaps the most sustained, and certainly the most complex thinking through of the terrain of the production of subjectivity today, not least in the radical rethinking of the subject/object split in terms of an expanded machinics. Equally important is Guattari's careful consideration of new technologies as well as his interest in art, gesture and ritual. In general then, and in contradistinction to Lacan, Chapter 3 foregrounds the importance of asignifying elements in the production of subjectivity – and of a certain molecularity that operates beneath molar aggregates such as our identity. This is to attend to Guattari's own idea of subjectivity as a diagram between the finite and the infinite (or the actual and the virtual) in which there is a reciprocal determination (the infinite is not barred, nor deferred, but is in fact folded into the finite). The chapter also briefly considers some Italian autonomist writings (Paulo Virno, Franco Berardi and Antonio Negri) that develop Guattari's interests, specifically in relation to our late capitalist context.

Badiou is perhaps the key thinker of the subject alive today and my fourth chapter concerns itself with his two major philosophical statements. Beginning with an exegesis of his 'Theory of the Subject' from *Being and Event* this chapter goes on to contrast Badiou's subject with Deleuze's individual, specifically in relation to *Difference and Repetition*. The chapter then looks to Badiou's theorization of the body in *Logics of Worlds*, which is, in many senses, a response to some of the problems of *Being and Event*. At stake here, again, is a puzzling through of the finite–infinite relation in terms of the subject (and, in Deleuze's case, what we might call 'larval subjectivities'). The distinction between the thinkers might be figured as involving a certain horizontality within Deleuze

(a transversality, or becoming-animal) versus a certain verticality with Badiou (an ascendance, or becoming-subject). In general then this chapter might be said to be defending a certain kind of Deleuzian (and Spinozist–Bergsonian) finite–infinite diagram of the subject against what might be seen as its most trenchant and rigorous critique.

The final chapter of my book looks at Deleuze's work post *Difference and Repetition*, and specifically his collaborations with Guattari, namely the *Capitalism and Schizophrenia* project and *What is Philosophy?* The former creative philosophical endeavour, perhaps the most inventive and experimental of recent times, offers a distinctive diagram – or what the authors call an abstract machine – for thinking the experimental, constructive and 'future-orientated' nature of the production of subjectivity understood as a specifically aesthetic and ethical pursuit. The chapter begins with an oblique return to Lacan in the consideration of 'desiring-machines' (from *Anti-Oedipus*) as a radical framework for thinking subjectivity, before going on to excavate a strange notion of 'chaos-subjectivity' from *What is Philosophy?* The chapter then turns to *A Thousand Plateaus*, and specifically to the concept of 'probe-heads' that points to a break with dominant state regimes, but also to the need for new forms of organization or simply new forms of subjectivity. This concept also involves the deployment of different times of and for the subject, and, as such, the chapter also attempts something slightly different – a more 'practical' exploration of the latter in terms of contemporary art practice (as future orientated) and modern paganism (as utilization of the past). Indeed, it is in this final part of the main body of my book that I lay out what, I think, a Deleuze–Guattarian production of subjectivity might look like.

My conclusion involves a restatement, via diagrams, of the trajectory of the book. I also provide a brief sampling of some of the philosophical viewpoints of what has become known as 'Speculative Realism' with some comments about the distances and proximities to my own project, insofar as the latter might itself be thought of as notes towards a speculative subject.

1
From Joy to the Gap: The Accessing of the Infinite by the Finite (Spinoza, Nietzsche, Bergson)

1.1 Introduction

In this first chapter I want to lay the philosophical groundwork for the further explorations, encounters and composite diagrams of the following four chapters. In particular I want to map out three different models of the production of subjectivity or, which amounts to the same thing, of the finite–infinite relation. In fact, I want to link these three together under one diagram that itself will recur throughout the remainder of this book. I begin with Spinoza's *Ethics* (cited in references as *E*) and with the account of the different kinds of knowledge a subject might embody, before looking more briefly at Nietzsche's ideas of affirmation and the eternal return as they occur specifically in *The Gay Science* (cited in references as *GS*). In both of these works it is especially the idea of joy as a kind of technology and passage – as well as a destination – that I am interested in. The longer third section of the chapter looks in some detail at Henri Bergson's celebrated cone of memory – the diagram mentioned above – from *Matter and Memory* (cited in references as *MM*). Here, I am interested in a certain gap that, again, allows a passage from one intensive state to another, and especially, in Bergson's terms, to beyond the realm of matter with its particular linear temporality. In general this chapter presents less an overview than an introductory sampling of the thought of these three philosophers, with an eye to extracting certain details and demonstrating certain resonances between them.

1.2 Spinoza's three kinds of knowledge (and the passage between)

> What does Spinoza mean when he invites us to take the body as a model? It is a matter of showing that the body surpasses the

knowledge we have of it, *and that thought likewise surpasses the consciousness we have of it*. There are no fewer things in the mind that exceed our consciousness than there are things in the body that exceed our knowledge. (Deleuze 1988a, p. 18)

1.2.1 Introductory remarks: the *Ethics*

In an autobiographical passage from the *Treatise on the Correction of the Understanding*, Spinoza succinctly states his motivation and intention in writing the *Ethics*:

After experience taught me that all things which occur frequently in ordinary life are vain and futile; when I saw that all the things on account of which I was afraid, and which I feared, had nothing good or bad in them except in so far as the mind was moved by them, I resolved at last to inquire if there was some good which was genuine and capable of communicating itself, and by which the mind would be affected even if all the others were rejected; in sum, if there is something such that, when it has been discovered and acquired, I might enjoy for eternity continuous supreme happiness. (Quoted in Parkinson 1989, p. ix)

In the terms of the thematic of my own book this intention might be figured as the desire of a finite body to access the infinite, or what Spinoza will call the eternal. The relation of the finite to the infinite, which is so often portrayed as a *non*-relation (especially in religion), is, in fact, outlined by Spinoza in his *Ethics* as a decidedly livable relation. Indeed, in contradistinction to Kant, this finite–infinite dyad is less a split between a phenomenal world apparent to a subject and a noumenal one beyond, than rather, two poles on a continuum. In relation to this, Spinoza also famously lays out a thesis of parallelism between thought and extension, both being attributes of the same infinite substance. In this sense a subject, or 'modal essence', can develop an idea of their own composition as it were – a knowledge that results, ultimately, in a further intuitive knowledge of the infinite substance of which they are a part.

Spinoza's *Ethics* is then exploratory and analytic, but it is also fundamentally programmatic. It operates as a manual for life and specifically for the production of a life that is not merely beholden to the world, but that ultimately authors its own existence.[1] In fact, the *Ethics* involves two distinct transformative moments in this continuing assumption of the subject of their own causality (although, as we shall see, the definition of a body, or mode, does not necessarily go through a definition

of the subject *per se*). What then are these two moments – or specific technologies – of transformation? In order to answer this question this first part of my first chapter provides a brief account of Spinoza's *Ethics* via a diagramming of the topology of the three kinds of knowledge found therein.[2] In particular I will be interested in the points of passage between the first and the second, and then the second and third.

1.2.2 The first kind of knowledge

For Spinoza the first kind of knowledge names our general condition of being in – or, we might say, being thrown into – the world. We are constituted by 'shocks', the more or less random affects that are determined by the more or less random encounters of our life. 'Affect' names here the passage from one state of being to another, the risings and fallings in intensity (or becomings as Deleuze and Guattari will come to call them). This is to posit a toxicology of the world insofar as, from our point of view as individuated beings, it is made up of poisons and food. Indeed, our bodies and minds are, in one sense, a history of these chemical encounters in that they are constituted *by* these encounters. The first kind of knowledge is also perception (understood as a general 'sensing'), since the latter involves the registering of these various encounters and collisions between the different elements of our world.

The reason for this basic mutability follows from Spinoza's particular theory of bodies. We are composed of an infinity of parts – of smaller and smaller particles (that ultimately have no interiority) – in relations of movement and rest. This is the realm of extension, and insofar as we have extensive parts we are bound to the logic of this world – a logic, we might say, of dissolution. We are, in this sense, necessarily finite. My particular individuality is simply that a part of this infinity of parts belongs to 'me' under a certain relation, but only for a certain duration (as we will see, these relations express a certain degree of power; in this case the particular degree of power that I am an expression of). My individual relation subsumes other relations within my body, relations that constitute my individual organs and so forth.[3]

We might say then that we are fractal beings in this sense, composed of a multiplicity of particles in constantly differing relations of movement and rest that in themselves mean we have different capacities to affect and be affected. Deleuze, in his reading of Spinoza, is especially attuned to this alternative cartography of beings – or becomings – in and of the world:

> You will not define a body (or a mind) by its form, nor by its organs or functions, and neither will you define it as substance or a subject.

> Every reader of Spinoza knows that for him bodies and minds are not substances or subjects, but modes. It is not enough, however, merely to think this theoretically. For, concretely, a mode is a complex relation of speed and slowness, in the body, but also in thought, and it is a capacity for affecting or being affected, pertaining to the body or thought. (Deleuze 1988a, pp. 123–4)[4]

In Deleuze's *Spinoza: Practical Philosophy* a mode, as defined above, is understood as moving on, or across, the plane of immanence on which '[t]here is no longer a form, but only relations of velocity between infinitesimal particles of unformed matter', and where '[t]here is no longer a subject, but only individuating affective states of an anonymous force' (Deleuze 1988a, p. 128). This immanent plane 'is concerned only with motions and rests, with dynamic affective changes' (Deleuze 1988a, p. 128). This is then to posit an affective ethology in place of notions of fixed forms or functions.[5] It is also a call to experiment insofar as any given body cannot know in advance which bodies might, or might not, combine successfully with it. I will return to this 'combinatory knowledge' in a moment.

In the first kind of knowledge then we are subject to the world and, we might say, victim to it. This is the zone of battle, a constant struggle over the capture and appropriation of parts by different competing relations. We might describe this as the animal realm; certainly Deleuze and Guattari's becoming-animal develops from this notion of affective capture or contagion. In passing it is worth noting that Deleuze and Guattari's Spinoza, particularly as utilized in *A Thousand Plateaus*, is a kind of animal or creaturely philosopher.[6] This might be contrasted with a thinker like Badiou who also turns to Spinoza, albeit for a specifically *non*-creaturely philosophy (one could describe this as a turn towards a vertical becoming-subject as opposed to a horizontal becoming-animal). I will return to this particular philosophical *contretemps* in Chapter 4.

For Spinoza our desire to persist in our being and, indeed, to increase our capacity to act in the world, is our very essence ('The endeavour (*conatus*) wherewith a thing endeavours to persist in its being is nothing else than the actual essence of that thing' (*E* Book III, Prop. 7, p. 91)). This understanding of desire is the animating principle of the *Ethics*, since the latter intends to produce an understanding of what, really, is 'good' for us (ultimately, the community of free men). It is in this sense that we perceive the external world as either a threat or an aid to our fundamental desire for continuous existence. In the first kind of knowledge we perceive the world as *causing* our various pains and

happinesses. Spinoza's Book VI of the *Ethics* erects a whole physics of the different emotions, or affects, on this simple truth about life – whether something aids or abets our survival (including different variations depending on whether the apparent cause of a certain affect is in the past or present, whether it is necessary or contingent, and so forth). As Spinoza remarks, affect, as well as a degree of intensity, is then also 'an Idea wherewith the mind affirms a greater or less force of existing of its body than before' (*E* Book IV, Prop. 7, Proof, p. 148). Spinoza was excommunicated for the heresy of *Deus sive Natura*, but we might note a more subtle, insidious heresy that follows from this: good and evil are determined, ultimately, by joy and sadness, or simply the continuing survival, or not, of the organism.

The ideas we have when 'in' this kind of knowledge are necessarily inadequate inasmuch as we only have effects, 'on' our body as it were, to go on. We are, we might say, blown around by the 'worldly winds'. We are like the baby who cries from what is immediately apparent (or absent) without any understanding of a deeper causality. This is a passive knowledge that develops from the taking of effects for causes: 'We are passive in so far as we are a part of nature which cannot be conceived through itself without others' (*E* Book IV, Prop. 2, p. 146). This kind of knowledge also relates to extrinsic laws, morality and, indeed, any kind of knowledge that is not built on a knowledge of the constitutive relation of things (Deleuze refers to the former as 'opinion' and 'hearsay').[7] In passing, we might note that our current state of capitalism thrives on passive affects and the masking of causes (it stymies participation and any real knowledge). Capitalism, we might say, organizes encounters so as to produce a situation in which we are the spectators of our own lives. In this sense, the apparent 'joys' of consumerism and accumulation are always transitory and vicarious. In fact, it seems to me that the predominating character of our contemporary affective landscape is fear, and a kind of paralysis that arises from it (as evidenced, for example, by the overwhelming fear–anxiety affect of mass media 'news' programmes). I will be returning to this below.

This is then a world in which effects rule, one in which there is no true knowledge of causation. Deleuze, in his essay on the 'The Three Ethics' from *Essays Critical and Clinical* draws out a topology of signs based on this distinction. Signs refer to states of bodies that are themselves mixed states of affairs, confused, concerning only the shadows cast by actual objects. There are scalar signs that are 'slices' in our duration and then also affect signs that name the transitions between states, the becomings.[8] Simply put, we dwell here in a world of signs in

which we confuse effects for causes. Indeed, we 'mis-read' the causes of our experience as coming from 'outside' ourselves as subjects. Hence the logical inversion we typically assume: we think it is the other that is causing our pain (or, indeed, our happiness), but in fact, following Spinoza, we are partly responsible. As in the Buddhist theory of karma, the cause of my suffering is not the fist that hits me, but the fact that I have a particular fleshy body to be hit and that can thus experience pain (my body being, in this sense, literally 'old karma'). Deleuze characterizes this reversal of causation – an illusion in which we position the other as cause – in his 'Lecture on Spinoza' as 'a scream that we will not stop having so long as we remain in the first kind of knowledge…' (Deleuze 1978, p. 6).

In another essay, Deleuze refers to the three kinds of knowledge as three individualities that co-exist as if superimposed on one another (Deleuze 2003a). The individuality of the first kind of knowledge is the body of 'parts' that has an existence within a certain space–time and thus has a certain duration in that world, a duration that constitutes that individual's very world. We can note Spinoza's mind–body parallelism again here: the ideas we have in this first kind of knowledge are determined by this body of parts, just as our body of parts is, in a sense, determined by the ideas we have about our body. I will return to what we might call this relation of reciprocal determination below, and again in Chapter 4.

We might simply picture this world of random encounters between bodies – Spinoza's first kind of knowledge – as in Figure 1.1.

1.2.3 The second kind of knowledge

Spinoza's second kind of knowledge arises from the effort we make to understand, and then determine, these hitherto random encounters. If, in the first kind of knowledge, we are conscious of – and act on – our appetites, in the second we become conscious of the reasons for the appetites themselves. With the second kind of knowledge we attempt to fathom

Figure 1.1 The first kind of knowledge

why it is that we act in the way we do. This is to move from a knowledge of effects to a knowledge of causes (we might note here that it is in this precise sense that Marx might be seen as a Spinozist). Indeed, freedom, for Spinoza, is not necessarily the apparent freedom to act a certain way, but consists in understanding why we act in a certain way.

For Spinoza, this understanding of causation cannot be achieved through immediate experience (that is, through the confused mixture of bodies). There is then a specifically speculative aspect to Spinoza inasmuch as the second kind of knowledge is necessarily of that which is beyond the immediately given (beyond the senses as it were). We might say that an abstraction of some kind is required, a distancing from the world, that will allow for a reflection on the mixed state of affairs that constitutes our being in that world. It is this speculative aspect that determines Spinoza as part of the scientific revolution of the seventeenth century, since science, in its most radical form, also involves a knowledge that goes beyond the subject-as-is, at least insofar as the latter subject is not determined by reason.

More specifically, the second kind of knowledge involves the formation of 'common notions' that come about when we understand how two or more things relate, or, more precisely, when we understand what two or more things have in common (beginning with the least universal, that is, our own body's agreement, or not, with one other body). This complicates the idea that the second kind of knowledge is purely speculative. Indeed, Deleuze, in his reading of Spinoza, specifically warns against a purely theoretical/abstract 'understanding' of the second kind of knowledge because it evacuates the body and experience from Spinoza's system: 'In this moment of the second kind of knowledge, I simply insist on this: that the way I have tried to put it does not imply that this is at all an abstract form of knowledge ...' (Deleuze 1978, p. 5). Deleuze gives the case of learning to swim as a paradigmatic example of what we might call this bodily knowledge: if in the first kind of knowledge we 'splash about', precisely as victims to the wave that sometimes crashes into us, sometimes not, in the second kind of knowledge we learn to compose the relations that make up our body – relations of movement and rest – with the relations that make up the body of the wave, and thus 'conquer' this element of our world. In learning to swim we have formed a 'common notion' (Deleuze 1978, p. 5).[9]

These common notions can only be formed off the back of joyful encounters that allow for this knowledge of, as it were, the constitution of the world. This is, crucially, the point of passage, the bridge, between the first and second kinds of knowledge. It is through joy that we begin

to understand the various ways in which two bodies agree, and thus we learn something about the constitutive relations (of movement and rest) of these two bodies. It might be thought that such an emphasis on joy, what has sometimes been labelled the 'affirmative turn' in the humanities, does not, for example, account for knowledge that might arise from sadness, or even anger.[10] However, for Spinoza it is only with joy – experienced when two bodies come together that essentially agree – that we begin to understand something about the commonality of those two bodies in the sense of their respective relations. This is to grasp something about the rules of combination and composition of life.

This is also a specifically active knowledge in the sense that through these 'common notions' we begin to determine the affects that constitute us. We move from being the recipients of shocks to actively organizing our encounters and thus, in this sense, producing our own lives. With the second kind of knowledge we move from spectatorship to participation in and with the world. We are also less affected by passive affects in and of themselves, especially when we are able to separate these affects from their apparent external cause. Indeed, when a passive affect is understood in terms of the second kind of knowledge, in terms of true causality, it ceases being passive. We 'claim' these hitherto passive affects, assuming the causality for them ourselves. To pre-empt slightly what follows, we might note here the connections with the Nietszchean affirmation – or 'claiming' – of even the most negative of affects. We might also note, once again, capitalism's privileging and production of passive affects and the concomitant production of what might be called a subject of the spectacle. A subject that is, precisely, subjected.

The second kind of knowledge is then of relations rather than of just parts. Here, we are still in extension, but have raised ourselves to an understanding of the dynamic and kinetic composition of (at least parts of) the world. It is these relations that give a certain cohesiveness or individuation to a life and that also determine the intrinsic laws of combination with other bodies (the capacity to affect and be affected). We might argue that here we become attuned to the different rhythms of life (and that we can thus combine and compose ourselves with different elements of our world). It is a knowledge in which we move from more or less blind reactivity to understanding. The second kind of knowledge is then no longer merely to follow external 'rules' but also to know the reasons and the logic behind such rules. Relations might themselves cease to be effectuated, but there is nevertheless an eternal truth to them insofar as such relations are independent of their terms (they are not, as it were, exhausted in their effectuation in extensity).

In terms of Deleuze's essay on 'The Three Ethics' the second kind of knowledge involves an understanding of the structure of the world, the reality 'behind' appearance as it were. It is a knowledge of objects rather than merely of the shadows they cast.[11] Such a knowledge must however necessarily arise from the first kind of knowledge. The formation of common notions – or concepts – can only proceed from a particular combination of affects, simply joy, operating as a precursor of conceptual thought and indeed as the platform, or springboard, for the formation of the latter.

These relations are composed all the way to infinity. Indeed, this infinite plane of relations *is* the plane of life or the plane of immanence mentioned above. With the second kind of knowledge it is as if we are on this plane – like water in water – but that we also have a knowledge of the laws of combination within this complex terrain. This is also to understand the *necessity* of this terrain and of the relations thereon. It is in this sense that the 'common notions' themselves express God, or Nature, as the source of all constitutive relations. This knowledge, which, as we shall see, is also knowledge of our own power (or, rather, of the power of which 'we' are an expression), is a knowledge from which, as finite bodies, we are barred at birth, and thus the acquisition of this knowledge involves work (that is, simply, ethics).

We might picture, or more precisely diagram, this understanding of causation and of relations – Spinoza's second kind of knowledge – as in Figure 1.2.

1.2.4 The third kind of knowledge

For Spinoza, the adequate ideas of the second kind of knowledge are not the final word on understanding. There remains something still to be determined, a deeper mystery: what is it that causes the relations themselves? In the third kind of knowledge we arrive at this knowledge, or source (from where and to where the common notions lead). This 'place' is not to do with the history of a specific body–mind (although it is the latter that allows for the journey to be made towards it). It is

Figure 1.2 The second kind of knowledge

knowledge of those essences that express themselves in relations. The passage to this third kind of knowledge is then specifically through the second kind of knowledge – the ethical organization of one's life and the formation of common notions (both of these, in fact, being the same operation) – but it also involves a different kind of operation, a different speed as it were. For, although arrived at through the work of the common notions, essences themselves can be intuitively grasped (this, according to Spinoza, being the knowledge of the 'True Christ').[12] The third kind of knowledge is thus a knowledge of modal essences, a knowledge that leads, ultimately, to God/Nature understood as the source of these essences (or the infinity of modes of substance).[13]

Essences exist outside space and time, that is, in, and as, intensity rather than extensity. They can also be understood as a degree of power or, as Deleuze remarks elsewhere, a particular threshold, or limit point, of intensity. To pre-empt some of the work of Chapter 3 we might say, in Guattari's terms, that the move from the second to the third kind of knowledge is a move from individuality to singularity when the latter is a concern with the pure intensity of life, meaning a general concern with life, death, and so forth, beyond the individual circumstances of a particular life. We might also understand this as what Deleuze himself calls 'Immanence … A life', that anonymous inorganic force that pervades living beings but is not reducible to them. I will be returning to this idea below. For Guattari, again, as we shall see in Chapter 3, it is less essence than a 'strange attractor' that brings these relations of a living being into effect, but the operating procedure seems to be the same: there is a kind of autopoietic point around which a given subjectivity might cohere.

The understanding of causality that is the second kind of knowledge operates as a launch pad for this other intuitive understanding of causality (indeed, the second kind of knowledge produces a kind of thirst for this further knowledge, for further causes beyond adequate ideas). At its limit, however, a leap is required to move from the second to the third. This third kind of knowledge being non-conceptual, and not tied to individual and specifically passive affects, cannot be communicated as such, or commodified.[14] Insofar as capitalism operates predominantly in extensity, that is, concerns itself with bodies and the relations between them (and specifically the extraction of surplus from this), then this knowledge is 'outside' its operating logics.

However, a question here might be whether contemporary capitalism now includes a certain intensive register alongside the extensive: hence the currency of terms such as 'affective labour', 'cognitive capitalism',

and the like. I will briefly return to these issues in my coda to Chapter 3; suffice to say here that it would seem to me that although capitalism's terrain of operation increasingly involves the affective (it siphons surplus value from affective labour) nevertheless this is affect as passive insofar as those whose labour is exploited are not the 'authors' of these affects. As far as this goes, it seems to me that Spinoza's third kind of knowledge, and indeed active affects in general, work against even this latest form of 'affective capitalism'. To a certain extent this addresses a problem inherent in my claim above that the third kind of knowledge is 'outside' capitalism since what is really at stake is a refiguration of what 'is', a converting of the passive to active.[15]

Spinoza's *Ethics* is then a programme followed by an intuition (it proceeds by proofs, but, ultimately, by flashes of truth). The third kind of knowledge involves the same understanding as that produced by the second, but is 'more powerful' in affecting the mind (*E*, Book V, Prop. 36, note, p. 219). It involves adequate ideas, but they are arrived at differently – again, through intuition rather than through proof. Just as joy, a particular complex of affects, allows for – or provokes – the formation of common notions, we might say that common notions themselves allow for – or provoke – this intuitive knowledge of essences. In each case a kind of platform is constructed in order to move beyond that very platform.

Bodies perish insofar as they are in duration, that is, to the degree that they are positioned within time and space, but essences also have a reality outside of this existence ('The essence of things produced by God does not involve existence' (*E*, Book I, Prop. 14, p. 22)). To understand things from the perspective of the third kind of knowledge is then to know a body–mind outside its particular space–time, and under, as Spinoza remarks, a species of eternity. Eternity is not an immortality which remains tied to a certain linear temporality, simply put, a before-and-after. Rather, eternity is here and now. We might say that it parallels, or doubles, our own finitude. This is the infinite as ground of the finite. To make, once more, a passing remark about capitalism, we might say this third kind of knowledge is necessarily not determined by those bodies that are themselves determined by capitalism (such knowledge is 'outside' a homogenized lived-capitalist time).[16] Again, it cannot be bought or sold, precisely because it has no existence within time and space.[17]

As with the second kind, we are born cut off from this third kind of knowledge, separated from our own degree of power. The third kind of knowledge is always there, but we are habitually blind to it, hindered, we might say, by our body of extensive parts. In a move which, as we shall see in the following chapter, informs Lacan's understanding of

the function of psychoanalysis, we must then come to assume this power that we already 'are', converting the passive to the active and ultimately becoming a cause of ourselves. If the first and second kinds of knowledge are of effects and objects, the third is then knowledge of that degree of power that constitutes a self (beginning, necessarily, with a knowledge of the essence of which we are an expression (our own intensive threshold)). Nevertheless, we are also necessarily 'in' duration and thus will always be affected by encounters in the world. Indeed, duration and eternity co-exist in and as our very own bodies (as we shall see in Chapter 3 this is the crucial idea that Negri takes from Spinoza for his idea of the 'materialist field').

It is also in this sense that life becomes a question of what Deleuze calls 'proportionality': making the inadequate part the smaller, and those parts of ourselves that have expressed our essence the larger. We can think this through in terms of our mortality. Because we have a body in duration, a body in extensity made up of parts under a certain relation, we will most certainly die. But insofar as the part of our selves which has expressed our essences is eternal, that part has an existence 'in' eternity. Death occurs only in relation to a specific time and place whereas essences, once more, are eternal. The question for a given subject thus becomes: have you expressed the essence that you are? Have you become the intensity that you are? Existence becomes a test of sorts, a question as to what, in your life, you have assigned importance.

All essences agree (disagreement and destruction can only take place in duration). Part of the character of this third kind of knowledge is then to see things in their necessity. This is to understand the larger web of causality. It is the 'arrival' in a place where everything agrees with oneself, which is to say, produces joy (sadness can only happen in the realm of extensity). The entire world affirms one's being and one's capacity to act (one becomes, as it were, the world, or to put it differently, one causes oneself). This is the beatitude of the third kind of knowledge, a knowledge that is determined by this third kind of extended body.

In terms, once more, of Deleuze's essay on 'The Three Ethics' this third kind of knowledge, a knowledge of essences/singularities, involves a different speed of thought that is mirrored in the actual writing of Book V of the *Ethics*.[18] The propositions and proofs are like a river book, the scholia, a book of fire (or of volcanoes), and Book V a book of air and of lightning flashes.

We might diagram this realm of intensity and essences – Spinoza's third kind of knowledge – in relation to relations and bodies, as in Figure 1.3.

Figure 1.3 Spinoza's topology of expression: 1 Essences; 2 Relations; 3 Bodies; 4 Expression; 5 Effectuation

This is from the 'perspective' of an essence, which expresses itself in relations that are effectuated in bodies. To go in the other direction, that is, from a body that is thrown into the world and which then follows an ethical programme (the three kinds of knowledge) – joy, common notions, then intuition – we might reverse the cone (Figure 1.4).

In passing, it is perhaps worth conducting a thought experiment and superimposing these two cones on one another. This would be to diagram what Deleuze calls a relation of 'reciprocal determination' between modal essences and their existence in extensity. I will return to this – the theme of Deleuze's Univocity – in Chapter 4. What might also be said here is that these two diagrams can seem as if they imply a certain transcendence, whereas, in fact, the three kinds of knowledge might be said to co-exist *on the same plane*, and, as such, might be diagrammed as in Figure 1.5.

To jump to some of the material discussed later in my book, we might say that this composite diagram of the three kinds of knowledge – Spinoza's system flattened – is, in Deleuze and Guattari's terms (as we shall see in Chapter 5), the 'Body without Organs' that operates on and across the plane of immanence (and, in terms of Guattari and Chapter 3, we might say that Spinoza's essences have here become autopoietic nuclei around which a subject might cohere). As Deleuze and Guattari remark in *A Thousand Plateaus* (cited in references as *ATP*):

Figure 1.4 Spinoza's ethics: 1 First kind of knowledge; 2 Second kind of knowledge; 3 Third kind of knowledge; 4 Joy/understanding; 5 Joy/intuition

Figure 1.5 Spinoza's body without organs (with essence/autopoietic nuclei at centre)

> After all, is not Spinoza's *Ethics* the great book of the BwO? The attributes are types or genuses of BwO's, substances, powers, zero intensities as matrices of production. The modes are everything that comes to pass: waves and vibrations, migrations, thresholds and gradients, intensities produced in a given type of substance starting from a given matrix. (*ATP*, p. 153)

The subject, understood as a mode, is then a specifically intensive subject – and a nomadic one at that, insofar as it is in a constant state of becoming (and not, as it were, entirely separate from the process that produces it). In Deleuze's essay 'Spinoza and the Three Ethics' the third kind of knowledge is also described as being a knowledge of 'percepts' (Deleuze 1998, p. 148).

We can turn from *A Thousand Plateaus* to *What is Philosophy?* (cited in references as *WP*) here, where percepts are defined as the 'non-human landscapes of nature', itself another definition of the Body without Organs (*WP*, p. 169). Crucially, the subject here is the result of a process of which it is not the origin. In fact, the process is always more than the subject, which, we might say, is nothing but a selective abstraction and retroactive appropriation of certain parts of the process. Again, I will be returning to this complex and important point in Chapter 5 and at the very end of my book, but it is perhaps worth suggesting here that for Spinoza, a subject is likewise a finite appropriation of a part of the infinite.

1.2.5 Concluding remarks: joy as passageway

It is joy that operates as the passageway between the first and second kinds of knowledge in that it allows the formation of common notions; it is the common notions themselves that operate as a further platform, or preparation, for the intuitive knowledge of essences, which also constitute a form of joy, or beatitude – an affirmation, in and of, the world. This joy is not merely a state of the subject in terms of its ego – or in terms of the first kind of knowledge (that is, a certain 'happiness', when 'I' get what 'I' want) – but is, we might say, a more impersonal intensive state. It represents the conversion of the passive to the active, and, as such, is a particular technology in the production of subjectivity, as well as the very destination of that subject. As well as an intensity it is, as the name suggests, also a kind of knowledge, albeit non-conceptual, insofar as the beatitude of the third kind of knowledge is an idea that, as it were, expresses all of God from God's point of view. In the third kind of knowledge a modal essence thus assumes a perspective of eternity; or in other terms, the finite understands and accesses the infinite of which it is a part.

1.3 Nietzsche's affirmation and the eternal return

> Nietzsche suspected that beyond the (cerebral) intellect there lies an intellect that is infinitely more vast than the one that merges with our consciousness. (Klossowski 1998, p. 33)

> Joy, however, does not want heirs or children, joy wants itself, wants eternity, wants recurrence, wants everything eternally the same. (Nietzsche 1969, p. 256)

1.3.1 Introductory remarks: *The Gay Science*

As I hope I have demonstrated in my relatively brief account of the *Ethics*, joy, for Spinoza, is less an ego state than an ethico-ontological

principle that arises from the understanding of what two or more things have in common – what they agree in – and from the formation of 'common notions' attendant on this agreement. *This* is the role of affirmation in Spinoza's *Ethics*: a kind of technology of the subject's processual production. Negation, in this sense, does not produce any knowledge of commonality, or even of causality, since an understanding of the latter is premised, for Spinoza, on an understanding of the former. This is not to deny that there might be a productive moment in disagreement, critique and so forth, but it is to position the latter as always a second moment, provoked by affirmation itself.[19]

As for Spinoza, so for Nietzsche: affirmation is less a question of happiness *per se* than a particular technology of passage from a certain level of 'knowledge', or state of being, to another. Affirmation is, ultimately, a technology of transformation. This is especially clear with the notion of the eternal return, which I shall be looking at below, but it is also the characteristic tonality of the entire corpus of Nietzsche's writings. In what follows I take as paradigmatic Nietzsche's book *The Gay Science*, also translated as *The Joyful Wisdom*. More specifically, I will be focusing on Book Five, *St Janarius*, the most affirmative of the books therein, and the one in which we find Nietzsche's first articulation of the eternal return. In what follows I also make reference to Deleuze's essay 'On Nietzsche' from *Pure Immanence: Essays on A Life* (cited in references as *I*) and it is to the title essay of that work that I will conclude this second section of Chapter 1.

First, however, a word about Nietzsche's aphoristic style. As opposed to Spinoza's *Ethics*, in *The Gay Science* we have less a system, geometric or otherwise, and more a landscape of sorts, or rather certain features of a landscape which is yet to come, suddenly illuminated by lightning flashes. We are also offered less a diagram of the production of subjectivity and more a dramatization of the latter. This becomes explicit in *Thus Spake Zarathustra*, but in *The Gay Science* it is as if this drama is already being played out with different personae, or personified intensive states, taking on the different parts (all of them gathered under the proper name 'Nietzsche').

1.3.2 Against the capitalist subject

In *The Gay Science* Nietzsche offers up a portrait of the self as typically produced within capitalism. This is a capitalism as it is implicated and integrated within the subject, a capitalism that is 'in here' as it were. In resonance with Spinoza, such a subject is presented as passive and resenting, always subject to someone or something else. We might call

such a subject a specifically reactive mode of being.[20] Indeed, Nietzsche diagnoses our current state as part of the general victory of reactive over creative life. In a foreshadowing of Bergson and his thesis on 'static religion', Nietzsche, in Deleuze's words (in *Pure Immanence: Essays on A Life*) suggests that 'everywhere we see the victory of No over Yes, of reaction over action. Life becomes adaptive and regulative...' (*I*, p. 75).

In its specifically subjective form, this reactive life takes the form of blame or 'projective accusation and recrimination' (*I*, p. 79). There arises an endless cry of 'It's your fault!' This point is the same as that made by Spinoza in relation to the first kind of knowledge: insofar as we inhabit a world of inadequate ideas, or simply reactivity, we invariably mistake effects for causes, blaming always a someone or something else for what we must finally come to assume as our own responsibility. For both Spinoza and Nietzsche this is to be victim in, and to, a world that is not of our authoring.

In contradistinction to this subjection Nietzsche calls for the subject to turn away from any external transcendent principle and, in the words of Pindar, 'become what you are'. Again, the resonances with Spinoza are clear and, as we shall see in the following chapter, the very same injunction is taken up once more in Lacan's *The Ethics of Psychoanalysis*, which involves the same refusal of transcendence. In *The Gay Science* this self-fashioning is to be followed through the cultivation of what Nietzsche calls a certain 'style' of life – that is, through the application of optional rules to one's own subjectivity. As Nietzsche remarks in aphorism 290:

> *One thing is needful* – To 'give style' to one's character – a great and rare art! It is practiced by those who survey all the strengths and weaknesses that their nature has to offer and then fits them into an artistic plan until each appears as art and reason and even weakness delights the eye. (*GS* 290, p. 163)

In a foreshadowing of Foucault's thesis (as we shall again see in the next chapter) to cultivate such a style of life necessarily involves constraint. As Nietzsche remarks: 'It will be the strong and domineering natures who experience their most exquisite pleasure under such coercion in being bound *but also perfected under their own law* [my italics]' (*GS* 290, p. 164).

The Gay Science operates then as an outline for a different production of subjectivity, but also as a kind of diagnostic of the typical subjectivity produced by a transcendent operator, whether this is God – or, in our

own specific time, increasingly Capital. Indeed, this becomes explicit in aphorism 329, where we are offered a powerful diagnosis and critique of the speed of contemporary life and of its profit-driven character. To quote Nietzsche:

> already one is ashamed of keeping still; long reflection almost gives people a bad conscience. One thinks with a watch in hand, as one eats lunch with an eye on the financial pages – or lives like someone who might always 'miss out on something'. (*GS* 329, p. 183)

Nietzsche opposes this 'life in the hunt for profit' to a life of *otium* and leisure, where slowness, hesitation and boredom become the progenitors of genuine thought. As we shall see below, this has a profound resonance with what Bergson will write about the origin of what he calls 'creative emotion'.

Nietzsche's aphorisms in *The Gay Science* are in effect a set of maxims for creative living. This is philosophy as a way of life, as Pierre Hadot might say. Crucially, they involve a series of exhortations to assume responsibility for the production of one's own subjectivity, as opposed to being content with a subjectivity that is already given. Nietzsche's thought is, however, not merely a self-help manual, but aims, ultimately, at nothing less than the undoing of this habitual 'self' which is in itself a reactive mode of being.[21]

1.3.3 Beyond the capitalist subject

Nietzsche's affirmation and call is to a mode of being yet to come. It is in this sense that *The Gay Science* is peopled by 'Preparatory human beings' (see *GS* 283, pp. 160–1), themselves awaiting and prophesizing 'The "humanity" of the future' (see *GS* 337, pp. 190–1). The latter are those who live the gay science and whose lives are thus characterized by joy. Indeed, Nietzsche writes of the 'superabundant happiness' of the passionate ones *contra* the 'soul doctor' Schopenhauer and his 'lie' that happiness is only achievable via the 'annihilation of passion' (see *GS* 326, pp. 181–2).

As opposed to negation and resentment, where any affirmative moment comes second, here affirmation comes first, always first, with any negation operating as a kind of after effect. As Nietzsche remarks (in favour of criticism): 'We negate and have to negate because something in us *wants* to live and affirm itself, something we might not yet know or see!' (*GS* 307, p. 175).[22] In an echo of Spinoza, this state of joyful

affirmation of the world is also characterized by an increase in the capacity to affect and be affected:

> Higher human beings distinguish themselves from the lower by seeing and hearing, and *thoughtfully* seeing and hearing immeasurably more – and just this distinguishes human beings from animals, and the higher animals from the lower. The world becomes ever fuller for someone who grows into the height of humanity; ever more baited hooks to attract his interest are cast his way; the things that stimulate him grow steadily in number, as do the kinds of things that please and displease him – the higher human being always becomes at the same time happier and unhappier. (GS 301, p. 171)[23]

It is worth noting here that this joy does not mean there is no unhappiness, for the latter is the always-present accompaniment of happiness. *Both* of these ego states are affirmed in joy. Joy, we might say, is a specifically inhuman affect (when 'human' denotes simple likes and dislikes). For Spinoza, as we have seen, this increase in the capacity to affect and be affected results, ultimately, in that third kind of knowledge, or beatitude, where everything in the world agrees with one – or, to say the same thing, where one agrees with everything. One becomes world as it were. This is also the power of affirmation – and of the affirmation of the affirmation – in Nietzsche. I shall be returning shortly to this profound moment.

A concomitant characteristic of the higher man is a dedication to knowledge and analysis, or what Nietzsche calls 'physics' (GS 335, pp. 187–9). The latter includes biology, and, in anticipation of Freud, specifically implies an understanding of the drives. Such knowledge is pitted against religion, morality or indeed any transcendent authority. Physics – or science generally – is also, in this sense, inhuman, when the human denotes a particular transcendently determined model. This is an affirmation of immanence insofar as it is an affirmation of the human brain–body assemblage as distinct from a transcendent morality or 'consciousness'.[24] It is in this sense that Nietzsche is the second anti-Christ, after the prince of immanence, Spinoza, and that both thinkers might be understood as the true prophets of the Enlightenment project in its most radical aspect.[25]

This physics, although apparently excluding any morality, is also an ethics in that it implies a mode of behaviour: a searching dedication to analysis and knowledge. *'Life as a means to knowledge'*, as Nietzsche puts it (GS 324, p. 181). It is an affirmation of experimentation that will

inevitably and necessarily be pitched against received opinion. This is to live life as a test and thus to discover the 'great liberator', or simply 'the thought that life could be an experiment for the knowledge-seeker' (*GS* 324, p. 181). As with Spinoza, and, as we shall see, with Bergson also, this is a knowledge that parallels, indeed is premised on, the body. Although there is a speculative, future-orientated character to Nietzsche's thought it is still a knowledge premised on the affects of a biological organism, a knowledge that the body lives, as it were. This is the case, as both Klossowski and Deleuze have persuasively pointed out, in that Nietzsche's physical ill health (his exile *from* health) precisely allowed the affect of joy and the eventual thought of the eternal return. Indeed, Nietzsche's varying health allowed this perspectivism, this passage *through* different intensive states and different personae that characterize his philosophy (in fact it is this mobility that is itself the 'Great Health').[26] I will return to this in my discussion of Deleuze and Guattari's *Anti-Oedipus* in Chapter 5.

In contradistinction to Spinoza, this is then a body that is far from simply 'well', healthy or determined by moderation. It is a body that in its extreme becomings allows for different experiences, different experiments against self-control. As Nietzsche remarks: 'For one must be able to lose oneself if one wants to learn something from things that we ourselves are not' (*GS* 305, p. 174). It is also a knowledge that is not necessarily conscious or rational. Indeed, in a later aphorism, Nietzsche suggests that all knowledge ultimately arises from the drives rather than from the supposedly 'spontaneous' occurrence of a thought in consciousness:

> Since only the ultimate reconciliation scenes and final accounts of this long process rise to consciousness, we suppose that *intelligere* must be something conciliatory, just, and good, something essentially opposed to instinct, when in fact *it is only a certain behaviour of the drives toward one another.* (*GS* 333, p.185)

This is to posit an unconscious, or simply a *body*, that is more intelligent than consciousness since it surpasses the simple – and reductive – idea which the latter has of the former. It is in this unconscious that a large part of 'thought' has its origin, and, we might say, actually takes place.[27] Despite the apparent differences on one level then, the similarities with Spinoza are again remarkable because for Spinoza also, in Deleuze's phrase, 'the body surpasses the knowledge we have of it, *and ... thought likewise surpasses the consciousness we have of it*' (1988a, 118). Following

Nietzsche we might even say that there is an unconscious of sorts in Spinoza insofar as consciousness is a limited – or 'subtracted' – state. Indeed, the third kind of knowledge might be understood as a knowledge of this unconscious, or rather, a knowledge in which this unconscious (of the body, of thought) is made conscious. A pure consciousness in which everything is known clearly and distinctly.

This point is developed in aphorism 335 where Nietzsche's critique of conscious thought also becomes a critique of morality: 'Your judgement, "that is right" has a prehistory in your drives, inclinations, aversions, experiences …' (GS 335, p. 187). Indeed, we have in this aphorism an anticipation of Lacan's own *Ethics*, with its critique of transcendent moral operators and especially of Kant. For both Lacan and Nietzsche, Kant had 'broken open the cage' of an all too human ethics, but had then retreated back with the 'categorical imperative'. The aphorism ends with the same call as is made by psychoanalysis – a call for a kind of authenticity to be lived against received and accepted morality. An authenticity in which we assume responsibility for ourselves: 'We, however, want to *become who we are* – human beings who are unique, incomparable, who give themselves laws, who create themselves!' (GS 335, p. 189).[28]

1.3.4 Affirmation and the eternal return

So, with Nietzsche we have a call for a new mode of being wholly affirming of life and dedicated to a knowledge of the latter. But the question remains how to get there? How to produce this different kind of subjectivity, especially given our own inherent tendency to reactivity? The secret is affirmation itself. As Nietzsche puts it in the very first aphorism of Book Four: 'I want only to be the Yes-sayer!' (GS 276, p. 157). This is to affirm all, and specifically even the negative. To will all, and its return, just as it is. It is this affirmation that transforms even the most passive of affects. For Nietzsche, as for Spinoza, affirmation is a technique of transmutation in and of itself. Indeed, affirmation resonates with the character of life itself when the latter is understood *as* difference, *as* diversity.[29] With the eternal return it is only this – what Deleuze famously names 'becoming' – that truly returns.

In his essay on Nietzsche in *Immanence … A Life* Deleuze is particularly eloquent on this double meaning of the selective nature of the eternal return. First, that it implies an ethics, as we shall see again in a moment, and second that it implies an ontology:

> The eternal return is not only selective thinking but also selective Being. Only affirmation comes back, only what can be affirmed

> comes back, only joy returns. All that can be negated, all that is negation, is expelled by the very movement of the eternal return ... The eternal return should be compared to a wheel whose movement is endowed with a centrifugal force that drives out everything negative. Because Being is affirmed of becoming, it expels all that contradicts affirmation, all the forms of nihilism and of reaction: bad conscience, resentment ... we will see them only once. (*I*, p. 89)

Inasmuch as it is only becoming that truly has Being (fixed 'Being' being nothing but an illusion, and thus, precisely, *false* Being), all else is expunged. The return of the same is only the case in nihilism, when it is an unchanging Being that is affirmed. In the eternal return, as Deleuze remarks 'what is affirmed is the One of multiplicity, the Being of becoming' (*I*, p. 86). Or, as Deleuze has it elsewhere:

> what returns, or is apt to return, is only that which *becomes* in the fullest sense of the word. Only action and affirmation return: Being belongs to becoming and only becoming. Whatever is opposed to becoming – the Same or the Identical – is not, rigorously speaking. (Deleuze 2006, p. 206).

This question of affirmation is also the determining characteristic of the ethical sense of the eternal return. Indeed, in the penultimate aphorism of Book Four of *The Gay Science*, the latter is pitched as precisely a question posed of experience – a wager – that tests this affirmation: 'What if some day or night a demon were to steal into your loneliest loneliness and say to you: "This life as you now live it you will have to live again and innumerable times again; and there will be nothing new in it ..."' (*GS* 341, p. 194). The demon announces the eternal return of the same to which the typical response, as Nietzsche tells us, is abject horror. But, Nietzsche asks, can we imagine a state in which we would affirm this return – and indeed, desire nothing more than the eternal recurrence of the same? *This* is the test: to affirm even the most awful and (hitherto) regrettable moments and, in so doing, transform them. The affirmation called for by the eternal return would then demonstrate a certain attitude to life in which the negative and reactive is wholly expunged. In Deleuze's terms the eternal return, as such, 'gives a law for the autonomy of the will freed from any morality: whatever I want (my laziness, my cowardice, my vice as well as my virtue), I "must" want it in such a way that I also want its eternal return' (*I*, p. 88).

We might note here that the production of a subject *beyond* capitalism is not only characterized by a certain set of knowledges or even of counter-knowledges, but also, and more importantly, by an affective shift away from resentment (the latter being, in fact, the determining characteristic of typical knowledge since the latter is determined by reactivity). We might pause and ask here whether capitalism also involves, anywhere, this kind of affirmation? Capitalism certainly pays lip service to something apparently similar (witness, for example, advertising: 'live for today', 'just do it!' and so forth.) However, it seems to me that these slogans mask deeper affects of sadness and resentment, and further, insofar as they are presented to the subject as external determinants (ultimately to be produced by commodities, or so the promise goes), they are passive in character. The affective landscape of capitalism needs careful analysis in this sense. In Spinoza's terms, for example, the promise of happiness (as with advertising) is itself a form of passive affect because it holds this state off for a future always yet to come. In Nietzsche's terms this analysis needs to be, as it were, a microphysics, an account of the relations between active and reactive forces that make up all phenomena, including individuals.

Ultimately, Nietzsche's affirmation is not, it seems to me, an affirmation of the conscious subject that is constituted through reactivity, and whose horizon of thought is thus its own self-preservation. It is, in this sense, not a human technology at all. Indeed, it is an affirmation that takes over such a subject, and in so doing destroys or transforms it. The eternal return is this inhuman becoming, this yes to the universe outside the human, to a becoming outside identity, to difference 'beyond' sameness and being.[30]

In *Thus Spake Zarathustra* the eternal return likewise becomes an ode to that inhuman joy that is the affective twin of the latter thought:

All joy wants the eternity of all things, wants honey, wants dregs, wants intoxicated midnight, wants graves, wants the consolation of graveside tears, wants gilded sunsets,
what does joy not want! It is thirstier, warmer, hungrier, more fearful, more secret than all woe, it wants *itself*; it bites into *itself*, the will of the ring wrestles within it,
it wants love, it wants hatred, it is superabundant, it gives, it throws away, begs for someone to take it, thanks him who takes, it would like to be hated;
so rich is joy that it thirsts for woe, for Hell, for hatred, for shame, for the lame, for the *world* – for it knows, oh it knows this world!

You Higher Men, joy longs for you, joy the intractable, blissful – for your woe, you ill-constituted! All eternal joy longs for the ill constituted.

For all joy wants itself, therefore it also wants heart's agony! O happiness! O pain! Oh break, heart! You Higher Men, learn this, learn that joy wants eternity,

Joy wants the eternity of all things, *wants deep, deep, deep eternity*! (Nietzsche 1969, p. 258)

Once more, this joy cannot be reduced to happiness, for it also wants the opposite. Like Spinoza's third kind of knowledge, the joy of the eternal return involves an affirmation of all encounters (since in the third kind of knowledge there cannot be a sad encounter). This is a veritable state of identification with the world, where all agrees with one, and one agrees with all. The eternal return is also a joy 'under the species of eternity' as Spinoza might have it. It is a joy that wants eternity, that seeks eternal recurrence. In the final section of this first chapter I shall be looking at Bergson's intuitive leap into the pure past or that ontological ground of our individual being. It seems to me that this is the leap that Nietzsche also makes. A leap into eternity, or that 'place' where all life, every past state, is repeated. In anticipation of the diagrams to come we might draw this leap, and thus the eternal return, as in Figure 1.6.

Figure 1.6 Nietzsche's eternal return (through different 'levels' of intensity)

1.3.5 Concluding remarks: on a life

In the essay on 'Immanence ... A Life' Deleuze remarks that the subject of great literature is precisely this ontological ground or inorganic life that expresses itself through us but which cannot be reduced to the life of an individual. It is life as anonymous force, something 'within' us that connects us to the outside of ourselves. Indeed, literature – after Spinoza, Nietzsche and Bergson – might be said to be the fourth key philosophical touchstone for Deleuze because literature, for Deleuze, is itself a kind of philosophy. It is also a further resource for the production of subjectivity. Literature operates as a diagnostic of states of affairs, but is also concerned with that inorganic and impersonal 'life' from which these lives have been individuated.[31]

In Deleuze's essay this 'life' is also called the transcendental field, a plane of a-subjective consciousness, from which subjects and objects are themselves 'transcendents' (*I*, p. 26). Subjects and objects are both, in this sense, events that have been actualized in specific states of affairs. This transcendental field is only visible on the thresholds of life: thus death (as with the example Deleuze takes from Dickens with the 'rogue' on the very edge of extinction) and birth (and, as Deleuze suggests, with young children in general). However, we might also say, following our discussion of Nietzsche, that it is through illness that this life, or 'Great Health', becomes visible. Here, illness provides a point of view on health (again, the moving between health and illness, between different intensive states *is* the 'Great Health'). This is Nietzsche's peculiar and powerful thesis on perspectivism, a thesis that he lived.

Following Spinoza we might say that 'A Life' partakes of essences and of that beatitude that is the intensive state of the latter. As Deleuze remarks: 'We will say of pure immanence that it is A LIFE, and nothing else. It is not immanence to life, but the immanent that is in nothing is itself a life. A life is the immanence of immanence, absolute immanence: it is complete power, complete bliss' (*I*, p. 27). Following Spinoza once more, and in a foreshadowing of Bergson, this is also a life that moves in a different kind of temporality to that of bodies and states of affairs. It is a strange kind of 'duration' in which the past, present and future are all co-extensive, 'the immensity of an empty time where one sees the event yet to come and already happened, in the absolute of an immediate consciousness ...' (*I*, p. 29). This is the 'experience' of a motionless time in which all life is repeated endlessly. Is this not the same temporal terrain as Nietzsche's eternal return?

1.4 Bergson's plane of matter and the cone of memory

> ... there is in matter something more than, but not something different from, that which is actually given. Undoubtedly, conscious perception does not compass the whole of matter, since it consists, in as far as it is conscious, in the separation, or the 'discernment' of that which, in matter, interests our various needs. But between this perception of matter and matter itself there is but a difference of degree and not of kind ... (*MM*, p. 71)

1.4.1 Introductory remarks: *Matter and Memory*

Henri Bergson's *Matter and Memory* amounts to a revolution in thought, a radical 'switch' in how we understand ourselves, and especially our relation to the past (understood as that which is 'outside' our present experience). For Bergson, we are not composed of a body and of a mind inhered within the latter. Indeed, we are not a vessel or a container for our memories (Bergson's thesis is a critique of interiority in this sense), but more like a point or probe that is moving through matter and which is itself part of the very matter through which it moves. In order to negotiate this strange landscape, with its challenges to common (or Cartesian) sense, two principles are useful. The first, as Bergson himself suggests in his foreword, is that we remember that all mental life, ultimately, is determined by action. An absolutely speculative function of the mind, divorced from experience and action, does not, for Bergson, exist (although, as we shall see, this does not prohibit a kind of speculation understood as intuition). The second principle, that in some sense follows from this, is that the past has not ceased to be, but has merely ceased to be useful as regards this action. It is in this sense, again as we shall see, that the past is coextensive with the present. It survives in a pure, albeit unconscious, state.

In what follows I will be especially concerned with the status of, and possibility of accessing, this pure past, which might also be understood as a kind of ontological ground of our individual being. It is my contention, following Bergson, and especially Deleuze's reading of him, that this past might be a resource of sorts in the production of a specifically different kind of subjectivity. Another way of saying this is that in what follows I am interested in the possibility of breaking habit since the latter, in its extreme form, staples us to the present and stymies access to this realm of potentiality (indeed, typical subjectivity *is* a habit, constituted as it is by a bundle of repeated reactions).

Bergson's particular philosophical method allows for a form of 'travel' beyond our habitual, or all too human, configuration. It involves the

dividing of composites – in this case matter (objectivity) and memory (subjectivity) – along lines that differ in kind, following these lines beyond the particular composites to the extremes before returning, armed with a kind of superior knowledge of what, precisely, constitutes the mixtures. Habitually, we do not 'see' these divergent lines because we are condemned, in Deleuze's terms in *Bergsonism* (cited in references as *B*), 'to live among badly analysed composites, and to be badly analysed composites ourselves' (*B*, p. 28). We are subject to certain illusions about who and what we are, and the world in which we find ourselves – caught within representation as it were. Bergson's intuitive method hence involves a kind of thinking, or more precisely intuiting, of a larger reality 'beyond' this confused state of affairs, beyond our particular 'human' mode of organization and our specific form of intelligence that is derived from utility. Following Spinoza, we might add that this intuition is also a kind of knowledge of that which lies 'beyond' our own very particular (that is, human) spatio-temporal coordinates.

It is in this sense that despite Bergson's idea of the utilitarian nature of thought, or, we might say, of intelligence, philosophy itself is an attempt at a kind of speculation – an intuitive speculation as it were – beyond Kant's conditions of possible experience (in Bergson's terms, simply habit) towards the conditions of 'real experience'. This is what Deleuze calls 'transcendental empiricism': 'To open us up to the inhuman and the superhuman (*durations* which are inferior or superior to our own), to go beyond the human condition: This is the meaning of philosophy...' (*B*, p. 28).

This work of speculative intuition might also lead to a pragmatics of experimentation insofar as attempting to 'think' beyond the confused mixture that we are itself opens up the possibilities for constituting ourselves differently. Indeed, if capitalism controls the matrices of emergence, or simply determines what is possible (what we can buy, what there is 'to do', and so forth) then Bergson allows a kind of thinking outside these parameters. In understanding the mechanisms of actualization of the virtual – I will go further into these terms in a moment – it becomes possible to think of, and perform, different actualizations. In an echo of Spinoza there is then an implicit ethics here, since Bergson's philosophy addresses the question of what our bodies, understood as actualizing machines, are capable.[32]

My commentary, that attends specifically to Chapter 3 of *Matter and Memory*, 'On the Survival of Images', coheres around one diagram – taken, initially, from Bergson's book – that will be built up in the following two sections. The final part of this third part of the chapter extends

this diagram through a brief commentary on another of Bergson's major works, *The Two Sources of Religion and Morality* (cited in references as *TS*). Here, I am especially interested in the mystic as the one who accesses/actualizes this pure past/virtuality, and 'utilizes' it in the production of a specifically different kind of subjectivity.

I attend in some detail to Bergson's thesis, as the diagram – the rightly celebrated cone of memory – is important to the arguments in my book in general, showing as it does a particular relationship between matter and memory, the actual and virtual, but also, one might say, between subject and object, or, indeed, between the finite and infinite. It can be used, as I intimated at the end of the last section above, to image Nietzsche's eternal return (and thus perhaps also Spinoza's third kind of knowledge); it is central to Deleuze's three syntheses of time in Chapter 2; and, it makes a re-appearance – superimposed on to other diagrams – in Chapter 3 on Foucault–Lacan, and in Chapter 4 on Guattari.

Before beginning my exegesis however, a word about Bergson's often difficult style that marks it out from both Spinoza and Nietzsche. *Matter and Memory* is characterized by looping repetitions, with Bergson coming at the same problem time and again with different inflections. There is also the gradual building up of definitions and the concomitant use of familiar terms to name specifically different entities or processes (for example, image, representation, or the 'general idea'). There is also the fact that Bergson tends to pitch his ideas against other more dominant theories of memory. All of this makes *Matter and Memory* less than a straightforward read, and yet it also adds force to Bergson's thesis, as if the style of presentation itself works to undo typical dualistic (again, Cartesian) ideas one might have about life, subjectivity and memory.

1.4.2 The plane of matter

For Bergson the past has not ceased to exist, but has merely ceased to be useful in the present. As Bergson remarks: 'My present is that which interests me, which lives for me, and in a word, that which summons me to action; in contrast my past is essentially powerless' (*MM*, p. 137). In fact, this present, in which we are situated, always occupies a certain duration, the actual present moment itself being an unattainable mathematical point. My present is precisely a 'perception of the immediate past and a determination of the immediate future' (*MM*, p. 138). It is in this sense that we are determined by our pasts, but are also specifically future-orientated beings.[33] It is also this orientation that determines our particular world, our consciousness being nothing other than the awareness of this immediate past, and especially of this impending future.

Another way of saying this is that 'my present consists in the consciousness I have of my body', which '[h]aving extension in space', 'experiences sensations and at the same time executes movements' (*MM*, p. 138). My body, in this sense, is simply a 'centre of action', or locus of stimulus and reaction: 'Situated between the matter which influences it and that on which it has influence, my body is a center of action, the place where the impressions received choose intelligently the path they will follow to transform themselves into movements accomplished' (*MM*, p. 138).

I will return to this question of intelligence below, but we might note here the similarities that this motor-sensori schema has with Spinoza's first kind of knowledge: both name our general condition of being in, and reacting to, the world. In both accounts we are, simply put, extended bodies among other extended bodies on a plane of matter. Indeed, this sensori-motor schema – as Bergson calls it – constitutes our experience of material reality.[34] Again, the similarities with Spinoza, and especially with Deleuze's reading of the latter, are remarkable, for what Bergson is saying here is that our capacities to affect, and be affected by, the world constitute our world insofar as it is a world of matter.

Our body, understood as this 'system of sensation and movements', occupies the very centre of this material world since the latter is necessarily arranged around it. The body, in Bergson's terms, is then a 'special image', situated among other images, that constitutes a 'section of the universal becoming' of reality itself (*MM*, p. 151). 'It is ... the *place of passage* of the movements received and thrown back, a hyphen, a connecting link between the things which act upon me and the things upon which I act – the seat, in a word, of the sensori-motor phenomena' (*MM*, pp. 151–2). This 'sectioning' of reality is determined by perception, and the interests of the organism that determines the latter. The body might then be thought as a kind of hole in the universe: that which does not interest me, and thus that which is un-sensed, passes through me and carries on in that network of contact and communication in which all things participate. It is 'I' that disrupts this contact and communication of the universe. 'I' am the interruption. 'I', as a centre of action, am a partial obstacle in the endless becoming of the universe.

It is also in this sense that the universe is bigger than any consciousness we, or any other organism, might have of it. Indeed, we are like a series of shutters closed against different aspects of this universe. This is not, however, to posit an unbridgeable gap between my own world and a universe 'beyond', for my own world is capable of being expanded (or indeed

narrowed). In passing we might note here Bergson's sidestepping of the Cartesian trap that posits an 'I' *and then* a world. For Bergson – and it is *this* that gives his writings their speculative character – it is always the world, or universe, that comes first and then the 'I' as a subtraction from it.

The plane of matter that we perceive, or indeed *can* perceive (given our particular psycho-physical structure *as it is*), might then be doubled by another plane that contains all that has no interest for us *as we are*. A kind of spectral (and dark) double to our own universe. The plane is infinite in character in both cases. 'Our' plane of matter – our world as it were – carries on indefinitely: there are always further objects behind the present ones. We can call this first plane the system of objects. It constitutes our 'natural' world, but also our manufactured one: a plane of capitalism insofar as it is the plane of bodies and markets, of commodities, shopping and other 'possibilities' of life. It contains, in a word, that which has interest for me as a human organism, but also as a subject of capitalism. Since we have a body, or bodily functions, we have an existence in this world and on this plane. The other plane – the double – is also infinite in character insofar as it 'contains' an infinite field of not-yet-actualized virtualities (things that are unperceived – unsensed – by me). I will be returning to this idea of a double to the plane of matter in my discussion of Badiou in Chapter 4.

It is then the interests of the organism that dictate the arrangement of its world, since 'the objects which surround us represent, in varying degrees, an action which we can accomplish upon things or which we must experience from them' (*MM*, p. 144). And it is this spatial organization that also determines a particular temporality. As Bergson remarks:

> The date of fulfillment of this possible action is indicated by the greater or lesser remoteness of the corresponding object, so that distance in space measures the proximity of a threat or of a promise in time. Thus space furnishes us at once with the diagram of our near future, and, as this future must recede indefinitely, space which symbolizes it has for its property to remain, in its immobility, indefinitely open. Hence the immediate horizon given to our perception appears to us to be necessarily surrounded by a wider circle, existing though unperceived, this circle itself implying yet another outside it and so on, ad infinitum. (*MM*, p. 144)

We might diagram this plane of matter, with an 'I' at the centre and the circles of the future arranged concentrically around the latter as in Figure 1.7.

Figure 1.7 Bergson's plane of matter (with 'I' at centre)

But this plane, and its spectral double, is not everything, for things also exist that do not have an interest for me and thus that do not produce sensations (which is to say are not in my consciousness), but that are also not, as it were, on the plane of matter at all. The past is precisely this: inextensive and powerless, it still exists albeit in an unconscious state. As Bergson remarks: 'We must make up our minds to it: sensation is, in its essence, extended and localized; it is a source of movement. Pure memory, being inextensive and powerless, does not in any degree share the nature of sensation' (*MM*, p. 140).

This past might become useful and thus conscious, but when it does this it ceases to belong to this realm of the past and becomes present sensation. The actualization of a virtual memory – recollection – is precisely this becoming-present of the past. Just as we do not doubt the existence of objects that we do not perceive, as long as they are objects that have been perceived or are, at some point, capable of being perceived (such objects being merely outside of our immediate concern), Bergson suggests, likewise, that our past exists – or subsists – even though it is not fully present to consciousness at that time. Again, the past has not ceased to exist in this sense but has only ceased to be of interest to us.

In passing we might posit the existence of a further spectral double to this past that is unconscious, a spectral past that contains the pasts of other consciousnesses – pasts that are not mine, and that perhaps are not even human. I will return to this towards the end of this chapter, but we might note here, again, that it is intuition, and not intelligence, that allows access to these other non-human durations.

Just as in Deleuze's Spinozist definition of a tick (with its small world determined by just three affects), or, indeed, in Leibniz's definition of a monad, any given world is constituted against a dark background, the 'immensity of the forest' that holds no interest for the organism in question.[35] This dark background is not simply composed of those objects that are yet to be perceived, but is composed of that matter which holds no interest whatsoever, at least to the particular organism

Figure 1.8 The line of matter and the line of memory

as it is at that moment of perception. Once more, however, the crucial point is that this 'larger world' is not inaccessible, not barred from experience, but is indeed a given in experience. It is the background, or simply ground, from which the body/organism, and its particular perception, is a subtraction.[36]

Following Bergson's own diagram, we can then draw this image of matter and memory on two axes that can be superimposed on our earlier diagram of the plane of matter that is itself constituted by ever wider circles of those objects that interest us (capitalism) – an infinitely receding horizon that constitutes our future – superimposed on the dark background of that which holds no interest (Figure 1.8).

In Figure 1.8 line AB represents objects in space, while line CI represents objects in memory (objects which no longer interest us). As complex bodies – or subjects – we exist at the point of intersection between these two lines, this point being the '...only one actually given to consciousness' (*MM*, p. 143). These lines are then drawn against the two dark backgrounds mentioned above: of that which has no interest for me in the future, but also of that which has no interest for me in the past. In fact, these two backgrounds are one and the same: the powerless past and the future in which I have no interest constitute the virtual worlds that surround my actuality.[37]

We are active on the plane of matter, which is to say, following Spinoza, we are not just the passive receivers of shocks. Nevertheless, it is an activity that is still premised on passive affects, and especially

on fears and desires, threats and promises, themselves determined by pleasure and pain. We might say then, again following Spinoza, that it is still the realm of the first kind of knowledge insofar as in it – on the plane of matter – we are still subject *to* the world.

Indeed, memory itself, as it is called forth by a present action, might also be thought of as part of the first kind of knowledge since it only becomes effective on the plane of matter when it operates to aid an already determined action on that plane (I will return to this process of recollection in a moment). This is habit, and, at an extreme, it determines our character, understood as a kind of extreme compression of all our past habitual reactions. Looking once more at Figure 1.8 the point here is that it is only those memories that are useful that become conscious. So, as for the infinitely receding circles of the plane of matter, so too there are receding circles for the past. Indeed, 'the adherence of this memory to our present condition is exactly comparable to the adherence of unperceived objects to those objects which we perceive; and the *unconscious* plays in each case a similar part' (*MM*, p. 145).

1.4.3 The cone of memory

It is as if then there are two memories, different but connected. The first, 'fixed in the organism, is nothing else but the complete set of intelligently constructed mechanisms which ensure the appropriate response to the various possible demands' (*MM*, p. 151). This is a memory stored in the body as habit. A memory whose proper terrain of action is the plane of matter or totality of objects. This is the realm of reactivity, the realm of typical response in which we follow, blindly as it were, our desires and turn away from our fears. It is an animal realm of sorts, or, at least, a realm determined by a pleasure principle.

The second is 'true memory', which, 'coextensive with consciousness', 'retains and ranges along side of each other all our states in the order in which they occur, leaving to each fact its place and, consequently, marking its date, truly moving in the past and not, like the first, in an ever renewed present' (*MM*, p. 151). This is a memory that is more neutral, and ultimately, apersonal. We might even say inhuman in that it is not selective or connected to the needs of the organism as the latter exists on the plane of matter. It is less memory as such than a general 'pastness'. Ultimately, it is also a species-memory, or even a kind of cosmic memory of the universe in that it extends far beyond the individual (and it is in this sense that both 'my' cone of memory, and that of any life beyond me – the double I mentioned above – are one and the same). The individual is nothing more than a local

46 *On the Production of Subjectivity*

stoppage within this pure past, which we might also call, following Deleuze–Bergson, the virtual.

In many ways it is more appropriate to no longer think of this as the past at all – and the plane of matter as the future – but simply to think about these two realms in terms of what is useful and what is not. After all, notions like past, present and future constitute, for Bergson, particularly confused illusions about the world and our own situation within it. This virtual realm might then be understood as a realm of infinite potentiality, whereas the plane of matter – the actual – is very much the terrain of our finitude, tied as it is to the specific interests of the organism. Indeed, following Spinoza's understanding, death only occurs on the plane of matter. The realm of the pure past, on the other hand, precisely, survives. Part of our own incorporeal reality partakes of this realm, or, again following Spinoza, part of ourselves has an existence under a species of eternity. We are not just the finite organism (we are somehow 'part' of this virtual) – although in another sense this is precisely all we are (a habitual set of mechanisms). The connecting link between these two distinct kinds of memory is simply our body that exists on the plane of matter but which, in the very act of perception, calls up images from memory. Thus we have Bergson's celebrated cone of memory (Figure 1.9), where this true memory hangs, 'like a gyre',

Figure 1.9 Bergson's cone of memory (from 'On the Survival of Images', *Matter and Memory*)

over the plane of matter – anchored by a body on that very plane, but with its base extending far into the virtual realm.

Here are Bergson's comments on his diagram:

> If I represent by a cone SAB, the totality of the recollections accumulated in my memory, the base AB, situated in the past, remains motionless, while the summit S, which indicates at all times my present, moves forward unceasingly, and unceasingly also touches the moving plane P of my actual representation of the universe. At S, the image of the body is concentrated, and, since it belongs to the plane P, this image does but receive and restore actions emanating from all the images of which the plane is composed. (*MM*, p. 152)

The cone then, fixed to the plane of matter by the sensori-motor schema but extending far into the past, is specifically dynamic involving two kinds of memory that are nevertheless connected. The first, 'bodily memory', or habit, is the apex of the cone, ever moving, inserted by the second, 'true memory' in the 'shifting plane of experience' (*MM*, p. 152). Each kind of memory lends the other its support:

> For, that a recollection should appear in consciousness, it is necessary that it should descend from the heights of pure memory down to the precise point where *action* is taking place. In other words, it is from the present that the appeal to which memory responds comes, and it is from the sensori-motor elements of present action that a memory borrows the warmth which gives it life. (*MM*, pp. 152–3)

For Bergson it is the 'constancy of this agreement' between these two movements, between the apex and the base, that characterizes what he calls a 'well balanced mind', or a 'man nicely adapted to life' (*MM*, p. 153). A lived life involves the coming and going, the oscillation, between these two states.[38]

There are two extreme positions that help define this process. First, the 'man of impulse' who lives predominantly on the plane of matter and for whom memory's role is solely the exigencies of immediate action: 'To live only in the present, to respond to stimulus by the immediate reaction which prolongs it, is the mark of the lower animals: the man who proceeds in this way is a man of *impulse*' (*MM*, p. 153). Following Spinoza once more, this would be an individual consigned to live solely in the first kind of knowledge. A purely reactive mode of being.[39] Second, there is the dreamer: 'But he who lives in the past for

the mere pleasure of living there, and in whom recollections emerge into the light of consciousness without any advantage for the present situation is hardly better fitted for action: here we have no man of impulse but a *dreamer*' (*MM*, p. 153). In passing we might note here Nietzsche's comments (see footnote 23) about the spectator of life as opposed to the active creator. As Bergson remarks: 'Between these two extremes lives the happy disposition of memory docile enough to follow with precision all the outlines of the present situation, but energetic enough to resist all other appeal. Good sense, or practical sense, is probably nothing but this' (*MM*, p. 153).

Nevertheless, good sense can also be understood as a kind of limiting common sense that adapts to things the way they already are. Again, this would be the 'use' of memory to serve the present and any action determined by the plane of matter as it is already constituted. To a certain extent this is the production of an efficient and functional being (within capitalism as it were). It is in this sense that it might be 'useful' to think about those cases when memory actualizes the pure past, but not necessarily for any utility. In fact, Bergson goes on to write about such cases, and specifically the dream state mentioned above:

> But, if almost the whole of our past is hidden from us because it is inhibited by the necessities of present action, it will find strength to cross the threshold of consciousness in all cases where we renounce the interests of effective action to replace ourselves, so to speak, in the life of dreams. (*MM*, p. 156)

This is the temporary suspension of the sensori-motor schema that allows the past to be actualized, *not* in the service of the present but in and as itself. Following my comments above we might say that this is the actualization of the virtual in and of itself, outside of the immediate interests and concerns of the organism. We might turn again to Nietzsche here, this time to his more positive definition of idleness as the progenitor of genuine creative thought (see page 30). Walter Benjamin also says something similar in his own aphoristic style: 'Boredom is the dream bird that hatches the egg of experience. A rustling in the leaves drives him away' (Benjamin 1999a, p. 90). Here non-productivity – hesitation, stillness – is in and of itself creative.

In fact, this hesitation of the sensori-motor schema – situated at point S between the actual and virtual – is also that which is constitutive of

us *as* humans beyond habit as it were. The gap between stimulus and response is produced, almost as a side effect, by our brain–body assemblage (or, simply, our nervous system), which in its complexity, instantiates a temporal gap insofar as any reaction to a given stimulus has the 'choice' of a variety of pathways in response. A moment of indeterminacy is introduced into the system. A 'stopping of the world' we might say, that constitutes our difference from the 'lower animals' and brings about a certain freedom of action (insofar as we are no longer tied to immediate reactivity). This is not a difference set in stone, for it might be the case that such a hesitation can be produced in other 'higher animals' and certainly that it might be produced in life forms to come, or in AI for that matter.

In any case this gap, that can be further opened up by slowness or stillness (or indeed other 'strategies' of non-communication), might in itself allow a certain freedom from the call of the plane of matter with its attendant temporality (as we have seen the plane of matter, or system of objects, implies a certain temporality – of past, present, future – and of time that passes between these). Again, this is the actualization of an involuntary memory, via a gap in experience, that has no utility for the present.[40] In an echo of Spinoza, this gap is then a passageway of sorts 'out' of the plane of matter that determines a certain reality. It is an access point, or portal, to the infinite as that which is within time, but also outside it.

As we shall see in the next chapter, the content of this Bergsonian cone might also be understood in Lacanian terms as the Real insofar as it 'contains' everything not part of the sensori-motor schema (habit) which here can be understood – in its most expanded sense – as the realm of the symbolic (language, as it is typically employed, consisting of a certain adaptation, however complex this might be, to the concerns of the plane of matter).[41] In Badiou's terms, as we shall see in Chapter 3, we might understand the 'content' of the cone as 'inconsistent multiplicity' in that it 'contains' everything not counted in the situation/world as it is (located on the plane of matter and within the system of already counted objects). It also explains why certain elements of the past *are* counted, simply that they 'aid' the present situation. Here history is always a history of a given 'present', counted by and for that 'present'. We might note the importance of circumnavigating this particular 'history of the present' and of excavating a different history, what we might call a 'present of history'.[42] Indeed, the present in this latter sense is *produced*, in part, by the reactivation of past present moments.[43]

Figure 1.10 Bergson's cone of memory with 'levels' (from 'On the Survival of Images', *Matter and Memory*)

We return to Figure 1.9 and add, following Bergson, more detail to obtain Figure 1.10. And, once more, Bergson's comments:

> between the sensori-motor mechanisms figured by the point S and the totality of the memories disposed in AB there is room ... for a thousand repetitions of our psychical life, figured as many sections A'B', A"B", etc., of the same cone. We tend to scatter ourselves over AB in the measure that we detach ourselves from our sensory and motor state to live in the life of dreams; we tend to concentrate ourselves in S in the measure that we attach ourselves more firmly to the present reality, responding by motor reaction to sensory stimulation. (*MM*, pp. 162–3)

The realm of memory is then fractal in nature. Depending on the level 'accessed', less or more detail comes into focus, or, in Bergson's terms: 'So a nebulous mass, seen through more and more powerful telescopes reveals itself into an ever greater number of stars' (*MM*, p. 166). Indeed, as I briefly intimated above, on the 'highest' level all recollections are shared. This is also the most dispersed level, where every memory – every virtuality – has its own place complete in every detail. The content of the cone is a veritable universe of galaxies, each a complex constellation of different durations.

Depending on its location towards the summit or the base this repetition is smaller or larger, but, in each case, is a 'complete representation of the past' (*MM*, p. 168). The lowest point of the cone, point S, 'corresponds to the greatest possible simplification of our mental life' (*MM*, p. 166). At AB, on the other hand, we 'go from the psychical state which is merely "acted," to that which is exclusively "dreamed"' (*MM*, p. 167). Here, in a 'consciousness detached from action' there is no particular reason why any given memory will actualize itself – no reason that we would 'dwell upon one part of the past rather than another' (*MM*, p. 167). 'Everything happens, then, as though our recollections were repeated an infinite number of times in these many possible reductions of our past life' (*MM*, p. 169).[44] We have here an explanation of the different 'tones' of mental life – slices through the cone – a whole temporal mapping as yet unexplored.

Just as there are relations of similarity, that is to say *'different planes*, infinite in number' of memory (*MM*, p. 170), so there are relations of contiguity on these planes: 'The nearer we come to action, for instance, the more contiguity tends to approximate to similarity and to be distinguished from a mere relation of chronological succession … On the contrary, the more we detach ourselves from action, real or possible, the more association by contiguity tends merely to reproduce the consecutive images of our past life' (*MM*, p. 171). In this sense there is a whole complex ecology of memories – or what Deleuze calls 'regions of being' (*B*, p. 61) – inhabiting each plane, with 'always some dominant memories, shining points round which others form a vague nebulosity. These shining points are multiplied in the degree to which our memory expands' (*MM*, p. 171).

We might note again that we have here a different theory of history (indeed, we could imagine Bergson writing a philosophy of history using the cone as diagram). At different degrees of detail different moments/events will be foregrounded and take on relevance and importance. We also have something stranger with the idea that there might be different 'personal' histories – composed of intensive states – 'contained' within the cone. Is this not Klossowski's Nietzsche, who in the eternal return passes through different intensive states – precisely as an oscillation between base and apex – that he 'identifies' as different historical characters? We shall also see in Chapter 5 that this has some bearing on Deleuze and Guattari's idea of subjectivity as processual (and the subject itself as a residuum) as it appears in *Anti-Oedipus*.

We might then draw this complex ecological subjectivity, and the plane of matter on to which it is pinned, as in Figure 1.11.

Figure 1.11 'Shining points'/fractal ecology in cone

1.4.4 The mystic

> It is only at its topmost point that the cone fits into matter; as soon as we leave the apex, we enter into a new realm. What is it? Let us call it the spirit, or again, if you will, let us refer to the soul, but in that case bear in mind that we are remoulding language and getting the word to encompass a series of experiences instead of an arbitrary definition. This experimental searching will suggest the possibility and even probability of the survival of the soul ... Let us betake ourselves to the higher plane: we shall find an experience of another type: mystic intuition. And this is presumably a participation in the divine essence. (*TS*, p. 264)

The plane of matter, or what I have also been calling the system of objects, is also the realm of 'static religion' as it is laid out in Bergson's *The Two Sources of Religion and Morality*. Here habit includes intelligence and the myth-making function as modes of utilitarian adaptation to the world. Indeed, just as instinct meets its terminal point in insects and the hive, so intelligence is also a terminal point that finds its ends in man. But Bergson's 'vital impulse', in man at least, finds ways of extending itself beyond this intelligence. Indeed, it is from the plane of matter – and through the especially complex organisms that inhabit it – that the journey of life continues. This is precisely intuition in Bergson's sense, an intuition that operates *contra* intelligence and that allows an

access to that which lies 'beyond' the plane of matter, rediscovering, as Deleuze puts it 'all the levels, all the degrees of expansion (*détente*) and contraction that coexist in the virtual Whole' (*B*, p. 106).

Indeed, the 'creative emotion' of *The Two Sources* is 'precisely a cosmic Memory, that actualizes all the levels at the same time, that liberates man from the plane (*plan*) or the level that is proper to him, in order to make him a creator, adequate to the whole movement of creation' (*B*, p. 111). Again, it is a certain hesitancy that allows for this journey. The gap between stimulus and response is here an 'interval' that is opened up within the habits/rituals and intelligence of society (a specifically disinterested interval as it were). Just as the body, at a certain degree of complexity, allows for this hesitancy, so the myth-making function itself (or, static religion) puts the conditions in place for a further gap – again, a 'stopping of the world' – and a concomitant movement 'beyond' itself. This is Bergson's definition of 'dynamic religion'.

Deleuze notes that: 'This liberation, this embodiment of cosmic memory in creative emotions, undoubtedly only takes place in privileged souls' (*B*, p. 111). Indeed, it is the mystic that embodies the latter, and, in a direct echoing of Spinoza, the experience of such a mystical persona, or personified intensive state, is characterized by joy. To quote Bergson:

> It would be content to feel itself pervaded, though retaining its own personality, by a being immeasurably mightier than itself, just as iron is pervaded by the fire which makes it glow. Its attachment to life would henceforth be its inseparability from this principle, joy in joy, love of that which is all love. In addition it would give itself to society, but to a society comprising all humanity, love is the love of the principle underlying it. (*TS*, p. 212)

In a further echo of Spinoza's third kind of knowledge, this mystical experience is then also seen as divine: 'In our eyes, the ultimate end of mysticism is the establishment of a contact, consequently of a partial coincidence, with the creative effort which life itself manifests. This effort is of God, if it is not God himself' (*TS*, p. 220). Indeed, for Bergson, mystical experience is God – or the 'creative effort' – acting through an individual soul. This then is the movement of intuition beyond intelligence. The latter stymies the former, but also puts the conditions in place for its activation. The cone of the mystic might then be drawn as in Figure 1.12.

Figure 1.12 Cone of the mystic: 1: Static religion (habit/ritual), 2: Dynamic religion (introspection/intuition), 3: The mystic

1.4.5 Concluding remarks: capitalism and the attention to life

The above might lead one to believe that contemplation is the final moment of the *élan vital* and, as such, that inaction is the privileged mode of a different production of subjectivity. Certainly, capitalism encourages and extracts surplus from an endless productivity, and, in this sense, a certain slackening in the sensori-motor schema (and concomitant dreaming) works to upset a utilitarian outlook, to counteract the dominant injunction to live at a certain speed of life (the 'always-being-switched-on', or, more generally, the regulative speed of the market) and to resist the world of commodities that accompanies the latter.[45] With no movement beyond the plane of matter there is no freedom from this capitalism as it were, at least, no freedom from the present plane of purely utilitarian interest.

This then is to suggest a strange kind of agency in which non-agency is key. A production of subjectivity in which production, at least of one kind, is stymied. It is to privilege an involuntary memory that does not come to the service of the plane of matter but allows a circumnavigation of the concerns of this terrain. It is a call to slow down, to hesitate, to open and occupy what Deleuze calls 'vacuoles of non-communication' (Deleuze 1995, p. 175). Ultimately, it is a kind of super-productivity that arises from non-productivity; the sidestepping of given subjectivity – that is already determined by the plane of matter – and a surrendering

of kind to that which lies 'outside' the subject-as-is.[46] Bergson suggests in *The Two Sources* that this intensive state is also produced by wine, drugs, hashish, 'protoxide of nitrogen', indeed any Dionysian mechanism that disables the intelligence (the latter, again, being that which stymies access to the divine) (*TS*, p. 218).[47]

On the other hand, to dream is to remain passive. This passivity is the second peril that arises from too great a detachment from life. It lacks the activity – or participation – that the plane of matter gives life. One might think here of the Situationist thesis on the Spectacle understood as not just the world of commodities, advertising and so forth, but also the way these inculcate a position of being a spectator of one's own life. We might also return here to Bergson's thesis in *Matter and Memory* and note what he says about a certain 'attention to life' that is determined *by* action:

> Our body, with the sensations it receives on the one hand and the movements which it is capable of executing on the other hand, is then, that which fixes our mind, and gives it ballast and poise … these sensations and these movements condition what we might term our *attention to life*, and that is why everything depends on their cohesion in the normal work of the mind, as in a pyramid which should stand on its apex. (*MM*, p. 173)

Following Bergson then, and despite what I have said above about a common sense that is limiting, we might say that although the gap and the passage to the virtual is crucial, on its own this is not enough. It must, in fact, be translated back into action on that plane from which it departed. This is the case for an individual who returns from memory to action, but also for the mystic who returns from cosmic-memory to action:

> there is an exceptional, deep-rooted mental healthiness, which is readily recognizable. It is expressed in the bent for action, the faculty of adapting and re-adapting oneself to circumstances, in firmness combined with suppleness, in the prophetic discernment of what is possible and what is not, in the spirit of simplicity which triumphs over complications, in a word, supreme good sense. Is not this exactly what we find in … mystics? (*TS*, p. 228)

Indeed, for Bergson mystics are characterized less by contemplation than by a 'superabundant activity' (*TS*, p. 232). They are filled with the 'superabundance of life' and thus have a 'boundless impetus' for action (*TS*, p. 232). Crucially however, this is not, it seems to me, the

recollection of a past in the service of a predetermined action – that is, habit. Rather, it is precisely the opposite of this: the return circuit is used as a means for freeing up a habitual repetition which has lost some of this circularity and mobility. In passing we might suggest that it is the latter – a kind of freezing of actual–virtual circuits – which, it seems to me, characterizes capitalism's terrain of operation to the extent that this extends into the virtual.

In the terms of my own book's thematic this travel is precisely from the finite to the infinite, but involves a return back to the finite. In more prosaic terms we have here the beginnings of an ethico-politcal account of memory: the actualization of past events in the present in order to counteract that present. A kind of calling to, or re-calling of, the past. The past operates here as resource against the present, at least to the degree that such a present is limited to a logic of the possible – determined by a perspective of what, precisely, already constitutes the plane of matter. We might also think here of Badiou's militant who, as we shall see in Chapter 4, has a fidelity to an event that might have happened in the past, but that is actualized in the present in order to transform the latter.[48] The militant 'lives' history in this sense.

Again, following Badiou, we might suggest that the two circuits – of the mystic and militant – are similar, each accessing that which is beyond the plane of matter/the situation or world as it is in order to

Figure 1.13 Return path/circuit of the mystic/militant

return and transform that very plane 'using' whatever has been learnt on the 'journey' (Figure 1.13). In each case it is action – or the attention to life – that determines the circuit, although this action must be understood as one that is undetermined by habit. It is, in fact, the possibility of a different future action that directs the circuit of the mystic and the militant and that in itself implies and produces a different world (in passing, we might also say that it is this return to the plane of matter that constitutes the realm of politics in general insofar as the latter is concerned with the former).

It is a human – at point S – that is then both the possibility of this journey and that which prevents it (the attentive reader will notice here that the diagram in Figure 1.13 is the same as in Figure 1.6 – Nietzsche's eternal return – albeit there are further arrows that constitute it as a diagram of politics). It is what we do on the plane of matter – again, at point S – that determines whether we can exit this plane, as well as the consequences of this exiting (and of our subsequent return). In terms of the latter I will be thinking more about fidelity and consequences – in relation to Badiou – in Chapter 3. In terms of the former, is it the case, for example, that certain arrangements of matter might work as a platform for the journey? Certain specific practices for example? Indeed, what is the role of preparation in this diagram? This is the subject matter of my next chapter that brings Bergson's cone into conjunction with both Lacan's *The Ethics of Psychoanalysis* and Foucault's 'Care of the Self'.

2
The Care of the Self versus the Ethics of Desire: Two Diagrams of the Production of Subjectivity (and of the Subject's Relation to Truth) (Foucault versus Lacan)

2.1 Introductory remarks: desire contra ethics?

With the 'discovery' of the unconscious, and the introduction of desire into questions of an individual's motivation, Freud in one fell swoop renders all previous accounts of ethics, and thus of the subject, partial.[1] Bluntly put, psychoanalysis demonstrated explicitly for the first time, that there is something else that determines our behaviour up and beyond (or indeed, below) the 'good,' whether it be our own, someone else's, the good of society/humanity, or 'the good' in a more general and abstract sense.[2] It is this revolution in ethical thought that is the subject of Jacques Lacan's seminar on *The Ethics of Psychoanalysis* (cited in references as *EP*), a revolution that is also a redefinition inasmuch as the latter is then not to do with the good at all, at least not in the above sense, and also not to do with what Lacan calls 'the service of goods' (that includes the accumulation of wealth, commodities and so forth), but with that very desire – unpredictable, non-productive and unconscious – that will necessarily upset any such moral position. It is also this that marks psychoanalysis with tragedy insofar as such desire, in operating *contra* this good (and especially the good of the individual), is also a being towards death.

The goal of Lacanian analysis – if it can be said to have one – is then less a 'cure' or the production of a healthy productive individual (that is, the building up of the ego and the making of a 'good' person) than the assumption of what might be called the subject of the unconscious that can only take place via the dismantlement of the various imaginary identifications that led to the former, including the various ethical ones (precisely about being a good person and so forth). This is not an ethics

of the individual at all, at least not of the conscious subject, rather, it is an ethics concerned with that impersonal desire that the former masks and which, for Lacan, constitutes the very truth of our being. It is, we might say, an ethics turned upside down.

In this second chapter I want to excavate further this strange notion of ethics, and the concepts of desire and truth that it implies, via a commentary on the concluding session of Lacan's seminar.[3] I am especially interested in how the deployment of these concepts implies a particular kind of subject, or, we might say, a particular production of subjectivity.[4] As a foil to this I will be comparing the latter with Michel Foucault's ideas about ethics as they are laid out in the introductory lectures of *The Hermeneutics of the Subject* (cited in references as *H*) (with some asides to Foucault's interviews on his late work and especially 'On the Genealogy of Ethics: An Overview of Work in Progress' (from the collection *Ethics: Subjectivity and Truth* [cited in references as *EST*], pp. 253–80). If it is Lacan more than any other post-Freudian who sharpens and accelerates the challenge implied by psychoanalysis for ethics, then it is Foucault who takes up the further critical project of excavating an alternative tradition of ethics – the 'Care of the Self' (the *epimeleia heautou*) – first practised by the ancient Greeks, but which Foucault argues is directly relevant to our own ethical situation in the contemporary world. I am specifically interested here in whether this particular ethical programme, which in some senses is pitched against Lacan's subject of desire, might itself be understood as a form of 'the good' in Lacan's terms. Is Foucault's 'Care of the Self' part of that ethical tradition that Lacan undermines, or does it in fact involve a different understanding of ethics that brings it closer to the psychoanalytic programme itself? Following this evaluation I will also be concerned with the specifically constructive nature of Foucault's 'Care of the Self', and, explicitly in Section 2.3, with Foucault's notion of spirituality – or simply the idea that access to truth must involve a prior preparation by the subject who is then, in turn, transformed by that very truth.

There are major differences between my two archives, not least the one positioning desire as central, the other pleasure, but there are also, as I have just intimated, important resonances.[5] Indeed, an immediate similarity is that both were intended specifically as oral discourses (being delivered as 'seminars'). Both were open to all, and in both, I would argue, we see thought in action with the working out of the possibilities for a contemporary ethics (albeit this is often done via various historical analyses). A second resonance is that both attend to the relation one has with oneself *contra* any external power (Lacan) or

control/dependence (Foucault). This important point will be explored throughout the chapter. For myself there are also resonances around the programmatic nature of both thinkers that lead from this orientation. These will be addressed in Section 2.2 by the reintroduction of Spinoza, whose own *Ethics* works, it seems to me, to bridge the ethical positions of Lacan and Foucault (and who therefore remains a presence throughout this second chapter).

A fourth and more secret resonance, which I attend to in Section 2.4 (with some help from Deleuze and through diagrams), and which the previous two sections of commentary have been working towards, involves what might be called the ethical destination and the subject's relation to truth. Another way of putting this is that both Lacan and Foucault announce a finite subject that holds the infinite within, albeit in two different articulations that will then involve two different kinds of relation – or non-relation. In shorthand, and to think diagrammatically, these are the torus for Lacan and the fold for Foucault. Towards the end of this section I attempt a synthesis of these two: a composite diagram of the production of subjectivity that also draws in the key diagram of the previous chapter, Bergson's cone of memory, as a further 'connector' between my two protagonists.

In Section 2.5, which operates as an afterword of sorts, I conclude my comparative study with an examination of the two different articulations of the subject's work that follow from these diagrams: the 'path of the hero' in Lacan's *Ethics* and the idea of 'life as a work of art' that Foucault develops in his late interviews. Here I am explicitly interested in something that is implicit throughout the chapter, namely the turn both thinkers make away from the typical Cartesian subject towards what we might call a subject-yet-to-come, and it is towards this future subject (again with some help from Deleuze) that my concluding remarks are directed.

One further introductory remark. In general what follows intends a reading of Lacan that attends to the seminar as a pragmatic text for the production of subjectivity rather than to any structural interpretation that, for example, looks at Lacan's interest in the signifier or focuses exclusively on language in the construction of the subject (although I will return to this briefly at the very end of the chapter). As far as this goes I am interested in Lacan's *Ethics* as a kind of technology of the self, to use Foucault's term. In my treatment of Foucault the logic is reversed in that I will not be dwelling on the specifics of his historical analyses, or on the particularities of the technologies of the self that he excavates, except in passing, but will focus rather on the notion of the 'Care of

the Self' itself as a kind of structural event – an event in thought that produces a relation to oneself and a concomitant freedom for and of the subject.[6]

2.2 Spinoza between Lacan and Foucault

Lacan begins the final session of his 1959–60 seminar on *The Ethics of Psychoanalysis* with the comment that any ethics whatsoever presumes a judgement on an action that in itself contains a judgement of sorts, which is to say a meaning. Freud's insight, or hypothesis, that 'human action has a hidden meaning that one can have access to', means, as far as Lacan is concerned, that psychoanalysis too has an ethics, or a 'moral dimension', and that 'in what goes on at the level of lived experience there is a deeper meaning that guides that experience' (*EP*, p. 312). As Lacan suggests, this is less a discovery as such than the 'minimal position' of psychoanalysis, albeit it is also the founding theory of any notion of what Lacan calls 'inner progress' (*EP*, p. 32).

There is, however, a crucial difference between the latter and psychoanalysis and this comes down to the question of the good. For typical/traditional ethics (following this notion of 'inner progress') there is, at bottom, and according to Lacan, the assumption that once meaning has been worked out there will be 'goodness'. Goodness is, as it were, the origin and *telos* of traditional ethics (in the seminar Lacan demonstrates that this tradition has its roots in Aristotle's *Nicomachean Ethics*, a work that then operates as a cornerstone for all subsequent ethical definitions). In order to counteract this prevailing ethical assumption Lacan reminds us of the thought experiment of the 'Last Judgement' that he introduced earlier in the seminar. Put simply, this is to project forward and imagine oneself at the end of one's life, or, in a parallel manner, to bring death forward as an event in life. The Last Judgement is then the operation of a standard by which to reconsider ethics in relation to 'action and the desire that inhabits it' (*EP*, p. 313).[7] From the perspective of the Last Judgement the question becomes: have you lived the life you wanted to lead beyond any injunction to the good, or, in more concrete terms, in terms of the acquisition of goods themselves (that is, wealth, commodities, status, and so forth)? As Lacan remarks: 'The ethics of psychoanalysis has nothing to do with speculation about prescriptions for, or the regulations of, what I have called the service of goods' (*EP*, p. 312).

In contrast to this traditional and typical ethical position, which judges an action against the good (however this is thought), the ethical

judgement for psychoanalysis, arising from a recognition of the nature of desire that lies at the heart of experience, is simply: 'Have you acted in conformity with the desire that is in you?'(*EP*, p. 314). This question might be opposed, as Lacan remarks again, to the 'service of goods that is the position of traditional ethics' and that invariably involves '[t]he cleaning up of desire, modesty, temperateness, that is to say, the middle path we see articulated so remarkably in Aristotle' (*EP*, p. 314). The latter is, for Lacan, the 'morality of the master, created for the virtues of the master and linked to the order of powers' (*EP*, p. 315). Such an ethics is then one that is tied to a transcendent schema and thus one that *subjects*.

It might be remarked straight away that Foucault's 'Care of the Self' would seem to fall precisely into this latter category of ethics that Lacan's own *Ethics* seeks to undo. Certainly, the 'Care of the Self' involves an ethical trajectory of sorts – towards the good – and in the outlining of a mode of life that is beneficial for the subject there seems to be implied an ethical judgement that arises from an external rule against which such a judgement is made. There seems, on the face of it, as if some kind of transcendent operator is in place.

However, this would be to misconstrue how ethics, or simply the notion of a good life, is deployed within the archive that Foucault excavates. Indeed, for Foucault's ancient Greeks the ethical rule is specifically one that is chosen freely by the subject and then applied to the self by the self. The 'Care of the Self' must then be understood as a distinctly individual matter, a personal choice (and thus a personal judgement) made by the subject himself rather than as a judgement made on an action from an outside agent or as the result of an external law. As such, the ethical judgements of the 'Care of the Self' might be seen as precisely a turning away from transcendent principles and be understood rather as a kind of pragmatics that brings the 'Care of the Self' closer to psychoanalysis itself (and indeed to the Nietzsche of the previous chapter).

In fact, Foucault gives us a succinct definition of this 'Care of the Self' at the very beginning of his seminar on *The Hermeneutics of the Subject* that clearly show its distance from Aristotle (at least as Lacan reads him), and also, at least in the first two points, its resonances with psychoanalysis. First then, the 'Care of the Self' is 'a certain way of considering things and having relations with other people'; it is an 'attitude towards the self, others, and the world' (*H*, p. 11). Second, it is a 'form of attention, of looking'; 'a certain way of attending to what we think and what takes place in our thought' (*H*, p. 11). And third, perhaps most important, it also names a series of actions – or practices – that are

'exercised by the self on the self' and 'by which one takes responsibility for oneself and by which one changes, purifies, transforms, and transfigures oneself' (*H*, p. 11). The 'Care of the Self' is then less an ethics based on a transcendent law or authority than an intention, a mode of attention, and a particular practice or set of practices.

We can note in passing that it is perhaps the nature of these practices of the 'Care of the Self' that mark a distance from psychoanalysis. Such practices, which involve 'techniques of meditation, of memorization of the past, of examination of conscience, of checking representations which appear in the mind, and so on', do not just involve 'talking' or indeed any other signifying regime (although they might mobilize these) (*H*, p. 11). Indeed, to borrow the terminology of Guattari, one of Lacan's analysands and perhaps, eventually, his most trenchant critic, such technologies will tend to operate on an asignifying register.[8] I will be returning to this important point towards the end of the chapter (and to Guattari's asignifying semiotics in Chapter 3).

Nevertheless, as I suggested above, there is a sense in which the 'Care of the Self' does seem to operate from a knowledge or presumption of what is good for the subject in the sense that it cannot but imply a judgement about actions, thoughts and so forth. This can be illustrated with just one of the technologies Foucault writes about, that of 'checking representations which appear in the mind' (*H*, p. 11). This has a striking similarity to Cognitive Behavioural Therapy with its emphasis on the production of a healthy functioning subject (the building up of the ego), with all the criticisms that Lacan makes of this. There is then something to be worked out further here, namely the question of whether Foucault's subject can be identified with the ego in Lacan's terms (that is, the conscious subject) and thus whether these two thinkers are indeed ethically opposed.

In order to think this through, it is useful to return to Spinoza, who, I would argue, very much stands between Foucault's ancient archive and Lacan's more contemporary articulations. Indeed, I would argue that Spinoza calls forth the ethical revolution that Lacan *and* Foucault (in his turn to the ancients), both, in their own manner, continue. This is a revolution that involves a critique of any transcendent notion of the good (and a concomitant thinking of immanence), written by, as Deleuze and Guattari once called him, the 'Christ of philosophers' (*WP*, p. 60).

On the face of it however, Spinoza, like Foucault's ancient Greeks, seems to be precisely an ethical thinker in the sense Lacan portrays the ethical canon 'before' psychoanalysis. Certainly the 'middle path' of

modesty, temperance and so forth is exactly that advocated by Spinoza.[9] As with Foucault then, there seems to be an ethical dictate within Spinoza insofar as there are certainly injunctions to the subject to live a 'good life'. Simply put, there are judgements as to what is good and what bad for the subject. As such Spinoza, like Foucault, appears to follow the typical notion of ethics understood as a dictate to follow the 'service of goods'. There is also a sense in which Spinoza, like Foucault (at least in some of the technologies of the self he examines), suggests a turning away from the 'worldly winds', the habits of pleasure seeking and so forth, towards a life determined by reason and discipline. This, on the face of it, is also a turn from desire; certainly it is a call to mastery, which, for Lacan, is always a discourse of power.

There are however also striking resonances between Spinoza's *Ethics* and Lacan's. On the one hand, for Spinoza, as we saw in the previous chapter, ethics involves an understanding of causation and then acting accordingly, that is to say, ethically in one's best interest. Such best interest is not necessarily what one might automatically assume, at least from the position of the subject as constituted – in Spinozist terms, we might say from the perspective of the subject of the first kind of knowledge (the situation we find ourselves in the world as it were, or, we might say, the subject who is *subject to the world*). Indeed, a thorough understanding of causation will necessarily involve going beyond the interests of the subject-as-is – and this will necessarily also involve going against the desires of such a subject insofar as the latter are determined by what Freud–Lacan would call the pleasure principle (this is a form of desire that Lacan's own ethics of desire runs counter to). Spinoza's *Ethics* might be understood then as a kind of framework for self-analysis in terms of producing a knowledge not immediately apparent to the subject-as-is.[10]

As far as the outlining of a 'good life' goes, we can also say that Spinoza's *Ethics* is more a set of operating procedures, or a pragmatics, than a system of moral precepts. Indeed, although Spinoza does outline a lifestyle that is optimum for realizing more and more knowledge (of causation), for becoming more of what one is, it follows from his *Ethics* that it is experimentation rather than such dictates that constitute the real ethical mode of behaviour insofar as we cannot know in advance whether a given encounter will be productive and generative for us (and, as such, we also cannot legislate ethically for others). The only thing we can be sure of is that we *do not know* – from the perspective of our ego, as Lacan might say – what we are, and thus, ultimately, what is 'good' for us, at least in advance of any given encounter.

This amounts to a further, more profound resonance around what might be called the ethical destination. As we saw in the previous chapter, for Spinoza, as for Lacan, the relentless pursuit of causation will necessarily go beyond the mere 'knowledge' of this causation. Indeed, the avowed goal of analysis, 'to become a cause of oneself', is the same as the goal of Spinoza's *Ethics*, namely to 'arrive' at a state of being when one is no longer subject to the world (and to those within it), but authors oneself.[11] Through a kind of work on the self one must take responsibility, paradoxically, for that which came before one's self and indeed caused one to come into being (it is in this sense that Lacan, like Spinoza, announces a strange temporality of the subject: its always retroactive formation).

Foucault's 'Care of the Self' is also about working on oneself in this sense in order to access a certain kind of understanding – or truth – that otherwise is masked. This work necessarily involves a taking responsibility for oneself. Indeed, as we shall see, it is this – what might be called a principle of *self*-mastery – that constitutes the importance of the ancient Greeks for Foucault, insofar as they demonstrate a method of self-governance that, for Foucault, might operate against neo-liberal governmentality and a politics of a self beholden to the transcendent operator that is Capital (or, in more precise neo-liberal terms, 'the Market').

We might say then that Foucault's 'Care of the Self' *does* involve an ethical trajectory and judgement, but ultimately, as with Spinoza, it is one not legislated for by anything outside that subject, and it is also one that is *not* for the good of the subject-as-is, but rather is in preparation for a subject that is yet to arrive. In fact, as Jean Mathee has convincingly argued, Lacan's own ethics, as laid out in the seminar, also involves a trajectory of this kind inasmuch as it is structured as a journey of sorts in which different ethical dictates, or masters, are 'overcome' in the production – or assumption – of the self as cause of itself. It is, in Mathee's figuring, a journey from the outside edge of the torus – where our habitual life is led as it were – to the very centre, the place of desire, what Lacan, following Freud, calls *das Ding*. I will be returning to this topology below.

We can now return to the question of whether Foucault's subject is opposed to Lacan's – and make the provisional claim that, in fact, they have much in common. For both, as for Spinoza, there is a similar turn away from any transcendent ethical dictates *and* from the privileging of the subject as they are already constituted in the world. In each of these thinkers this is a turn away from the conscious subject – the ego – to something stranger, something that interrupts this economy of the

subject-as-is, of business as usual.[12] In Badiou's terms, and to pre-empt some of what follows in Chapter 4, we might say that it is a turn from the subject of knowledge to a subject of truth. It is now time to look a little more closely at what Foucault says about this truth and in particular about the subject's accessing of it.

2.3 Spirituality and the accessing of truth

At the very beginning of his 1981–2 seminar at the *Collège de France*, published as *The Hermeneutics of the Subject*, Foucault announces his interest in attending to what he sees as an important historical and philosophical shift that occurs around the understanding of the self and our attitude towards it. This shift, which results ultimately in the Cartesian subject, involves the supplanting of an older idea of the 'Care of the Self' with the more familiar ethical precept to 'Know Thyself'. In fact, this particular historical study is, for Foucault, part of a more general enquiry, that again we might say has recently been reanimated by the writings of Badiou, and which is summarized by Foucault thus: '[i]n what historical form do the relations between the "subject" and "truth" ... take shape in the west?' (*H*, p. 2).

Foucault posits a number of hypotheses for this change in ethics and especially for the concomitant denigration of the 'Care of the Self' that occurs thereafter. First, that this older ethical injunction to care for one's self sounds – to modern ears – like either an individualist and self-centred 'moral dandyism' or 'like a somewhat melancholy and sad expression of the withdrawal of the individual ...' (*H*, p. 13). Foucault points out that originally the injunction to care for one's self did not have these negative connotations (of egoism and withdrawal), but in fact purely positive ones. A further paradox is that the austere disciplines and practices called for by this 'Care of the Self' do not in fact disappear, but are taken up again albeit in the milieu of Christian asceticism with its doctrine of the renunciation of the self and in the shift to the more confessional 'Know Thyself'. As Foucault has it in the interview 'On the Genealogy of Ethics': 'between paganism and Christianity, the opposition is not between tolerance and austerity but between a form of austerity linked to an aesthetics of existence and other forms of austerity linked to the necessity of renouncing the self and deciphering its truth' (*EST*, p. 274).

The main reason for the shift, however, is more philosophical and has to do with the subject and truth, and indeed with how truth itself is understood. In fact, Foucault identifies a specific 'Cartesian moment' in

which the practices of the 'Care of the Self' are replaced with practices of knowledge, with the latter understood as that which is apparent to the senses and to the subject-as-is. This is the positioning of self-evidence as origin of truth. It is, we might say, to install knowledge in the place of wisdom. In passing, we might note that this is the beginning of what Quentin Meillassoux calls the 'correlation': with the Cartesian moment the subject becomes the origin of knowledge of the world, but a world he or she is ultimately barred from in the very deployment of that knowledge (or mediation).[13]

Foucault contrasts this modern (and somewhat reductive) account of knowledge with a notion of 'spirituality', which 'posits that the truth is never given to the subject by right' (H, p. 15).[14] Foucault continues:

> Spirituality postulates that the subject as such does not have right of access to truth. It postulates that truth is not given to the subject by a simple act of knowledge (*connaissance*), which would be founded and justified simply by the fact that he is the subject and because he possesses this or that structure of subjectivity. It postulates that for the subject to have right of access to the truth he must be changed, transformed, shifted, and become, to some extent and up to a certain point, other than himself. The truth is only given to the subject at a price that brings the subject's being into play... It follows from this point of view that there can be no truth without a conversion or a transformation of the subject. (H, p.15)[15]

Truth, in this older tradition, is only reached on the condition of a prior preparation and of a price paid by the subject, that is, by an asceticism of some kind. Not only this, but such truth, once accessed, has a reciprocal feedback impact on the subject, a 'rebound' effect as Foucault calls it: 'The truth enlightens the subject: the truth gives beatitude to the subject' (H, p. 16). Truth, we might say, is a transformative technology that takes the subject out of him or herself.

Indeed, this experience of truth, although prepared for by the subject, is not of the same order as the preparation. It is not, we might say, 'of' the subject at all. We might note here the similarities with the movement from the second to third kind of knowledge in Spinoza (as well as in the description of beatitude common to both accounts).[16] As we saw in the previous chapter, the second kind of knowledge – the work of reason and the formation of 'common notions' – prepares a platform as it were for the third, intuitive kind of knowledge (which we might also call a more immediate knowledge of truth). However, as I also suggested

in Chapter 1, a leap of sorts is required by the subject that wishes to traverse the first two kinds of knowledge and access the third. Another way of thinking this is that something beyond, or 'outside' the subject-as-is must play its part. It is as if, at the last moment, and after any preparation made by the subject, the object must itself act and reach out to that subject. We might say, following Jean Mathee's formulation, that there must be a moment of grace – but also a subject who is prepared and open to such grace (or simply open to an 'outside' understood as that which is beyond the subject as already constituted).

With the Cartesian moment, which in fact is less a single moment than a historical development, there is then a privileging of knowledge – understood in the Cartesian sense – over this other form of knowledge. As Foucault remarks, such knowledge, in the Cartesian sense, does 'not concern the subject in his being' or indeed 'the structure of the subject as such', but only 'the individual in his concrete existence' (*H*, p. 18). This has profound implications for the ethical subject. As Foucault remarks in the interview 'On the Genealogy of Ethics':

> Thus I can be immoral and know the truth. I believe this is an idea that, more or less explicitly, was rejected by all previous culture. Before Descartes, one could not be impure, immoral, and know the truth. With Descartes, direct evidence is enough. After Descartes we have a nonascetic subject of knowledge. (*EST*, p. 279)

Once again, the similarities with Badiou's own theory of the subject are worth commenting on: the production of subjectivity – when it is not merely the production of a subject of knowledge – operates *contra* knowledge (or, at least, such knowledge can only be a preparation for such a subject). In Badiou's terms, this subject has nothing to do with the encyclopaedia (that is, the set of knowledges about the world as is), but is concerned with a truth that is always at odds with the latter and indeed calls the very subject into being (via an 'event').

The redefinition of truth as knowledge (in the Cartesian sense) immediately achieves a number of things. Positively, it sets up the conditions for science and for the Enlightenment more generally (the infinite progression of theorems and proofs). It also sets up the human sciences and the will – and confidence – to 'explain' life via knowledge. Negatively however, it reduces the subject to a subject of science, a subject limited to what already is, and to a particular idea of what knowledge is or can be. As such it also produces a concomitant suspicion towards any knowledge not based on scientific principles (for example those that

imply a mutable subject position such as meditation and other introspective technologies).[17]

Importantly however, Foucault suggests that nineteenth-century philosophy still has elements of the aforementioned spirituality (Foucault mentions the German tradition: Hegel, Schelling, Schopenhauer, Nietzsche, Husserl and Heidegger) in which 'a certain structure of spirituality tries to link knowledge, the activity of knowing, and the conditions and effects of this activity, to a transformation in the subject's being' (*H*, p. 28).[18] There are also other kinds of knowledge in which the state of the subject is directly implicated in any access to truth (albeit this spiritual dimension has tended to be obscured, or played down, shifted to questions of social organization and the like). It is at this point in *The Hermeneutics of the Subject* that Foucault mentions, alongside Marxism, psychoanalysis and Lacan (*H*, p. 27). To quote Foucault, once more at length:

> The interest and force of Lacan's analyses seems to me to be due precisely to this: It seems to me that Lacan has been the only one since Freud who has sought to refocus the question of psychoanalysis on precisely this question of the relations between the subject and truth ... Lacan tried to pose what historically is the specifically spiritual question: that of the price the subject must pay for saying the truth, and of the effect on the subject that he has said, that he can and has said the truth about himself. By restoring this question I think Lacan actually reintroduced into psychoanalysis the oldest tradition, the oldest questioning, and the oldest disquiet of the *epimeleia heautou*, which was the general form of spirituality. (*H*, p. 30)

This is then to understand psychoanalysis, in Foucault's terms, as a form of *parrhēsia*, or truthful speech. It is, again, to think analysis as a specific technology of the self, albeit one in which a non-intrusive change is brought about as the result of the subject overhearing him or herself speaking. However, Foucault follows this insight with the immediate qualification, and reservation, about whether psychoanalysis can in fact formulate this spiritual question given that, for Foucault, the former involves the deployment of knowledge about the subject which is precisely what the *epimeleia heautou* does not do. Indeed, knowledge – however this is thought – is not enough for Foucault. The 'Care of the Self' has to be a practice that results in a transformation.

But, given my account above, we might ask whether Lacan's ethics can be reduced to knowledge in the sense Foucault gives the term? Certainly the former is positioned *against* ethical knowledge in terms of

dictates from without (from any masters), but also in terms of the turn it makes from the Cartesian subject and from the knowledge implied by the latter.[19] Indeed, if any kind of knowledge is implied by psychoanalysis it is a knowledge that has more in common with Spinoza's second and third kinds of knowledge – that is, a knowledge of causation and ultimately of truth. Indeed, Lacan's subject is, like Foucault's, not a subject of knowledge understood in the Cartesian sense at all but something that undermines the latter and, especially in Lacan's case, the certainty with which the Cartesian gesture proceeds to found its particular subject. Again, we might call this distinctly other state of being simply a subject of truth.

Perhaps the question to ask here is then about the relation between Foucault's and Lacan's notions of truth. Certainly, for Foucault, truth is something 'outside' the subject as constituted. It is something non-human if by human we understand something specifically Cartesian. Truth is the state of being once one's finite self, in terms of worldly desires and so forth, has been 'mastered' allowing one, as it were, to then experience the infinite. In fact, we might say then that such truth, as an experience of the infinite, 'extracts' the subject from their finitude or simply their mortality. Again, the resonances with Spinoza are worth remarking on: for the former ethics is likewise a work against the passions (or passive affects), or, to give this a Nietzschean slant, a 'becoming active' that ultimately produces a mode of being *sub specie aeterni* (but *not* an immortality). This is the accessing by a finite being of the infinite out of which they have been constituted.

For Lacan's *Ethics*, on the other hand, truth is *das Ding* or simply the Real. And the Real is everything that is left out in the constitution of the subject of knowledge, or, in Lacanian terms, the subject of the symbolic (desire then is not 'of' this Real as such, but is the state of the subject alienated from the latter and thus always desiring it). For Lacan the analytic interest is how this alienation in the symbolic has taken place, or in his own turn of phrase (in the *Ethics*) how a subject has 'eaten the book'. In *The Ethics of Psychoanalysis* it is implied that a subject can, ultimately, arrive at this Real, the void of *das Ding* at the heart of experience, but it is equally implied that this truth would be the subject's undoing. *Das Ding* is the place of greatest desire but also greatest fear, hence, the pleasure principle that throws up diversions at every step of the way, diversions that include the 'service of goods'.

Indeed, psychoanalysis, by inventing an unconscious – the place of *das Ding* – that is fundamentally other to the subject-as-is might be seen, despite its avowed intention, to be setting up a bar of sorts that

in fact stymies the subject's transformation. The specifically Lacanian unconscious is marked further by the alienation of this Real within the symbolic (indeed the unconscious is the result of the subject's alienation 'within' the latter). This might be compared with Spinoza (and Nietzsche) for whom rather than a conscious/unconscious division there are just different degrees of knowledge of causation. In a Spinozist sense then, the unconscious might be understood simply as the fact that there is more to what we are than what we think we are, or, to put it another way: we do not know what we are and we certainly do not know of what our bodies are capable. It might be said, again from a Spinozist perspective, that the majority of the processes of the body (and thus of the mind) *are* unconscious, *but* they are not barred from knowledge; they are simply yet to be known. Again, put simply, for Spinoza, there is a continuum between what is known and what is unknown and depending on the state of the subject, that is their ethics, the line moves from the unknown to the known. A similar point might be made from a Bergsonian perspective insofar as that which we do not know is merely yet to be of interest.

For Foucault too there is a sense that the subject can access the unknown through work on the self and specifically, as with Spinoza, through a life of temperance.[20] Indeed, such a life – lived against the pleasure principle we might say – allows for this increase in knowledge when the latter is understood as a movement towards truth. As with Spinoza, this is to foreground the importance of practice in terms of an ethical life over and above any notions of an abstract 'good', but also against any notions of confession, or of the deciphering/unveiling of an authentic self – or more truthful desire – 'behind' the subject as manifested.

2.4 The question of power and the question of topology (the fold and the torus)

It might be argued then that Lacan's definition of traditional ethics as a judgement made in the light of 'the good' leaves out the crucial matter of practice that both Foucault and Spinoza foreground. For Spinoza especially, such practice, or what we might call an ethical programme (of experimental encounter, but also of temperance) allows for an increase in our body's capacity to affect and to be affected, and thus for a concomitant increase in our understanding of causation. Ultimately, the aim of such an ethical code is less to be 'good' (or indeed bad) in whoever's eyes, than simply to increase our capacity to be. In Spinoza's terms it is to express more and more of 'our' essence, resulting,

paradoxically, in becoming more of what we already are. This implies a processual attitude to subjectivity as a kind of practical work in progress.

I will be returning explicitly to this notion of the work of the subject in my final section of this chapter, but I want to address here the question of mastery that is necessarily implied by it. Indeed, if for Lacan traditional ethics is, by his definition, the ethics of the master, then we might want to ask about the question of *self* mastery that is so crucial to the programmatic nature of Foucault's 'Care of the Self'. This is, in fact, to address the crucial issue of power in relation to ethical conduct.

In fact, for Lacan, and in relation to the field of desire, the position of power is, in every case the same: to make desire wait. In Lacan's words: '[t]he morality of power, of the service of goods, is as follows: "As far as desires are concerned, come back later. Make them wait"' (*EP*, p. 315). Thinking this the other way round we might say that for Lacan desire acts *against* power. Indeed, for Lacan, this constitutes desire's peculiar ethicality (and we might say also its radicality).

For Foucault on the other hand power must be addressed in and of itself. It must be made one's own. Thus, 'this work on the self with its attendant austerity is not imposed on the individual by means of civil law or religious obligation, but is a choice about existence made by the individual' (*EST*, p. 271). Again, the crucial point here is that such an ethics arises from a free decision made by the subject and a concomitant 'mode of action' or *practice* of freedom that follows from this decision.

In Lacanian terms the question then becomes whether this self-power – power enacted on the self by the self – is also a form of the deferral of desire, or even of giving up of one's desires, or whether it is something more productive and generative: a form of self-mastery that allows one to resist power when the latter is understood as that which subjects. Certainly, as I have suggested above, the desires that the 'Care of the Self' militates against are *not* the same as that desire which for Lacan is the metonymy of our being (in fact, the former are part of those distractions and diversions thrown up against the latter). The question still remains however as to what this self-power enables? Where does it take the subject?

At this point it is worth a digression to Deleuze's powerful book on Foucault, and especially to the closing chapter where Deleuze discusses the relation of self to self and what it implies. Indeed, Deleuze provides a succinct commentary on Foucault's project of tracking how power and knowledge constitute subjectivity, but also about the possibility of subjectivation, or the self-fashioning of the subject by themselves via the 'folding' in of outside forces. For Deleuze this fold of subjectivation in and of itself produces a kind of inner space of freedom within the

Figure 2.1 Deleuze–Foucault's fold of subjectivation (from 'Foldings, or the Inside of Thought', *Foucault*)

subject. Figure 2.1 shows how Deleuze diagrams this fold, with its relationship to the strata (of power and knowledge), but also to the outside that has been folded within.

With this technology of subjectivation, which is first invented by the ancient Greeks (in Foucault's reading), it is, Deleuze remarks, 'as if the relations of the outside folded back to create a doubling, allow a relation to oneself to emerge, and constitute an inside which is hollowed out and develops its own unique dimension: "enkreteia", the relation to oneself that is self-mastery' (Deleuze 1988c, p. 100). This is 'the inside as an operation of the outside' (Deleuze 1988c, p. 97). As Deleuze suggests in an interview about Foucault's work, 'Life as a Work of Art', it is an outside 'that's further from us than any external world, and thereby closer than any internal world' (Deleuze 1995a, p. 97).

For Deleuze, following Foucault, it is this folding that constitutes the 'novelty of the Greeks', insofar as 'they bent the outside, through a series of practical exercises':

> they folded force, even though it still remained a force. They made it relate back to itself. Far from ignoring interiority, individuality, or subjectivity they invented the subject, but only as a derivative or the product of a 'subjectivation'. They discovered the 'aesthetic existence' – the doubling or relation with oneself, the facultative rule of the free man. (Deleuze 1988c, pp. 100–1)

In the final chapter of the *Foucault* book Deleuze suggests two ways in which this outside might be negotiated by the subject: in a general un-folding, or being towards death; and in a continuous folding and refolding. For Deleuze, the Greeks chose the latter (whereas the Orient followed the former) (Deleuze 1988c, p. 106). Deleuze suggests that the 'proper' name of this continuous folding of the outside is memory, in

Figure 2.2 Bergson's cone of memory (from 'On the Survival of Images', *Matter and Memory*)

fact a kind of '"absolute memory" which doubles the present' (Deleuze 1988c, p. 107). As Deleuze remarks: 'Memory is the real name of the relation to oneself, or the affect on self by self' (Deleuze 1988c, p. 107).

We might say then that the Greeks invented the monad, the folding of the whole world within the subject. We might note the connections with Leibniz here, at least as Deleuze reads him (indeed, the books on Leibniz and on Foucault are both concerned with subjectivation as folding). But we also have here a compelling splicing of Bergson's thesis in *Matter and Memory* to Foucault's 'Care of the Self'. The 'inside-space' created by the free individual is that ontological ground – the 'pure past' – that, as we saw in the previous chapter, Bergson posits as the 'background' to a reduced human experience. Deleuze is drawing out something profound within Foucault here, namely how the processes of subjectivation produce a space of the infinite within the finite, a folding-in of the universe (or, in Bergson's terms, the whole of the past). The fold might then be refigured as Bergson's cone of memory. Indeed, the cone *is* a fold figured in three dimensions. Just as the Bergsonian cone 'reaches' from finite man to infinity, so too the folding of the outside doubles that infinity with an infinite inner space. We might then draw again the cone of Chapter 1, this time with A–B (the content of the cone) representing an infinite outside that has been folded 'inside' a subject located at point S (Figure 2.2).

Figure 2.3 Deleuze–Foucault–Bergson composite diagram (fold as cone)

By inverting the cone and superimposing it on Deleuze's fold we can grasp these two logics (Figure 2.3).[21] We might also note here that this folding is the loop we ended the previous chapter with (albeit, again, reversed). We might note further that this fold can also be thought as a hole of sorts – in the plane of matter as it were – that is produced by the folding. Indeed, outside and inside – as void and boundary – are themselves created by a fold that is prior to them and, in fact, the condition of their existence. It is in this sense that the outside comes into existence at the same time as the inside. This fold-cone that 'contains' the outside within might then be compared with a similar void that, for Lacan is located at the heart of experience: *das Ding*, or the Real. This is something at the very heart of the subject, but that is necessarily avoided, if not effaced, in the very production of that subject. As Jean Mathee has persuasively suggested in her own work on Lacan's *Ethics*, the structure of this Lacanian ethical subject can then be diagrammed as a torus, with *das Ding* at its centre and the subject's 'path' figured as leading from outer to inner edge (via the overcoming of various ethical masters). Mathee diagrams this psychic structure as in Figure 2.4.

We might return here to the final pages of the *The Ethics of Psychoanalysis* where Lacan writes of this void as having been first opened by Kant in his ridding of morality of any 'interest', thus making the question of ethics into a purely categorical imperative. For Lacan, on the other hand, psychoanalysis sees this void as 'the place occupied by desire' and thus replaces the Kantian 'Thou shalt' with a more Sadean 'fantasm of *jouissance* elevated to the level of an imperative'

Figure 2.4 Lacan's *Ethics* diagrammed as torus: 1 Ethical masters/boundaries; 2 The path of the subject/hero; 3 *das Ding*

(*EP*, p. 316). (In Aleister Crowley's terms we might phrase this desiring imperative as: 'Do as thou wilt shall be the whole of the law'.)

So, Kant begins the revolution in ethics by abstracting the moral impulse, but he does not follow this audacious move through. In fact, he erects a transcendent space, a place in which the 'unrealized harmony' of the moral dimension of experience might be realized. A transcendent enunciator is instated as it were, a divine presence, or, in Lacan's phrase, a 'Great Book' (*EP*, p. 317). This is a book of accounts, in which everything that happens, finally, is weighed up. 'It is this that is signified by the horizon represented by [Kant's] immortality of the soul' (*EP*, p. 317). The promise of immortality, the religious wager *per se*, is then a way of deferring desire. In Lacan's arresting turn of phrase: 'As if we hadn't been plagued enough by desire on earth, part of eternity is to be given over to keeping accounts' (*EP*, p. 317). The promise of immortality, we might say, is a way of guaranteeing accounts and thus of guaranteeing power.

This is then the split articulated fully by Kant albeit not originating with him. It is a split – or a bar – between mortality and immortality, between the finite and the infinite. In fact, as Deleuze remarks in another context, the judgement of God actually produces this finite–infinite split, with the infinite then operating as a separate realm, one to which we do not have access *in this life* but that works precisely as a guarantee that the debts of this life will be repaid at a later date and in another place (as the religious saying goes: 'your reward is in the next world').[22] The pay-off of the 'good life' is then not this life itself, but the promise of a life always after the present one.

For Lacan, on the other hand, there is no other place in which accounts are being kept (for Lacan, following Nietzsche, God is most certainly dead). There is no law as it were, except, we might say, the

law of desire. It is in this sense that, contrary to many accounts, Lacan might be thought of as a champion of immanence. In fact, this is an immanence that does not stop with man, but is of an apersonal desire, a *Thanatos* that decentres our anthropomorphic pretensions on to a further field of immanence of inorganic drives. The void is then not a sublime and other worldly place but is the very truth of our being and, as such, is located at the very centre of our experience, albeit masked by habits of the good, that is, the subject-as-is.

What then of our access to this secret place of desire? As I have suggested it is not clear with Lacan whether one can truly assume this desire in its fullness. It must in fact always be signified and thus alienated. Indeed, although Lacan denies the transcendent space erected by Kant, there is a sense in which desire inevitably produces another place, beyond experience as it were – where desire is fully itself – and that, as such, our experience in the world as is is characterized by a lack. Lack, in this sense, inevitably produces – or promises – another world, while Lacan's subject, however far he proceeds on his path, is fated to dwell in this one.

With these two diagrams of the fold and the torus we have then two figurations of the finite subject's relation to truth, or to the infinite. For Lacan truth, as desire, is at the centre of our being (rather than being 'beyond' us) but we are essentially barred from it inasmuch as our milieu of existence is the symbolic (our human habits – of the good – mask this truth).[23] For Foucault, following Deleuze's reading, truth is folded within us and it is we who make this fold by choice. Such a fold brings the outside within. In fact the fold suggests, again, that the inside is nothing but a fold of the outside, both being created, as it were, by the fold. Truth then is accessed, and we might also say, is actively produced, by the subject. We might also, as I suggested above, diagram this fold in three dimensions as a cone.[24]

To conclude this section on the topology of these two thinkers I want now to attempt something more experimental and splice the fold-cone to the torus. It seems to me that with this we begin to get a more complex picture of the subject's relation to truth and also one that introduces duration, in its Bergsonian sense, into psychoanalysis (Figure 2.5).

This composite diagram explicitly links the pure past/absolute memory, or simply the outside of Foucault–Deleuze–Bergson, with the Real or *das Ding* of Lacan (it also suggests that Lacan's torus can be understood as the plane of matter, or system of objects, we looked at in the previous chapter). It further implies that there is only a bar at the inner rim of the torus if one approaches from that direction – from edge to

Figure 2.5 Deleuze–Foucault–Bergson–Lacan composite diagram (fold/cone-torus)

edge of the torus as it were. But there is *no* bar if one follows the cone, which is to say, concerns oneself with oneself (the 'Care of the Self') rather than with a position always elsewhere, one that is always on the horizon, always deferred.

Indeed, Figure 2.5 suggests, in a nod to Badiou, that the accessing of truth might be less a journey from one side of the torus to the other, and more the result of an event of sorts *on* the torus – an event, which, we might say, arises also from a preparation made by the subject on that torus. Indeed, for Bergson, as we saw in the previous chapter, the point of opening to the pure past (the apex of the inverted cone) involves just such a preparation, in this case simply the suspension of the sensori-motor schema – a hesitation or 'stopping of the world'. As we also saw in the previous chapter, Bergson suggests that this is equally the path of the mystic who in turning away from the fixed rituals and habits of society (and religion) accesses 'creative emotion'. We might say that any accessing of this outside must indeed involve a turn away from the habits and concerns of the world, which is to say, knowledge, towards something specifically other. What then is the specific nature of this turn and how does it produce a subject when this is thought of as *not* a

subjected individual, but a free one? What is it that determines such a subject for Lacan and Foucault?

2.5 The production of the subject: the path of the hero versus life as a work of art

For Lacan guilt is the determining affect of typical subjectivity, the dominant emotional state of a subject that is subjected to a transcendent enunciator (insofar as such a subject leads a 'good' life, legislated by a master of some kind, and in so doing does not follow their own desire). Guilt is the affective state in which desire has been put off until a later date. As Lacan remarks: 'on the far edge of guilt, insofar as it occupies the field of desire, there are the bonds of a permanent bookkeeping, and this is so independently of any particular articulation that may be given of it' (*EP*, p. 318). A life lived in this manner involves then the substitution of the 'service of goods' for a desire that is consequently and endlessly deferred. In fact, this is for Lacan the situation of the modern world and of the subject therein:

> Part of the world has resolutely turned in the direction of the service of goods, thereby rejecting everything that has to do with the relationship of man to desire – it is what is known as the postrevolutionary perspective. The only thing to be said is that people don't seem to have realized that, by formulating things in this way, one is simply perpetuating the eternal tradition of power, namely, 'Let's keep on working, and as far as desire is concerned, come back later.' (*EP*, p. 318)

This is as much the case, Lacan argues, in a communist imagined future as one in which there is a 'divine presence of an orthodox kind' (*EP*, p. 318). In both, accounts are kept. In terms of the former, in place of 'the inexhaustible dimension that necessitates the immortality of the soul for Kant, there is substituted the notion of objective guilt' with the concomitant 'promise' that the 'sphere of goods to which we must all devote ourselves may at some point embrace the whole universe' (*EP*, p. 318).

For Lacan, on the other hand, and as we have seen, 'the only thing of which one can be guilty is of having given ground relative to one's desire' (*EP*, p. 319). Indeed, for Lacan, this is what a subject always feels guilty about in the last instance, even, in fact especially, when this giving ground has been for the very best motives, for the 'good' of others (hence, according to Lacan, the deep resentment of Christians). This

desire will however always, at some point and in some manner, return (hence, neurosis), being as it is the 'unconscious theme' of our lives, the metonymy of our being. Desire will always demand that the debt be paid, putting us back on the track of what Lacan calls 'something that is specifically our business' (*EP*, p. 319).

For Lacan then '"giving ground relative to one's desire" is always accompanied in the destiny of the subject by some betrayal' (*EP*, p. 321). Lacan continues a few lines later, '[s]omething is played out in betrayal if one tolerates it, if driven by the idea of the good – and by that I mean the good of the one who has just committed the act of betrayal – one gives ground to the point of giving up one's own claims ...' (*EP*, p. 321). It is here that contempt – for the other, and for oneself – arises. Contempt is the accompanying affect to guilt; it is contempt that fixes us to what we already are, to the subject-as-is. Contempt keeps us going around the torus as it were, beholden to someone or something that is not, ultimately, our business, but is merely the 'service of goods'.

Lacan however suggests another reaction by the subject to this betrayal: impunity. Indeed, for Lacan, this is 'the definition of the hero: someone who may be betrayed with impunity' (*EP*, p. 321). The hero is then someone who carries on following his or her desire despite everything (and, in tragedy, even the threat of their own death).[25] For Lacan:

> this is something that not everyone can achieve; it constitutes the difference between an ordinary man and a hero, and it is, therefore, more mysterious than one might think. For the ordinary man the betrayal that almost always occurs sends him back to the service of goods, but with the proviso that he will never again find that factor which restores a sense of direction to that service. (*EP*, p. 321)

It is not so much that the hero and the ordinary man are two separate figures, for, as Lacan remarks '[i]n each of us the path of the hero is traced' (*EP*, p. 319). In Lacan's terms it is then the hero, he or she who has been betrayed with impunity, that constitutes the subject of desire, or, we might say, the subject of immanence who has turned away from the transcendent enunciator who judges. This is someone who has not given ground to that which is specifically their business, and someone who has paid the price for this commitment. Indeed, for Lacan, '[t]here is no other good than that which may serve to pay the price for access to desire – given that desire is understood here, as we have defined it elsewhere, as the metonymy of our being' (*EP*, p. 321). There is always a price to be paid for following one's desire and it is this price that is

the only one worth paying. It is the subject's commitment to this truth of their own being – in the face of anything else – that, we might say, constitutes them *as* a subject.

In the interview 'On the Genealogy of Ethics' (*EST*, pp. 253–85) Foucault also refers to the subject as a 'hero', and to the latter 'as his own work of art' (*EST*, p. 278). Indeed, for Foucault, as for Lacan, the hero is involved in a specific concern with the self aside from any external – transcendent – legislation. We might say, again, that the hero can be defined as a subject dedicated to truth. As with Lacan, there is also a price to be paid for accessing – and speaking – this truth about oneself. This, as I mentioned above, is the price of asceticism.

However, for Foucault, there is also a constructive attitude to the self that is at stake besides this asceticism. Indeed, the ethical imperative, for Foucault, is less to treat one's life as an enigma – a riddle of desire to be deciphered – than as a work of aesthetic production. Ultimately, and following the Greeks, it is 'to give one's life a certain form in which one could recognize oneself, be recognized by others, and which even posterity might take as an example' (Foucault 1990, p. 49). It is to live as an exemplar. This fashioning of a self as an aesthetic practice is something that accompanies, and is implied by, the notion of ethics as the choice of certain rules of conduct inasmuch as both imply a certain style of living. As Deleuze remarks in his interview on Foucault's work:

> it's a matter of *optional rules* that make existence a work of art, rules at once ethical and aesthetic that constitute ways of existing or styles of life (including even suicide). It's what Nietzsche discovered as the will to power operating artistically, inventing new 'possibilities of life'. (Deleuze 1995a, p. 98)

For Foucault it is Sartre who develops the idea that the self is not given to us; however, unlike Sartre for whom there is then a turn to authenticity (which, we might argue, is continued with Lacan), Foucault suggests, following Nietzsche, that with the Greeks '[i]t was a question of making one's life into an object for a sort of knowledge, for a *teckhne* – for an art' (*EST*, p. 271). In the same interview Foucault talks further about '[t]he idea of the *bios* as a material for an aesthetic piece of art' (*EST*, p. 260). Again, one's life becomes an object to be fashioned through an art of living. Foucault continues in the same vein some pages later:

> We hardly have any remnant of the idea in our society that the principle work of art which one must take care of, the main area to which

one must apply aesthetic values, is oneself, one's life, one's existence. We find this in the renaissance, but in a slightly academic form, and yet again in the nineteenth-century dandyism, but those were only episodes. (*EST*, p. 271)

In a further interview, 'What is Enlightenment?' (*EST* pp. 303–20), Foucault links this aesthetics of existence more explicitly to modernity and to the Enlightenment, understood as an attitude of self-critique, that implied 'a way of thinking and feeling; a way, too, of acting and behaving' (*EST*, p. 309). This is a modernity that comes to parallel the Cartesian scientific world view and which, to a certain extent, undermines it. For Foucault it is Baudelaire that exemplifies this attitude in his own celebration of the heroism of modern life, with its attendant attempt to capture something eternal within the contemporary moment, but also in a certain attitude that we might call a peculiarly modern 'Care of the Self':

> modernity for Baudelaire is not simply a form of relation to the present; it is also a mode of relation that must be established with oneself. The deliberate attitude of modernity is tied to an indispensable asceticism. To be modern is not to accept oneself as one is in the flux of passing moments; it is to take oneself as object of a complex and difficult elaboration: what Baudelaire, in the vocabulary of his day, calls dandysme. (*EST*, p. 311)

For Foucault there is then a modern 'asceticism of the dandy' who remains unsatisfied with his subjectivity-as-is (we might say with his life on the torus ('in the flux of passing moments')), and who thus 'makes of his body, his behaviours, his feelings and passions, his very existence, a work of art' (*EST*, p. 312). Indeed, *contra* Lacan, '[m]odern man, for Baudelaire, is not the man who goes off to discover himself, his secrets, his inner truth; he is the man who tries to invent himself' (*EST*, p. 312). This self-invention arises from a decision made by the subject and a concomitant practice of living differently, against the norms of the world that such a subject is born in to (insofar as these norms tend to be instigated by a transcendent enunciator, which again, in our own time, is Capital). It is this, what we might call (following Guattari) an ethico-aesthetic paradigm for the production of subjectivity, which determines a freedom of sorts for that subject. Following my discussion of Lacan's and Foucault's topologies above, we might also call this the self-drawing of a new and different diagram of the finite–infinite relation, or simply

of the relation a finite subject might cultivate to that which hitherto was 'outside' themselves.

For Foucault then, psychoanalysis ultimately falls short of this ethico-aesthetics of existence insofar as it presumes a truth already given and ultimately determining of the subject (although, as I have attempted to demonstrate, it is also a truth, ultimately, that is barred from the subject). Indeed, the theory of desire, at once liberating for Lacan, becomes a universalist and ahistorical limitation in Foucault's eyes. The resonances between Foucault and Deleuze and Guattari's own critique of psychoanalysis are perhaps worth concluding with here. In *A Thousand Plateaus* it is precisely the way in which Lacanian analysis operates as a tracing – of a predetermined truth – rather than as a map of a territory yet to come that defines it, in Deleuze and Guattari's eyes, as a form of micro-fascism.[26] 'Schizoanalysis', with an emphasis on a machinic unconscious yet to be made, replaces this theatre, where parts and set pieces are already worked out, with a programme, following Spinoza, of experimental encounter and assemblage, or, as Deleuze and Guattari call it, a factory of the unconscious.[27] Perhaps we can say then that schizoanalysis is a peculiarly contemporary 'Care of the Self' that develops its own techniques and technologies, especially around the group and the institution, but that stays true to what we might call the Foucauldian ethico-aesthetic injunction to refuse transcendent enunciators, to be the source of one's own ethics and, ultimately, to treat one's life as a work of art.[28] This will be the subject mater of the next chapter.

2.6 Concluding remarks: the question of practice and the subject-yet-to-come

Lacan's own concluding remarks in his *Ethics* are that psychoanalysis cannot be understood as one of the human sciences, or at least that such an attitude would amount to a 'systematic and fundamental misunderstanding' insofar as the latter are a 'branch of the service of goods' (*EP*, p. 324). Indeed, Lacan's *Ethics* is in many senses one long critique of the 'passion for knowledge' that has come, for Lacan, to occupy the place of desire in the modern world. Such knowledge, as I have tried to show, only concerns what Lacan calls the 'service of goods', or, we might say, the subject-as-is.[29]

Indeed, Lacan's subject is fundamentally at odds with other more generally accepted notions of the subject inasmuch as it has to be assumed (this being the role of analysis – to 'uncover' this 'other' unconscious subject). It is certainly not the subject of any conscious

agency or of the centred self. The latter might seem to define Foucault's subject with its degree of assumed mastery over the passions, however, as I have tried to suggest, such a subject is merely the preparation or platform to allow for something else that is definitely *not* the subject as given to emerge. As with Lacan, so then for Foucault: the production of the subject – of truth – cannot be reduced to a science (or a substance), or indeed be understood as the result of any kind of knowledge understood in a Cartesian sense. As Foucault says, the subject is not merely 'constituted in a symbolic system', but rather, 'in real practices – historically analysable practices. There is a technology of the constitution of the self which cuts across symbolic systems while using them' (*EST*, p. 277).

In conclusion then, it seems to me that this question of practice, ultimately, is the key difference between these two thinkers in their understanding of the ethical subject. Lacanian psychoanalysis, as psychoanalysis, involves a *speaking* 'cure'; its realm of operation is the symbolic. It cannot but foreground language, and specifically the signifier, in the constitution of subjectivity. Indeed, it is the symbolic that causes alienation/produces the neurotic subject, but is also that which has the potential to 'free' such a (always neurotic) subject (this being the shuffling of signifiers – the *'bien-dire'* – that allows the neurotic to signify their desire and thus be released from whatever impasse they find themselves within).[30]

Speech, and indeed writing, certainly play a part in Foucault's account of the subject. We have the *hupomnēmata*, notebooks, diaries, account books and so forth that are used as particular technologies of the self and there is also the importance of *parrhēsia*.[31] The latter especially – the telling of the truth about oneself – would seem to prefigure the analyst's couch, albeit that it was a specifically public exercise. On the other hand technologies of the self, those codes and practices applied to the self by the self, were as often as not non-linguistic: friendship, or meditation for example. Indeed, in general for Foucault the 'Care of the Self' is a practice that is not merely verbal or linguistic, though it might employ these as partial methods. It is, as it were, a practice of freedom that can only be experienced in its active application by a subject.

We might return to the question of the master here. For Foucault a master – 'one who knows best' – might well operate as an ethical guide, at least to begin with. A master might also, in a call for total obedience, aid in that self-examination crucial to the 'Care of the Self'.[32] For Lacan, on the other hand, the one who knows best is precisely the operator of power – a transcendent enunciator – that desire will always work

against. Indeed, transference – where the analysand attributes a certain 'knowingness' to the analyst – is only a first step in analysis (and a dangerous one), a first moment in the subject's understanding and assumption of his or her own desires.

Might not however the same be said of Foucault? That a master is only the first step in a programme of self-mastery, and that the latter might itself be understood, in Lacanian terms, as becoming a cause of oneself? To practice self-mastery is then to be involved in the production of a subjectivity that turns away from received values and from transcendent operators. Such a move – what we might call an affirmation of immanence – is then, ultimately either to refuse power in the name of desire (Lacan) or to assume it in the operation of a self-power (Foucault). In either case it is to change oneself and to change one's relation to that which is outside one's self.

For Deleuze it is these new kinds of relations with the outside, these new kinds of folding, which ultimately constitute the core and importance of Foucault's last writings.[33] Indeed, for Deleuze, following Foucault, new kinds of folding will ultimately produce new forms of life that might well go beyond subjectivity understood in the specifically Greek sense. As Deleuze (1995a, p. 99) remarks:

> the production of new ways of existing can't be equated with a subject, unless we divest the subject of any interiority and even any identity. Subjectification isn't even anything to do with a 'person': it's a specific or collective individuation relating to an event (a time of day, a river, a wind, a life …). It's a mode of intensity, not a personal subject. It's a specific dimension without which we can't go beyond knowledge or resist power. (Deleuze 1995a, p. 99)

For Deleuze's Foucault the fold we call the human subject is a nineteenth-century production, for it is then 'that human forces confront purely finitary forces – life, production, language – in such a way that the resulting composite is a form of Man' (Deleuze 1995a, pp. 99–100). As such, and 'just as this form wasn't there previously, there's no reason it should survive once human forces come into play with new forces: the new composite will be a new kind of form, neither God nor man' (Deleuze 1995a, p. 100).

In the last pages of the *Foucault* book Deleuze extends this meditation on what he calls the 'superfold' that might itself produce Nietzsche's Over-, or superman: 'what is the superman? It is the formal compound of the forces within man and these new forces. It is the form that results

from a new relation between forces. Man tends to free life labour and language *within himself'* (Deleuze 1988c, p. 132). This is an individual that is no longer human in the sense in which Foucault drew and then erased him. It is a 'something' that encapsulates the outside within, although this outside will have a different sense to that which it had for the nineteenth-century subject. If this thing can still be called a man, then it is a man unrecogniszble in terms of the Greeks, or in terms of the *cogito*. It is a man who:

> is even in charge of the animals (a code that can capture fragments of other codes, as in the new schemata of lateral or retrograde). It is a man in charge of the very rocks, or inorganic matter (the domain of silicon). It is a man in charge of the being in language (that formless 'mute, unsignifying region where language can find its freedom' even from whatever it has to say). (Deleuze 1988c, p. 132)

In a final twist, however, could not something similar be said of Lacan and of the injunction not to give ground on a desire that is fundamentally inhuman, alien to the subject as given? This is to identify an inorganic death drive at the very heart of life; a being towards death that supplants a consciousness when the latter remains a declaration of the 'I think, therefore I am' with its all too human arrogance of knowledge and attendant morality based on a transcendent operator. Indeed, it seems to me that in both Foucault and Lacan, despite their differences (and despite what I have said about Lacan's bar between the real and the symbolic), there is a turning away from this kind of subject – what I have called the subject-as-is – towards something stranger, something, perhaps, more objective? This is the subject *as* object, but a peculiar privileged kind of object that contains, folded within, all other objects, the whole of Bergson's pure past. It is the folding in of the outside as the constitution of a veritable inner universe. An instance of finitude that paradoxically holds the infinite within.

3
The Aesthetic Paradigm: From the Folding of the Finite–Infinite Relation to Schizoanalytic Metamodelization (to Biopolitics) (Guattari)

3.1 Introduction

As I suggested in my Introduction to this book, it might be argued, as regards the subject, that a bar is in operation between the finite and the infinite within certain strands of recent post-Kantian philosophy, and, indeed, as we saw in the previous chapter, within Lacanian psychoanalysis. In the next chapter I will be looking at the philosophical system of Alain Badiou (as laid out in *Being and Event* and *Logics of Worlds*) as an example of this kind of topology, comparing it with the system of Deleuze (in *Difference and Repetition*) where there is no such bar, but rather a continuum of sorts (a 'reciprocal determination') between what Deleuze calls 'virtual ideas' and 'actual' states of affairs. The present chapter begins this investigation – of a finite–infinite continuum – by looking to Deleuze's erstwhile collaborator, Félix Guattari and to two essays – 'The New Aesthetic Paradigm' and 'Schizoanalytic Metamodelization' – from his major ontological statement: *Chaosmosis: An Ethico-Aesthetic Paradigm* (cited in references as *C*).

However, before beginning this somewhat technical commentary a brief word about the philosophical orientation of the latter complex work might be useful to set the scene. For Guattari there is always an *a priori* moment of creativity, or simply desire, that prefigures any given entity or any subject–object relation.[1] Indeed, life, in whatever form it takes (organic or inorganic), emerges from a ground of sorts – one that is unfixed and ontologically unstable – that at all times accompanies the very form that emerges from it. Guattari calls this groundless ground 'chaosmosis', while the entities formed from it, although they are given different names, can simply be called 'subjectivities'. Elsewhere

I have attended specifically to Guattari's writings on the production of subjectivity in what we might call an ethico-political sense (see O'Sullivan 2005, pp. 87–95). The present chapter attempts to get to grips with the ontological argument behind the politics, while attending more explicitly to the therapeutic or analytic implications of the ontology, and in particular to Guattari's modelling of a processual and ecological subjectivity *contra* Lacan. This is a modelling in which asignifying components become crucial (although not exclusively so) and in which aesthetic practices play a privileged role. It is also, as I indicated above, a diagram of subjectivity in which the finite and the infinite, or what Guattari calls complexity and chaos, are in a reciprocal relation.

Two further points are worth noting in relation to the above (and in general on reading Guattari), each of which, at least to a certain extent, works to differentiate his thought from Deleuze's. First, as well as looking to certain philosophical resources, Guattari utilizes the paradigm of the new sciences, and especially quantum theory, where he finds the conceptual tools adequate for his processual modelling. He is also a prodigious inventor of his own neologisms. This can make *Chaosmosis* a difficult read, especially for those used to a more typical humanities, or even 'continental philosophical' discourse. Second, even when his writings are most abstract, Guattari is always especially attentive to the vicissitudes of our particular lived late-capitalist situation. This is evidenced in two further preoccupations of *Chaosmosis*: the identification of capitalist or 'universal' time that flattens and reduces local and singular durations; and the emphasis on new technologies that produce an ever increasing alienation and atomization, but that also have the potential to produce new forms of life – and subjectivity – that go beyond the latter.

What follows then, are two commentaries of sorts on Guattari's two essays, where commentary is to be understood as involving not just synopsis (although I attempt also to provide this) but also the expansion of certain aspects of the commented-upon text, as well as occasionally a diversion or digression. Throughout, and especially in the lengthy footnotes to this chapter, material is drawn in from the other essays of *Chaosmosis* as appropriate, and occasional reference is made to Guattari's collaborations with Deleuze. Reference is also made to other thinkers who are either more or less contemporary with Guattari (the Foucault of the previous chapter and the Deleuze and Badiou of the next one) or are important philosophical precursors (specifically the Spinoza and Bergson of Chapter 1, albeit nether of these two leave much of a visible trace in Guattari's actual writings). Each of these thinkers,

with the exception of Badiou, might be said to be working within a similar aesthetic paradigm to Guattari's in the sense of positing a mind–body parallelism and in attempting to think 'beyond' a founding subject–object split. In what follows then, when these thinkers do make an appearance it is because they can add something – from their own diagrams as it were – to Guattari's own particular diagram of the finite–infinite relation. The chapter ends with a coda in which I look briefly at three Italian theorists who, it might be argued, take Guattari's insights into the finite–infinite relation more explicitly into the realm of contemporary politics insofar as they each evidence what one of them, Franco Berardi, names as the encounter between 'French desiring thought' and 'Italian autonomist politics'.

3.2 The three assemblages

At the very beginning of 'The New Aesthetic Paradigm' Guattari makes the important point that art, considered as a separate autonomous activity, is a relatively recent development in our world and that before this it was part of what we might call the general practices of life and of living. This is, as Guattari points out, difficult to appreciate, as the past is invariably understood from the perspective, and also the logics and interests, of the present. Although specific instances of contemporary art might then be part of the aesthetic paradigm (and, at times, its privileged point of access), the notion of art in general can stymie access to the latter in that it reduces aesthetic practice to a specialism. In a first definition then, the aesthetic paradigm might be thought of as an expanded field of creative life practices that are not necessarily restricted to what is typically considered art, and, as such, this paradigm certainly has something in common with previous or pre-modern paradigms.

We are not, however, fully within this expanded aesthetic paradigm, but rather experience and begin to produce the latter through a number of distinct practices, each of which operates as an interface between the finite and infinite. Such practices, which include 'science, technology, philosophy, art and human affairs', are involved in their own distinct explorations and experiments (*C*, p. 100). They conduct their local enquiries following their own logics and using their own particular means. With art it is 'the finitude of the sensible material' that 'becomes a support for the production of affects and percepts which tend to become more eccentred with respect to performed structures and coordinates' (*C*, p. 100). These 'subjective affects' are part of 'the infinite and its virtual references', but are often relegated, or 'bracketed

out' in our dominant techno-science paradigm, which, instead, privileges 'the finite, the delimitable and coordinatable' (C, pp. 100–1).[2] Art, in fact, also involves a finite assemblage, but one that maintains and presents the infinite to us in a singular manner in contradistinction to the more typical assemblages that surround us on a day-to-day basis (which, again following a techno-scientific paradigm, tend to 'place the emphasis on an objectal world of relations and functions' (C, p. 100)). In fact, this 'metabolism of the infinite' might be figured as moving in two directions: from the finite to the infinite but also as a 'movement from infinity to the passage of time' (C, p. 101). In passing, it is worth noting that this movement is also transversal in another sense: a 'mutation' in one practice or particular area of life can have effects on another. As opposed to a thinker like Badiou, for whom, as we shall see, an event's effect is solely vertical as it were, here the event – of the finite *presenting* the infinite/the infinite becoming embodied in the finite – is horizontal, working *across* milieus. This is to map out an immanent field of events (or finite–infinite interfaces) without a supplementary dimension above or behind them. I will return to this.

As we shall see, the aesthetic paradigm, which is implied in art practice though not fully realized, has a particular privileged role to play in the production of subjectivity in our contemporary world; aesthetics in general, however, or what Guattari calls 'a dimension of creativity in a nascent state', is also characteristic of pre-capitalist societies that are involved in the production of 'polysemic, animistic, transindividual subjectivity' (aspects of which can also be found in our time in the 'worlds of infancy, madness, amorous passion and artistic creation') (C, p. 101). Guattari describes this first type of territorialized Assemblage as follows:

> Polyphonic spatial strata, often concentric, appear to attract and colonise all the levels of alterity that in other respects they engender. In relation to them, objects constitute themselves in transversal, vibratory position, conferring on them a soul, a becoming ancestral, animal, vegetal, cosmic. These objectities-subjectities are led to work for themselves, to incarnate themselves as an animist nucleus: they overlap each other, and invade each other to become collective entities half-thing, half-soul, half-man half-beast, machine and flux, matter and sign ... (C, p. 102)

This then is a *proto*-aesthetic paradigm in which the distinctions of subject–object have yet to be fixed and reified, a world of strange

mutually implicated beings cohering around objects and practices (in 'Machinic Heterogenesis' Guattari presents a case study, following Marc Augé, of just such a complex practice in the voodoo object/ritual/belief of 'Legba' (*C*, p. 46)).[3] It is also a world in which 'the spheres of exteriority are not radically separated from the interior', but rather implicated in a general folding that is also a reciprocal fold – and determination – of the infinite and the finite (*C*, p. 102). As Guattari remarks: '[h]ere there is no effort bearing on material forms that does not bring forth immaterial entities. Inversely, every drive towards a deterritorialised infinity is accompanied by a movement of folding onto terrritorialised limits' (*C*, p. 103).

The second kind of deterritorialized Assemblage – the capitalist regime proper – involves an ordering and reduction of the first. It 'erects a transcendent autonomised pole of reference' over and above what we might call the multiplicity of worlds evident in the previous regime (*C*, p. 103). This is the instalment of dualisms or binary oppositions, each of which necessarily involves the setting up of a privileged term. This might involve fixing a transcendent 'Truth', or notion of the 'Good', the 'Beautiful' and so forth, but crucially it is also the implementation of Capital as ordering principle of lived life and the concomitant reduction of heterogenetic multiplicity to the principle of exchange. This then is a flattening (exchange principle) and also a hierarchization (with Capital at the apex). We might say that such a regime is one that subjects its people (albeit a subjection often masked, as I suggested in Chapter 1, by slogans invoking individual freedom and the possibilities of participation: 'Just do it!' and the like). In technical terms, it involves a 'segmentation of the infinite movement of deterritorialisation' (the latter, as argued in *Anti-Oedipus*, being the determining factor of capitalism insofar as capitalism *is* desire) that 'is accompanied by a reterritorialisation' (again, following *Anti-Oedipus*, this capture might be thought as the second moment of capitalism – the capture, or siphoning off of surplus value from the flows of desire) (*C*, p. 103).[4] In this Assemblage then, '[t]he valorisation which, in the preceding illustration, was polyphonic and rhizomatic, becomes bi-polarised' (*C*, p. 103). Here subjectivity is under the rule of the 'transcendent enunciator', held in a constant state of lack, debt, procrastination and so forth (*C*, p. 104). Immanence is captured by a transcendent apparatus and, as such, subjectivity is standardized through the neutralization of difference.[5]

The above two Assemblages cannot be reduced to specific epochs for they can, and invariably do, co-exist within the same period (for example, animist beliefs and practices co-exist with advanced capitalism in

the hyper-modern culture of Japan). Likewise, the third Assemblage is present within our own – although only in an embryonic state. It bears some relation to the first, but crucially does not involve a simple return (if this were ever a real possibility), but, we might say, a return that is itself coloured by its passage through the second Assemblage. Certainly, the third Assemblage, the aesthetic paradigm proper, has in common with the first that the interiority of atomized individuated subjects is exploded and that a multiplicity of different regimes and practices are implicated.[6] However the difference – between first and third – is important. As Guattari remarks:

> One does not fall back from the regime of reductionist transcendence onto the reterritorialisation of the movement of infinity in finite modes. The general (and relative) aestheticisation of the diverse Universes of value leads to a different type of re-enchantment of the expressive modalities of subjectivity. Magic, mystery and the demonic will no longer emanate, as before, from the same totemic aura. Existential Territories become diversified, heterogenised. (C, p. 105)

This affirmation of difference is then not animist in the sense of the first paradigm. It is not, we might say, a return to a pre-individual subjectivity composed of apersonal strata. For, as Guattari goes on to say: 'The decisive threshold constituting this new aesthetic paradigm lies in the aptitude of these processes of creation to auto-affirm themselves as existential nuclei, autopoietic machines' (C, p. 106). Difference, or alterity, is then cohered together rather than dispersed as in the first Assemblage. I will be returning below to the crucial question of how this existential 'stickiness' takes place, but we can note here that it involves the invention of 'mutant coordinates' (C, p. 106). Indeed, ultimately, it is art's capacity to engender 'unprecedented, unforeseen and unthinkable qualities of being' through the invention of such different coordinates that gives it a privileged place within the third Assemblage (C, p. 106). As Duchamp once remarked (and as quoted by Guattari): 'art is a road that leads towards regions which are not governed by time and space' (C, p. 101).[7]

It is also important to remember that, as noted above, this third Assemblage will be marked by its passage through the second. In fact, I would argue it involves an implementation of sorts of the strategies of the second albeit with a significantly different orientation and for different ends: whereas there is a general *over*-coding in the second, here there is the instalment of *local* coding or singular points of organization.

We might usefully turn to the late writings of Foucault and the work we did in the previous chapter at this point and insert the diagram of the 'Care of the Self' into Guattari's aesthetic paradigm. Here, subjectivation, or the active production of subjectivity by the subject itself, involves a particular relationship to any outside transcendent organizer. As we have seen, it involves what we might call a 'folding-in' of transcendence within the subject (or, in Foucault's terms, the application of 'optional rules' to oneself). For both Foucault and Guattari it is this 'folding-in' of the outside – by the subject on his or her own terms – that constitutes a freedom of sorts from subjection. It is, as it were, a certain intention and orientation that will also involve a programme (Foucault's technologies of the self/Guattari's metamodelization) in which the subject, ultimately, assumes its own causality (or in Lacan's paradoxical claim 'becomes a cause of itself').[8]

It is here that we can also see the logic of Guattari's interest in the new sciences inasmuch as they involve a similar reorientation from a transcendent Truth to what Guattari calls 'operational modelisations that stick as close as possible to immanent empiricism' (C, p. 106). This is the privileging of points of view over any objective and universal Archimedean point. It is also the operating logic of schizoanalysis that itself involves a turn away from the standard and normalizing models of psychoanalysis, tied as they are to the second Assemblage (C, p. 106). It is only a short step from this to Guattari's theory of metamodelization, understood as a theory of the auto-composition of different models of subjectivity that involves the incorporating, repositioning – and implicating – of the models of the first and second Assemblages (C, p. 106).

Guattari gives us a succinct description of how this new kind of Assemblage implies a different mode of organization – or 'crystallisation' – that draws on the two previous Assemblages: 'No longer aggregated and territorialised (as in the first illustration of Assemblage) or autonomised and transcendentalised (as in the second), they are now crystallised in singular and dynamic constellations which envelop and make constant use of these two modes of subjective and machinic production' (C, p. 108). The third Assemblage is then a composition of sorts that involves components of both the previous: a 'folding-in' of the transcendence of the second Assemblage that in itself produces autopoietic nuclei around which the fields of alterity of the first Assemblage might crystallize. Again, this is to fold the outside – or infinite – within; to produce a relation to one's self that is akin to self-mastery (when the latter is understood also as self-organization). In this aesthetic paradigm we become the authors, as it were, of our own subjectivities. This is not

Figure 3.1 Guattari's three assemblages: 1 Territorialized assemblage (pre-capitalist) (trans-individual); immanence/animist; polysemic/collective; 2 Deterritorialized assemblage (capitalist) (individual); transcendent over-coding; standardization/ reduction; 3 Processual assemblage (post-capitalist) (post-individual); 'folding-in' of transcendence/autopoietic nuclei; autonomous/singular

however solely the production of separate and isolated monads, for such an autopoietic folding is always accompanied by an allopoietic function in which a given subject maintains lines of connection – or 'multidirectional relays' – to an outside, including other subjects (*C*, p. 114). In fact, each monad is always already ontologically related inasmuch as they are constituted on the same plane of immanence or 'ground' of the first Assemblage. In passing it is worth remarking that the actual political work of locating non-transcendent commonalities within the third Assemblage – or, we might say, of developing a politics of singularity – must invariably be one of continuous experimentation and testing; it cannot be given in advance as a general, or transcendent rule. To conclude this section of Chapter 3 we might then diagram the three Assemblages and their attendant subjectivities as in Figure 3.1.[9]

3.3 Folding the infinite

We come now to the more technical part of Guattari's essay with the laying out of precisely how this interface between the finite and the infinite – or between the subject and the object – operates. Guattari's claim for his 'transversalist' theorization of enunciation (that applies as much to specific practices as it does to the very cosmos itself) is that it establishes a bridge of sorts between the finite and the infinite, and, crucially, 'postulate(s) the existence of a certain type of entity inhabiting both domains, such that the incorporeals of value and virtuality

become endowed with an ontological depth equal to that of objects set in energetico-spatio-temporal coordinates' (*C*, p. 108). In Guattari's words 'these transversal entities appear like a machinic hyper-text', and further, imply that 'Being', far from being pre-established, or operating as some kind of container for life (or for 'all the possible modalities of being'), is, in fact, 'auto-consistency, auto-affirmation, existence for-itself deploying particular relations of alterity' (*C*, p. 109). This self-crystallization, or form constituting itself from the formless, applies as much to non-human and indeed inorganic life as is does to the human (after all, even molecules, as assemblages, have a virtual aspect). Guattari calls this active, generative and transversal process 'machinic being' (*C*, p. 109).[10] Such machines, or self-organizing entities, have then two specific aspects – or face in two directions: towards the finite and towards the infinite:

> The machinic entities which traverse these different registers of the actualised world and incorporeal Universes are two-faced like Janus. They exist concurrently in a discursive state within molar fluxes, in a presuppositional relationship with a corpus of possible semiotic propositions, and in a non-discursive state within enunciative nuclei embodied in singular existential Territories, and in Universes of ontological reference which are non-dimensioned and non-coordinated in any extrinsic way. (*C*, p. 110)

The manner of the strange co-existence of these entities which face the virtual (the 'non-discursive, infinite character of the texture of these incorporeals') and the actual (the 'discursive finitude of energetico-spatio-temporal Fluxes and their propositional correlates') involves speed (*C*, p. 110).[11] For Deleuze, reading Spinoza, this would be the absolute speed of the third kind of knowledge that surveys all things at the same time in eternity.[12] Here, for Guattari, it is Pascal who defines the operation of these entities as 'a point which moves everywhere at infinite speed because it is at all places and whole in each place' (*C*, p. 110, Guattari quoting Pascal). Only such 'an entity animated by an infinite speed ... can hope to include both a limited referent and incorporeal fields of possibles' (*C*, p. 110).

For Guattari, however, this Pascalian modelization is not enough, producing as it does 'an ontologically homogeneous infinity' (*C*, p. 110). The aesthetic paradigm is more generative and productive than this, involving 'more active and activating folds of this infinity' (*C*, p. 110). In order to develop this line of argument, Guattari introduces here a

further two terms, somewhat synonymous with the infinite and the finite, namely chaos and complexity. Each of the latter interpenetrates the other in a chaosmic folding – with the entities traversing the two fields. Here is the crucial passage from Guattari on this finite–infinite weave:

> It is by a continuous coming-and-going at an infinite speed that the multiplicities of entities differentiate into ontologically heterogeneous complexions and become chaotised in abolishing their figural diversity and by homogenising themselves within the same being-non-being. In a way they never stop diving into an umbilical chaotic zone where they lose their extrinsic references and coordinates, but from where they can re-emerge invested with new charges of complexity. It is during this chaosmic folding that an interface is installed – an interface between the sensible finitude of existential territories and the trans-sensible infinitude of the Universes of reference bound to them. (*C*, pp. 110–11)

This oscillation – and folding – gives the entities their character of consistency *and* dissolution, of complexity *and* chaos. Furthermore, the difference between the two milieus does not amount to a dualism as such given that both 'constitute themselves from the same plane of entitative immanence and envelop each other' (*C*, p. 111). We might at this point insert Bergson's cone of memory into the Guattari diagram and suggest that although there may indeed be no binary opposition between the two realms – of the actual and the virtual – there is nevertheless a difference in kind. Without this difference, as we saw in the previous chapter – and will see again in the next – actualization would not be a force of creation and difference but would remain tied to the plane of matter and to the logic of the possible (the entities would always be just 'more of the same' as it were). As Deleuze remarks – and the same might have been said by Guattari – this virtuality does not lack reality, only actualization (cf. Deleuze 1988b, pp. 96–7).

There is, however, a limit to this splicing of Bergson on to Guattari insofar as Guattari's modelization of chaos/complexity is different – more horizontal – to the virtual/actual topology of Bergson's cone. Certainly Bergson's virtual is not a transcendent realm 'above' (or, indeed, below) the actual, but there is a sense in which the actual/virtual divide cannot but maintain a topology of sorts. I will be looking further into this in the next chapter, suffice to say here that Guattari's chaosmosis is virtual, but not exactly as Bergson might understand it insofar as its difference

to the actual is not something that can be thought spatially, but, rather, is a question of different speeds. In passing we might note that it is this – an intensive and non-hylomorphic thinking of matter as containing within it both actual and virtual elements – that is one of the key contributions Guattari makes to *Capitalism and Schizophrenia*, to the extent that prior to this collaboration Deleuze's thinking on the actual/virtual was precisely Bergsonian (although, as we shall see, again in the next chapter, Deleuze always maintained that there was a relation of 'reciprocal determination' between his actual and virtual).

Indeed, Guattari points out that the 'primordial slowing down manifested in finite speeds' is already present *in* chaos (*C*, p. 112), or simply that 'infinite speeds are loaded with finite speeds' (*C*, p. 113). We might say that chaos already contains complexity and that complexity is always already composed out of a chaos from which it emerges and towards which it returns.[13] Furthermore, this chaosmic texture is lumpy, as it were. It is in fact less a case of an oscillation between two distinct and absolutely separate fields than of multiple encounters between different entities that are composed out of these two fields.[14] These entities, as well as being spatially heterogeneous, will also be so temporally. They will keep time in different ways, each individual entity vibrating at a different frequency, or – to return to a Bergsonian vocabulary – implicating a different duration. This is to posit a kind of patchwork of different rhythms or refrains. The present is never temporally homogeneous in this sense, but is always a multiplicity of these space–time machines.[15]

Here is the second crucial statement from Guattari on the finite-infinite relation:

> So chaosmosis does not oscillate mechanically between zero and infinity, being and nothingness, order and disorder: it rebounds and irrupts on states of things, bodies and the autopoietic nuclei it uses as a support for deterritorialisation; it is relative chaotisation in the confrontation with heterogeneous states of complexity. Here we are dealing with an infinity of virtual entities infinitely rich in possibles, infinitely enrichable through creative processes. (*C*, p. 112)

The relationship between virtual and actual, between infinite and finite is then incarnated in different entities in an entirely reciprocal manner. As Guattari remarks: 'the same entitative multiplicities constitute virtual Universes and possible worlds' (*C*, p. 113), or, as he also says, '[t]he movement of infinite virtuality of incorporeal complexions carries in itself the possible manifestation of all the components and all the

enunciative assemblages actualisable in finitude' (C, p. 112). The entity – and here perhaps we should also say the subjectivity – is at once a part of the world and apart from the world. More accurately, it has a part of itself in the world as actualized but also a part in that groundless ground – the virtual – from which it has been actualized. But crucially this is not a split subject as such (there is no bar between the two), and as such neither is it a melancholy subject (a being barred from the infinite in its very finitude). Rather it is a subject that is always already eternal, composed of different relations between these two fields, or simply different relations of speed and slowness all the way to the infinite. A properly Spinozist subject.

Indeed, Guattari suggests that the production of this entity necessarily involves a 'grasping' of the infinite that in itself involves an ontological slowing down. This – a gestural semiotics that has precursors in ancient Greek epistemology, but that is equally a product of Guattari's knowledge of phenomenological psychiatry – implies a meeting of sorts with something that provides some kind of friction: '[a]n incorporeal complexion, snatched up by grasping, will only receive its character of finitude if the advent-event of its encounter with a trans-monadic line occurs, which will trigger the exit, the expulsion of its infinite speed, its primordial deceleration' (C, p. 114). The entity or 'complex entitative multiplicity' has to be cohered, or 'indexed' to use Guattari's term, by 'an autopoietic nucleus' (C, p. 114). This moment of grasping and of slowing occurs then when the complex-chaotic field of the infinite encounters what Guattari calls a 'trans-monadism' (C, p. 114). The latter introduces within chaos an 'ordered linearity' that allows 'the ordination of incorporeal complexions to crystallise' (C, p. 114). Guattari likens this process to 'the pickup head of a Turing machine', arguing that 'linearity, the matrix of all ordination, is already a slowing down, an existential stickiness' (C, p. 115).[16] Like a tape-head that spools tape, or perhaps a turntable stylus that picks up dust and static, '[t]he chaotic nothing spins and unwinds complexity' carrying out 'an aggregative selection onto which limits, constants and states of things can graft themselves' (C, p. 114).[17] This is then the second, more active folding of chaosmosis that produces a teeming life world of entities, an actual–virtual ecology. In Guattari's arresting phrase, it is 'the "choice" of finitude' (C, p. 116): 'Transmonadism through the effect of retro-activity crystallises within the primitive chaotic soup spatial coordinates, temporal causalities, energy levels, possibilities for the meeting of complexions, a whole ontological "sexuality" composed by axiological bifurcations and mutations' (C, p. 115).[18]

It is this transmonadic line, an 'infinite twisting line of flight', that slows chaos down, in the process organizing it and giving it a consistency (*C*, p. 116).[19] Ultimately then, what is at stake in this new paradigm is the tracking of this creative and experimental line of flight, which we might call, following the analysis of the three Assemblages above, a 'folded-in' transcendence. This line, which is also an autopoietic nucleus or, in the language of the new sciences, a 'strange attractor', involves the production of unforeseen new finite–infinite diagrams, which is to say, precisely the production of new subjectivities, different, more flexible and processual than those typically produced within and by the second Assemblage discussed above.[20] This, finally, is the aesthetic paradigm proper, or the production of 'new infinities from a submersion in sensible finitude, infinities not only charged with virtuality but with potentialities actualisable in given situations ...' (*C*, p. 117). Such a paradigm also enables us to redefine politics and ethics around these processes of singularization as specifically productive and generative pursuits.[21] This will involve breaking with consensus, reduction, standardization, and what Guattari calls 'the infantile "reassurance" distilled by dominant subjectivity', as well as the affirmation of a 'heterogenesis of systems of valorisation and the spawning of new social, artistic and analytic practices' (*C*, p. 117).[22] Ultimately it is a call to participate in the auto-production of our own subjectivities, that in itself implies an auto-relationship to ourselves (the folding-in), that itself operates as a platform to then actualize a specifically different set of virtualities.

Although, as I mentioned above, Guattari's thinking of the actual/virtual cannot be completely identified with Bergson, nevertheless, by superimposing the Bergsonian cone of Chapter 1 onto our diagram of Guattari's Third Assemblage we get a composite diagram (Figure 3.2) that points towards a double movement of the production of subjectivity: the folding-in of transcendence (movement down from apex) and then the actualization of the virtual (movement up from inverted apex).

We might go further and draw the chaosmotic entities – the virtual-actual ecologies – that inhabit Bergson's cone/the third Assemblage (Figure 3.3). Indeed, the folding in and then moving back out constitute the very circuit of the chaotic-complex enunciative entities that *are* subjectivities.

However, again as I suggested above, there is a sense in which Guattari's thought collapses these cones (indeed, as we saw in Chapter 1 in relation to Spinoza, using the cone is simply a device to highlight certain logics and moments). Certainly with the folding in of the apex we have a collapsing (a folding in of transcendence 'on to' immanence); but,

102 On the Production of Subjectivity

Figure 3.2 The double cone Bergson–Guattari composite diagram

Figure 3.3 The double cone (with actual–virtual ecologies)

we might add, that the actualization of the virtual might be figured less as a movement 'up', than as a movement outwards on the same plane (the actualization of the virtual is here Guattari's slowing down of infinite speed). In a return to the final diagram of Spinoza's *Ethics* in

Chapter 1 we might then also diagram this particular Bergson–Guattari composite diagram, with its actual–virtual ecology, as the 'Body without organs' in Figure 1.5.

All of this is to suggest that, as different subjectivities, we will have our own very singular composition. The production of subjectivity involves the tracing of our own actual–virtual circuits – or, the composing of our own relations of speeds and slowness. This in itself means drawing our own particular diagrams and maps of the finite–infinite relation. It is to the pragmatics of this specific cartographic operation that I want now to turn.

3.4 Metamodelization

What precisely are the mechanisms or technologies that would allow us to produce ourselves differently, or, in the terms of the above commentary, to rearticulate our own relationship with the infinite and thus constitute ourselves as different finite–infinite composites? Put bluntly, what are the practical and pragmatic implications for the production of subjectivity of the new aesthetic paradigm as Guattari outlines it? These questions can be approached by way of the essay on 'Schizoanalytic Metamodelisation', wherein we find Guattari's distinct and complex *analytic* take on the production of subjectivity. In fact, Guattari pitches his theory of metamodelization against what he sees as a bankrupt psychoanalysis that, as a form of structuralism, insists on reducing all aspects of semiotic modelling to 'syntagmatic articulations' in which any 'points of ontological crystallisation', for example 'phonological, gestural, spatial, musical ... discursivities', become 'annexed to the same signifying economy' (C, pp. 59–60). Psychoanalysis, for Guattari, is then a paradigmatic example of the second Assemblage as explored above. In its place Guattari lays out his own system and anti-structure of sorts that attends specifically to a more expanded semiotics (asignifying and signifying) *and* to the processual nature of the production of subjectivity that in itself foregrounds the singular and local nature of each crystallization of Being. We can see immediately that this schizoanalytic project is implicit in the aesthetic paradigm, and, as such, involves the production of subjectivities leading from the third Assemblage discussed above.

In order to theorize this schizoanalytic programme – or theory of metamodelling (the two terms are used more or less synonymously) – Guattari provides his own distinct articulation of the four ontological functions (shown in Figure 3.4) that determine any given 'discursive system' or 'refrain of ontological affirmation' (C, p. 60).[23] Guattari's organizational

	Expression actual (discursive)	**Content** virtual enunciative nuclei (non-discursive)
Possible	Φ = machine discursivity	U = incorporeal complexity
Real	F = energetico-spatio-temporal discursivity	T = chaosmic incarnation

Figure 3.4 Guattari's diagram of 'The assemblage of the four ontological functions' (from 'Schizoanalytic Metamodelisation', *Chaosmosis*)

schema owes much to Hjelmslev, from whom the expression/content framework is taken (and which is Guattari's response to the Saussurean signifier/signified framework determinant in Lacanian modelizations). Any given being – or enunciative assemblage – might be seen to be constituted across these four realms. As far as the real goes, F denotes the actual constitution of any given entity within space and time, while T denotes the chaosmosis out of which that entity has emerged (and towards which it tends in a movement of its own dissolution). On the possible side, Φ denotes the actual machinic nature of the entity – its autopoietic and allopoietic character as it were – while U denotes the virtual 'universes of reference' or 'incorporeal complexity' that are available to, or opened up by, this machinic discursivity.[24]

The key intention here is to complexify rather than reduce the components that make up any given instance of subjectivity (especially those that instigate the reign of a master signifier or any rule of transcendence (again, as in the second Assemblage)). The above matrix thus allows for a multiplicity of different pathways and arrangements to be diagrammed. This is schizoanalytic metamodelization. As Guattari remarks:

> Schizoanalysis does not ... choose one modelisation to the exclusion of another. Within the diverse cartographies in action in a given situation, it tries to make nuclei of virtual autopoiesis discernible, in order to actualise them, by transversalising them, in conferring on them a diagrammatism (for example, by a change in the material of Expression), in making them themselves operative within modified assemblages, more open, more deterritorialised. Schizoanalysis, rather than moving in the direction of reductionist modelisations

which simplify the complex, will work towards its complexification, its processual enrichment, towards the consistency of its virtual line of bifurcation and differentiation, in short towards its ontological heterogeneity. (C, pp. 60–1)

Guattari's metamodelization is thus an attempt to proliferate models and also to combine models, or parts thereof, which might otherwise be seen as non-compatible (and, in this sense, my own use of diagrams in the present book might be seen as a form of metamodelization).[25] Crucially, the 'nuclei of partial life', which hold the assemblage or entity together (and which are, as we have seen, determinant in the third Assemblage above) involves a kind of 'self-knowledge' of 'being-in-the-world' that 'implies a pathic apprehension which escapes energetico-spatio-temporal coordinates' (C, p. 61). At stake then is a kind of auto-cohesiveness – or rhythm – that operates *prior* to signification. Nevertheless, this self-constitution might well involve narration as a secondary cohering mechanism of sorts:

> Knowledge here is first of all existential transference, non-discursive transitivism. The enunciation of this transference always occurs through the diversion of a narration whose primary function is not to engender a rational explanation but to promote complex refrains, supports of an intensive, memorial persistence and an event-centred consistency. It is only through mythical narratives (religious, fantasmatic, etc.) that the existential function accedes to discourse. (C, p. 61)

Guattari's argument here is that such 'narration' operates as a refrain, which is to say it is stripped of its signifying and discursive function in favour of the 'existential transference' of the non-discursive. Guattari gives us two examples of just such narrative refrains, or what we might call myth-systems: Christianity, which ultimately produces a 'new subjectivity of guilt, contrition, body markings and sexuality. Of redemptive mediation'; and Freudianism, which produces an 'Unconscious presented as universe of non-contradiction' and a pragmatics of 'transference and interpretation' (C, p. 62). For Guattari, Freud himself was in fact a veritable inventor of concepts and narratives, opening up vast new possibilities for the modelization of subjectivity, but Freudianism 'quickly encountered limits with its familial and universalising conceptions, with its stereotyped practice of interpretation, but above all with its inability to go beyond linguistic semiology' (C, p. 63). Freudianism, we

might say, involved a petrification of the generative models of Freud, and a reduction of the latter to a wholesale signifier enthusiasm.

Crucially, whereas for psychoanalysis it is neurosis that operates as model, for schizoanalysis, following this notion of metamodelization, it is psychosis: '[b]ecause nowhere more than here is the ordinary modelisation of everyday existence so denuded; the "axioms of daily life" stand in the way of the a-signifying function, the degree zero of all possible modelisation' (C, p. 63). It is this confrontation with chaos (over which the above narrations are cast, as it were) that positions psychosis in such a privileged position as regards metamodelization (and indeed the aesthetic paradigm more generally). As Guattari remarks: 'The schizo fracture is the royal road of access to the emergent fractality of the Unconscious' (C, p. 64). As such, psychosis is not just an illness or aberration, but also an indication of, and insight into, our own ontological condition as chaosmotic entities:

> Psychosis is not a structural object but a concept; it is not an irremovable essence but a machination which always starts up again during any encounter with the one who will become, after the event, the psychotic. Thus here the concept is not an entity closed in on itself, but the abstract, machinic incarnation of alterity at the point of extreme precariousness; it is the indelible mark that everything in this world can break down at any time. (C, p. 64)

As well as involving asignifying rupture, psychosis also has its own narration – or produces its own myths (idiosyncratic, local, often strategic). Indeed the psychotic is a prodigious inventor of stories and concepts, and, like anyone else, has his or her own refrains that cohere a self or multiple selves, however fragile and transitory these might be (I will return to this below). Metamodelization is, then, an anti-structure of sorts in which different elements (signifying and asignifying, discursive and non-discursive) become loosened, moving between terrains, migrating across the four quadrants of Guattari's model. Guattari introduces Daniel Stern's child ethology as paradigmatic of this new and more fluid modelling of relations, involving as it does a mapping of the infantile world or 'primary assemblage of subjectivation' that involves existential territories and incorporeal universes that have yet to be fixed on the father, mother, and so forth (C, p. 65). Crucially this emergent self ('atmospheric, pathic, fusional, transitivist') is not itself a phase 'since it will persist in parallel with other self formations and will haunt the adult's poetic, amorous and oneiric experiences' (C, p. 66).[26] In the

collaborations with Deleuze, this emergent self is redefined as a 'becoming-child'; not a nostalgic return to childhood but the mobilization of 'blocs of childhood' within a so-called 'adult' life. Becoming-child is just one moment in an ongoing series or processual programme that ultimately involves less human becomings, even inorganic ones (and, as such, we can understand one of the key preoccupations of *A Thousand Plateaus* in terms of an exploration of the resonances between the first and third Assemblages discussed above).[27]

A further important developmental aspect of this emergent self is the discovery of 'sharable affects', or the 'recognition of the fact that the other can experience something that the subject experiences for itself' (C, p. 67). The emergent self (that continues throughout life, but is habitually 'masked' or erased by typical subjectivity) is one that knows no subject-object duality. 'It is at the heart of this proto-social and still pre-verbal Universe that familial, ethnic, urban, etc., traits are transmitted' (C, p. 67). Further phases follow, including the entry into language, but again, these phases – which we might also call, following Guattari's terminology, 'Universes of reference' – are not sequential but are rather 'superimposed in a kind of incorporeal existential agglomeration' (C, p. 67). This is a crystallization rather than a topology, a complex assemblage in which any given universe might foreground – or actualize – itself at any given time. Just as each of the three Assemblages are superimposed on one another within our own epoch, so the different aspects of a 'self' or a given subjectivity are likewise layered in a kind of palimpsest. Indeed, one might say that schizoanalysis, like the aesthetic paradigm more generally, involves the locating of an access point – or line of flight – from a given petrified individuality or transcendent mode of organization. It is in this context that we must understand Guattari's paradigmatic redefinition of the symptom, in this case the lapsus, which becomes 'not the conflictual expression of a repressed Content but the positive, indexical manifestation of a Universe trying to find itself, which comes to knock at the window like a magic bird' (C, p. 68). Here the semiotic (the index), the ethological (the bird against the glass) and the discursive (the scenario as metaphor) are combined in a modelling in which the symptom is no longer proxy of an unconscious that is always already there, but rather a precursor of an unconscious that is yet to come. The only way to 'shift petrified systems of modelisation' (and to open up to more expanded versions of the latter) is to follow these symptoms, to cross the barriers of non-sense and access 'asignifying nuclei of subjectivation' (C, p. 68).[28] We might say that, in Guattari's system, the symptom offers an escape route from

the impasses of the present, or, simply, belies the very presence of the infinite within the finite.

However, as we have seen, the rupturing of given signifying regimes is only one of the gestures of schizoanalysis. The other is more constructive and might well involve the reintroduction of signifying material – alongside other material – in a local and singular modelization. In fact, it seems to me that this utilization of signifying material might be figured in three temporal sequences. First, it might come *after* the accessing of any asignifying nuclei – this would be a retroactive recognition, as it were, an 'Ah, so that's what it was!', or even an 'Ah, so that's me!'[29] It might also, however, operate *prior* to the asignifying nuclei as a kind of platform or catalyst. Here signifying material is predictive, even prophetic. In both these cases what is at stake, as mentioned above, is the production of alternative narratives and myth-systems. I would argue that this is a kind of performative 'fictioning' in the sense that it will take existing signifying materials – with their order words and master-signifiers – but reorder or reframe them in a local and singular constellation (and for different ends). We might say here that fiction can operate as the friction – the cohering mechanism – discussed above. A third moment might be the use of signifying material in *parallel* with any asignifying moment. Here writing, for example (as Foucault notes in his comments on the ancient Greek practice of self-writing, or *hupomnēmata*), itself operates as a pragmatic technology in the actual processual production of subjectivity.[30] This is not to re-privilege the signifying over the asignifying but to note that the signifying element cannot be ignored (and in fact Guattari is always at pains to point out that signifying semiotics play their part in schizoanalysis).[31]

A confrontation with chaos then, but also the concomitant construction of an assemblage to give the latter consistency, to make it *workable*. This programme need not be abstract (although having an abstract diagram will foster a more general or generic applicability). Indeed, it might simply involve the encounter and use of different elements of the world/the body – signifying *and* asignifying – in a specifically different manner. In relation to this, Guattari gives us the example of the treatment of a psychotic. The description amounts to a succinct statement of the method of schizoanalysis:

> The treatment of a psychotic, in the context of institutional psychotherapy, works with a renewed approach to transference, focused henceforth on parts of the body, on a constellation of individuals, on a group, on an institutional ensemble, a machinic system, a semiotic

economy, etc. (grafts of transference), and conceived as desiring becoming, that is to say, pathic existential intensity, impossible to circumscribe as a distinct entity. The objective of such a therapeutic approach would be to increase as much as possible the range of means offered in the recomposition of a patient's corporeal, biological, psychical and social Territories. (C, p. 68)[32]

We are given the example of the kitchen at *La Borde* (the clinical institution in which Guattari worked) as just such a complex arena of heterogenetic encounter, a machinic assemblage and veritable 'opera scene' of resingularization (C, p. 69). In such an assemblage, '[s]chizoanalytic cartography consists in the ability to discern those components lacking in consistency or existence' (C, p. 71), and consequently in reintroducing them (or others) so as to allow individuals to resingularize themselves (or simply to creatively break debilitating patterns and petrified modellings – and produce new ones). In this respect it is especially the collective nature of institutional analysis that is important, when this collectivity is understood as operating at both the molecular and molar register, as sub- and supra-individual. To quote Guattari:

> Note that collective is not here synonymous with the group; it is a description which subsumes on the one hand elements of human intersubjectivity, and on the other pre-personal, sensitive and cognitive modules, micro-social processes and elements of the social imaginary. It operates in the same way on non-human subjective formations (machinic, technical and economic). It is therefore a term which is equivalent to heterogeneous multiplicity. (C, p. 70)

This emphasis on collectivity, especially in terms of the pre-personal, involves a 'repudiation of the universalist and transcendent concepts of psychoanalysis which constrain and sterilise the apprehension of incorporeal Universes and singularising and heterogenetic becomings' (C, p. 72).[33] Indeed, Guattari's metamodelization is here, once more, pitched specifically against the 'fundamental linearity' of the Lacanian signifier that 'homogenises the various semiotics' and thus 'loses the multidimensional character of many of them' (C, p. 22). As an illustration of this colonizing function of the signifier, Guattari gives us the example of Lacan's interpretation of Freud's fort-da game. For Freud it is a game of absence and presence (of the mother) and ultimately of a repetition compulsion that moves towards death. Lacan, instead, 'ties it down to the signifying discursivity of "existing language"': '[t]hus the reel, the

string, the curtain, the observer's gaze, all the singular characteristics of the assemblage of enunciation fall into the trap of the Signifier' (C, p. 74).

Schizoanalysis, on the other hand, will attend to the asignifying semiotics of the game that have been 'overlooked' in this interpretation, 'recognising that with this refrain the child encounters unforeseen Universes of the possible, with incalculable, virtual repercussions'.[34] Here the fort-da assemblage is less a theatre of language (or the playing out of an Oedipal drama) than a 'desiring machine', 'working toward the assemblage of the verbal self – in symbiosis with the other assemblages of the emergent self – and thereby inaugurating a new mastery of the object, of touch, of a spatiality' (C, pp. 74–5). Guattari does not dismiss the Lacanian theorization *tout court* (as we have seen, signifying economies of narrative might well be crucial in cohering a subject), but places it alongside other modelizations in a more expanded analytic – and aesthetic – framework.[35]

Worth noting here is also Guattari's own take on Freud's insight regarding repetition and the death drive. For Guattari it is less the 'encounter or relation of intimate intrication between two distinct drives, Eros and Thanatos, [than] a coming and going at infinite speed between chaos and complexity' (C, p. 75). A reciprocal relation between consistency and its loss, between 'differentiated complexion' and 'chaosmic submersion' (C, p. 75). In the terms of the theme of my own book, it is a relation – reciprocal, always in process, fragile and dynamic – between the finite and the infinite. We are then at the heart of schizoanalytic metamodelization returned to Guattari's ontology, which informs his analytic framework and is informed by it. It is a post-human ontology and practice (inasmuch as the human is invariably a transcendent apparatus – or projection onto immanence), one in which Freud's decentring of the subject (in relation to the drives) is further deterritorialized on to an even more general field of 'chaosmic immanence' (C, p. 75). The important point here is that individuation from this field, when it does occur, need not necessarily lie along typical lines or involve those habitual patterns that invariably produce atomized and alienated 'individuals'.[36] Indeed, the goal of schizoanalysis is precisely to reconnect the petrified models of subjectivity to the field of desire from which they have been extracted, a technique that involves a confrontation with chaosmosis but then also that one models it differently, utilizes other models alongside the more familiar ones, and holds all models lightly and strategically.[37]

For Guattari this metamodelization, which involves the production of new kinds of relation to our own finitude as well as to the infinite of

which we are part, has, of course, a pressing urgency given our present ecological crises.[38] Indeed, the dominant paradigm of subjectivity today involves, as I suggested in the first part of this chapter, a homogenization of life and its capture by transcendent points, especially the exchange principle. This is the organization of subjectivity around money and material production solely for its own sake (a subject that sees the world as a separate object and purely a resource to be exploited). Such a subjectivity cannot but involve a certain kind of blindness, or wilful ignorance, both to its own finitude (and that of the world) *and* to those virtual ecologies – the infinite – of which it is an actualized part. Indeed, it would not be an exaggeration to say that the removal of these blinkers and the concomitant refiguring of the finite–infinite relation in alternative modellings is a matter of not only our own survival, but of the world in which we find ourselves.

3.5 Concluding remarks

Chaosmosis contains the most condensed and worked out statement of Guattari's very particular and complex schizoanalytic cartography. It also operates itself as a machine of sorts: a grasping and gathering of different materials that might be mobilized in the general project of forming an ontology 'beyond' the subject–object split and, leading on from this, of constructing a form of institutional analysis beyond Lacan (hence the many references to other thinkers, the new sciences, and so forth). In particular this philosophical and analytical programme involves the theorization of chaosmotic entities, an emphasis on asignifying semiotics, and the concomitant mapping out of an aesthetic paradigm for subjectivity in which process, or processuality, is foregrounded. One of the most important aspects of this project is its negotiation of the capitalist regime of transcendent capture. Indeed, it seems to me that Guattari's insights here concerning 'autopoietic nuclei of subjectivation', or what I call the 'folding-in' of transcendence, suggest, as I indicated above, a potentially very useful 'up-dating' of Foucault's thesis on the 'Care of the Self' that we looked at in the previous chapter.

To a certain extent all the essays in *Chaosmosis* repeat the same arguments from different perspectives and with different emphases – all of them characterized by a certain polemical urgency and an animating desire for a form of life that is not solely determined by capitalism with its principles of standardization and homogenization. Capitalism's reduction of subjectivity and of life in general is countered by a call for a complexification and resingularization that, rather than closing down

on mutation, opens itself up ever further to creativity and invention. This proliferation of models is the second important aspect of Guattari's writings, and in this sense *Chaosmosis* reads like Science Fiction, producing worlds beyond this one and inventing new terms with which to articulate and describe them.

Indeed, *Chaosmosis* offers us a theory of metamodelization, but also a modelization itself, one premised on Guattari's very particular ontology. Adjacent to this Science Fiction narrative and conceptual toolbox we are also given – through case studies such as *La Borde* – ample evidence that any theoretical work must itself be put to work in larger and more diverse realms of heterogenetic encounter. This is the third and arguably most important aspect of Guattari's thesis. Indeed, the paradoxical nature of Guattari's writings is that while they are often dense and complex, they call for something deceptively simple, namely, that each of us interacts with each other and the world in a specifically *different* manner. It is a call to become an active participant in changing our lives as they are at this moment, not to wait for an event that might force us to change. In fact, the nature of the event itself changes: it no longer 'arrives' from an infinite that is barred from the finite, but names the reciprocal interpenetration of the finite and infinite. This is to figure the world as a complex weave of micro-events – or simply becomings.

To conclude this chapter, we can say that Guattari suggests a continuum of sorts between the finite and the infinite. This fundamentally anti-theological view positions him against a certain post-Kantian tradition of philosophy (and psychoanalysis) that would erect a bar between phenomena and noumena, the real and the symbolic, and so forth. It also, however, places him in a rich alternative tradition, running from the pre-Socratics to Spinoza and from Bergson to Nietzsche, in which subjectivity – or the finite – becomes the means of accessing the infinite as well as its very substance. It is, of course, this very same line of anti-state philosophers that Deleuze claims as his own. No wonder then that when this anti-psychoanalyst and activist, this drawer of diagrams and inventor of concepts, met the contemporary philosopher of immanence, the thinker of absolute difference, they each found in the other not only a fellow traveller but also a stranger, someone who might take them on further adventures of thought. Would it be an overstatement to say that Deleuze and Guattari's collaboration itself diagrammed a new relation of the finite and the infinite? Certainly in works like *Anti-Oedipus* and *A Thousand Plateaus*, as we shall see in the last chapter of my book, many strange entities appear, traversing multiple fields,

moving at different speeds and often evidencing what Deleuze saw in Spinoza, and what lies at the heart of Guattari's *Chaosmosis*: a certain absolute velocity or infinite speed of thought.

3.6 Coda: on biopolitics

As a coda of sorts to the preceding technical discussion of Guattari I want now to briefly sample the thought of three thinkers who continue Guattari's investigations into the production of subjectivity and the finite–infinite relation, specifically in relation to contemporary politics and the latest form of capitalism: what Paulo Virno, following Foucault, calls biopolitics; Franco Berardi, semio-capitalism; and Antonio Negri, Empire. In fact, for each of these thinkers the finite–infinite relation is itself the terrain of this 'new' form of capitalism (as well as of its counter movements) inasmuch as it describes man's relation to his potentiality, or simply his labour power. Capitalism, we might say, has progressed from a concern with production *per se*, to an interest in our very capacity for production. It now increasingly exploits the forces of the infinite – the 'reserve' – that are folded within the finite body.

To a certain extent this is to problematize – and deepen – the account of capitalism that was alluded to in Chapters 1 and 2 (and indeed immediately above in relation to the definition of capitalism as a 'transcendent' Assemblage) insofar as here, we might say, capitalism itself operates as a processual assemblage, one in which there is no 'outside' as such. I will be returning to this idea of capitalism as an immanent operator – and what it means for the production of subjectivity – in my discussion of *Anti-Oedipus* in Chapter 5. Suffice to say here that it seems to me that the battlefield against this latest form of capitalism is, again, time. Hence the importance of exploring different temporalities of and for a subject that is itself produced on an affective, or intensive, register.

In what follows I spend a little longer on Negri, and his important concept of *kairos*, as the latter, I think, contributes most directly to a thinking of a temporality inimical to the operating logics of capitalism. *Kairos* might also be productively brought into relation with the Bergsonian cone of my first chapter, bringing, as it does, the idea of a certain attitude-orientation to bear on the question of the past/future. Insofar as *kairos* also names a decision of sorts (that in fact defines its subject), this final section of Chapter 3 also works as an introduction to the Badiou of the next chapter. Although this coda appears at the end of my chapter on Guattari, to a large extent each of these three thinkers explicitly follow Deleuze and Guattari's *Capitalism and Schizophrenia*

collaboration, and in this sense, again, this coda also operates as a preamble and precursor to my final chapter.

3.6.1 Paulo Virno: the individual/pre-individual weave

For Paulo Virno, in his book *A Grammar of the Multitude*, the finite–infinite relation might be cast in terms of the relation an individual is able to maintain with that which is pre-individual. This is not, however, the same individual that is the centred subject of liberal ideology. Indeed, following Guattari, Virno develops a notion of the individual that is specifically in opposition to this all too common – and atomizing – doctrine of individualism. Individuals, in Virno's terms, are rather composed from, and crucially maintain a connection with, a field of pre-existing pre-individual singularities. Virno identifies three such fields: the biological (or simply sensing), the linguistic (or language, a pre-individual singularity that also allows for singularization) and the historical (or the relations of production and the 'general intellect') (as we shall see in my final chapter, this last pre-individual field has profound resonances with Deleuze and Guattari's own ideas of production and of the 'historical subject' in *Anti-Oedipus*).

Virno's key philosophical resource here is Gilbert Simondon, for whom the process of individuation – the emergence of individuality from these pre-individual fields – is processual and reciprocal; there is always an ongoing interweaving of the individual and the pre-individual. Indeed, this weave is the very name of the subject. In terms of my own book we might call it a weave of the finite and the infinite:

> the *subject* consists of the permanent interweaving of pre-individual elements and individuated characteristics; moreover the subject *is* this interweaving. It would be a serious mistake, according to Simondon, to identify the subject with one of its components, the one which is singularized. The subject is, rather, a composite 'I', but also 'one', unrepeatable uniqueness, but also anonymous universality. (Virno 2004, p. 78)

For Virno the subject amounts to a 'battlefield' in this sense insofar as pre-individual characteristics often threaten individuation itself, or, on the other hand, the individual threatens to become too narrow, too 'closed off' from the pre-individual: 'Either an "I" that no longer has a world or a world that no longer has an "I": these are the two extremes of an oscillation which, though appearing in more contained forms, is never totally absent' (Virno 2004, p. 78). In anticipation of Berardi's

thesis below, we might call these the twin extremes of neurosis – being too closed to the world – and psychosis – being too open to it.[39]

Virno continues this line of argument with the important remark that: 'this oscillation is prominently signalled, according to Simondon, by feelings and passions. The relation between pre-individual and individuated is, in fact, mediated by feelings' (Virno 2004, p. 78). This is crucial: following Guattari (himself a reader of Simondon), subjectivity is predominantly, and primarily, a question of affect that exists alongside any signifying regimes and economies. This intensive register of subjectivity is explicitly opposed to the Lacanian insistence on the subject of the signifier, and, as we shall see, is central to Deleuze and Guattari's own theory of the subject, inasmuch as they have one, in *Anti-Oedipus*. It also harks back to a Spinozist understanding of the individual, and of life more generally, as being constituted by degrees of power and intense thresholds.

For Virno, again following Simondon, it is only through the group or collective that a true individuation can take place:

> By participating in a collective, the subject, far from surrendering the most unique individual traits, has the opportunity to individuate, at least in part, the share of pre-individual reality which all individuals carry within themselves. According to Simondon, within the collective we endeavour to refine our singularity, to bring it to its climax. Only within the collective, certainly not within the isolated subject, can perception, language, and productive forces take on the shape of an individuated experience. (Virno 2004, p. 79)

We have here then an answer of sorts to the problem that Guattari's writings pose, that is, the relation between an autopoietic monad and the collective. For Virno, following Simondon, it is, in fact, only *through* a collectivity that the monad can fully become 'autonomous' (another name for this collectivity is, in Virno's terms, the multitude). It might be said then that there are no true individuals apart from those that are produced collectively, just as there are no true collectivities that are not, at the same time, made up of individuals.

Virno links Simondon's thesis on individuation to Marx's idea of the 'social individual', itself understood as the coming together of the pre-individual and the individual, when the latter is thought, again, as not the liberal individual but the product of an individuation that occurs *through* the social. Virno also addresses the question of the 'labour power' of this social individual, understood as the potential to

produce, that is, its future capacity: '"labour-power" does not designate one specific faculty, but the *entirety* of human faculties in as much as they are involved in productive praxis' (Virno 2004, p. 84). Again, in terms of my own thesis, we might say that labour power is the infinite as it is folded within the finite. It is this potential – the whole life of the individual (including, as it were, their future) – that is bought by the capitalist, and with it the possibility of a surplus insofar as what is bought is always more than the actual labour performed. As such, biopolitics replaces politics, naming as it does a broader set of concerns to do with life (as infinite reserve) itself. As we shall see below this idea of the social individual has many resonances with Negri's writings where the body, or 'materialist field', is likewise a site of potentiality, a kind of bounded infinity or, following Spinoza, what we might call an infinity of immanence.

In summary we might note that for Virno the individual's relation with that which is unindividuated is crucial. This, the relation of a finite being with the infinite, is, however, also the terrain of operation of capital that increasingly focuses on the unindividuated understood as the potential of the individual for production. In a sense then, the terrain of capitalism and of anti-capitalism are the same: the infinite as it relates to the finite. Nevertheless, for Virno different kinds of collective might allow for a different kind of incorporation of the unindividuated within the individual, just as a tracing back of various negative emotional tonalities to their neutral core might allow them to be developed differently.[40] In each case it is a question of how, specifically, the infinite has been folded in to the finite – and how this, in itself, either fosters a greater capacity to be and act in the world, or stymies it.

3.6.2 Franco Berardi: the soul must negotiate chaos

Franco Berardi, as an astute reader of Guattari and an autonomist thinker, is likewise attentive to the pre-individual moment of subjectivity:

> The methods of Autonomous theory and Schizoanalysis coincide in their Compositionist method: they both reject any constituted subjective primacy, looking instead for the processes of transversal formation of those unstable, varying, temporary, singular aggregates that are called subjectivities down to their molecular dimension. Subjectivity does not pre-exist the process of its own production. (Berardi 2010, p. 123)

This idea of subjectivity as a kind of secondary, supplementary product in a primary process of production is something Berardi takes from *Anti-Oedipus* (as we shall see in my final chapter). As with Virno, however, this field of pre-individual molecularity is also a threat to the subject, in this case – following Guattari – in the formlessness of chaos. Indeed, for Berardi, following Deleuze and Guattari in *What is Philosophy?*, subjectivity must be thought of as a chaoid: a piece of chaos that has been given consistency but that always threatens to return to its previous chaotic state:

> Subjectivity or rather the process of subjectivation is measuring itself against chaos. Subjectivity constitutes itself precisely in this constant relation to an infinite velocity, from which the conscious organism derives the conditions for the creation of a *cosmos* and of a provisory order, variable and singular. But subjectivity does not side with order, since this would paralyze it. Chaos is an enemy, but also an ally. (Berardi 2008, p. 126)

In his recent book *The Soul at Work*, from where the first quote above is taken, the business of productively and affirmatively negotiating this chaos is defined as precisely the work of the book's title – the soul here being understood, following Virno, as our potential to produce or, again, our 'labour-power'. Berardi offers a much more sober account of the relation to chaos than that explicitly put forward by Guattari in *Chaosmosis*, thinking the former through also in connection to the increasing 'old age' of our world and the concomitant loss of consistency in its subjectivities.[41]

In relation to this it is worth noting that Berardi, occasionally figures chaos as not only the ontological ground of our being as it were, but also as the name for the 'infosphere' understood as the increasing acceleration of media that interpenetrates our lives, especially in terms of the proliferation of information (again, this general condition Berardi also names 'semiocapitalism'). Berardi's thesis on old age (and also depression) is then tied to the concomitant asymmetrical relation between transmitters (machinic technologies) and receivers (biological organisms), a temporal asymmetry that, if you like, leaves us either too open to the world (schizophrenia), or, in reaction, too closed (neurosis/depression).

For Berardi, strategies to deal with this chaos must then themselves involve a shift in speed:

> Concepts, artistic forms, and friendship are the transformers of velocity allowing us to slowly elaborate what is infinitely fast without

losing its infinite complexity, without having to recall the common places of opinion, communication, and redundancy. (Berardi 2010, p. 126)

In this regard Berardi is especially attentive to the resonances between the therapeutic (schizoanalysis) and the aesthetic (art practice), or rather, is particularly attentive to Guattari's thoughts on this cross-over:

> Guattari establishes a privileged relation between the aesthetic and the psychotherapeutic dimensions. The question of the relationship between chaotic velocity and a singularity of lived time becomes decisive. In order to grasp temporal flows, the mind needs to build its own temporalities: these singular temporalities are *refrains* that make orientation possible. The notion of refrain leads us to the core of the schizoanalytic vision: the refrain is the singular temporality, the niche for individualising the self where the creation of cosmos becomes possible. (Berardi 2008, p. 130)

As we saw above, for Guattari it is indeed the production of singular and specifically different temporalities against chaos – but also, we might add, against the homogenizing time of capitalism – that defines the production of subjectivity. I will return to this important idea of subjectivity as refrain, and as a chaoid, in Chapter 5.

3.6.3 Antonio Negri: *kairos* against time

For Antonio Negri the question of maintaining our infinite capacity against those forces that wish to appropriate it might be rephrased thus: how to construct a war machine against transcendent power? For Negri, following Deleuze and Guattari's own definition of the war machine as that which operates in a different space-time to the state, this must involve the deployment of a different kind of temporality of and for the subject. Indeed, in his book *Time for Revolution* (cited in references as *TR*), Negri, offers a compelling perspective on the temporal predicament of how to resist the present when one is in that present, while also offering a slightly different perspective on 'what' or 'where' the depth, or virtuality, of the Bergsonian cone of Chapter 1 actually 'is'.

For Negri there has been a total subsumption of life by Capital. A colonization of all space, but also of time itself. As such Negri develops the concept of *kairos* as an attempt to think through and against this spatially and temporally complete system. Indeed, it is in this

sense that *kairos* names a temporality that is not to do with the past (unless, as we shall see in a moment, that past is reconstituted in the present) nor with the future (which can be just a mirror image of the present). Past-present-future, in this linear and uni-directional sense, operates as a kind of trap for thought and being. Time, we might say, is figured as a kind of 'frozen container' in which all is already determined. This is, in fact, how transcendent power operates – by delimiting the limits and laws of what can happen in this container (for Deleuze, as we will see in the next chapter, this is the logic of the possible in which any future is merely an extension of certain logics of the present. In a return to the terminology of Chapter 1, we might say that this is a future as it already exists on the plane of matter). Such an idea of time precisely misses the generative moment that is the event, or, rather, can only 'see' the latter once it has happened – translating it into a past, or, precisely, a *history*.

Kairos, on the other hand, does not name a time as such, but rather an orientation and attitude, perhaps best characterized as a certain restlessness and opening out to the 'to-come'. Again, this time – of the event – is not dissimilar to Deleuze's own ideas of the 'untimely', and, indeed, has much in common, as we shall see in the following chapter, with Badiou's own thoughts on vacillation and the decision. We might picture this *kairos* as an oblique line – a 'disjunctive synthesis' to use Deleuze and Guattari's terminology – away from the present (but, not, as it were, to an already determined future). In fact, it is not a line as such insofar as it is yet to be drawn or, put differently, produces its trajectory as it goes. It might be thought more as a point of view and an intention.

This is to figure lived time as praxis, generative in and of itself and thus always orientated against any transcendental logic that refers back to the laws of what already is: 'We will define the time that is coming as the *to-come*, and the *to-come* as ontological constitution in action' (*TR*, p. 163). Negri continues this line of argument in aphorism 4.6. of 'The Immeasurable':

> The everyday sense of life confirms the definition of that 'which is coming' as *to-come*, rather than as future. It is indeed in the struggle for the free appropriation of the present that life opens itself to the *to-come*, and desire perceives – against the empty and homogenous time in which all is equal (including, and in particular, the future) – the creative power of *praxis*. If life is not based on this active experience of the *to-come*, it cannot be life. (*TR*, p. 163)

120 *On the Production of Subjectivity*

Is then *kairos* a passage into the virtual? Negri remarks in aphorism 4.4: 'The passage to the *to-come* is always a difference, a creative leap. Repetition, and with it duration, are de-structured by the current experience of the *to-come*, and the real is in this way comprehended in a new manner in the making of *kairos*' (*TR*, p. 163). As we shall see in the next chapter, this is then indeed to follow Deleuze's thesis of difference and repetition, although, in fact, Negri distances himself from what he sees as the Bergsonian notion of time as 'temporal flux'. However, it seems to me that the content of Bergson's cone might be figured as the realm of Negri's *res gestae*, of events past. Could we not say then that *kairos* is a line into this realm? Certainly we could diagram it on to our Bergsonian cone: an oblique line – that draws itself as it goes – away from the past, present and future, as the latter are already laid out on the plane of matter (Figure 3.5).

In fact, this line of the '*to-come*' has a certain specific relation to the past. It implies a past that must be tested. The past here is less the sedimentation of dead matter than a constellation of 'nows', a collection of previous *kairos* (again, this might be seen as the 'content' of our cone). To quote Negri:

> Men and women amuse themselves in making history (historiography), interpreting (they say) the past, falsely imagining the time that

Figure 3.5 Diagram of *kairos*: 1 Past; 2 Present; 3 Future; 4 *Kairos*

went before them as accumulated according to a cemetery-like order. But there is no possibility of immersing oneself in that being which comes before, if not by illuminating it with the present, reconstructing it and feeling it live in the present. In other words, the common name of historical *praxis* cannot but be a 'genealogy of the present', that is, an imagination that brings to being that which 'came before' in the same manner as it constitutes the *to-come*. One does not interpret the past, one tests it out. (*TR*, pp. 164–5)

As we shall see, the resonances with the ideas of Badiou are remarkable (in fact, we might say that both Negri and Badiou, as Marxists, articulate an idea of history and the future as that which is *made* by man). We have here a theoretical elaboration of the 'living archive' I mentioned in Chapter 1. An archive that must be tested in the present. This is the revolutionary's attitude to previous revolutionary moments, or the artist's attitude to those artistic 'movements' that came before their own practice: they do not constitute a dead history but are moments that might be reactivated, reignited as it were. It is a militant idea of history, when militancy names a generative life of the present.

Importantly, this has implications for Negri's idea of subjectivity. In fact, there is no subject before *kairos*. Indeed, Negri, like both Virno and Berardi, follows *Anti-Oedipus* in this critique of the subject as first term (as we shall see, Badiou's own definitions of the subject–event relation also follows this logic). As Negri remarks in Aphorism 3.3 of 'The Materialist Field', referring to more typical theorizations of the subject:

> The philosophers of the subject place the determination of the meaning 'here' (in the materialist field) in the act of knowing that perceives and reflects. But this epistemological pre-eminence of the subject, this ontological supremacy of the subject, is the product of a transcendental illusion and is immediately in contradiction with the ontological experience of *kairos*. For subjectivity is not something that subsists: it is – on the contrary – produced by *kairos*, and ... depends on the connection of monads of *kairos*. Subjectivity is not before but after *kairos*. (*TR*, pp. 172–3)

To the extent that *kairos* is 'outside' time it has a relationship with the eternal as Spinoza understood it. In fact, *kairos* is that which creates 'in' the eternal. It is the edge, where the eternal becomes productive. For Negri, this productive 'site', what he calls the 'materialist field', is the body. The body, as it is for Bergson, but also Guattari, is *the*

actualizing machine. Another way of putting this is that the body is situated between the eternal (past) and the *to-come*. As Negri remarks in Aphorism 4.2 of 'The Materialist Field':

> We can thus say: when the body reflects, it is on the one hand immersed in a materialist field (the 'before'), and on the other hand that it is open to innovation (the 'after'). If the before is the eternal and the after is the *to-come*, the body reflects the eternal by putting it in contact with the *to-come*, because even if this relationship is immeasurable, it is still, at the same time, production. (*TR*, p. 174)

It is in this sense that the body is the 'incarnation of *kairos*' (*TR*, p. 174). We might say that the body is itself a kind of corporeal diagram between the finite and the infinite.[42]

In relation to this body *kairos* also names a 'naming' at the edge of the finite: the calling forth of a world from the infinite. Here language is creative and future orientated, an exploratory probe of sorts.[43] Imagination itself also plays a role in this 'surveying', involving as it does a projection on to reality motivated by a desire to understand and organize, but also to construct something new. The name is then precisely generative, it calls forth the thing (although the thing also, in a sense, calls for the name).[44] The name is then a leap into the *to-come*. As we shall see in the following chapter this has further resonances with Badiou and his own idea of forcing. In a return to Chapter 2 and Lacan's *The Ethics of Psychoanalysis* we might say that it is the writing of the book rather than merely the receiving – or 'eating' – of it. It is an active rather than passive mode of knowledge.

From the perspective of *kairos* truth is this practice of naming, but also the practice of being adequate to and worthy of that which is named: 'knowing the true [*vero*] is watching, expressing, experiencing and living being from the stand point of *kairos*...' (*TR*, p. 153). Indeed, in an echo of Badiou's own thesis in *Being and Event*, *kairos* is 'the praxis of truth' (*TR*, p. 161). It 'is the instant verification of the name. For the name presents itself in the vacillation of *kairos*, and it is through this vacillation that the true is revealed' (*TR*, p. 153). Naming is then a moment of decision: 'The solution of the vacillation, its necessary decision, is the presentation of the name' (*TR*, p. 153). And again: 'the power of truth is not behind, nor in the depth; it is in front, in the risk of vacillation' (*TR*, p. 153). As we shall see this notion of vacillation, and of the decision attendant on it, is also crucial to Badiou's *Logics of Worlds*. In passing it is worth remarking that it is the common name that especially interests

Negri. The common name, by collecting and grouping, defines a new spatiality.[45] *Kairos* then ultimately names a common project, or even, following Spinoza, a common notion insofar as 'every time an encounter takes place there is a construction of being.' (Negri 2004, p. 126).

We might say then that Negri brings the important idea of a generative temporality to Guattari, as well as an emphasis on the commonality of this creative gesture. Perhaps it is these two that characterize the 'take up' of Guattari's thought within Italian Marxism (after all both are fundamentally Marxist ideas). Certainly, in *Empire*, Hardt and Negri, although paying their dues to Deleuze and Guattari, somewhat distance themselves from Deleuze's own account of the virtual as being too abstract, not connected explicitly to the realm of praxis. In Guattari – and Deleuze's – defence we might say that it is precisely the abstract quality of the virtual that unties it from the logics of the possible understood as an already predetermined field. In fact, it seems to me, that contra *Empire*, in *Time for Revolution* a specifically Deleuzian concept of temporality is in fact mobilized, albeit it maintains a link with the realm of the possible as the very location point of political and militant engagement.

4
The Strange Temporality of the Subject: Life In-between the Infinite and the Finite (Deleuze contra Badiou)

4.1 Introduction

Alain Badiou is perhaps the most important, and certainly the most prominent thinker working on the question of the subject today, and this chapter attempts to get to grips with his particular philosophical system. The chapter is divided into two sections: the first works through Badiou's 'Theory of the Subject' as mapped out in his major philosophical work, *Being and Event* (cited in references as *BE*). Specifically, I am interested here in the way in which the subject, as a figure of finitude, 'interacts', or does not, with the infinite, which in Badiou's system determines them *as* a subject. I then go on to explore this issue by comparing Badiou with Gilles Deleuze, specifically in relation to the latter's own major philosophical statement, *Difference and Repetition* (cited in references as *DR*), in which a relation of 'reciprocal determination' between the actual and virtual is at play in the constitution of any given 'individual'. I hope to show that at stake in this confrontation are two distinct understandings, or diagrams, of the production of subjectivity.

The second section looks to *Logics of Worlds* (cited in references as *LW*), Badiou's sequel to *Being and Event*, in which some of the problems of the former volume are addressed. In particular, the question of the body, entirely absent from *Being and Event*, is brought to the fore as that which gives a subject an existence in a world. For Badiou, it is also this body that gives finite existence to the infinite, although, as we shall see, the relation between these two remains, I will argue, problematic. This second section of my chapter involves a critical introduction to *Logics of Worlds* rather than any sustained critical engagement, but I do end by locating what I see as the same aporia – about a bar between the finite

and infinite – to that found in *Being and Event*. As with the first section of the chapter, my approach here will be to give a close reading of parts of Badiou's book, attending specifically to the passages in which the body and subject are addressed.

4.2 *Being and Event* (or, the strange temporality of the subject)

4.2.1 Introductory remarks: two systems...

Before embarking on what is at times a quite technical discussion of Badiou's theory of the subject I want first to briefly introduce Badiou's (and, even more briefly, Deleuze's) philosophical systems, especially as they pertain to subjectivity, and say a word or two about what is at stake in the following encounter. First then, Badiou. In *Being and Event* what we are offered is a radical and polemical account of the event's extra-ontological nature and the implications this has in producing a militant subjectivity. An event arrives unbidden from an 'elsewhere', impacting on a given situation that it is at odds with and in so doing produces a subject who thus seeks to transform the situation in terms of what the event has, we might say, 'announced'. This situation might be of a political nature, an art world, a scientific paradigm – or simply an individual life. In each case there are a number of elements that are 'counted' as belonging to the specific situation; they are 'presented' in the situation as it were. A further term, the 'encyclopaedia', names the set of knowledges about these elements.[1] The subject then – although this will be complexified below – is to whom an event happens and crucially who recognizes the importance of this event and consequently organizes their life differently and in fidelity to it, testing the different elements of their particular situation (through 'enquiries') against what this event has announced. In fact, a subject only comes into existence as such through an event and through this fidelity (the subject, in Badiou's system, is then not the individual as such, nor, strictly speaking, the subject as constituted through language, discourse or even the symbolic). We have three important terms here: the situation (or Being), the event (extra-Being) and the subject. A further crucial term, truth, names what we might call the impact of the event on the situation, in fact the way in which the event calls attention to that which is generic within the situation. Hence the subject of fidelity can also be called a 'truth procedure', or a 'generic procedure', or even, to quote Badiou, 'any local configuration of a generic procedure from which a truth is supported' (*BE*, p. 391). It might then be said that

Figure 4.1 Two diagrams of the subject: Lacan versus Badiou

Badiou's system is specifically concerned with the relation (or indeed non-relation) between a situation, an event, truth – and a subject. This involves a thinking through of ontology in terms of set theory, which alone, according to Badiou, is able to articulate accurately the relationship between the four terms – and crucially with the work of the mathematicians Cantor and Cohen – allowing for proof of the 'existence' of a place outside ontology (from where, as it were, the event 'arrives'). This 'inconsistent multiplicity', or simply the infinite, that always goes beyond any given situation, is in fact paradoxically also part of any given situation. Again, it is that which is generic to the situation, what Badiou calls the 'generic set' – or the void – albeit the latter is necessarily effaced in the very constitution – or count – of any given situation. If for our Lacan of Chapter 2 the void (*das Ding*) is located at the very centre of the subject (at the centre of the subject's 'world'), for Badiou the void is precisely external to the subject, and has an 'existence', as it were, irrespective of any subject or situation in which the latter finds themselves (Figure 4.1).[2]

Deleuze's philosophical project in *Difference and Repetition*, which is even more difficult to sum up away from the details, might be characterized as an attempt to rethink ontology – Being – in terms of difference in itself. To think an originary multiplicity as it were. In fact, we might say, more accurately, that Deleuze is interested in the relationship of the One and the Many. In his book on Deleuze, Badiou himself situates Deleuze as *not* a true thinker of multiplicity but rather a thinker of the One – synonymous with a vitalism that lies at the heart of Deleuze's metaphysics – in order to set himself, Badiou, apart as *the* philosopher of multiplicity (*a propos* set theory). Here is not the place to go into detail about this positioning of Deleuze by Badiou (that arises from a close reading of Deleuze, though, tellingly, no reading of the collaborative works written with Guattari), but what can be said fairly

straightforwardly is that Badiou understands Deleuze's Univocity as a form of transcendence to the extent that, although it attends to difference among beings, it still upholds the sense in which they are all, ultimately, determined *by* Being. For Badiou this 'One becoming Two' can be tracked through in Deleuze's various couplets, for example the actual and, in Badiou's terms its determining ground, the virtual. I will be looking at this in a moment, but what can be said as an immediate corrective here is that for Deleuze, as we also saw for Guattari in the previous chapter, the actual and virtual must be understood as being in a reciprocal relation – or, more simply, that there is a movement from Being to beings, but also from beings to Being. *This* is Deleuze's thesis of Univocity. In terms of my own thesis in this book, there is, we might say, a passageway, or continuity between the two fields.[3]

In fact, in other works besides *Difference and Repetition*, Deleuze does indeed posit something he calls *the* plane of immanence – the plane of life as it were – but, again, this is characterized by difference, by, precisely, multiplicity. Indeed, both the plane and the beings that live 'on' it, although distinct are also, as I intimated above, in an important sense inseparable. Deleuze's ontology is one in which 'life' in general is in a state of constant becoming, constantly differing from itself. Accompanying this notion of difference is Deleuze's idea of repetition as that which names what might be called the movement of Univocity – the actual production of difference – when this is understood as specifically non-representational generation. In what follows, it is especially this notion of repetition – from *Difference and Repetition* – and the different idea of time implied by it that I shall be focusing on, as it is with this that we come closest to excavating a 'Deleuzian subject' when the latter is understood as both sub-subject (larval self) and post-subject (Overman) (although, once again, it is certainly worth noting that Deleuze's philosophy is really less concerned with instigating a subject as such, but might be thought as an attempt to dismantle any given subjectivity – the subject-as-is as I have been calling it).[4]

The difference between each philosopher's system can also be summed up in their contrasting definitions of what an event is, where it 'comes' from, what a situation or world might be – and, following these definitions, what being active and creative in that world entails. For Deleuze, we might say that events are very much in the world (there is, as it were, nowhere else). The event names the passage from that which merely has potential to that which has a full presence, and, indeed, the reverse of this. In Deleuzian terms this is the movement of virtual to actual and of actual to virtual. Crucially, as Deleuze is always

at pains to point out, the virtual does not lack existence, but only needs to be actualized. Again, put very simply, for Deleuze, everything is already here; there is no 'other' place from which an event arrives. Deleuze's virtual might appear similar to Badiou's inconsistent multiplicity, but, as I hope to demonstrate below, the latter, despite Badiou's own words, is tied to a transcendent schema of sorts whereas Deleuze's virtual, I would argue, names a more radical immanence (which is to say my argument explicitly attempts to reverse Badiou's own take on Deleuze).[5] The implications for the subject are important in all this. For Badiou, to pre-empt some of the argument below, the subject is always a subject of an event that is essentially irreducible to, and outside of, their world as subject. Such events are very rare and only happen in very specific realms. For Deleuze, events might be thought of as very much in the world, and common, there being a constant reciprocal relationship between the virtual and the actual. In fact, this relationship, or movement, means a subject, if this is still a useful term, is always in a state of becoming.

As I hope will also be clear from my discussion below this implies two different relationships of the finite (the subject) to the infinite (that which is 'outside' the subject). Again, to pre-empt somewhat my conclusions, Badiou's system, it seems to me, produces a subject forever barred from the very truth that the event announces albeit this subject is also, in some senses, actively producing – or forcing – this truth into being. Such a subject, I would argue, is then necessarily constituted by a logic of deferral. For Deleuze by contrast, and as I suggested above, it is those events that undo the subject that are important, or, at least those events that re-connect the subject with a world of virtual intensities of which they are part – those molecular becomings, as Guattari might call them, that, in an echo of Spinoza, allow an 'individual' to 'become-world'.

A final brief word about what we might call the ethico-political implications of these two distinct positions. For Badiou the subject is that which is in fidelity to an event that has constituted them, but from which they are, to a certain extent, distant; hence, the importance of confidence or faith in Badiou's account of the subject and the importance of militancy (Badiou's typical example being his own militant subjectivity produced in the crucible of 1968 and in a continuing fidelity to that event). For Deleuze the question of an ethico-politics is more subtle, but what we can say, bearing the later collaborations with Guattari especially in mind, is that Deleuze's system has the ethical aim of producing a non-fascist mode of being, when the latter is thought

as one that 'escapes' identity, and, to a certain extent, the categories and coordinates (and habits) of 'being human'. Hence, the later project of schizoanalysis and the crucial notion of becoming in *A Thousand Plateaus* – and concepts such as the 'Body without Organs' which precisely diagram the different kinds of relation an individual might have with the virtual, or simply an 'outside' to themselves.[6] This has further implications for politics *per se* insofar as it leads, again especially in the collaborations with Guattari, to a 'micro-politics' in which molecular events and revolutions determine change on a molar level. Enough of an introduction, which, although inevitably highly reductive, has, I hope, provided at least some context and rationale for the more philosophical and technical discussion that follows.

4.2.2 Badiou's subject (and inconsistent multiplicity)

In Meditation 35 of *Being and Event*, on the 'Theory of the Subject', Badiou outlines what, for him, the subject is not (see *BE*, pp. 391–2). First, a subject is not a substance, or not 'counted as one in a situation' (a subject is not part of the encyclopaedia (the system of knowledges concerned with any given situation)); second, a subject is not a void point (this being the name reserved for Being and thus, as such, strictly speaking, an ontological concept (the subject is not ontological)); third, a subject is not 'the organisation of a sense of experience' (which would necessarily designate presentation, which the subject is not involved in); fourth, a subject is 'rare' (inasmuch as it is at a 'diagonal of the situation'); fifth, a subject is what Badiou calls 'qualified' (meaning that its particular and singular nature depends on the regime it operates within); and sixth, perhaps most crucially, a subject is not a result or an origin (but again, precisely, 'the *local* status of a procedure').

The subject, for Badiou, might then be better thought as an intention or orientation – and subsequent trajectory. A state of being that is always in process. Subjectivization, in a nod to Lacan, is the name Badiou gives for what we might call, this time in a nod to Deleuze, this becoming subject (although, in fact, this is not a becoming in Deleuze's strict sense). In Badiou's system, subjectivization faces in two directions: towards the intervention, or event, that has, as it were, called the subject into being, and towards the situation within which the subject is at least partially located. The event, crucially, is irreducible (and, as we shall see, in some senses irreconcilable) to the situation as is, whereas the subject, although 'of' the event, is also very much 'of' the situation. In fact, although a subject is not a 'count-as-one' in a given situation, it *is* a form of counting in that it counts that which is connected to the name of the event (its

counting is precisely its fidelity) (*BE*, p. 393). Subjectivization is then a rule of sorts that 'subsumes the Two' (the event and the situation) under a proper name, which, strictly speaking, is 'in-significant' (or, simply, lacks signification in the situation as is). Subjectivization is, in this sense, the 'occurrence of the void' within any given situation (*BE*, p. 393). We might also understand subjectivization – again in a nod to Deleuze's own ideas of the virtual/actual relation – as an attempt at a resolution of sorts of a problem (that of the event's eruption within a situation). A resolution in process as it were.

Subjectivization might also be thought as a test. Starting from the evental site (the place in the situation where the event 'occurred') subjectivization tests each essentially random encounter that comes after the event to enquire whether it is faithfully connected to the name of the event (*BE*, p. 394).[7] (In fact, in *Being and Event*, this naming of the event is, at least in some senses, constitutive of it inasmuch as it is a declaration that an event has indeed happened.) Subjectivization is then this moving through, and judging of, the situation from the perspective of the event. This procedure, that involves the production of a further situation that contains those elements of the previous situation that are positively connected to the event, is fidelity.

Crucially, inasmuch as every subject is the local configuration of a generic procedure, the former is necessarily finite and thus, as I have already mentioned, a part of the situation it finds itself within (that is to say the subject *is* a part of the encyclopaedia – a part of knowledge – at least in one sense). The object of the enquiries, on the other hand, is infinite (the enquiries being 'directed' towards the generic, or simply, truth). Hence we get the odd temporality of subjectivization in that the subject never knows in advance what might count as being connected to the event. In fact, there is no end to this not knowing; the enquiries are themselves potentially infinite in number. There can be no conclusion to this process. This subjectivization, or truth procedure, is opposed to the retroactive, or properly historical function of knowledge that counts the enquiries after they have happened (them now being of a finite number). Knowledge, in this sense, involves no genuine encounters. It is also in this sense that the subject's trajectory is 'militant and aleatoric' (*BE*, p. 395). The subject then is separated from knowledge 'by chance' (or, simply by the random encounters of a life post-event) (*BE*, p. 396). We might say, following our reading of Lacan in Chapter 2, that the subject is itself the result of a retroactive claiming, or, more simply, that a militant only knows what they have been about *after* they have acted.

A further strange relationship to truth also defines the subject, for as a 'local moment of the truth' the subject does not coincide with truth in general that is infinite. As Badiou himself remarks: 'a truth alone is infinite, yet the subject is not coextensive with it' (*BE*, p. 395). The subject is, we might say, barred from this truth that works as motivation for that very subject (the truth is always 'to come' in this sense). As such, the subject's relation to truth is invariably one of 'belief', a belief that occurs in the form of a kind of knowledge, although one that is distinct from the encyclopaedia itself (or, even, presumably from the future knowledge of positive encounters post-event). Badiou names this 'knowing belief', '*confidence*' (*BE*, p. 397). Confidence, which is really the confidence of the subject in itself (and in its own trajectory) sustains the enquiries, or in Badiou's terms, is the idea that the gathering of the chance encounters together under the banner of fidelity is not made in vain (*BE*, p. 397). Faith, we might say, is the very *modus operandi* of the subject.

A paradox of sorts then occurs here, for the subject is plainly a part of the situation *and* a part of the encyclopaedia of the situation (after all, we are all *known* beings – at least to some extent – in the world). How then to 'access' this 'newness' that the event heralds? How to discern that which, by its very definition, is indiscernible within a situation? Nomination, or naming is for Badiou, in *Being and Event*, the means by which the subject marks out this new territory. However, these names are necessarily also names within a situation (how could they be otherwise?). As such, the crucial matter here is what a name *refers* to, again, precisely, an indiscernible part of the situation. The veracity of such names – of this 'subject-language' – can only be said to have been proved once the truth that they name has come about. These names have no referent in the situation as is, but in fact 'designate terms which "will have been" presented in a *new* situation' that comes about through the very operation of the subject and their fidelity (*BE*, p. 399). Hence Badiou's remark, again echoing Lacan: 'A subject always declares meaning in the future anterior' (*BE*, p. 400). It is in this sense that the subject 'uses names to make hypotheses about the truth' (of which it is itself a local moment) (*BE*, p. 399). The subject then is both the real, in the sense of being an active, militant enquirer *and* the hypothesis that the enquiry in question will bring about a new situation or 'some newness into presentation' (*BE*, p. 399).

'Forcing' is Badiou's term (taken from Cantor) for this peculiar future-orientated gesture. Forcing is the making of a statement that can only be verified in a future situation, one which the forcing itself helps bring about.[8] As the end of Meditation 31 demonstrates, it is a truth (this

time in the guise of a local operator of fidelity, that is to say, a subject) that *'forces the situation to accommodate it'* (*BE*, p. 342). Such a generic truth however, inasmuch as it is indiscernible within a situation can, as I mentioned above, only be *believed* in by the subject in question: 'insofar as if it exists, it is outside the world' (*BE*, p. 373). Hence, again, the importance of faith, *but also* of the creative practice of naming that which has not yet come to pass (it is in this sense that all subject-languages are necessarily poetic, or simply, that the name creates the thing). The subject is then the very operator of truth inasmuch as it produces the latter albeit without ever 'knowing' it.

In fact, although the forcing statements are indeed hypotheses about a situation that is yet-to-come, nevertheless the subject can decide which statements at least 'have a chance of being veridical' in the future situation, and those that do not (*BE*, p. 406). This can be proved mathematically (and Badiou does this in the difficult Meditation 36), but in non-mathematical language it is simply because of the subject's privileged relation to the truth, or the indiscernible (via the event that has 'happened' to, and thus produced, the subject in question). As Badiou remarks, a subject *'knows* – with regard to the situation to-come, thus from the standpoint of the indiscernible – that these statements are either certainly wrong, or possibly veridical but suspended from the will-have-taken-place of *one* positive enquiry' (*BE*, p. 404). In fact, this ability to tell the difference between those statements that may be decided upon and those that cannot is the very definition of the subject as 'that which decides an undecideable from the standpoint of the indiscernible. Or, that which forces a veracity, according to the suspense of a truth' (*BE*, p. 407).

A subject then 'is at the intersection, via its language, of knowledge and truth' (*BE*, p. 406). It is suspended from the indiscernible inasmuch as it is finite (on this side of the bar as it were), *but* through forcing is able to ascertain the 'veracity of a statement of its language for a situation to-come' (*BE*, p. 406). A subject, suspended as they are from the very truth of which they are the enquirer, nevertheless, through forcing, can 'authorise partial descriptions of the universe to come in which a truth supplements a situation' (*BE*, p. 406). We might say that the subject, as somehow part of the truth that is to come, can evaluate statements about this future (again, a subject is 'that which decides an undecideable from the standpoint of an indiscernible' (*BE*, p. 407)). Put simply, the subject is a knot of sorts between the present within which it is situated and a future to come (that in fact the subject will have contributed to bringing about). Or, put another way, the subject – in

its function of forcing – is a fragment of a future hurled back in order to bring that future into being. Forcing, we might say, is, in this sense, a peculiar future-orientated action within the present. A technology of prophesy.

As we shall see in more detail below, in Badiou's work post *Being and Event* this notion of a single subject to truth is extended and complexified, replaced by a subjective space or diagram with four different kinds of subject, or four different reactions/responses to the event. Despite this complexification the fundamental question of the subject's relationship to truth remains: is there fidelity to the event or not? In terms of the strange temporality of the subject the future orientation also remains in place. The subject remains a figure that lives a problem, namely, how to be in the present but also produce the new. Forcing, then, accompanies faith as the name of the subject's *modus operandi* – its function in relation to the situation to come.

I mentioned above that this technique of forcing can be proved mathematically. In fact, crucially for Badiou's whole system, the very existence of a generic set, that is, truth, can also be proved. As Badiou remarks in Meditation 33, Cohen's 'revolution' in 1963 demonstrates that 'there exists an ontological concept of the indiscernible multiple', and '[c]onsequently, ontology is compatible with the philosophy of truth. It *authorizes* the existence of the result-multiple of the generic procedure suspended from the event, despite it being indiscernible within the situation within which it is inscribed' (*BE*, p. 355). As such, for the ontologist (read mathematician) it is a matter of fact (at least, if one follows the maths). For an inhabitant of a given situation however, the existence of such a generic set, that is, of truth, can, again, only be a matter of faith. Indeed, it is the *decision* to *believe* (and in fact, faith would always seem to be the result of a decision in this sense) in the latter's existence that brings it about (and defines the subject's own existence). The crucial issue, again, is that the subject cannot 'know' this truth that they themselves are producing. The subject, as finite being, as 'captured' in typical knowledge/the encyclopaedia, that is, the given terms of the situation, is barred from the infinite that nevertheless has moved and motivates them. The series of investigations – or truth procedure – are also, in a parallel sense – and as I mentioned above – infinite. There is no 'arrival' at the truth, only the production of it as it were. The subject is then inevitably defined by a certain tenacity in this respect and truth is characterized by its very deferral. We might say that the finite subject believes in the truth (or, we might say, the infinite), but *as* a finite subject, is barred from it.

It is perhaps worth making a brief digression from *Being and Event* at this point to some other – we might say more minor – writings of Badiou in which he tracks through the various truth procedures as they occur in the four realms or 'conditions' (of philosophy): art, politics, love and science. In each case this strange temporal predicament, or logic of a bar between the finite and the infinite remains. Thus, in the realm of art, we have Badiou's assertion that: 'the essence of the question [*what is the pertinent unity of what is called "art"*] has to do with the problem of the relation between the infinite and the finite. A truth is an infinite multiplicity ... A work of art is essentially finite' (Badiou 2005b, p. 10).[9] Art then is 'the production of an infinite subjective series through the finite means of a material subtraction' (Badiou 2004). Art's domain, properly speaking, and its first term, is the finite. Politics, on the other hand begins with the infinite inasmuch as it is directed to the all, to the universal. The figure of this equality is the 1. Hence, the political procedure 'proceeds from the infinite to the 1' (Badiou 2005c, p. 151). We might say, again, that the infinite – the generic – is the background, the cause, *but also* the goal (ever receding) of the political intervention. As Badiou remarks in the same essay, love, or the 'amorous procedure', 'proceeds from the 1 to the infinite through the mediation of the two' (and this is why, 'love begins where politics ends' (Badiou 2005c, p. 151)). Here, again, the infinite is the target, although it is the two that allows for progression towards this (and, crucially, the amorous couple are barred from that very infinite truth that they are in a sense blindly producing). As Badiou remarks in his major statement on love as an event: 'the experience of the loving subject, which is the matter of love, does not constitute any knowledge [*savoir*] of love' (Badiou 1996, p. 40). Finally, science, or mathematics, as paradigmatically the case with Cantor, demonstrates that the infinite, or the generic, does indeed exist – and further, that there are different sizes of infinity. Nevertheless, this knowledge is necessarily abstract, not 'available' to the subject itself. To end this digression, it is worth noting, as the essay on 'Politics as Thought' from *Metapolitics* reminds us, that although truths are indeed produced within different regimes (by specific kinds of subjects), truth itself is universal: 'truth as such is subtracted from every position. A truth is *transpositional*. It is, moreover, the only thing which is, and this is why a truth will be called generic' (Badiou 2005c, p. 42). Truth then is doubled. It is generic (although 'outside' of any given situation by definition), but it nevertheless produces a subject *in* a situation, who, although barred from this truth, also paradoxically, themselves produce it. I will be returning

to this complex terrain of truth towards the end of the second section of this chapter.

We are not so far from Jacques Derrida here. Certainly, in the subject's experience, truth might be positioned as an 'absent presence', having an effect on the subject but effectively barred from the latter. (In passing, it is also worth remarking that Badiou's 'concept' of inconsistent multiplicity seems to have much in common with Derrida's *différance* understood as that system of differences and deferrals which is the condition for knowledge but not 'of' it as it were (we shall see further resonances with Derrida when we come to look at *Logics of Worlds* in a moment)). Forcing is Badiou's 'bridge' to this 'other place', *but*, and this seems to me crucial, the subject is always inevitably barred from the latter – the new/the truth that they in some sense summon into being. When 'it' 'arrives', 'it' will, by definition, be 'of' the situation (that is to say will have become knowledge). The truth procedure will have had to move on as it were. We might say that this is a further strange temporal predicament of the subject within Badiou's system; they are destined to a certain restlessness, and, I think, to a certain melancholy – forever barred from the very thing they have faith in.

In a sense then there are two key figures here: the ontologist (and here the last condition of philosophy mentioned above, science, seems to merge with philosophy *per se*, at least insofar as philosophy concerns itself with ontology) who *knows* (post Cantor) that the indiscernible exists, and the subject who can only *believe* in its existence. The first is barred from 'experiencing' this truth (the operation of proof is necessarily abstracted from the situation; set theory provides a view, precisely, from 'outside' any given situation). The second is also barred from direct experience of this truth because of their very situatedness within that situation, their very finiteness. If the first is too far removed from the situation, the second is, we might say, too much within it. In Badiou's system it is philosophy that ontologizes and the scientist, activist, lover or artist that believes (although it would seem logical and pragmatic that the former subjects might read the philosophy in order to 'prop up' their faith as it were). At any rate, the problem seems to be an either/or: either in the world and thus no vantage point on it or outside the world and thus no experience of it.

In fact, in the seminar 'The Subject of Art', again, in anticipation of *Logics of Worlds* (as we shall see), Badiou introduces the notion of a 'world' (of existing, or appearing) as a way of dealing with this problem. A subject is now 'between an event and the world', or more precisely, the 'consequence of an event in a world' (Badiou 2005d, n.p.).

Two further terms are introduced to complexify this further: the 'trace' (of the event – what the latter 'leaves behind' as it were after its appearance/disappearance) and the 'body' (Badiou 2005d, n.p.). A subject, even more specifically, is the 'distance' between a trace and a body. Crucially, a subject is not reducible to the body (that is, part of the world) or separable from it (that is, identified solely with the event). In fact, these two latter positions, Badiou argues, result in the two dominant subjective paradigms of today: 'enjoyment' (or, death in life) and 'sacrifice' (or, life in death) (Badiou 2005d, n.p.). Badiou, of course, is interested in mapping out a third paradigm between these two (which he sees as the subject positions of democratic materialist and religious fundamentalist respectively). We might say that this third way involves being somehow in the world but not entirely of it. Importantly, in this seminar at least, it is towards art that Badiou turns for the exploration of this subject. Art is specifically involved in the invention of new forms or, we might say – and as we saw above – in the invention of new relations between the finite and the infinite. Hence, we might point out in passing, the crucial importance of art, for Badiou, for any politics today. In the seminar, as elsewhere, Badiou claims that this infinite is not necessarily transcendent but can be thought of as a plenitude of the world, albeit a world that is mostly indiscernible. More crucial, I would argue, is deciding what this relation between the finite and the infinite actually involves. Is it in fact a relation at all? Or, following my reading of *Being and Event*, is it in fact a non-relation – a place of non-passage (destining the subject to be forever cut off, forsaken, and so forth)?

In an interview with Peter Hallward, Badiou himself specifies that it is this relation – that he hitherto positioned as a non-relation – between the finite and the infinite that he is interested in revisiting in his sequel to *Being and Event* (Badiou 2003a). In the latter work, essentially, there is a bar. As we have seen, the subject is closed off from the infinite of which it is an operator. *Logics of Worlds*, Badiou remarks, will be concerned with attempting to figure a 'new' dialectic (following Hegel's idea of 'absolute knowledge') between the two, played out in the notion of consequences (Badiou 2003a, p. 132). To quote Badiou:

> I demonstrate that the subject is identified by a type of marking, a post-evental effect, whose system of operation is infinite. In other words, subjective capacity really is infinite, once the subject is constituted under the mark of the event. Why? Because subjective capacity amounts to drawing the consequences of a change, of a new

situation, and if this change is evental [*evenemential*] then its consequences are infinite. (Badiou 2003a, p. 132)

It is not entirely clear how this notion of consequences differs from fidelity, and thus how, exactly, the bar has been negotiated. As with the enquiries, the consequences of the event might well be infinite but they are not 'of' the infinite. In fact, the bar seems an inevitable element of Badiou's system, which captures the subject in the temporal predicament that we might name here, post-Kant, as modernity. I will be returning to these questions and problems in the second half of this chapter.

4.2.3 Deleuze's individual (and the actual–virtual)

We are now in a position of sorts to begin thinking the differences between Badiou and Deleuze in terms of the finite–infinite relation as this pertains to the subject (although, again, the latter is not necessarily a category that Deleuze concerns himself explicitly with, focussing rather on the category of the 'indvidual'). Put simply, Badiou, in the formulation of his thesis on the subject, remains tied to a Lacanian schema. His inconsistent multiplicity or generic set that moves the subject, and indeed produces the latter (via an event) is nonetheless barred from that very subject. It is the Real, inaccessible by definition from within a situation (the symbolic) but exerting a pressure of sorts (that is, the appearing/disappearing event) on that situation.[10]

It seems to me that Deleuze's actual/virtual couplet, borrowed from Bergson, is, amongst other things, an attempt to remove this bar, which, we might say, really goes back to Kant (noumena/phenomena) and continues to haunt much post-Kantian philosophy and, indeed, other modes of thought – not least the psychoanalysis of Lacan and especially those that follow in his wake. In fact, for Deleuze, there is not a bar so much as a passageway, we might even say a continuum, between his virtual and actual. It is not that these two are not distinct realms (indeed, as we saw in Chapter 1 in relation to Bergson, they are different in kind), but the line between them is, as it were, flexible and porous. Virtualities are actualized depending on the technologies involved, from bodies to cinema, but further, there is also a 'feedback' as it were of the actual to the virtual.

As we saw in the previous chapter, Guattari holds to a similar notion of reciprocal determination in his figuring of the chaos-complexity relation (although he does not use the former term himself) and especially of the entities that partake of both these fields. Deleuze

himself develops his thesis on reciprocal determination in Chapter 4 of *Difference and Repetition*, although my comments immediately below are more indebted to James Williams' laying out of this difficult terrain in his rigorous, but very readable, introduction to *Difference and Repetition* (Williams 2003). To begin with, reciprocal determination means that both the actual and virtual *together* constitute reality: the virtual needs its actualization, just as the actual is not complete without an account of its virtual side (thus, for example, Deleuze's account of the virtual as problem, and the actual as a case of a solution). That virtual intensities and the relations between them (what Deleuze calls 'Ideas') are actualized in actual things is easier to appreciate than the reverse movement in which a given thing, an 'individuality', then determines its own virtual 'ground'. Perhaps the easiest way to grasp this second and somewhat counter-intutitve determination is in the way an individual, through experimentation and selection/repetition, alters those virtual relations of which it is a manifestation (in this sense the virtual and actual are less two 'places' than two sides of a coin as it were; when one side is altered, so too the other). In the actual living of a life some aspects of this virtuality *become* more clear and distinct, others retreat into obscurity. The register of this virtual/actual relation is, in this sense, affect.

We might note here that although the actual/virtual couplet is Bergsonian, the thesis of reciprocal determination is more Spinozist insofar – as I suggested in Chapter 1 – as the movement from essence to individuality is one of actualization (or expression), whereas the movement from first to third kind of knowledge is, properly speaking, a move to a determination of the virtual (insofar as through such knowledge we change what we are in the sense of the Ideas – or virtual relations – that we express) (see the diagrams in Figures 1.3 and 1.4, which, as I suggested in Chapter 1, might be superimposed on one another). Reciprocal determination is, as such, another name for Deleuze's Univocity.[11] In another book on Deleuze, James Williams, rightly I think, makes the claim that 'Immanence ... A Life' is a restatement of this logic of reciprocal determination, insofar as a life is precisely the embodiment of a virtual event in a state of affairs (see Williams 2005, pp. 80–5). Or, an individual is a *dramatization* of this reciprocal determination, a singular case, we might say, of the relations of distinctness and obscurity (there is in this sense, as Williams points out, an aesthetic – or an ethico-aesthetics – at the very heart of Deleuze's metaphysics (Williams 2005, p. 96)). As we saw in my own Chapter 1, 'Immanence ... A Life', it seems to me, is also a restatement of Deleuze's Univocity insofar as a life is

both that particular mode (actual) and the substance (virtual) of which it is an expression. The crucial point here, once more, is that the virtual is as real (indeed, it has a material reality) as the actual (lacking only its actualization), and further that there is a continuum – again, in the sense of reciprocal determination – between the two.

In Chapter 3 of *Difference and Repetition*, on 'Repetition in Itself', this virtuality is also figured – in a return to a more Bergsonian understanding – as the second passive synthesis of a 'pure past' that co-exists with the present. In fact, the present moment (or, simply, experience) is 'of' this past, which, as we saw in Chapter 1, is really a sort of primary ontological material, the background to the first passive synthesis that defines an organism. Before returning to our question of the virtual it might then be useful to map out Deleuze's important three syntheses of time in more detail – insofar as they relate to his notion of an individual – and in so doing point to some further differences between Deleuze and Badiou.

The first synthesis involves contraction, simply a before and the anticipation of an after, or immediate future: 'it constitutes our habit of living, our expectation that "it" will continue' (*DR*, p. 74). It is, following Bergson, the sensori-motor schema, although, following Hume, it is also 'the primary habits that we are; the thousands of passive syntheses of which we are organically composed' (*DR*, p. 74). This is a properly Whiteheadian moment in Deleuze (see footnote 33 of Chapter 1) – the setting out of a non-sensing perception, or what Deleuze calls 'contemplation' (and in the 'capture' of parts by other parts that Deleuze calls 'contraction'): 'We speak of our "self" only in virtue of those thousands of little witnesses which contemplate with us: it is always a third party who says "me"' (*DR*, p. 75). In passing it is worth remarking that these larval subjects, which constitute the 'system of the self' are involved in a primary affirmation: 'Contemplations are questions, while the contractions which occur in them and complete them are so many finite affirmations' (*DR*, p. 78). Larval selves are Spinozist in this sense, with a kind of auto-affection, or self-enjoyment, characterizing their mode of existence as well as their very cohesiveness:

> Pleasure is a principle in so far as it is the emotion of a fulfilling contemplation which contracts in itself cases of relaxation *and* contraction. There is a beatitude associated with passive synthesis, and we are all Narcissus in virtue of the pleasure (auto-satisfaction) we experience in contemplating, even though we contemplate things quite apart from ourselves. (*DR*, p. 74)

It is in this respect that Deleuze's philosophy is creaturely. Indeed this is a profound difference to Badiou for whom the biological body is precisely a kind of obstacle to the abstract reasoning that philosophy is. For Badiou, we might say, intelligence is non-bodily; for Deleuze it is precisely through these larval selves that the body has intelligence.[12]

The second, more profound passive synthesis – memory proper – although in a sense produced by the first is, in fact, its ground. It is Bergson's pure past that is coextensive with the present. As Deleuze remarks: 'The present exists, but the past alone insists and provides the element in which the present passes and successive presents are telescoped' (*DR*, p. 85). We have here, once more, Bergson's two kinds of memory: 'In one case, the present is the most contracted state of successive elements or instants which are in themselves independent of one another. In the other case, the present designates the most contracted degree of an entire past, which is itself coexisting totality' (*DR*, p. 82).

For Deleuze the question is 'whether or not we can penetrate the passive synthesis of memory; whether we can in some sense live the being in itself of the past the same way we live the passive synthesis of habit' (*DR*, p. 84). Following Bergson's thesis in *Matter and Memory*, but also Proust and his theory of reminiscence, it is 'through' the gap between stimulus and response that this past – or virtuality – becomes, as it were, accessible. (Conscious recollection – in which we look 'in' to the past for a particular memory is the active synthesis of memory, itself the result of a prior transcendental illusion that is the subject). We might say that reminiscence – the movement down the cone of the pure past into the present – constitutes the movement of the infinite into the finite. Put simply, again as we saw in Chapter 1, the gap between stimulus and response, and the virtuality that it implicates, defines our ability to creatively respond to a situation rather than simply habitually react.[13]

We might then diagram these two forms of passive synthesis as in Figures 4.2 and 4.3. As Deleuze says of these two syntheses: 'One is bare, the other clothed; one is repetition of parts, the other of the whole; one involves succession, the other coexistence; one is actual, the other virtual; one is horizontal, the other vertical' (*DR*, p. 84).

There, is, however, a third passive synthesis of memory (Figure 4.4). If the first passive synthesis operates on the plane of matter, and the second is properly of the 'cone' (naming as it does the different levels of the cone and their actualization in the present, on the plane of matter), then the third names an existence within the pure past itself. This is a stationary time. The time of Aion. The time of Thantos. It is this third synthesis that also has the name, *pace* Nietzsche, of the eternal return.[14]

Figure 4.2 First passive synthesis: habit (contraction-horizontal). Proper name: Hume

Figure 4.3 Second passive synthesis: memory (contraction-vertical). Proper name: Bergson

As I suggested in Chapter 1 this third synthesis might also be thought of as a particular kind of actual–virtual circuit – in Nietzsche's case, a living out of a whole species memory.

Figure 4.4 Third passive synthesis: aion (static). Proper name: Nietzsche

To return to the contretemps with Badiou, we can say then that in Deleuze's system man, as located within the present, is not barred from the infinite – the pure past – of which they are part, but rather are subtracted from the latter (in Bergson's terms, as we saw in Chapter 1, man is a centre of indetermination, a kind of 'hole' in the universe). The stakes then become altered: it is no longer a question of how to 'overcome' a certain barrier or bar (or, indeed, how to 'heal' a split) but rather how to 'open up' to the world, or to a certain 'larger' virtuality.[15]

We can then further pinpoint the difference between Deleuze and Badiou. Whereas Deleuze's system allows a move from virtual to actual, and from actual to virtual – again, a reciprocal determination between the two – for Badiou, despite the positing of inconsistent multiplicity as a kind of background to any and every situation, a subject, is, as it were, determined in only one direction (from inconsistent multiplicity *to* situation *via* the event), and, as such, is necessarily barred from that which has, as it were, called them in to being.

In fact, it seems to me that Badiou's inconsistent multiplicity, in Deleuze's terms, is precisely not a virtual yet to be actualized but rather a possible that needs to be realized. A possible, which, inasmuch it is defined in the concept – or, we might say, within set theory – remains merely a mirror image of the real whose possible it is (it doubles 'like

with like'. It is precisely a logic of the same, as opposed to '[t]he actualisation of the virtual', which 'always takes place by difference, divergence or differenciation' (*DR*, p. 212). Inconsistent multiplicity, following the Bergson of Chapter 1, is already laid out on the plane of matter (albeit it is the spectral double to this plane). It is not, in this sense, different in kind to the situation it doubles. In the case of Badiou, the existence of this possible is posited and 'proved' by the ontolologist, but inevitably deferred in a subject's experience that cannot but be, for Badiou, 'of' the plane of matter. Here is Deleuze on this crucial difference:

> The only danger in all this is that the virtual could be confused with the possible. The possible is opposed to the real; the process undergone by the possible is therefore a 'realisation'. By contrast, the virtual is not opposed to the real; it possesses a full reality by itself. The process it undergoes is actualisation. It would be wrong to see only a verbal dispute here: it is a question of existence itself. (*DR*, p. 211)

In a sense Badiou's claim to a more radical immanence than Deleuze's, insofar as it refuses, for example, a virtual ground determining the actual, is the problem – for in setting out everything on one flat plane Badiou's system cannot but set things out in terms that have already been predetermined, here the logics and protocols of set theory, which delimit all possibilities (again, in a return to the diagrams of Chapter 1 we might say that here everything is set out on the same horizontal plane of matter). Inconsistent multiplicity is defined 'from' this plane, but defined retroactively as that which was missing from any given situation. In fact, Deleuze's virtual itself cannot really be defined as a determining ground as such. It is, rather, a principle of radical ungrounding. Indeed, the virtual is itself a realm of difference in itself, difference undefined by the concept as it were: chaosmosis, pure multiplicity. As Deleuze remarks in Chapter 1 of *Difference and Repetition*, on 'Difference in Itself': 'By "ungrounding" we should understand the freedom of the non-mediated ground, the discovery of a ground behind every other ground, the immediate reflection of the formless' (*DR*, p. 67). Importantly, Nietzsche's eternal return (in its 'superior, and secret form') is invoked here as the specifically *bodily* means of this discovery (*DR*, p. 67).

At the same time, the same move – positing an inconsistent multiplicity as a kind of truth to any given situation (precisely a ground) – puts a bar, or gap, in place between the subject in that situation and this truth, which is to say, makes the latter, in an important sense, transcendent to the

situation. Finally this logic of the possible also, in Deleuze's terms, suggests a strange eruption of existence *ex nihilo* as it were. As Deleuze remarks:

> Every time we pose the question in terms of the real and the possible, we are forced to conceive of existence as a brute eruption, a pure act or leap which always occurs behind our backs and is subject to a law of all or nothing. What difference can there be between the existent and the non-existent if the non-existent is already possible, already included in the concept and having all the characteristics that the concept confers upon it as a possibility? Existence is *the same* as but outside the concept. (*DR*, p. 211)

Badiou's existence – any given 'situation' – is precisely the result of an eruption, a leap, or, in Badiou's terms, an axiomatic decision (there is, as it were, nowhere from which Badiou's set theory situations could have come – no process of actualization, or simply formation – insofar as everything is always already laid out). There is also, once more, a barrier between such situations and inconsistent multiplicity that can only itself be negotiated by a jump, or, problematically, by forcing. In fact, this inconsistent multiplicity, the generic, is, again, merely the double of the situation that posits it as possible (it is only lacking realization).

Two key critiques might then be made from a Deleuzian perspective: the first is that in Badiou's system everything is laid out on the same plane, thus, no real difference emerges (and there is thus also the concomitant problem of the existence of situations that come into existence as 'brute eruption'); the second is that despite this laying out of a single plane another 'place' is posited, but in fact is separated from the situation as if by a gulf of sorts.

The difference between Deleuze's virtual and Badiou's inconsistent multiplicity is then indeed not just a verbal dispute – but a question of existence itself, or, we might say, of the different subjects they imply. For Deleuze, the subject – or individual (simply the human brain/body configuration) – is a subtraction from the plenitude of the world, a veritable centre of action/indetermination. Crucially, such a body can, via various technologies, open up further to this world. Equally crucially this actualization of the virtual also moves in the other direction insofar as how one lives also alters those virtualities that one expresses. For Badiou, on the other hand, the subject, albeit called forth by an event that traverses the gap, is nevertheless caught, limited as it were, within the terms of a situation that defines and determines them as subject.

Certainly, the situation itself is 'premised' on the generic, the indiscernible, or simply, the void *but* the subject is barred from this by definition (and, in any case, this inconsistent multiplicity is merely the double of the multiplicity of the situation; again, there is no difference in kind between the two – they are laid out on the same plane).[16] Crucially, whereas it is the body that operates as Deleuze's privileged actualizing machine – that allows the reciprocal determination of the actual and virtual (the body (understood as extensive *and* intensive) is the bridge between the two multiplicities of the actual and the virtual – for Badiou the body, as finite matter, is the very name of this bar to an infinite inconsistent multiplicity (hence Badiou's interest in a specifically non-corporeal system on which to base his philosophy – that is, maths).

Badiou's recourse to forcing is, it seems to me, a response of sorts to Deleuze's theory of actualization and perhaps inevitably, as we saw above, it involves a kind of naming – language, following Lacan, being that which defines a subject but also strictly speaking being that by which a subject 'frees' themselves (the substitution of signifiers releasing the neurotic from their impasse). Language for Badiou (and despite his occasional claims otherwise) becomes the privileged medium of the subject, just as maths is the privileged medium of the ontologist. For Deleuze on the other hand, it is not just a question of names and language but also, as his last essay reminds us, of 'A life'. We might say simply of affect, understood as those virtual 'Ideas' (relations of intensity, or, as the collaboration with Guattari has it, 'becomings') that constitute us as individuals. Within Badiou's system it is difficult to see how a body might experience this life, or, if they do, what relevance this might have. Indeed, the body, as part of the situation by definition, is that which must be left behind – evacuated – in order that an individual becomes a subject (although, again, this is far from a Deleuzian becoming). Put bluntly, affect has no place in Badiou's system and is the lynch-pin of Deleuze's.

It is then, finally, the body – when this is thought as the site of the three passive syntheses of time – that becomes for Deleuze the very means of experimentation and transformation for a given individual. Deleuze's identification of Spinoza as the prince of immanence and himself as a Spinozist before anything else is an affirmation of what we might call this expanded corporeality (to recall the oft quoted phrase of Spinoza: 'For no one has thus far determined the power of the body, that is, no one has yet been taught by experience what the body can do merely by the laws of nature' (*E* Book III, prop. 2, Note, p. 87)). For Deleuze, it is this bodily adventure, this passage from the virtual to the

actual (and from the actual to the virtual) that defines life in general, and any specific life when it is truly lived.

There is no bar in this schema, although there might be an edge, or several, where the processes of actualization actually take place (this edge being the very definition of an individual). As I suggested in my introduction to this chapter, this philosophical schema is given further flesh in the collaborations with Guattari, where it is also given a political urgency of sorts – and a pragmatics; to always live part of one's life away from the strata that constitutes one as a 'subject', to always be open to the non-human becomings that populate the world. In such a mapping of the world the 'subject' can in fact be figured as yet one more fetter placed on a creative and vital existence. The 'subject' can become, in fact, the very bar to this non-organic life.

We might restate this difference between Badiou and Deleuze in relation to the name. For Badiou, in Lacanian terms, the subject is what we might call 'sinthomic': the result of a self-naming; for Deleuze, on the other hand, it is the blurring of the subject, its dissolution, that is important. Two competing orientations: the assumption by the subject of their own name versus the same subject's abandonment of their name in a general imperceptibility. We might call these two 'technologies of the self' (to borrow Foucault's terminology): fidelity versus becoming.

4.2.4 Conclusion: St Paul

In conclusion to this first part of the chapter we might then map out two diagrams of the subject/individual, or of the relationship of the finite with the infinite: (1) Badiou's couple of the ontologist and the subject. The first, too far removed from the world is necessarily barred from experiencing the infinite although able to prove its existence, the second, very firmly in the world as finite being, is barred from the infinite though in fact paradoxically produces it; and (2) Deleuze's actual/virtual couplet that allows us a way in to think the co-presence of the finite and the infinite 'within' a given individual – inasmuch as they can be reconfigured as the actual and the virtual – and, crucially, demonstrates the continuous passage between the two, their reciprocal determination.

We might care to situate these two philosophical attitudes to the production of subjectivity – or, simply, the finite–infinite relationship – in a more straightforward, if reductive way (if only to counterbalance the rather more abstract thinking through of the same terrain above). Whereas for Badiou the subject is that which goes beyond what we might call the animal state of our being in the world, for Deleuze it is precisely this animal state – or becoming with the world – that is foregrounded.

This is a privileging of a certain horizontality (becoming-animal) as opposed to Badiou's verticality (becoming-subject). In fact, it is this molecular transversality, with an attendant emphasis on experimentation, which for Deleuze defines a creative and ethical life. At a more rarefied level the difference might be summed up by the attitude each philosopher has to the Christian mystic St Paul. For Badiou, the latter, in his fidelity and faith to an event beyond the world, Christ's resurrection, is Badiou's pre-eminent model of a militant subject (see Badiou, 2003b). For Deleuze on the other hand, and following Nietzsche, St Paul erects a transcendent schema of judgement on the back of Christ's crucifixion/resurrection, instigating and managing a priesthood and the production of 'Christian subjects' (see Deleuze's essay 'Nietzsche and Saint Paul, Lawrence and John of Patmos' (Deleuze 1998, pp. 36–53)). For Badiou then it is St Paul's appeal to something beyond the world that marks his importance; for Deleuze it is precisely the same orientation that marks a betrayal of immanence.[17]

4.3 *Logics of Worlds* (or, what is a body? And the destination of the subject)

4.3.1 Introductory remarks: worlds within worlds ...

In place of the set theory of *Being and Event*, *Logics of Worlds*, although equally intimidating in its deployment of maths (this time category theory/sheaves) lays out, alongside the abstractions and demonstrations, a compelling and poetic set of case studies of appearing in worlds: from the opera Bluebeard to a typical French villa in Autumn to a pastoral painting; from an ancient battle to the political situation in Quebec to a street demonstration in Paris; from the architecture of Brasília to a poem to the composition of a solar system (these being just a few among many more). Indeed, it is this that really characterizes the second volume of *Being and Event*. It is, precisely, wordly, and although Badiou is at pains to demonstrate his logic mathematically, it is the phenomenological examples that really convince and engage (at least for those less well versed in the maths). Alongside these worlds Badiou ushers on stage various conceptual personae from whom he will borrow components and concepts for his own construction site or from whom he will polemically (and sometimes in a reductive account) differentiate his own position. Indeed, Badiou operates through his own transcendental logic, that is to say, through maximal and minimal identifications with other thinkers and other philosophical positions (and, as such, his thought might be said to constitute a world in his own terms). In particular, and perhaps

unsurprisingly, it is Deleuze who most often appears as a kind of fellow traveller, but also as the 'near enemy' of Badiou himself.

In terms of the above discussion of *Being and Event*, one might say that the guiding principle behind Badiou's sequel is the attempt to reintroduce the body, and its particular appearing within a world, into what was, as I hope I have demonstrated, a system in which the latter was absent. It is in this sense that *Logics of Worlds* progresses by stages, answering related questions and tackling subsidiary issues in order to be able to tackle this issue of appearing, and thus adequately answer the question: what is a body?

In fact, we can answer this question straight away: the body is the mediating term between the finite and the infinite. As we have seen, throughout his work Badiou is specifically interested in this finite–infinite dyad. Indeed, for Badiou 'truths' can be defined as precisely the infinite exceptions to a finite world. Such truths are provoked by an event, the irruption of what we might call 'Truth' into the world (I will return to this question of the difference between 'Truth' and 'truths' below, a difference, it seems to me, that has something in common with Heidegger's Being and beings). Here, in *Logics of Worlds*, as I intimated in the first section of this chapter, a subject (of truth) is then positioned between a world and an event. In fact, Badiou complexifies this further, drawing ever more subtle distinctions: it is here that the body makes its appearance, alongside the trace, as that which stands between the world and the event.

For Badiou then the question of the subject, as itself the exception to a given situation, is still the key problem in his thought, but here it is the subject's materiality, its location in a situation, or in a world, that is the issue under examination. In Badiou's terms this is to construct a logic (of appearing) to accompany the ontological statement of *Being and Event*. To focus, this time, on onto-*logy* rather than *onto*-logy. Insofar as an enquiry into what a body is is also an enquiry into what a body is capable of, this is also an enquiry that is marked by Spinoza (and, as such and in many ways, as we saw above, it is the same as Deleuze's own enquiry).

4.3.2 What is a body?

Badiou's body is specifically *not* a biological one. Although there are some comments made about affect in *Logics of Worlds* Badiou is explicit in demarcating his own theory of bodies from what he sees as the attitude of 'democratic materialism' for which there is nothing but bodies and language. In fact, Badiou positions Hardt and Negri's particular type of Spinozism in this 'dominant' paradigm. We might say, following my conclusion

to Section 4.1 above, that Badiou is here explicit about his denigration of the animal body. As he remarks: 'In order to validate the equation "existence = individual = bodies", contemporary *doxa* must valiantly reduce humanity to an overstretched vision of animality' (*LW*, p. 2). For Badiou, on the contrary, the materialist dialectic (his own) is as follows: 'There are only bodies and languages, except that there are truths' (*LW*, p. 4):

> We admit therefore that 'what there is' – that which makes up the structure of worlds – is well and truly a mixture of bodies and languages. But there isn't only what there is. And 'truths' is the (philosophical) name of what interpolates itself into the continuity of the 'there is'. (*LW*, pp. 4–5)

As Badiou remarks, this amounts to opposing the 'real infinity of truths to the principle of finitude which is deducible from democratic maxims' (*LW*, p. 7). For Badiou, simply put, there is something more than the finite body (and thus finite existence). The key issue here is that the body, at least as defined in democratic materialism, is not seen as the repository of this 'more', whereas for Deleuze-Spinoza (and, indeed, for Negri) the biological body – as long as it is thought beyond any reductive account, beyond our typical understanding of it – is precisely the site of the latter.[18] Put simply, the body (in this expanded biological sense – as intensive and extensive) is, for Deleuze-Spinoza, the site of the infinite, whereas for Badiou it is what stymies the latter.

Interestingly, in *Being and Event*, Badiou also claims Spinoza as his predecessor. We have here then a philosophical *differend* with claims to a common root: Deleuze's body/animality and Badiou's matheme. For each, it is Spinoza's understanding that a part of existence is eternal that holds their interest, although for each philosopher the 'thing' that incarnates this eternity is radically different. In passing, and thinking back to Chapters 2 and 3, we might move the register from philosophy to psychoanalysis and note that there is the same opposition between Lacan, with his emphasis on structure, and Guattari with his emphasis on bodies, gestures and so forth.[19] An opposition, ultimately, between the signifier and an asignifying semiotics. As we have seen these two understandings of the subject imply different 'technologies': the speaking cure for Lacan versus heterogenetic encounter and recombination for Guattari. A denial, of sorts, of the importance of the body for subjectivity versus an affirmation of its constitutive role. Each of these four positions might then be diagrammatically arranged around Spinoza: Deleuze and Guattari on one side, Lacan and Badiou on the other.

Badiou's own particular idea of a body, in *Logics of Worlds*, follows Lacan to a certain extent insofar as, again, it is dismissive of the animal body, though it also involves a re-theorization of the body as a particular form in which truths appear. Such bodies are then to be understood as specifically 'post-eventual bodies' or, in Badiou's terminology, 'singular bodies' in which certain formalisms, specifically subjective ones, are 'given life' (*LW*, p. 9). It is these formalisms that give an eternal – or infinite – existence to the finite subject *contra* the democratic materialist idea of the (biological) body. I will return to this below.

The important point, in terms of my own argument, is then that in this sequel to *Being and Event* truths are not abstracted from the world but very firmly within it:

> I give the name 'truths' to real processes which, as subtracted as they may be from the pragmatic opposition of bodies and languages, are nonetheless in the world. I insist, since this is the very problem that this book is concerned with: truths not only *are*, they *appear*. (*LW*, p. 9)

Truths are, as it were, in the world but are not entirely of it. They are incarnated in a particular kind of body. It becomes then, as Badiou remarks, 'a matter of knowing if and how a body participates in ... the exception of a truth' (*LW*, p. 34).

Indeed, for Badiou it is precisely the question of how this 'except that' of a truth is incorporated into a body that defines the work of this second volume of *Being and Event* (and especially how this definition of a body is different to that of democratic materialism): 'The most significant stake of *Logics of Worlds* is without doubt that of producing a new definition of bodies, understood as bodies-of-truth, or subjectivizable bodies' (*LW*, p. 35). In fact, this is a preparation for what Badiou sees as the real question involving 'a definition of life which is more or less the following: To live is to participate, point by point, in the organization of a new body, in which a faithful subjective formalism comes to take root' (*LW*, p. 35).

For Badiou it is 'the resolution of the problem of the body, which is in essence the problem of the appearance of truths' that 'instigates an immense detour' through logic. The missing part, as it were, from *Being and Event* is precisely this move from being-qua-being to being-there-in-a-world. *Logics of Worlds* intends then to make thinkable the very category of world, or appearing, and thus to demonstrate 'how to grasp, in their upsurge and unfolding, the singularity of those phenomenal exceptions – the truths on which the possibility of living depends'

(*LW*, p. 36). Although, again, this is only preparatory work for Badiou's ongoing primary interest in the subject as operator of truth: 'I subordinate the logic of appearing, objects and worlds to the trans-wordly affirmation of subjects faithful to a truth' (*LW*, p. 37). In a sense then although the terrain has shifted – from ontology to appearing – the orientation and trajectory of Badiou's larger project remains the same.

It is not my intention here to rehearse the dense and difficult 'Greater Logic' that Badiou puts forward as adequate to his account of the subject and as a counter to a more typical logic based on linguistic formalisms (as in democratic materialism). A few words are however necessary, before we can turn to Books IV and V, to Badiou's account of the body, and then back to his metaphysics of the subject. The Greater Logic, then, consists of three books and with them the outlining of three great concepts:

1. *The Transcendental*. It is this that determines appearance in a world on the basis of differences (and identities) between elements of that world as well as between their respective degrees of intensity, or how 'close', we might say, they are to Being (in this sense the transcendental of a world echoes Derrida's notion of *différance*.[20] In fact, Badiou pitches his own notion of an originary difference, or inconsistent multiplicity, not against Heidegger, but against Hegel and the notion of an originary or teleological One).[21] Badiou sums up his transcendental logic towards the end of *Logics of Worlds*: 'Three operations effectively suffice for all the types of appearing or all the possibilities of differentiation (and identity) in a determinate world: minimality, conjunction and the envelope. Or the inapparent, co-appearance and infinite synthesis' (*LW*, p. 452). It is especially important, given Badiou's notion of the event, to be able to attend to the last of these, to 'think the non-apparent in a world', as it will be 'from' here that an event issues forth (*LW*, p. 105). Equally important is the idea that this transcendental logic determines a world irrespective of any subject ('The transcendental that is at stake in this book is altogether anterior to every subjective constitution, for it is an immanent given of any situation whatever' (*LW*, p. 101)).[22]

2. *The Object*. The object is the 'transcendental indexing', or 'objectivating' of a multiple, and, again must be understood 'entirely independent from that of the subject' (*LW*, p. 193).[23] In this sense the object is between ontology and appearance (it is a 'chiasmus between the mathematics of being and the logic of appearing' (*LW*, p. 197)). Importantly, this involves a choice of sorts or a materialist axiom (insofar as it cannot

itself be deduced transcedentally), namely, that there, 'where the one appears, the One is' (*LW*, p. 219). Following Lacan this is to suggest 'a quilting point of appearing within being' (*LW*, p. 218). This might also be put as follows: 'every object that appears in a world is composed of real atoms' (*LW*, p. 452). Appearing is then part of Being (and not, as it were, a shadow of it). There is a gap between the two, but here, in *Logics of Worlds*, there is also a passage of sorts between. Badiou pitches this particular argument against Kant and the notion of an irreducible gap between phenomena and noumena. With the object both of the latter are, as it were, co-present (this is also, in maths, the logic of sheaves, and a particular structure called the 'Grothendick topos' (*LW*, p. 295)). In this sense the object is both ontological and logical, indeed, according to Badiou there is a retroactive effect back on the multiple by/from its appearing. Being and appearing, Badiou clams in *Logics of Worlds*, are then in a structural relation of reciprocity (and, in this sense, Badiou's system begins to gesture towards Deleuze's, at least in terms of its understanding of objects).

3. *Relation*. The term object is sufficient to the dialectic of being and existence, or being and appearing, however it remains to think the relation between objects in a given world. It is then here that Badiou discusses the co-existence of different kinds of objects in a world. This is done through a sustained analysis of the political 'world' of Quebec and the solar system of a star in the galaxy – and of the various relations that might attend/apply within these worlds. Particularly important is that there is 'neither sub-sistence nor transcendence' to any particular world (*LW*, p. 309). 'Neither matter (beneath) nor principle (above), a world absorbs all the multiplicities that can intelligibly be said to be internal to it' (*LW*, p. 308). We might note here, in a return to the contretemps with Deleuze, that for Badiou there is only one (inconsistent) multiplicity that 'contains' all others. Nevertheless, this is a multiplicity, or world, that is infinite in its composition, or, precisely, in its relations, albeit it is also limited by definition *as* a world. A world is, in this sense, fractal ('this paradoxical property of the ontology of worlds – their operational closure and immanent opening – is the proper concept of their infinity' (*LW*, p. 310)). Leibniz with his own fractal ontology is here the conceptual persona used to help sharpen Badiou's own theory of relation. Again, Badiou is especially interested in the 'proper inexistent of an object', or simply an *'element of the underlying multiple whose value of existence is minimal'* (*LW*, p. 322). This will become the event site insofar as the event can be defined as the becoming maximal of this minimal element.

At this point in *Logics of Worlds*, having laid the groundwork, Badiou turns to his real interest (as a thinker of militancy) in how change might come about. Indeed, Book IV is specifically concerned with delimiting different kinds of change. There is, for example, change that happens in a world, between its already counted elements. For Badiou this is merely modification. There is, however, also change that comes about from an event-site. Here, depending on whether the change has a minimal or maximal intensity it will be either a fact or an event (as Badiou has it later: 'an event is a site which is capable of making exist in a world the proper inexistent of the object that underlies the site' (*LW*, p. 452)). This is itself a major change from *Being and Event* insofar as Badiou is attempting to attend to the 'nuances of transformation' instead of the 'rigid opposition between situation and event' (and, we might add, without the notion of forcing, or as Badiou has it: 'without any recourse to a mysterious naming' (*LW*, p. 361)).

Badiou gives a compelling account of the Paris Commune at this point of *Logics of Worlds* as precisely an event-site in the above sense, a place in which that which was nothing – the workers – becomes everything. It is also here that we further encounter Badiou's account of his differences with Deleuze that amount to two distinct takes on the event: his own, the event as radical cut, and Deleuze's which Badiou defines as the 'immanent mark of the One-result of all becomings' (*LW*, p. 384) (for Badiou discontinuity needs to be thought contra any Univocity). As I suggested in my introduction to this chapter, events are in the world for Deleuze, but otherworldly for Badiou (although Badiou's particular understanding of Deleuze's Univocity, as I suggested above, is perhaps not as nuanced as it might be).[24]

An event site, such as the Paris Commune, cannot, however, be maintained, contradicting as it does the laws of being (in technical terms it is a reflexive multiplicity, which belongs to itself, and thereby transgresses the laws of being (*LW*, p. 369)). 'Because it carries out a transitory cancellation of the gap between being and being-there. An event-site is then the instantaneous revelation of the void that haunts multiplicities (*LW*, p. 369). It is an 'ontological figure of the instant: it appears only to disappear', and, as such, its true duration is to be located in its consequences (*LW*, p. 369). I will return to these consequences in a moment.

If Deleuze's city is the rhizomatic labyrinthine streets, cafés and apartments of Paris, then Badiou's is the clean grandeur of the neatly demarcated Brasília, a city that Badiou uses, in Book V, to illustrate his theory of points: those locations in a world in which the infinite is

reduced to the stark choice between one path and another. Points then 'provide a topological summary of the transcendental. They space out a world' (*LW*, p. 416). Here Kierkegaard is the philosopher that leads Badiou, with the 'either/or' decision the 'useful' component that is borrowed. It is also here that we get the most clear cut statement of Badiou's politics – a politics of the militant – that follows from this violent yes or no ('a point is the crystallization of the infinite in the figure – which Kierkegaard called "the Alternative" – of the "either/or", what can also be called a choice or a decision' (*LW*, p. 400). Of particular note is Badiou's defining of 'atonic' worlds in which such points are scarce, or even absent, as opposed to 'tensed' worlds in which every encounter is a point that calls for a decision. It is also Kierkegaard who lends the idea that it is one thing to philosophically 'know' the truth, another to actively construct it. To know the rules of the game is not to play it. Again, I will return to this important distinction below.

It is also here that we encounter the importance of faith once more. Indeed, it is Kierkegaard who accurately pinpoints the Christian paradox, which, in fact, is, for Badiou, the 'paradox of truths', namely that 'eternity must be encountered *in* time' (*LW*, p. 428). As we will see this is a fundamental assumption of Badiou's – an assumption shared with Christianity, but also, strangely, with psychoanalysis, which as we saw in Chapter 2, pitches itself specifically against Christianity. It is because of this paradox that the subject must believe: 'belief is the subjective form of the true' (*LW*, p. 430). It is also this that determines that choice, or the decision, must be one of the subject's primary modes of operation. I will return to this question of truth in a moment, but it is worth noting here that the central paradox is the same as the central aporia in *Being and Event*: 'If the subject is purely local, it is finite … This is a classic aporia: that of the finitude of human enterprises. A truth alone is infinite, yet the subject is not coextensive with it' (*BE*, p. 395).

And so, after these detours and definitions, we arrive at Badiou's concept of the body:

> We are always in a world (there is a transcendental); in the world objects appear, which are atomically structured; between these objects there exist relations (or not). An object can 'become' a site. Of course, as such it vanishes without delay, but the amplitude of its consequences sometimes characterizes it as an event. And it is on condition that an event has taken place … that a body is constituted. (*LW*, p. 453)

Badiou continues:

> Simplifying considerably ... the static system of consequences of an event is a (generic) truth. The immanent agent of the production of consequences (of a truth), or the possible agents of their denial, or that which renders their occultation possible (that which aims to erase a truth) – all of these will be called subjects. The singular object that makes up the appearing of a subject is a body. (*LW*, p. 453)

A body is then a very singular type of object, one that is able to 'bear the subjective formalism' (*LW*, p. 453). Indeed, a body is two things at once: it is an object of the world complete with relations and so forth (and which, as we have seen, also has a relation with the multiple that it is, so Badiou claims, in reciprocal determination with), but it is also more than a simple object of the world insofar as it incorporates an (eternal) subjective formalism – or simply a specific attitude to an event (bearing, as it does, the trace of the latter).

Badiou develops – and sharpens – this definition some pages later: 'a post-evental body is constituted by all the elements of the site which invest the totality of their existence in their identity to the trace of the event. Or, to employ a militant metaphor; the body is the set of everything that the trace of the event mobilizes' (*LW*, p. 467). Or, to put it yet another way: 'a body, in its totality, is what gathers together those terms of the site which are maximally engaged in a kind of ontological alliance with the new appearance of an inexistent, which acts as the trace of the event' (*LW*, p. 470). This body is then oriented towards the consequences of the becoming maximal of what was minimal. It proceeds by decision, point by point, and as such is characterized by 'regional efficacy', or precisely organs (for example those concepts that might 'define' the body of modern algebra). We might say that the body, as well as having organs, also has a front and a back of sorts. Its back is turned towards the event that has called it forth; its front faces the world, drawing out the consequences of this event-encounter, gathering its effects. Like Benjamin's angel of history, this is a body, it seems to me, that cannot turn around.

Badiou ends his meditation on the body and *Logics of Worlds* more generally (as he ends *Being and Event*) with some comments on Lacan, and on his Master's own idea of the body. What Badiou responds to in Lacan is the idea of the subject as primarily a structure that is, again, irreducible to the biological body. The body is, as it were, inhabited by a parasite – something specifically 'Other' – that constitutes it *as* a subject.

For Badiou, Lacan restricts this to language and to the psychoanalytic situation, but the resonance with his own thought is clear: the life of the subject is not reducible to the biological body but, in fact, is radically different to it.[25]

4.3.3 The destination of the subject

It is also with this crucial idea of a subjective formalism that is irreducible to a body (however this is thought) that Badiou begins *Logics of Worlds*. Put simply such a formalism accounts for a variety of different positions a given subject might have in relation to an event, or, more specifically, to the trace of the event in a world. The subject is formal in the precise sense that it 'designates a system of forms and operations' that is ultimately 'indifferent to corporeal particularities' (*LW*, p. 47). It is this that allows Badiou to begin *Logics of Worlds* with his metaphysics before he has accounted for the actual body any given subject must, ultimately, take in a world. In an echo of *Being and Event* Badiou demarcates this theory of the subject from those that would reduce it to a 'register of experience' (phenomenology), a 'category of morality' (neo-Kantianism), or 'an ideological fiction' (following Althusser). The subject, simply put, is that which is 'at the service of truth, or of its denial or of its occultation' (*LW*, p. 50). Indeed, this meta-physics has more in common with *Being and Event*, and specifically the section we looked at above on the 'Theory of the Subject' (to which it operates as a kind of supplement), than it does to the logic laid out in the rest of *Logics of Worlds*.

Each subject position might be defined by the particular combination of a set of operations and a set of destinations. The operations are: the bar, the consequence (or implication), erasure (the diagonal bar), and negation. The four destinations, or acts, are: production, denial, occultation, and resurrection. Each of these must be thought in relation to the event and specifically its trace (written ε), and to a body that is 'issued from' the event (written C). In an echo of Lacan's famous account of the four discourses, Badiou proposes formal mathemes of the three subject positions that follow from specific combinations of the above, with π signifying the present or the set of consequences that lead from the different formal organizations (we might say from the successive treatment of points). The body itself is under erasure since it is:

> only subjectivated to the extent that, decision by decision, it treats some points ... a body is never entirely in the present. It is divided into, on the one hand, an efficacious region, an organ appropriate to

the point being treated, and, on the other, a vast component which, with regard to this point, is inert or even negative. (*LW*, p. 52)

Badiou fleshes out this formal theory with an account of the Spartacus revolution and especially of the decisions and actions made by the body of slaves. So, we have, first, the faithful subject – Spartacus and his followers – written thus:

$$\frac{\varepsilon}{¢} \Rightarrow \pi$$

And here is Badiou's summing up of this particular matheme:

> It is important to understand that the faithful subject as such is not contained in any of the letters of the matheme, but that it is the formula as a whole. It is a formula in which a divided (and new) body becomes, under the bar, something like the active unconscious of a trace of the event – an activity which, by exploring the consequences of what has happened, engenders the expansion of the present and exposes, fragment by fragment, a truth. Such a subject realizes itself in the production of consequences, which is why it can be called faithful – faithful to ε and thus to that vanished event of which ε is the trace. The production of this fidelity is the new present which welcomes, point by point, the new truth. We could also say it is the subject in the present. (*LW*, p. 53)

The reactive subject, that denies the event (the slaves that saw Spartacus' bid to return home as impossible) can then be written thus:

$$\frac{\neg \varepsilon}{\frac{\varepsilon}{¢} \Rightarrow \pi} \Rightarrow \pi$$

As Badiou remarks, 'when the law of negation of any trace of the event imposes itself, the form of the faithful subject passes under the bar, and the production of the present exposes its deletion' (*LW*, p. 56). Badiou asks us to note both that the body is held under a double bar (it is the one thing that must be denied at all cost), and also that, in fact, the matheme of the faithful subject is maintained 'within' this one. It becomes the unconscious of the reactive subject. In passing we might return to the material of Chapter 2 here and note Lacan's idea of desire as that which will keep returning, a debt that must be paid. Badiou's event follows a similar logic in relation to its subject: one

may deny it, but it will return, and, as it were, haunt one's life in its conspicuous absence. As Lacan remarks in *The Ethics of Psychoanalysis*, the return to the 'service of goods', after exposure to what we might call the event of desire, will inevitably be characterized by the lack of finding satisfaction therein. Denial offers no easy escape from the call of the event.

The obscure subject (in the Spartacus example, the Romans) wishes to occult the new present of the faithful subject by recourse to a 'pure transcendent body, an ahistorical or anti-evental body (City, God, Race ...) from which it follows that the trace will be denied (here the labour of the reactive subject is useful to the obscure subject) and, as a consequence, the real body, the divided body, will also be suppressed' (*LW*, pp. 59–60). The matheme for the obscure subject is this:

$$\frac{C \Rightarrow (\neg \varepsilon \Rightarrow \neg \mathcal{C})}{\pi}$$

In many ways, and as Badiou notes, this is a much more insidious and dangerous position than simple reaction insofar as – as we have seen – the latter maintains the formula of the faithful subject intact, whereas the obscure subject performs a double annihilation – of the trace of the event and then of the possibility of any body that might have been adequate to the event. The obscure subject is, in this sense, a kind of anti-subject.

There remains one final position, that of resurrection, or simply the reactivation 'of a subject in another logic of its appearing-in-truth', that in itself 'presupposes a new world, which generates the context for a new event, a new trace, a new body – in short, a truth-procedure under whose rule the occulted fragment places itself after having been extracted from its occultation' (*LW*, p. 65). It is this resurrection of an event from the occulted past that the faithful subject can perform. In an echo of my remarks on Bergson in Chapter 1, and in resonance with Negri's notion of 'past' moments of *kairos* in my coda to Chapter 3, we might say the subject of resurrection involves a kind of utilization of history as a living – and militant – archive.

Fidelity might then be fidelity to an event in the past as it were. Indeed, events themselves look back; they reactivate previous events in a kind of 'evental-history'.[26] We are not so far from Deleuze's own idea of the event here as the 'Untimely', a kind of vapour that rises above history, and a concept that Deleuze himself takes from Nietzsche.[27] The matheme of the subject of resurrection is then the same as that of the

faithful subject, but, if we were to diagram it in three dimensions as it were, then perhaps we could say that it looks like the diagram at the end of Chapter 1 (see Figure 1.13). I will return to this idea of a composite Bergson-Badiou diagram in a moment.

Badiou ends his metaphysics of the subject with a comment that the body itself has yet to be defined, and that, as a body, 'there must exist traits of separation, cohesion, synthetic unity, in short, organicity' (*LW*, p. 67). He is, however, equally clear that this cannot be the body of democratic materialism where the body is understood as the 'institution of a marketable enjoyment and/or spectacular suffering' (*LW*, p. 68). Indeed, in the materialist dialectic the body 'refers only in exceptional cases to the form of an animal body', and, as such, Badiou's idea of the body in general 'is anything but "bio-subjective"' (*LW*, p. 68). This laying out of a logic of the body that is not merely biological, is, of course, the reason for the Greater Logic.

In passing we might note here further resonances with, and differences to, the Deleuze–Bergsonian body. On the one hand, as we saw in Chapter 1, Bergson's body is the sensori-motor schema – point S in the cone diagram – and, as such, Bergson's reactive 'man of action' has much in common with the 'subject' of democratic materialism. For Bergson however this body is also the locus of memory, or, again, of virtuality. Indeed, this virtuality is pinned to the plane of matter – like a quilting point – by the body. It is not that the body 'contains' this, or not exactly, rather this virtuality is a given, but is normally 'masked' by the utilitarian interests of the organism. For Bergson then it is a question of a certain relaxing of the sensori-motor schema (that is, a hesitancy or the gap) that allows 'access' to this larger ontological field. For Badiou, on the other hand, it is rather an event arising from this field – inconsistent multiplicity – that, as it were, allows for a kind of transcending of the animal plane of matter. Despite these important differences, we might say then that Bergson's mystic has something in common with Badiou's militant. Certainly for both, 'accessing' a kind of 'beyond' to the plane of matter is crucial. And, for both, it is really the return from this journey that determines the active character of both types of non-typical subject.

In a return to some of my comments in the first part of this chapter we can suggest that the key difference is then one of direction. With Badiou the event comes from the void to 'address' the subject; for Bergson-Deleuze, as I suggested above, the subject is themselves in a relation of reciprocal determination with the virtual (there is a two way traffic as it were). We might then diagram this Bergson-Badiou

Figure 4.5 Diagram of Badiou's production of the subject: 1: Situation/world; 2: Elements/count; 3: Event site; 4: The subject; 5: Path of the militant/re-count; 6: The event; 7: Inconsistent multiplicity

composite diagram as in Figure 4.5, but, in this case – following Badiou – emphasizing the unidirectional nature of the event (and, if only to differentiate it from the Bergsonian schema let us draw the cone this time reaching 'below'). Of course, as I suggested above, Bergson's pure past – or virtual – cannot be completely identified with Badiou's inconsistent multiplicity insofar as the former names a difference in kind from any given situation or world. And, in fact, from Badiou's own perspective, Bergson's virtual is an ontology of the One, whereas his own inconsistent multiplicity is an extra-ontological realm of difference. For Badiou there would be no genuine events from this continuous pure past (we might say, here, that Badiou's idea of revolution – as radical cut – is pitched against Bergson's idea of a continuum, or creative evolution). Indeed, for Badiou, introducing the cone – and with it the determining fact of the virtual – would amount to a betraying of his own radical immanence, and, in this sense, to be 'true' to Badiou, the cone must be flattened (as it will be once more in my final chapter). It is less below or above the situation than 'within' it, albeit invisible from the typical perspective of the encyclopaedia.[28]

What this diagram does show, however, as well as picturing Badiou's theory of subject non-discursively as it were – is how both philosophers posit a realm of matter – the sensori-motor schema, a

situation/world – but also a 'something else' (when compared with the composite diagram of Chapter 2 – Figure 2.5 – it also suggests some of Badiou's indebtedness to Lacan). In fact, it is the status of this 'something else' that determines its access points. As we shall see it is my contention, once more, that Badiou's particular positioning of the former – inconsistent multiplicity – ultimately stymies 'access' (we have to wait, as it were, for the latter to come to us). In a sense Badiou's inconsistent multiplicity is closer to us than the virtual (it is on the same plane – of the possible – on which we habitually live), and yet much further away (it cannot be reached by a subject on that plane).

To return, after this digression, to Badiou's subject:

> Subjective formalism is always invested in a world, in the sense that, bourne by a real body, it proceeds according to the inaugural determinations of a truth. A complete classification of subjective formalisms therefore requires, if at all possible, a classification of the types of truth, and not just the classification, which we have constructed of the figures of the subject. (*LW*, p. 69)

This is the final aspect of the metaphysics of the subject, a demarcation of the different truths, as, obviously, this will dictate the different subject-bodies that come to appear in a world. However, before laying out the four truth conditions Badiou makes some highly pertinent remarks about truth in general that are worth quoting at length:

> A truth procedure has nothing to do with the limits of the human species, our 'consciousness', our 'finitude', our 'faculties' and other determinations of democratic materialism. If we think such a procedure in terms of its formal determinations alone – in the same way that we think the laws of the material world through mathematical formalism – we find sequences of signs (A, ε, C, π) and various relations ($—$, $/$, \Rightarrow, \neg, $=$), arranged in a productive or counter productive manner without ever needing to pass through 'lived experience'. In fact, a truth is that by which 'we', of the human species, are committed to a trans-specific procedure, a procedure which opens us to the possibility of being immortals. (*LW*, p. 71)

We are, as Badiou reminds us again at the end of *Logics of Worlds*, animals inhabited by – in the sense that we can choose to adopt – a formal parasite that allows immortality (insofar as the matheme is eternal).

As we are, according to Badiou, we 'know' only four types of truth, although this might not always be the case given that nothing can rule out the possibility that future forms of life might well know more. To revise, once more, these four truths – and four subjects – they are: 'Political', 'Artistic', 'Amorous' and 'Scientific'. Badiou lays out the three subject positions – and that of resurrection – in relation to each of these four conditions, before accounting for the more 'local signs' of their present, namely the 'new intra-wordly relations', and even more interestingly certain bodily affects that accompany the faithful subject:

> It is thus that a political sequence signals its existence point by point through an *enthusiasm* for a new maxim of equality; art by the *pleasure* of a new perceptual intensity; love by the *happiness* of a new existential intensity; science by the *joy* of the new enlightenment. (*LW*, p. 76)

In the scholium to Book I Badiou returns to this question of affect, delimiting a further four that '*signal the incorporation of a human animal into a subjective truth process*' (*LW*, P. 86): Terror, or the desire for the '*great point*', the moment of decision and instigation of a new world (*LW*, p. 86); anxiety, or the retreat from all points – all decisions, the desire for '*monotonous shelter*' (*LW*, p. 86); courage, or the acceptance of the plurality of points, and indeed the desire of the subject to face these (*LW*, p. 86); and justice, whereby the various consequences, or '*categories of the act*', are weighed up and '*subordinated to the contingency of worlds*' (*LW*, p. 86).

Despite these short comments this affective landscape of the subject is relegated to a very minor place within Badiou's system, almost as if this affective tonality – this emotional complexity of the world – must be held apart from the other-wordly subjective formalisms (lest, perhaps, it upsets their careful lines of demarcation and operation?).

4.3.4 Conclusion: to live for an idea

Structurally speaking then there are two major moves – in relation to the subject – that *Logics of Worlds* makes beyond *Being and Event*. The first is to multiply and diagram the different subject-positions and their contrasting relations to the event. The second is to account for the actual being in a world of a subject. Here, it seems to me, it is the introduction of the terms trace and body that are crucial, coming, as they do, between subject and world (what was, in *Being and Event* subject and situation) and adding a certain complexity to the latter – perhaps inevitably when the cold stellar mathemes of ontology are brought into

the warm fleshy mess of the world (although Badiou's world, in *Logics of Worlds*, is, it seems to me, still very cold).

To return, finally then, to the question of the subject and its relation to an outside, what I have been calling the relation of the finite to the infinite. I would argue that ultimately, despite the introduction of new terms, ever finer 'gradations', a gap is maintained – an ontological rift as it were – between an event and a subject, or simply between the finite and the infinite. Another way of saying this is that the subject, this time firmly in the world, is still blind to the truth which they are paradoxically producing (as I suggested above, the subject's back is turned in this sense and cannot but be turned). The *modus operandi* of this subject is still, necessarily, faith. Indeed, I would suggest that Badiou's 'joyful militant' is also a melancholy subject insofar as they inhabit a forsaken world, barred from an infinite that has nevertheless called them to action.

In fact, it seems to me that within Badiou's system, truth, insofar as it is inconsistent multiplicity, is ultimately irreducible to the world a subject-body finds themselves within, even if their actions in that world are the consequences of somehow being touched by that truth. There is, as it were, the animal realm, and then there is a 'somewhere else', even if this is in fact characterized as a kind of non-place of formalism. Put bluntly, there is a realm of the finite and a separate one of the infinite. Badiou would not agree with my claim that a gap is kept open. Indeed, for Badiou, the subject can partake of the life of the infinite: can, themselves, become an immortal. What then is this mechanism, finally, that allows Badiou to make this claim, that allows this participation? It is to subordinate life itself to that which transcends it, namely the Idea.

Indeed, for Badiou to truly live is not to be merely in a world, but to follow that which interrupts the latter, that which, strictly speaking, is other-wordly. It is to follow the *trace* of an event in the world. But, in fact, it 'is not enough to identify a trace' (*LW*, p. 508). One must incorporate oneself into what this trace authorizes, following and testing the consequences of the latter. This – the following of consequences – is, as we have seen, the production of a body. In passing we might note that this is a further important difference to *Being and Event* in that to 'accept and declare this body is not enough' (*LW*, p. 508). One must, rather, actively enter into its composition.

The movement of this body – the following of consequences – occurs point by point, when the 'infinite appears before the Two of choice' and a decision is made. It is this that produces the present. 'To live is thus an incorporation into the present under the faithful form of a subject' (*LW*, p. 508). Or, more simply put, it is the embodiment of a

subject-formalism. Importantly such a life will avoid conservation, or the reactive (the life instinct), but also the mortification of occultation (the death instinct).[29] Indeed, Badiou's take on life is that it is 'what gets the better of the drives' (*LW*, p. 509) (we will see in the next chapter a diagram of the subject that is exactly the opposite of this).

All of this can be summed up in Badiou's terms by the dictate 'to live for an Idea'. Indeed, it is the Idea *rather than* the body that really determines Badiou's subject. Here is the crucial passage:

> If we agree to call 'Idea' what both manifests itself in the world – what sets forth the being-there of a body – and is an exception to its transcendental logic, we will say, in line with Platonism, that to experience in the present the eternity that authorizes the creation of this present is to experience an Idea. (*LW*, p. 510)

A major difference with *Being and Event*, following this definition of an Idea, is that here, at the end of *Logics of Worlds*, Badiou suggests that 'several times in its brief existence' every individual is in fact 'granted the chance to incorporate itself into the subjective present of a truth' (*LW*, p. 514). As such: 'The grace of living for an Idea, that is of living as such, is accorded to everyone and for several types of procedure' (*LW*. p. 514).[30] Ultimately it is the very infinite plurality of worlds that allows this participation – and the fact that the human animal, to use Badiou's terminology, is able to traverse so many of these worlds.

It is then *this* infinity of worlds, for Badiou, that saves us from our own finitude, that gives us the chance to live as immortals. Or, as Badiou puts it in the section on Hegel: 'All of this culminates in the complex question of the plurality of eternal truths, which is the question of the (infinite) plurality of subjectivizable bodies, in the (infinite) plurality of worlds' (*LW*, p. 141). This infinity of worlds is *not* the same as the eternity of truth, but is the ongoing possibility of the production of the latter in an ongoing infinite series of worlds. Truth, or indeed truths, have then two aspects. On the one hand they are eternal, and, to that extent, have no need of worlds. And yet they must be created in a world – according to the 'contingency of worlds, the aleatory character of a site, the efficacy of the organs of a body and the constancy of a subject' (*LW*, p. 513). We have then a doubled notion of truth that is, to a certain extent, also implicit in *Being and Event* (or, at least, in my reading of it above): the infinity of truths produced in worlds versus the eternity of 'Truth'.

In *Logics of Worlds*, we are then still, as it were, turned away from this latter Truth since we are in a world, and yet, in the very progress

we make through that world, as long as we are subjects, we also create truths – although the latter are never completely commensurable with the former. Or, to put this differently, it is the same inconsistent multiplicity which is missing from any given situation, but the counting of this hitherto invisible element, by a subject, is always specific to that situation. As far as truths go, we might say that the subject's relation to truth is generative insofar as the subject actively produces truths (and here, as John Mullarkey has suggested, Badiou moves closer to Deleuze and his 'powers of the false').[31] However, as far as the larger – determining – Truth goes, the subject is barred from that which has nevertheless called them into being as a subject (since this Truth, by definition, is not knowable from within the situation as is (here, it is Lacan that marks the set-up).[32] The logic that I identified in the first section of this chapter then remains the same, the bar stays in place: the subject lives a strange doubled relation to a truth they are incapable of 'knowing', but are nevertheless in some sense the agent of.

Badiou's 'negotiation' of this bar, or gap, is the business of fidelity, or of decisions and their consequences through which a subject might change a world. In *Being and Event* it was faith that was the support for this subject, here in *Logics of Worlds* it is faith, but also, perhaps more concretely, the Idea – 'the secret of the pure present' (*LW*, p. 514) – that operates as sustaining motivation for a subject who is fated, as a finite being, to live in a world that can never be as it should. Always the disappearing horizon, always more points behind the present one. Always more decisions.

In the terms of my own book's thematic we might say that the subject is then barred from the infinite inasmuch as they are instantiated in a finite world, and yet, according to Badiou they do have a kind of access to another kind of infinity because of the infinite number of possible worlds. But these two senses of the infinite are, it seems to me, different. The latter, the infinite sequence of worlds is, we might say, still within the logic of the possible. The other infinite – Truth – can only have an *in*direct impact on a world via an event that a subject, as we saw above, retroactively names – and claims – as an event.[33] The idea is the sustaining image of this passing event and it is this, for Badiou, that allows one to live as an immortal.

Badiou differentiates this position from what he sees as Bergsonian–Nietzchean–Deleuzian vitalism that conceives of the 'escape' from finitude as a kind of intuitive accessing of the One (life, force, God, or whatever). Badiou's take is that there is no 'One' in this sense. Indeed, Truth is precisely the truth of a not-One, or of inconsistent multiplicity. It is in this sense that truths can only be produced sequentially as it were (this being the path of the subject). However, as we will see in the

next chapter, it is not clear that Badiou's characterization of Deleuze is entirely accurate, especially in terms of his collaboration with Guattari. Certainly desiring-machines – or larval subjectivities – only produce the One as they go along, alongside multiplicity, as a further component as it were. There is certainly no positioning of the One as determinant to this process. But we might also say, following my own reading, that Badiou himself holds to a certain escape from finitude, this time in a speculative positing of a larger Truth beyond any given finite world.

In fact, rather than an issue about the One and the Many, this contretemps, it seems to me, is ultimately about the body. Living for an Idea, in Badiou's sense, *ignores* the body. Indeed, the body – in both its extensive and intensive character – is, once more, the problem. For Deleuze however, as we have seen, there is a kind of intelligence to the body. Here the mind is the problem, at least insofar as the typical concepts it has about the body are a drastic simplification of this complex structure which, as Nietzsche suggests, in the last instance, determines those concepts. In *Difference and Repetition*, following Spinoza, Ideas are important, but in each case they are not a formalism (even a formalism that inhabits a given body), but the name for a more intensive register (for Deleuze, as we saw above, the Idea names those virtual intensities that are, in part, constitutive of the body). Indeed, for Badiou, it is really thought, as an entirely separate realm from the body, that is crucial – and that finds its apotheosis in his own understanding of the Idea as that to which the body must subordinate itself in order that the subject might live as an immortal.

Ultimately, in an echo of both Lacan and Foucault, to live for an Idea is, for Badiou, to support a kind of heroism of the subject: 'the mathematical heroism of the one who creates life, point by point' (*LW*, p. 514). Unlike Hegel, who philosophically maps out this relation of the subject to truth or of the finite to the infinite, but who starts, as it were, from a presumption of eternity, it is, finally, Kierkegaard, with his either/or, who best encapsulates this heroic production of truth from within a world. Indeed, the choice is the moment in which eternity is experienced – or accessed – within existence. Again, the moment when the infinite presents itself in terms of the two. Hegel, we might say, is too distant from the world (like all philosophers). Non-philosophy – from Kierkegaard to Nietzsche to Lacan – concerns itself rather with worlds and the production of truth within them. We have here then a restatement of the fundamental paradox-aporia of truth, or, we might say, of the twin orientations towards it: to know the Truth but to be barred from experiencing it versus the production of a truth without any knowledge of it. This, it seems to me, is the double bind of Badiou's subject.

5
Desiring-Machines, Chaoids, Probe-heads: Towards a Speculative Production of Subjectivity (Deleuze and Guattari)

5.1 Introduction

This chapter attends to Deleuze and Guattari's collaboration, and specifically parts of *Anti-Oedipus* (cited in references as *AO*), *A Thousand Plateaus* and *What is Philosophy?* In the first two sections of the chapter I attempt to extract a definition of the production of subjectivity, understood as a speculative and processual project, from the first and the third books mentioned above. In the first section I employ Bergson's cone for the last time (before finally abandoning it) in order to picture this production in relation to a radically decentred subject; in the second section I find two opposed subjects: one of *doxa* (or opinion) and one of desire (or chaos). In a sense this is where a particular trajectory of my book ends insofar as the third, longer, section, which looks at certain moments of *A Thousand Plateaus*, attempts something slightly different: a more pragmatic enquiry to parallel the speculative. I am especially interested here in the practical organization of subjectivity against more dominant forms of subjection, or what Deleuze and Guattari call faciality. This third section also attempts to think this production of subjectivity through in relation to two case studies, and, as far as this goes, follows what I think is a key modality of this second volume of *Capitalism and Schizophrenia*, namely that it is, again, a pragmatics *for* life as well as being *about* the latter.

5.2 Desiring-machines and the body without organs

5.2.1 Introductory remarks

In *Anti-Oedipus* the subject is an after-effect – or residuum – of a process that is oblivious to that subject. We have here perhaps the most radical

definition of subjectivity we have looked at so far, since the latter is entirely decentred in relation to a desiring-production of which it is precisely not the origin. Deleuze and Guattari's *Anti-Oedipus* is, in this sense, an attempt to think process – or desiring-production – as primary. Indeed, it is this intention that constitutes a specifically materialist psychiatry, as Deleuze and Guattari understand it, as opposed to those theories which posit the subject as first term. Put simply, for Deleuze and Guattari, there is not an I that produces, but a process of production of which the I is a kind of product. Or, to put this in the terms of *Anti-Oedipus*, and to jump ahead slightly, there is no subject *before* the syntheses of the unconscious.

It is this orientation and intention that gives *Anti-Oedipus* its speculative character insofar as it involves speculation from the perspective of a subject about a process that is 'outside', comes before, and indeed determines, that subject. Such speculation also implies a paticular kind of practice, namely, the 'accessing' of this 'outside' through experimentation – and the concomitant production of a different kind of subjectivity (one that is specifically closer to the process it is a product of). As we saw in Chapter 3, this is the business of schizoanalysis. Indeed, there is, in this sense, an ethics in *Anti-Oedipus*, albeit it is a properly inhuman ethics.[1]

To a certain extent this is to follow Marx and Freud in that both decentre man (in terms of the relations of production and the drives), however *Anti-Oedipus* is also pitched against both of these, at least in terms of what we might call their institutionalization. As far as psychoanalysis goes it is especially Lacanian formalizations that are the target, with their privileging of structure and the signifier, and in a domestic/heterosexual modelling as evidenced in the pre-eminence of the Oedipus complex. For Deleuze and Guattari, on the other hand, '*the unconscious is an orphan*' (*AO*, p. 49). In terms of Marxism, *Anti-Oedipus* orientates itself against the concept of ideology, especially in its Althusserian articulation, which, for Deleuze and Guattari, likewise fixes the possibilities of the subject/represses desire (as we will see, Deleuze and Guattari replace ideology with a concept of 'recording' which is itself very much part of the larger system of production). In each case we might say desiring-production is pitched against representation.

In terms of my own book's thematic *Anti-Oedipus* offers a particularly nuanced version of the finite subject's relation to an infinite process of which it is a residuum. It also offers a specific diagram of this process of production, which I will attempt to draw below. In relation to the contretemps between Deleuze and Badiou we also find a very particular

account of the relation between the One and the Many. Here, in *Anti-Oedipus*, the One is constructed as a part alongside others and is not some kind of 'envelope' or transcendent principle that determines multiplicity. If the One is anything at all it is, as it were, a processual formulation.[2] Again, to jump ahead slightly, we might say that the One, if this term is still relevant, is the 'product' of an ongoing conjunctive synthesis and is not somehow before, or a *telos* to, this process. In what follows then I want to attend to the account of this process and its attendant subject as it appears in 'The Desiring Machines', the first chapter of *Anti-Oedipus*.

5.2.2 Desiring-production

For Deleuze and Guattari desiring-production is the immanent principle of the world. It involves two primary mechanisms: desiring-production itself (forces of attraction), and a principle of anti-production (forces of repulsion). This is the relation between desiring-machines and the body without organs. In Deleuze and Guattari's terms the first moment of this unconscious process is the connective synthesis, or simply the production of production. As an example of this first synthesis Deleuze and Guattari offer, via Büchner's Lenz, an image of the schizophrenic 'out for a walk' in which '[e]verything is a machine', everything is a 'process that produces' (*AO*, p. 2). This is to foreground a continuous machinic coupling with the world and of the elements within it. In this place the later syntheses of recording and consumption are themselves merely part of a larger machinic production in which the distinctions between man and nature are irrelevant. It is also, already, to mark a distance from Lacan: 'a schizophrenic out for a walk is a better model than a neurotic lying on the analysts couch' (*AO*, p. 2). In a return to the material of Chapter 1, we might note here that this schizoanalytic model is specifically Spinozist, with the subject constituting themselves in a realm of heterogenetic encounter in and with the world:

> Not man as the king of creation, but rather as the being who is in intimate contact with the profound life of all forms or all types of beings, who is responsible for even the stars and animal life, and who ceaselessly plugs an organ-machine into an energy-machine, a tree into his body, a breast into his mouth, the sun into his asshole: the eternal custodian of the universe. (*AO*, p. 4)

This connective synthesis is then a binary machine. It involves breaks in a flow, and a drawing off to produce other flows which in turn are

interrupted by further 'partial objects'. A continuous slicing and connection: 'there is always a flow-producing machine, and another machine connected to it that interrupts or partially drains off', 'which in turn produce other flows, interrupted by other partial objects' (*AO*, pp. 5–6).

The second aspect of this desiring-production – the disjunctive synthesis – is the moment when the above process stops: 'Everything stops dead for a moment, everything freezes in place – and then the whole process will begin all over again' (*AO*, p. 7). This is a moment of rigidity, the 'full body without organs', the 'unproductive, the sterile, the unengendered, the unconsumable' (*AO*, p. 8). It is the body without organs as death instinct: Thanatos, the third passive synthesis we looked at in the previous chapter:

> The body without organs is nonproductive; nonetheless it is produced, at a certain place and a certain time in the connective synthesis ... It is the body without image ... The full body without organs belongs to the realm of antiproduction; but yet another characteristic of the connective or productive synthesis is the fact that it couples production with antiproduction, with an element of antiproduction. (*AO*, p. 8)

In *Anti-Oedipus* Deleuze and Guattari turn from desiring-production to social production in order to think through this antiproductive moment. The full body without organs is the *socius*, whether this is understood as 'the body of the earth, that of the tyrant, or capital' (*AO*, p. 10). It is that which *appears* to stand outside production and from where the latter seems to miraculate (its apparent ground or presupposition): 'constituting a surface over which the forces and agents of production are distributed, thereby appropriating for itself all surplus production and arrogating to itself both the whole and the parts of the process, which now seem to emanate from it as a quasi cause' (*AO*, p. 10).[3] It is a strange inversion, a bastard abstraction in which there is the production of a 'fetishistic, perverted, bewitched world' (*AO*, p. 11).[4]

Here the first connective synthesis comes under a distributive principle in relation to this radically non-productive element: 'Machines attach themselves to the body without organs as so many points of disjunction, between which an entire network of new syntheses is now woven, marking the surface off into coordinates, like a grid.[5] The '"either . . . or . . . or" of the schizophrenic takes over from the "and then"...' (*AO*, p. 12). This 'either ... or' is not that of a single decisive choice (the Kirkegaardian 'either/or' of Badiou's decision-making

Figure 5.1 Connective synthesis (+)/disjunctive synthesis (⊕)

subject in *Logics of Worlds*) but, rather, 'refers to the system of possible permutations between differences' (*AO*, p. 12). It is like a continuous shifting or shunting of gears, a detachment from one line – of connective synthesis – to another; a move to a different track (Figure 5.1). This disjunctive synthesis includes within it a principle of recording as the either/or shunts are striated/scratched on to the body without organs itself. So far we have a process in which the subject is absent.

5.2.3 The subject and enjoyment

If there is first an opposition between the repulsion of the desiring-machines by the body without organs (paranoiac machine), and then also their attraction (miraculating machine), then the third synthesis is a reconciliation of sorts of these two: a celibate machine which forms 'a new alliance between the desiring-machines and the body without organs so as to give birth to a new humanity or a glorious organism' (*AO*, p. 17). This is a reconciliation of sorts between the pleasure principle (life preserving) and the death instinct. Indeed, each celibate machine is unique in this sense, a particular and singular relation between these two forces. The celibate machine itself produces 'intensive qualities', an 'I feel' that operates at the very deepest level. These intensities – or becomings – are precisely the result of this opposition of attraction and repulsion.

> In a word, the opposition of the forces of attraction and repulsion produces an open series of intensive elements, all of them positive, that are never an expression of the final equilibrium of a system, but consist, rather, of an unlimited number of stationary, metastable states through which a subject passes. (*AO*, p. 19)

Deleuze and Guattari's case study here is Judge Schreber insofar as he exhibited and *lived* this series of intensive states, these becomings: '*attraction*

Figure 5.2 Diagram of desiring-production 1 ('soaring ascents and plunging falls'): 1 Desiring machine/disjunctive synthesis (the 'gap'); 2 The body without organs; 3 Attraction; 4 Repulsion; 5 The eternal return; 6 Different intensive states

and repulsion produce intense *nervous states* that fill up the body without organs to varying degrees – states through which schreber-the-subject passes, becoming a woman and many other things as well, following an endless circle of eternal return' (*AO*, p. 19). Indeed, the reference to Nietzsche is apposite, for Nietzsche, too, as I suggested in Chapter 1, lived a series of intensive states (understood as a series of particular relations between active and reactive forces). In fact, as I suggested in Chapter 2, there is a Bergsonian moment in Nietzsche's eternal return in which an individual – here Nietzsche – passes through a whole species memory. We might diagram this desiring-production as in Figure 5.2.

Here the disjunctive synthesis is, in one sense at least, a move beyond the principle of connectivity that, we might say, in reference to Bergson, determines the plane of matter (the desiring-machine (or connective synthesis) is the sensori-motor schema; the body without organs (or disjunctive synthesis) is the 'gap' between stimulus and response (the breaking of habit)). In relation to Badiou, we might say that the disjunctive synthesis allows a move away from an all too human regime of reactivity

(what Badiou calls animality). For Deleuze and Guattari, however, this is not a move to somewhere 'outside' the process itself – to a realm of truth, of 'the subject', or anything else – but rather is a move to another level – or circuit – of desiring-production itself. Another track as it were. In a return to some of my comments in Chapter 1, we might note here that the disjunctive synthesis operates both counter capitalism, insofar as capitalism is desiring-production, but also *for* capitalism insofar as the latter needs the shift of gears to keep desire moving along. Desiring-production, in this sense, is not 'outside' capitalism, but, we might say, its very operating logic, at least to the extent that capitalism names both a process of reterritorialization (the extraction of surplus from the flows of desire) *and* deterritorialization (the flows of desire itself).

Again, the shift itself is registered – and mapped – onto the body without organs itself:

> The body without organs is an egg: it is crisscrossed with axes and thresholds, with latitudes and longitudes and geodesic lines, traversed by *gradients* marking the transitions and the becomings, the destinations of the subject developing along these particular vectors. (*AO*, p. 19)[6]

It is only now that the subject comes into play. The latter is the result of a third conjunctive synthesis that, in a sense, 'holds' the previous processes of attraction and repulsion (it identifies itself, as we shall see, with the celibate machine that it in some senses 'is'). This is a synthesis that is a side effect of sorts of the oscillation itself. In fact, it is an 'enjoyment' of the surplus energy produced by the latter (and it is in this sense that the production of such a schizoid subject mirrors capitalist production itself (hence the titling of Deleuze and Guattari's two volumes as *Capitalism* and *Schizophrenia*)).

This is a moment of consumption that follows the moment of recording that itself follows from the moment of production (although each is itself part of the larger and continuous 'production of production'). If the subject is located anywhere it is then at the very moment of the consumption of a disjunction. It is, again, a subject produced through enjoyment and through a certain satisfaction (as in Schreber and his enjoyment of a surplus – his 'residual share' – as a 'recompense for his suffering or as a reward for his becoming-woman' (or as with the baby at the breast who turns away, satisfied)) (*AO*, p. 16). We can think a resonance of sorts with Spinoza here: it is only through joy – or enjoyment (and, as Schreber demonstrates, suffering might itself be a kind

of joy) that the subject is produced as surplus (this is the basic 'I feel' of Deleuze's first passive synthesis of time, an auto-affection that is properly sub-representative): 'Just as part of the libido as energy of production was transformed into energy of recording (Numan), a part of this energy of recording is transformed into energy of consumation (Voluptas). It is this residual energy that is the motive for the production of consumption' (*AO*, p. 17).[7]

It is, however, a very strange subject that is produced:

> with no fixed identity, wandering about over the body without organs, but always remaining peripheral to the desiring-machines, being defined by the share of the product it takes for itself, garnering here, there, and everywhere a reward in the form of a becoming or an avatar, being born of the states that it consumes and being reborn with each new state. (*AO*, p. 16)

This 'nomadic, vagabond' subject is then produced as a mere residuum alongside the desiring-machines (*AO*, p. 26). It identifies itself with this third productive machine and with the residual reconciliation that it brings about: a conjunctive synthesis of consummation in the form of a wonder struck 'So *that's* what it was!' (*AO*, p. 18). Crucially this is a retroactive identification: a moment of 'recognition' that, for Deleuze and Guattari, has very little to do with family figures, or Oedipus, although we might say it has something in common with Lacan's own theorization of the strange temporality of the subject that we looked at in Chapter 2. I will return to this last point in a moment.

It is also, again, very different to Badiou's subject of fidelity to an event. Indeed, we might say that there are events in Deleuze and Guattari's production of the subject, but these events are not rare, nor do they demand that a subject be faithful to them. In fact, we might say events are common, if they are understood as the different moments of the three syntheses. Events are what make up the world as it is lived (and, as such, they are certainly not other-worldly). What can be said, however, is that in both *Being and Event* and *Anti-Oedipus* the event precedes the subject, even though the definition of the subject and the event differs in each book. In passing we might also say, as I suggested above, that Badiou's fidelity to the event is itself a disjunctive synthesis insofar as it determines a shift from a certain situation/world – or regime of connective synthesis – to another situation/world. Likewise, in Lacanian terms – and in a return to Chapter 2 – the disjunctive synthesis might be seen as a shift away from a particular pathway on the torus; again, a shunting of tracks as it were.

There is, however, a strange paradox here, for, of course, there must be a subject, at least of some kind, who makes the retroactive recognition/statement of becoming a subject. In a sense this is the Lacanian moment of *Anti-Oedipus* in that it involves the 'assumption of causality' by a subject. A retroactive 'claiming' of a prior determination. It is also, as I suggested in my introduction to this part of the chapter, the paradox of speculative thinking that must begin from a constituted subject as it were but move towards the pre-subjective.[8] In passing, it is worth noting that this might be seen as the key difference, but also the connecting link, between *Anti-Oedipus* and *A Thousand Plateaus*: the former de-individuates (on to a field of desiring-production), the latter re-individuates (as evidenced by the plethora of different forms of composition and organization found therein, one of which I will be looking at below).

In relation to this individuating character of *A Thousand Plateaus* we might note Deleuze's own remarks in an interview:

> What we're interested in, you see, are modes of individuation beyond those of things, persons or subjects: the individuation, say, of a time of day, of a region, a climate, a river or a wind, of an event. And maybe it's a mistake to believe in the existence of things, persons, subjects. The title *A Thousand Plateaus* refers to these individuations that don't individuate persons or things. (Deleuze 1995a, p. 26)

It is also worth noting here, once more, that this philosophical de- and re-individuation is also a pragmatics insofar as the practice of schizoanalysis follows from it. Schizoanalysis, we might say, is the speculative moment of Deleuze and Guattari's philosophy brought into material practice (or simply the production of subjectivity). In an echo of Foucault and Hadot, we might say that this is 'philosophy as a way of life'. I will return to this theme in the third section of this chapter. We might also note in passing that this understanding of philosophy, that, in many senses, is a constant of my own book, means that it is also a form of non-philosophy since it does not necessarily involve what Francois Laruelle calls the 'philosophical decision' that separates philosophy from life – or means philosophy can only be 'about' life.[9]

We come now to the admirable passage where Deleuze and Guattari 'diagram' the production of this subject (see Figure 5.3):

> How can we sum up this entire vital progression? Let us trace it along a first path (the shortest route): the points of disjunction on the body

178 *On the Production of Subjectivity*

Figure 5.3 Diagram of desiring-production 2 ('a succession of irregular loops'): 1 The celibate machine; 2 Disjunctive synthesis/recording process; 3 The body without organs/recording surface; 4 The subject

> without organs form circles that converge on the desiring-machines; then the subject – produced as a residuum alongside the machine, as an appendix, or as a separate part adjacent to the machine – passes through all the degrees of the circle, and passes from one circle to another. This subject is itself not at the centre, which is occupied by the machine, but on the periphery, with no fixed identity, forever decentred, *defined* by the states through which it passes. (*AO*, p. 20)

Deleuze and Guattari write of the 'circles traced by Beckett's Unnameable, "a succession of irregular loops, now sharp and short as in the waltz, now of a parabolic sweep"' (*AO*, p. 20), but also of the attraction/repulsion mechanism that produces the states themselves:

> Or, to follow a path that is more complex, but leads in the end to the same thing: by means of the paranoiac machine and the miraculating machine, the proportions of attraction and repulsion on the body without organs produce, starting from zero, a series of states in the celibate machine; and the subject is born of each state in the series, is continually reborn of the following state that determines him at a given moment, consuming-consummating all these lived states that cause him to be born and reborn (the lived state coming first, in relation to the subject that lives it). (*AO*, p. 20)

Deleuze and Guattari cite Klossowski here and, once more, the case of Nietzsche who lived these intensive states sequentially, inhabiting, as it

were, a series of individualities – or characters – that correspond to the 'soaring ascents and plunging falls' (*AO*, p. 21). Nietzsche thus identifies these states that he feels 'with the names of history: "*every name in history is I...*"' (*AO*, p. 21).

To return to the looping circles:

> The subject spreads itself out along the entire circumference of the circle, the centre of which has been abandoned by the ego. At the centre is the desiring-machine, the celibate machine of the Eternal Return. A residual subject of the machine, Nietzsche-as-subject garners a euphoric reward (Voluptas) from everything that this machine turns out ... (*AO*, p. 21)

Deleuze and Guattari also refer to Klossowski's insight that Nietzsche is, at this point of the eternal return, following a programme, identifying the intensive states he passes through with the names of history. Again, this is a retroactive identification on the basis of felt sensation: '"They're *me*! So it's *me*!"' (*AO*, p. 21).[10] As Deleuze and Guattari remark, this is to move from '*Homo natura*' to '*Homo historia*' (*AO*, p. 21). It is also to think the eternal return as a kind of intense recollection, an accessing of Bergson's pure past by an individual, in this case Nietzsche, in fact an increasing acceleration of recollection, until every name is lived in the duration of just one day.

How then to bring these two diagrams together? Well, we might say that they both diagram the same process albeit each foregrounding different aspects of desiring-production. In the cone it is the attraction/repulsion, the move from one intensive state to another, that is emphasized (the passage through different personae). In the circles it is the decentred path of the subject along the lines of desire that is most prominent. In fact, with the latter diagram it is as if the Bergsonian cone has been flattened.[11] There is, after all, no past, as it were, at the level of desiring-production.

Indeed, in the diagram of the cone the body without organs is not merely the flat plane, but also the area around the cone, and, indeed, the content of it (in our diagram – Figure 5.2 – all this might be numbered '2'). For, as we saw in Chapter 1, the pure past and that which remains unseen on the plane of matter are of the same kind – a virtual outside of the immediate interests of the sensori-motor schema as it loops around, connect ... connect ... connect ... We come here to the limits of our cone insofar as it presupposed a duality, when, in fact, there is none (or, rather, there is – a difference in kind, following Bergson – but only from the perspective of a sovereign subject as it were, located at point S in Bergson's cone).

Indeed, there is no virtual in this strange cartography of desire. This, it seems to me, marks a decisive distance from the Deleuze of *Difference and Repetition* with its Bergsonian three syntheses of time, but also with the Deleuze of the *Logic of Sense* with its emphasis on an interplay between surface and depth. Here everything is on the surface as it were, in an ever present now (might this not be, in fact, the time of the third passive synthesis?). We might also say that it is here that the issue of reciprocal determination between the actual and virtual, Deleuze's Univocity, is 'resolved' insofar as desiring-production, and the residual subject that is produced by it, are part of the same materialist extensive-intensive process.[12]

As the subject moves between circles, through different disjunctive syntheses, it passes through different intensive states. To a certain extent this is to follow the logic of the composite diagram of Chapter 2 (see Figure 2.5), and, in which case, we might say *das Ding* is the point of attraction and repulsion, a pulsating centre, around which the subject endlessly loops – along the lines of desire – until they 'find' another disjunctive synthesis and shift circles, shifting intensive state at the same time. Indeed, it seems to me, following Meillassoux's insight about reactive and creative death in Bergson's *Matter and Memory*, that there are two dangers here: the circles either become too small, too contracted; or they become too wide, too dissipated. In each case the subject loses a certain cohesiveness, and a certain freedom of movement between circles/states (in a return to the Nietzsche of Chapter 1, we might say the subject loses the mobility that determines the 'Great Health').[13]

Here then the different layers of the cone become the concentric circles traced by a subject as it circles the desiring-machines, shifting from line to line, circle to circle – from connective synthesis to disjunctive synthesis to connective synthesis – as it 'lives' different intensive states, or simply different relations between the forces of attraction and repulsion (and, in the conjunctive synthesis, identifies with these states).[14] In fact, this flat diagram with no supplementary dimension above or below (there is a 'horizon' in my diagram purely for illustrative purposes) might be diagrammed as a spiral (Figure 5.4) insofar as the disjunctive synthesis connects each concentric loop inwards and/or outwards.

We might go further and suggest that the body without organs is traversed by endless loops around which different (larval) subjects traverse, different lines of desire criss-crossing the surface of the body without organs, meeting and departing at different points of disjunctive syntheses (Figure 5.5). A veritable grid of becoming.

Again, the similarities of the diagram in Figure 5.3 to Lacan's torus of Chapter 2 (see Figure 2.4) are, it seems to me, not incidental. Just as

Figure 5.4 Desiring-production as spiral cone/flat spiral

Figure 5.5 The body without organs crisscrossed with lines of desire (1: Disjunctive synthesis)

there the Lacanian subject desires to move to the centre, towards *das Ding*, as the thing most desired, but which would also be the subject's death, so here the subject, it seems to me, spirals towards the centre, to where the desiring-machine meets the body without organs, a place where the oscillations cancel themselves out, degree 0, or death, before spiralling out once more.[15]

We might also compare the diagram in Figure 5.3 with Guattari's third Assemblage (see Figure 3.1 in Chapter 3) – in which the outside/transcendence has been folded in to produce autopoietic nuclei around which a subject might cohere. Here the degree 0, the meeting between desiring-machines and the body without organs is, in Guattari's terms, a strange attractor, a 'Z-point' or asignifying nuclei that 'collects' a subject around itself. Ultimately, this is a diagram of a process of production of which the subject is only a component, and a marginal one at that. However, it is an arrogant component in that it comes to assume 'ownership' of this process of which it is little more than an after-effect.

5.3 Chaoids and the brain

5.3.1 Introductory remarks

Deleuze and Guattari begin the chapter on 'Geophilosophy' in *What is Philosophy?* with a statement against what Quentin Meillassoux will come to call the correlation: 'Subject and object give a poor approximation of thought. Thinking is neither a line drawn between subject and object nor a revolving of one around the other' (*WP*, p. 85). Indeed, for Deleuze and Guattari the problem of the subject's access to the object – or the 'great outdoors' – is not one of finding a crack in the correlationist circle, but must involve, rather, a questioning of the idea of the correlation itself – and a concomitant refiguring of the idea of the subject in general. In fact, the subject is not a category that is given much attention in *What is Philosophy?*, beyond Deleuze and Guattari pointing out that subjective presuppositions, as with Descartes, set up problems that can only be addressed on their own plane of thought. It is not a plane that Deleuze and Guattari's philosophy operates on.

Indeed, when the subject is addressed in *What is Philosophy?* it is generally understood as a subject of '*urdoxa*', or opinion. In fact, the subject is the font of the latter, erecting a certain transcendence over immanence, a transcendence that operates by determining the significations that gather lived experience or, put simply, 'the lived': 'The concept of signification is all of this at once: immanence of the lived to the subject, act of transcendence of the subject in relation to variations of the lived, totalization of the lived or function of these acts' (*WP*, p. 142) The subject operates as a kind of capture, and, it must be said, as a cohering mechanism. Indeed, the subject, in this sense, is itself a kind of operating fiction. For Deleuze and Guattari it is Kant, then Husserl, who performs this task of producing (and centring) a 'transcendental subject', but, we might say, the project is continued, albeit with a different emphasis, in

Lacan and then Badiou with their insistence on the subject as 'name' or formal matheme (a subject of the signifier as it were).

Indeed, there are two competing paradigms at work here: the one emphasizing intensive states and a continuum, or becoming (a reciprocal determination) between 'subject' and world (articulated most fully, as we have seen, in *Anti-Oedipus* in which both subject and world are part of a nature that is both extensive and intensive); the other emphasizing formalism and a subject as radically other to the world and the body (the subject as radical cut, as defined precisely by its distance from the world). For the latter paradigm the subject is pre-eminent (hence the name); in the former the subject – insofar as they are separate from the world – is the problem as it were (here it is a becoming-nameless, or becoming-imperceptible, that is crucial).

5.3.2 Chaoids

But, we might ask, is there another kind of subject in *What is Philosophy?* A subject that is in alliance with chaos against the subject-of-opinion? A subject-of-thought perhaps? A philosophy-subjectivity, an art-subjectivity and a science-subjectivity. Each of these is not necessarily determined by a set of transcendental conditions that legislate for possible experience. They are not 'contained' within, or determined by, an already constituted subject with its attendant points of coordination (of space and time; of an inside and outside). They are, to that extent, less constrained, wilder.

Each of these forms of thought are themselves involved in a war against something even wilder than they – chaos itself – but also, and more crucially, in a second war against opinion, with its transcendent subject. The former war is one that is fought with a certain affinity with the enemy, for these great forms of thought are composed out of chaos, are, in fact, a chaos that is given at least some consistency. Deleuze and Guattari name these 'daughters of chaos' *chaoids*. We might say, following Guattari, that chaoids are the complexity that is formed from chaos, but which maintain a relationship with the latter (they do not, as it were, cancel their conditions of possibility in their emergence or actualization). In terms of my own book's thematic, we might say that a chaoid names a particular folding of the infinite (chaos) into the finite (thought).

Each of these forms of thought perform this folding in different ways:

> What defines thought in its three great forms – art, science, and philosophy – is always confronting chaos, laying out a plane, throwing a

plane over chaos. But philosophy wants to save the infinite by giving it consistency: it lays out a plane of immanence that, through the action of conceptual personae, takes events or consistent concepts to infinity. Science, on the other hand, relinquishes the infinite in order to gain reference: it lays out a plane of simply undefined coordinates that each time, through the action of partial observers, defines states of affairs, functions, or referential propositions. Art wants to create the finite that restores the infinite: it lays out a plane of composition that, in turn, through the action of aesthetic figures, bears monuments or composite sensations. (*WP*, p. 197)

Philosophy strives to give consistency to chaos through the construction of the concept; science, in its turn, performs a slowing down of chaos. Art, for its part, composes chaos, offering us a 'being of sensation' (*WP*, p. 203). It is not so much that a subject might 'use' these forms of thought, but that the forms of thought are themselves forms of strange subjectivity, albeit, of course, specifically non-human.[16] This, we might say, is in fact thought-without-subject insofar as it is a form of thought that does not necessarily follow the organization of what I have been calling, in this book, the subject-as-is. Here thought is not signification, opinion, or, indeed, any of the 'ideas' that we have about our 'selves'. It is also not a formula or a matheme. It operates through concepts and functions but, importantly, through affects too. The body itself 'thinks' in this intensive and Spinozist sense, or rather, the body *is* a thought – a moment of cohesion within chaos.

In fact, it is opinion that primarily protects us from chaos by linking thought together by a 'minimum of constant rules' (*WP*, p. 201). This is the association of ideas that are protective – 'resemblance, contiguity, causality' – and that themselves are linked to the sensations of the body. It is this, ultimately, that saves us from delirium: 'This is all that we ask for in order to *make an opinion* for ourselves, like a sort of "umbrella," which protects us from chaos' (*WP*, p. 202). Indeed, 'we require just a little order to protect us from chaos' (*WP*, p. 202).

This also returns us to Deleuze's first philosophical precursor, Hume, for whom its is precisely these relations, or principles – of resemblance, contiguity, causality – that give a consistency and cohesion to 'human nature' (Deleuze 2001, p. 39). We might note here that Hume is, as such, a further source for the idea of passive syntheses in both *Difference and Repetition* and *Anti-Oedipus*. This is then Deleuze's, but also Deleuze and Guattari's, transcendental empiricism: knowledge is through the senses (empirical), but is also through what we deduce from them as

it were (the conditions of this experience). Here it is not the matheme or language that gives access to something 'beyond' consciousness, but precisely the construction of a concept that allows this beyond – the infinite – to be thought in a specifically intensive sense.

'But art, science, and philosophy require more: they cast planes over chaos ... Philosophy, science, and art want us to tear open the firmament and plunge into chaos. We defeat it only at this price' (*WP*, p. 202). Deleuze and Guattari continue a page later: 'It is as if the *struggle against chaos* does not take place without an affinity with the enemy, because another struggle develops and takes on more importance – the struggle *against opinion*, which claims to protect us from chaos itself' (*WP*, p. 203). This struggle against opinion – the second war mentioned above – is also the struggle against cliché – including the cliché of the subject-as-is (the cliché, we might say, of the sensori-motor schema).

5.3.3 The brain

In the last chapter of *What is Philosophy?*, from where the last few quotes above are taken, Deleuze and Guattari turn to the brain, and to the relationship the latter itself has with chaos. For Deleuze and Guattari the brain is not, or not only, a constituted object, but is also a kind of virtual object – rhizomatic – in which the planes of science, art and philosophy intersect. Indeed, Deleuze and Guattari extend phenomenology's insight about 'being in the world', and in so doing depart from it:

> It is the brain that thinks and not man – the latter being only a cerebral crystallization. We will speak of the brain as Cézanne spoke of the landscape: man absent from, but completely with the brain. Philosophy, art, and science are not the mental objects of an objectified brain but the three aspects under which the brain becomes subject. (*WP*, p. 210)

This is a Bergsonian understanding of thought in which there is no interiority as such; thought takes place outside, in the world as it were. It is also, again, feeling – or intensive states – that characterizes this 'expanded' brain's operative field:

> It is the brain that says *I*, but *I* is an other. It is not the same brain as the brain of connections and secondary integrations, although there is no transcendence here. And this *I* is not only the 'I conceive' of the brain as philosophy, it is also the 'I feel' of the brain as art. (*WP*, p. 211)

This 'feeling' is the 'contracting' of chaos: 'sensation is the contracted vibration that has become quality, variety. That is why the brain-subject is here called *soul* or *force*, since only the soul preserves by contracting that which matter dissipates, or radiates, furthers, reflects, or converts' (*WP*, p. 212). We have here, again, a return to the passive syntheses of *Anti-Oedipus* that posit the self-enjoyment of this contemplation, itself a restatement of Deleuze's thesis in *Difference and Repetition*, itself a restatement of Bergson's thesis of the inorganic life of the universe:[17]

> Sensation is pure contemplation, for it is through contemplation that one contracts, contemplating oneself to the extent that one contemplates the elements from which one originates. Contemplating is creating, the mystery of passive creation, sensation. Sensation fills out the plane of composition and is filled with itself by filling itself with what it contemplates: it is 'enjoyment' and 'self-enjoyment'. It is a subject, or rather an *inject*. (*WP*, p. 212)

Deleuze and Guattari continue:

> Plotinus defined all things as contemplations, not only people and animals but plants, the earth, the rocks. There are not Ideas that we contemplate through concepts but the elements of matter that we contemplate through sensation. The plant contemplates by contracting the elements from which it originates – light, carbon, and the salts – and it fills itself with colors and odors that in each case qualify its variety, its composition: it is *sensation* in itself. (*WP*, p. 212)

We have here a properly non-human subject, insofar as a human subject might be understood as a transcendent capture – an appropriation – of certain of these processes. This is a (larval) subject alien to signification or any formalization (or, at least, prior to them). It is also not a subject opposed to an object (it is not part of the correlation in this sense). But a subject that is also, at once, object. After all, what else could we be? And what else are objects except other passive syntheses?

In the end the three chaoids intersect, each maintaining different kinds of relation with the others. The most profound relation, however, is with their opposite, with a nonphilosophy, a nonart, a nonscience:

> Now, if the three Nos are still distinct in relation to the cerebral plane, they are no longer distinct in relation to the chaos into which the brain plunges. In this submersion it seems that there is extracted

Figure 5.6 The three forms of thought: 1 Chaos; 2 Planes of thought (art, science, philosophy); 3 The brain

from chaos the shadow of the 'people to come' in the form that art, but also philosophy and science, summon forth: mass-people, world-people, brain-people, chaos-people – nonthinking thought that lodges in the three ... (*WP*, p. 218)

We might say, following the so-called 'speculative turn' in contemporary theory, that *this* is the speculative subject, a subject of the 'great outdoors' when this is thought also as the 'great indoors' of the brain.[18] Indeed, '[t]he brain is the junction – not the unity – *of the three planes*' (*WP*, p. 203). Perhaps we can diagram this subject-of-thought – unbounded by the subject-as-is (by the sensori-motor schema, by signification), but certainly a moment in which chaos is given coherence – as in Figure 5.6.

5.4 Probe-heads against faciality

5.4.1 Introductory remarks

It seems to me that one of the most compelling aspects of Deleuze and Guattari's writings is that they offer up a set of concept-tools for undoing certain habitual ways of being in the world and for constructing our lives, producing our own subjectivity, differently. It is this particular aspect, again what we might call its pragmatic character, that first

drew me to their work – and it is this that always draws me back.[19] Their writings are 'post-human' in this sense, when 'human' denotes a very particular (and historically specific) set of capacities, attitudes and knowledges; what we might simply call, following the above section, cliché and opinion.

As such, and philosophically speaking, one can identify a logic of 'dissolution' in this orientation, especially, as Peter Hallward suggests, in Deleuze's own writings.[20] There is, at times, a manifest desire to escape the 'human', and the world the latter moves through. This is also, as we have seen, the case in *Anti-Oedipus* where the human subject, such as there is one, is displaced in relation to a more inhuman desiring-production. Nevertheless, one can also identify a fundamentally constructive and creative project within the Deleuze and Guattari collaboration. Indeed, these two orientations often go hand in hand. This is perhaps most apparent in *A Thousand Plateaus* which, it seems to me, is the most intensely generative of the books Deleuze and Guattari wrote together, especially in terms of the question of the production of subjectivity.

In fact, in *A Thousand Plateaus* it is as if Guattari's contribution, and especially his experiences in his therapeutic work, operates as a grounding mechanism to Deleuze's own particular philosophical and post-human trajectory. As we have seen in Chapter 3, it is Guattari, rather than Deleuze, who focuses almost exclusively on the question of the production of subjectivity, alerting us in particular to the importance of art – and the aesthetic paradigm – in the creation of new incorporeal universes of reference and the new modalities of subjectivity attendant on these. As far as this goes it seems that Guattari also brought a different kind of philosophical 'modeling' to the collaboration insofar as the terrain shifts, in both volumes of *Capitalism and Schizophrenia*, from a system borrowed from Bergson, and especially the actual/virtual dyad, to what we might call a more intensive-materialist register.[21]

In relation to this Guattari's writings also draw attention to the hybrid character of contemporary subjectivity, for example, those 'archaic attachments to cultural traditions that nonetheless aspire to the technological and scientific modernity characterising the contemporary subjective cocktail' (*C*, p. 4). We might say that Guattari's work, in general, offers a different kind of spatial and temporal cartography for the production of subjectivity, understood as a material *practice*, while at the same time offering insights, again especially as regards art, into the possibilities of reconfiguration, or what Guattari calls 'resingularisation': 'the constitution of complexes of subjectivation' that 'offer people diverse possibilities for recomposing their existential corporeality' (*C*, p. 7).

In the final section of this chapter I want to attend to some of the actual mechanisms of this subject production by looking at certain moments of *A Thousand Plateaus* (although I will also return to both *Anti-Oedipus* and *What is Philosophy?* below) that might allow us to begin living our lives apart from the dominant regimes of the present – we might say that allow us to produce alternative finite–infinite machines in Guattari's sense. In fact, I want to focus on just one concept, 'probe-heads' – and think a little about the latter in relation to the production of subjectivity in the 'first world', and specifically the production of other forms of subjectivity 'beyond' the alienated and fearful metropolitan individual (which is to say, myself). This will involve a further exploration of what we might call two operating fields of probe-heads, in fact two different 'times' of the contemporary: the past and the future. In relation to the second of these, this last section also marks a return to Guattari and to the aesthetic paradigm more generally.[22]

5.4.2 From faciality to probe-heads

> To the point that if human beings have a destiny, it is rather to escape the face, to dismantle the face and facializations, to become imperceptible, to become clandestine, not by returning to animality, nor even by returning to the head, but by spiritual and special becomings-animal, by strange true becomings that get past the wall and get out of the black holes. (*ATP*, p. 171)

Faciality, or the white wall/black hole system, is the human system of organization of our present times. It lies at the intersection of two regimes: the signifying regime (premised on significance; on the desire for interpretation) and the post-signifying regime (subjectification; consciousness, or the turn inwards). This faciality machine is however not reducible to signifiance and subjectification, but 'subjacent (*connexe*) to them', operating as their 'condition of possibility' (*ATP*, p. 180). The faciality machine 'carries out the prior gridding that makes it possible for the signifying elements to become discernable, and for subjective choices to be implemented' (*ATP*, p. 180). Put simply, the faciality machine delimits, to a large extent, our particular mode of being. In Deleuze and Guattari's terms, it is the dominant abstract machine of the contemporary world, providing, as it does, the coordinates and contours that allow the signifying subject to emerge. As such faciality is an affair of economy and the organization of power (*ATP*, p. 175). It organizes a field of possibilities, determines, at least to a certain extent, what we are capable of seeing, saying – and doing.

Faciality proceeds, as a first moment, through the deterritorialization of the head, 'when the head ceases to be a part of the body, when it ceases to be coded by the body', and its subsequent overcoding/entry into another strata (that is, signification/subjectivation) (*ATP*, p. 170). In fact, this facialization does not end with the head but proceeds over the body and indeed the 'landscape' in which the facialized 'subject' moves (*ATP*, p. 172). As Deleuze and Guattari remark, the faciality machine 'performs the facialization of the whole body and all its surroundings and objects, and the landscapification of all worlds and milieus' (*ATP*, p. 181). We might say then that as well as producing a subject, faciality also produces the world he or she moves in and through.

This facialized subject/world is characterized by fear, a fear played upon and accelerated by various aspects of contemporary culture (and in particular the mass media), but which does not have its origin there.[23] Indeed, the source of this fear is the faciality machine itself. The faciality machine performs a basic abstraction of the 'human' from the world/the body, the latter then becoming a threat to the very regime of faciality. It is in this sense that aberrations to, or deviations from, faciality are intolerable. Lines of flight are blocked or become lines of abolition. Deterritorializations are quickly reterritorialized. Indeed, there is no easy escape from faciality, the strata that binds us being nothing if not resilient and resourceful. This fear is then a product of the very emergence of the subject, at least as he or she is in turn the product of the mixed semiotic that is faciality. Any attempt to live in the face of this fear must then trace the latter back to its root, account for it, and posit an alternative organization that is not premised on faciality and on this fundamental separation from the world.[24]

Deleuze and Guattari contrast this faciality machine – that operates through the conjunction of the two regimes mentioned above – with a more primitive, presignifying/presubjective regime ('nonsignifying, nonsubjective, essentially collective, polyvocal and corporeal' (*ATP*, p. 175)). This is a regime that involves specifically non-human becoming and a different relation to the world (and, as such, it has strong resonances with Guattari's first Assemblage of Chapter 3). However, for ourselves it is not a question of a return to some kind of primitive pre-faciality (if this were indeed possible) but rather of 'going through' faciality as it were, disrupting existing modes of organization from within that organization, utilizing the stuff of the world in which we find ourselves (what else is there?) but in a *different* way. 'Probe-heads' are Deleuze and Guattari's name for these alternative modes of organization. They are not involved in significance, or indeed with

subjectification, at least not to do with their particular combination in faciality, but in 'escaping' these two sticky mechanisms.

Probe-heads then 'dismantle the strata in their wake, break through walls of signifiance, pour out of the holes of subjectivity, fell trees in favour of veritable rhizomes, and steer the flows down lines of positive deterritorialization or creative flight' (*ATP*, p. 190). But they are also, as the name suggests, productive of other, stranger and more fluid modes of organization: 'Beyond the face lies an altogether different inhumanity: no longer that of the primitive head, but of "probe-heads"; here, cutting edges of deterritorialization become operative and lines of deterritorialization positive and absolute, forming strange new becomings, new polyvocalities' (*ATP*, pp. 190–1).

We might say then that it is a question of inventing our own faces, or rather our own heads – probe-heads – which themselves will be the platforms for other, perhaps even stranger modes of organization and subsequent deterritorializations (and in this self-organizing character – or autonomy – they would seem to have much in common with Guattari's third Assemblage of Chapter 3). But what *is* a probe-head? To a certain extent this is an open question; it will depend on the specifics of time and place, on the particular materials at hand – and on the concrete practices of individuals. A probe-head might in fact be any form of practice – any regime – that ruptures the dominant (faciality). An individual subject in his or her life might operate as a probe-head in this sense (but in which case are they any longer a subject?).[25] Groups might also function as probe-heads (radical political groupings, but also any intentional community that turns away from typical regimes and transcendent points of coordination). Artworks might likewise operate as probe-heads (Francis Bacon's portraits for example (at least as Deleuze writes about them), but we might also add the more 'expanded' practices from the 1960s to today that often offer even stranger – non-facialized – diagrams for subjectivity, for example with performance art, installation, happenings and the like).[26]

In fact, it is in the realm of art – or, more generally, aesthetic practices – that we can identify a key modality of probe-heads: that they are somehow orientated against the present time. I want now to attend to this strange temporality of probe-heads, in fact to think about two terrains, or resources, of probe-head construction: the past and the future. I want also to give two brief case studies involving these two: modern paganism and contemporary art. To thematize myself into this brief account, and I think a certain amount of foregrounding one's self is, ultimately, important when it comes to writing about the production

of subjectivity, I can say that these two modalities have both been of crucial importance to my own subjectivity, but also in taking me beyond a certain alienated subjectivity. Both, if you like, have offered up the possibility for resingularization with the diagramming of alternatives to those subjectivities on offer elsewhere.

5.4.3 Residual subjectivities

In a more general way, one has to admit that every individual and social group conveys its own system of modelising subjectivity; that is, a certain cartography – composed of cognitive references as well as mythical, ritual and symptommalogical references – with which it positions itself in relation to its affects and anguishes, and attempts to manage its inhibitions and drives. (C, p. 11)

In a time of what Negri has called the 'total subsumption of capital', strange and contradictory strategies for producing subjectivity, for building probe-heads, will be required (Negri 2003, pp. 23–9). Indeed, in a time in which the present has been colonized, other 'times' become a resource to be utilized. In his own work, as we have seen, Negri turns to Spinoza and to the notion of deploying a kind of future orientation (*kairos*), and indeed the eternal, against time. I shall be returning to this particular temporal orientation at the end of this chapter. First however I want to think through the potentialities enfolded within the past.

Before looking to Deleuze and Guattari we might turn briefly to another writer on alternative temporalities, a writer from a different tradition, and one who is increasingly overlooked in these allegedly post-Marxist times: Raymond Williams. Williams, perhaps more than any other cultural commentator on modernity attends to the complexity of times existing within any present moment, and thus operates as a useful entry point for thinking this field. Indeed, Williams' intention throughout the corpus of his writings is to explore the possibilities of resistance to our present hegemony, those places and spaces – and times – not already part and parcel of commodified subjectivity. Crucially, for Williams, this must involve a form of temporal mapping of the contemporary. In fact, Williams identifies two fields of possibility of/for resistance: the past (residual cultures) and the future (emergent cultures). To quote Williams on the former at some length:

> By 'Residual' I mean that some experiences, meanings and values which cannot be verified or cannot be expressed in terms of the dominant culture, are nevertheless lived and practised on the basis

of the residue – cultural as well as social – of some previous social formation ... A residual culture is usually at some distance from the effective dominant culture, but one has to recognise that it may get incorporated in it. This is because some part of it, some version of it – and especially if the residue is from some major area of the past – will in many cases have been incorporated if the effective dominant culture is to make sense in those areas. It is also because at certain points a dominant culture cannot allow too much of this practice and experience outside itself, at least without risk. Thus the pressures are real, but certain genuinely residual meanings and practices in some important cases survive. (Williams 1980, pp. 40–1)

Williams goes on to outline the sources of what he calls 'emergent' cultures (invariably a new class), while at the same time alerting us to the importance of 'very precise analysis, between residual-incorporated and residual not incorporated, and between emergent-incorporated and emergent not incorporated' (Williams 1980, p, 41). Although this particular inside/outside paradigm of political thought and strategy is increasingly open to question in our own late capitalist context, it nevertheless opens up the possibility for a thinking through of the utilization of the past within the contemporary, suggesting as it does that any given present is made up of a multiplicity of times, each with its own specificity and potentiality.[27]

We can usefully turn here to Deleuze and Guattari's plateau 'On Several Regimes of Signs' (*ATP*, pp. 111–48). As we saw above there is the signifying regime of signs (despotic, paranoid), but also 'the so-called primitive, *presignifying semiotic*', which 'fosters a pluralism or polyvocality of forms of expression that prevents any power take over by the signifier and preserves expressive forms particular to content; thus forms of corporeality, gesturality, rhythm, dance, and rite ...' (*ATP*, p. 117). And then there is also the postsignifying regime, the passional regime of subjectification.[28] Here a line of flight is drawn from the signifying regime, '*a sign or package of signs detaches from the irradiating circular network* and sets to work on its own account' (*ATP*, p. 121). In this regime 'there is no longer a centre of significance connected to expanding circles or an expanding spiral, but a point of subjectification constituting the point of departure of a line' (*ATP*, p. 127). As I remarked above, our own semiotic – faciality – is composed of a mixture of these two regimes.

'The point of subjectification is then the origin of the passional line of the postsignifying regime. The point of subjectification can be anything. It must only display the following characteristic traits of the

subjective semiotic: the double turning away, betrayal, and existence under reprieve' (*ATP*, p. 129). For Deleuze and Guattari this subjectification is the birth of modern man; it 'attains an *absolute* deterritorialization expressed in the black hole of consciousness and passion' (*ATP*, p. 133). Indeed, consciousness, we might say our interiority – and thus our alienation – is produced through this turning away, and concomitant turn inwards. This is not wholly to be lamented, for this procedure of subjectification – or what Deleuze elsewhere calls folding – is the condition of possibility of our modern subjectivity.[29] We might say then that further mechanisms of subjectification, and indeed of disrupting certain existing processes of subjectification, must proceed from this first turn, this first fold.

We might say further that the contemporary utilization of the past can involve this double turning away, this seizing upon a different object, a different point of subjectification. As Deleuze and Guattari remark: 'A thing, an animal, will do the trick' (*ATP*, p. 129). As such elements of the presignifying regime can be brought forward and become elements in our own regime. In fact, there is always a movement between regimes. We always exist within a mixed semiotic that is not reducible to faciality. It is here that we must note Deleuze and Guattari's comments on the translation between, and thus transformation of, different regimes of signs:

> A transformational statement marks the way in which a semiotic translates for its own purposes a statement originating elsewhere, and in so doing diverts it, leaving untransformable residues and actively resisting the inverse transformation ... It is always through transformation that a new semiotic is created in its own right. Translations can be creative. New pure regimes of signs are formed through transformation and translation. (*ATP*, p. 136)

It is also here that we might position Williams' residual cultures (and, indeed, Deleuze's own ideas about the contemporary use of myth, for example in Third Cinema).[30] Again, this is not necessarily the takeover of a presignifying element by a signifying regime, but the transportation of an asignifying element into our own regime, which thus operates to disrupt – and potentially transform – that regime. Such elements operate as what Guattari might call 'mutant nuclei of subjectification' (*C*, p. 18). Here a part object detaches itself from a specific regime thus allowing for a potential resingularization. That this element is from the 'past' constitutes its power to operate as an effective point of

deterritorialization from the present. Those practices – or rituals – that utilize the past in the present often involve this choice of an anomalous object – objects from an 'elsewhere' – that are then mobilized in the present and in order to move beyond that present.

Importantly, and in a resonance with the Williams quote above, 'in each case we must judge whether what we see is an adaptation of an old semiotic, a new variety of a particular mixed semiotic, or the process of creation of an as yet unknown regime' (*ATP*, p. 138). The utilization of the past is often invariably just the adaptation of an old semiotic in such a way that does not challenge, and perhaps even promotes those of the present regime (after all past cultures are often utilized to prop up dominant narratives and knowledges, or to sell present day commodities). Such a use of the past can however also involve the production of a new variety of a mixed semiotic, which in itself might suggest the possibility of an altogether new regime.

5.4.3.1 *Case study: modern pagans*

What is at stake in the practices of modern paganism, or 'folk culture'? Is it merely that they offer a form of 'escapism', an apparent turning away from those capitalist relations that produce the alienated metropolitan individual? Without doubt in many cases this is the case (at least as a first moment): the past, and often an idealized and sanitized past, can work as a panacea to the concerns and complexities of the present. However, such practices can also offer an alternative mechanism of subjectification, a turning away that in itself allows for a turning towards something else.[31] There is not a simple desire to 'return' to primitivism in many of the more involved and sophisticated rites and rituals of folk culture as it is practised today, rather there is something affirming of life as it is in our contemporary moment, albeit this is a life different to that which is alienated and deadened by typical contemporary consumer culture.[32]

We might also note here the importance of a performative element in such practices; one participates in such cultures (they are specifically ritualistic in this sense). We might say then that folk culture can involve a turn away from commodity obsession (there is nothing to buy, at least, not always), and indeed from many of our typical transcendent points of coordination (mainstream religion, but also nine to five careerism, accepted morality, and general telematic standardization), while at the same time involving a turn towards other worlds, other universes of reference.[33]

An interesting 'case study' of this mixed semiotic, in this case a meeting between modernity and a certain pre-modern paganism, is the art

historian Aby Warburg. Warburg, who wrote his lecture on the serpent rituals of the Pueblo Indians in order to prove that he was fit to leave the sanatorium in which he had been incarcerated, writes of his fascination with pagan pre-modern culture – and about his own involvement in the dances of the Indians (Warburg 1998). Indeed, Warburg demonstrates the ritualistic, or performative, aspect of myth mentioned above. Such practices allow for a different kind of connection – a magical connection – with the world (in the case of the masked serpent dances, a veritable becoming animal). For Warburg, Western modernity, and especially the telegraph and telephone, had closed the distances required for this connection and contemplation (we might add here that the advent of new communication technologies, although opening us up to many new worlds, has also further closed this distance). Western modernity had destroyed the 'sanctuary of devotion' (Warburg 1998, p. 206). Indeed, Western modernity had, for Warburg, produced a facialization of the world, personified in the picture of Uncle Sam with his white face and top hat that Warburg ends his lecture with, and which contrasts so sharply with the pictures Warburg took of the masked Indian dances.[34]

Warburg was also particularly attuned to the persistence, and also the importance, of the survival of 'pre-modern culture', of pagan elements, in the modern Western world, working as they might to counteract the increasing domination of the natural world and the concomitant production of an alienated subjectivity. Indeed, his lecture specifically maps out instances of this residual survival. We might say then that Warburg's essay is an example of Deleuze and Guattari's 'Pragmatics', and especially the latter's first two aspects: 'Generative – the demonstration of always already mixed semiotics (tracings of mixed semiotics), and transformational, showing how these regimes are translated between (maps of transformations)' (*ATP*, p. 139).

Again, it is worth remarking that this utilization of the past in the present can go both ways. We might point to that other apotheosis of modernity, Nazi Germany, and to the utilization of past, and, indeed, often non-western, myth in the promotion of a kind of hyper faciality (the Aryan *Übermensch*). Indeed, once more, a presignifying regime can always serve the dominant. It is in this sense that any analysis of a mixed semiotic must always involve a mapping of all the components of a myth-system, and in particular note whether the latter has a deterritorializing function, or what we might call a prophetic orientation. Even more crucial is to ascertain what kind of future, and what kind of people, is called forth. We might turn briefly to Deleuze and Guattari's book on Kafka here, and note that primary characteristic of a minor

literature: that it calls forth a people-yet-to-come, but one that is irremediably *minor* in nature.[35] We might also note the comments Deleuze and Guattari make about Heidegger in *What is Philosophy?* He mistook not only 'the German for a Greek but the fascist for a creator of existence and freedom' (*WP*, p. 109). Indeed, Heidegger 'got the wrong people, earth, and blood. For the race summoned forth by art or philosophy is not the one that claims to be pure but rather an oppressed, bastard, lower, anarchical, nomadic and irremediably minor race' (*WP*, p. 109).

5.4.4 Future subjectivities

> Artists can only invoke a people, their need for one goes to the very heart of what they're doing, it's not their job to create one, and they can't. Art is resistance: it resists death, slavery, infamy, shame. But a people can't worry about art ... When a people's created it's through its own resources, but in a way that links up with something in art ... or links up art to what it lacked. (Deleuze 1995a, p. 174)

If the present has been colonized, and the past is always in danger of being colonized, then what of the future? Certainly for Deleuze and Guattari the future holds the potential to be powerfully resistant to the present. Indeed, it is the future orientation of practices such as art and philosophy that holds their interest insofar as they are orientated towards a specifically *different* future to the one which is determined by the already existing logics of the present (or, in terms of Chapters 1 and 4, a logic of the possible). Art, especially, invokes its own particular audience and in so doing calls a people into being. We might say that art is not made for an existing subject in the world, or for a customer/client that might be predicted on the basis of existing models and algorithms, but to draw forth a new subject from within any existing configuration. This constitutes the very difficulty of art, we might even say its ontological difficulty (there is never anything to 'understand' with such art, it is not a form of knowledge in this sense). But if art's operating field is the future, how does this link with the production of subjectivity that must necessarily begin in the present? Well, we might say that art operates as an intentional object – again, a point of subjectification – while at the same time functioning as a corrective to any simple assertion and affirmation of a 'new' people already here.

We can turn here to Deleuze and Guattari's own ideas about art in *What is Philosophy?* In this final collaborative work, as we saw in the second section of this chapter, art is defined as a bloc of affects and percepts, a bloc of becomings frozen in time and space (*WP*, pp. 163–99).

Such blocs are impersonal monuments that can operate as alternative points of subjectification. It is in this sense that Deleuze and Guattari affirm the *difference* of art. It is different from those affective assemblages that surround us on a day-to-day basis and that operate as the props for our *doxa*, or simply the regime of opinion – and the subjectivites attendant on this.

In one sense then, the sense of the present as we typically experience it, art is always already captured within certain dominant regimes insofar as it cannot but be located in this present. But from another perspective this incorporation will always miss that which defines art: its future orientation, and specifically this calling forth of a different – a specifically *new* – future. It is in this sense that art, although it involves a refusal of sorts (precisely of the present and of any future already determined by it), must always begin with an affirmation of a something, or a somewhere, else. The field of art might, in this sense, be understood as a kind of future field – the field of the abstract machine itself: 'The diagrammatic or abstract machine does not function to represent, even something real, but rather constructs a real that is yet to come, a new type of reality' (*ATP*, p. 142). In fact, ultimately, it is the abstract machine that produces faciality, but the very same machine is also capable of producing deterritorializations from faciality – drawing out the contours for worlds yet-to-come.

Indeed, the abstract machine is the cutting edge, the point of deterritorialization, of any given assemblage. It is where everything happens. In order to understand this mechanism we can look once more to Guattari's writings. For Guattari, in the art experience, there is a 'detachment of an ethico-aesthetic "partial object" from the field of dominant significations' that 'corresponds both to the promotion of a mutant desire and to the achievement of a certain disinterestedness' (*C*, p. 13). The partial object then operates as a point of entry into a different incorporeal universe. Importantly, and as Guattari remarks above, this must involve a certain disinterestedness (Guattari is indebted to Kant in this sense). We might say that the 'activation' of art, in terms of the production of subjectivity, involves a prior preparation, at least of some kind, by the participant (after all anything can always be referred back, *read* through an already existing regime). We must be open to art and to the adventures that it might take us on.

Our interaction with art then has the character of an event; an event that must be seen, heard – felt – and responded to, *as* an event, 'as the potential bearer of new constellations of Universes of reference' (*C*, p. 18). This is to affirm those virtual ecologies that art can open

up, to affirm an 'ethics and politics of the virtual that decorporealizes and deterritorializes contingency, linear causality and the pressure of circumstances and significations which besiege us' (*C*, p. 29). Such affective-events are then the germ of a new world while at the same time operating as glitches in the dominant regimes and habitual formations of the present one.[36] We might say, in relation to our discussion of Guattari in Chapter 3, that these asignifying moments operate as autopoietic nuclei around which a new subjectivity might cohere and crystallize.

To return to 'On Several Regimes of Signs' from *A Thousand Plateaus*, pragmatics, or schizoanalysis:

> would consist in this: making a *tracing* of the mixed semiotics, under the generative component; making the transformational *map* of the regimes, with their possibilities for translation and creation, for budding along the lines of the tracing; making the *diagram* of the abstract machines that are in play in each case, either as potentialities or as effective emergences; outlining the *programme* of the assemblages that distribute everything and bring a circulation of movement with alternatives, jumps, and mutations. (*ATP*, pp. 146–7)

If Warburg's writings are an example of the first two moments, an enquiry into what 'statement' a given proposition (and this might be a thing as well as a word) corresponds to (that is to say, what regime of signs the proposition has been taken up by) *and* the possibilities of 'movement' of that proposition across regimes, then it is within the field of art that we see the latter diagrammatic and programmatic functions understood as more exploratory – involved perhaps in the production of new propositions, and certainly in freeing up propositions that have become fixed and frozen in a regime that empties them of their creative and deterritorializing power. As Deleuze and Guattari remark, after looking into the possibilities of translation and transformation:

> one could try to create new, as yet unknown statements for that proposition, even if the result were a patois of sensual delight, physical and semiotic systems in shreds, asubjective affects, signs without significance where syntax, semantics, and logic are in collapse ... cries-whispers, feverish improvisations, becoming-animal, becoming-molecular, real transsexualities, continuums of intensity, constitutions of bodies without organs . . . (*ATP*, p.147)

The work moves from tracing and mapping already existing regimes to something more experimental, something riskier: the production of new regimes of signs. It is in this sense that art leads us beyond the known, 'forming strange new becomings, new polyvocalities' (*ATP*, p. 191).[37]

5.4.4.1 Case study: contemporary art

Art from different periods of history can offer alternative points of subjectification, but it is within the field of contemporary art (and indeed with that which is contemporary, for us, in art of other periods) that this future-orientation – this diagrammatic and programmatic function – is particularly evident. Contemporary art can operate on a cusp between the present and the future. It is 'made' in the present, out of the materials at hand, but its 'content' often calls for a subjectivity to come. This stuttering and stammering of existent materials and languages, this deterritorialization of existing regimes of signs, constitutes the ethico-aesthetic function of art. We might say then that contemporary artists operate as traitor prophets, traitors to a given affective regime (and often to previous regimes of art).[38] In the best cases such artists turn away from the present, offering up new assemblages, new combinations, to those that surround us on an everyday basis. They offer up a new dice throw as perhaps Deleuze might say.

Indeed, such practices can be understood as probe-heads, alternative abstractions or crystallizations from a pre-existing field of potentialities. We might say that this is also what constitutes a certain politics of art, for political art does not necessarily look political (and art that looks political ('speaks' its message as it were) does not always operate politically). Such a politics comes from this play between different regimes of signs, and, indeed, with the production of new ones. We might make a further point about capitalism and its own forward movement here. Probe-heads are produced from within the capitalist mode of production, from the same materials as it were, but they are that which deterritorialize its flows further, plugging into its logics of invention and innovation. From the perspective of the present such probe-heads are redundancies – often they are unrecognized, dismissed, laughed at or provoke boredom (or, indeed, anger). They do not operate through faciality. Unproductive on one level they are super-productive desiring-machines on another.

Contemporary art is then less involved in putting a brake on capitalism's flows, than in pushing these further, displacing the limits as Deleuze and Guattari might say. 'To go still further, that is, in the movement of the market, of decoding and deterritorialization' (*AO*, p. 239).

'For perhaps the flows are not deterritorialized enough, not decoded enough ... not to withdraw from the process, but to go further, to "accelerate the process," as Nietzsche put it: in this matter, the truth is that we haven't seen anything yet' (*AO*, pp. 239–40). 'It is here', claim Deleuze and Guattari, 'that art accedes to its authentic modernity, which simply consists in liberating what was present in art from its beginnings, but was hidden underneath aims and objects, even if aesthetic ... – art as "experimentation"' (*AO*, p. 371).

We might add further, along with the artist Joseph Beuys, an individual who collapsed the above future orientation and utilization of the past in his own Shamanistic art practice, that everyone can be an artist in the above sense – at least to a certain extent. Everyone can experiment with the materials at hand and produce something new in the world – or produce themselves anew in that world. Indeed, we can follow Guattari here and suggest – in a return to the quote that began my book – that it is only with this creative participation in and with the world, the ethico-aesthetic paradigm proper, that we have the 'production of a subjectivity that is auto-enriching its relation to the world in a continuous fashion' (1995a, p. 21).

5.4.5 Conclusion: beyond the production of subjectivity

In this final part of my chapter I have attempted to begin the task of pragmatically mapping out a kind of dissident subject diagram. Lack of space prevents further development, although an obvious omission is the question of technology and especially, despite the alienating and atomizing aspects of web 2.0, the new universes of reference that are also being opened up by the World Wide Web, by VR, and by other contemporary prostheses (and this would need to involve a serious consideration of Science Fiction). Again, as I noted in Chapter 3, Guattari's own work is particularly attentive to this area. There is also the notion of collectivity that I mentioned briefly above, and especially the production of collaborations and alliances that work against that atomized individualism produced by the faciality machine. Deleuze's work on Spinoza would be particularly relevant here – the mapping out of productive, joyful encounters that increase our capacity to act in the world (that is, friendship). In fact, as we saw in Chapter 1, for Deleuze's Spinoza this affective mapping – or ethics – is just a stage in an ongoing programme towards the attainment of that third kind of knowledge, or 'beatitude'; a state of involved disinterestedness and compassion – looking out on a world of pure intensities. It is also the experience of eternity within duration (we might even say the deployment of the

eternal against duration). This is a kind of non-human state, in fact a 'beyond' subjectivity.[39]

It is here that we can note Deleuze's 'correction' of Guattari, his readings of Spinoza, Nietzsche and Bergson in particular giving him a feel for the production of a state beyond subjectivity. We might note as well Deleuze's essay on Michel Tournier's *Friday*, and on what happens to an individual in which a certain subject-constructing mechanism (one that is produced by 'others') breaks down.[40] Indeed, we have an intimation in Deleuze's reading of Tournier's novel of what might happen in a world in which the faciality machine has ceased to function. Robinson, on his desert island, operates as a probe-head, an experiment in living against the strata that bind us. Once again it is partial objects, strange assemblages, rites and rituals that allow Robinson to 'access' this 'beyond', to 'become world'. Whether these are elements from the past, or elements that point towards a future, they are positioned in the now, in the contemporary world, but utilized in such a manner as to allow a movement beyond that very world.

Conclusion: Composite Diagram and Relations of Adjacency

C.1 Composite diagram

As a conclusion to this book we might subtract the proper names – and indeed all the discursive material – and map out this book's diagrammatic trajectory as in Figure 6.1.

We can picture this as a sequence of sorts – a processual image of the production of subjectivity: Chapter 1 diagrams the relation of the finite to the infinite and the possibility of a passageway between; with Chapter 2 the 'content' of the cone is telescoped 'into' the centre of the torus, an operation that might also be figured as the folding of the infinite into the finite; in Chapter 3 there is another folding in of the outside to produce an autopoietic nuclei around which a subjectivity might cohere; in Chapter 4 the cone is reintroduced, but, we might say, the third synthesis of time also names the pure surface of the base of the cone (it is diagrammed here as a 'below' the plane, in a nod to Badiou's inconsistent multiplicity); and in Chapter 5, following this idea (and the diagram of Chapter 3) the collapsing of the cone is diagrammed as the concentric circles/spiral of the path of the subject on a pure surface.

C.2 Relations of adjacency

Slavoj Žižek has remarked in a recent collection of writings on the so-called 'Speculative Turn' in continental philosophy that what the latter lacks is a theory of the subject (Žižek 2011, p. 415).[1] Although I would not claim that what I have laid out in this book amounts to the missing subject of this recent philosophical event (indeed, to a certain extent, the category of the subject is a necessary exclusion that determines this speculative turn), what I would say is that my own project – a work of

Figure 6.1 Five diagrams of the finite–infinite relation

commentary, but also a thinking through of a production of subjectivity that refuses the bar between the finite and the infinite – has some resonances with some of the thinkers associated with this particular strain of recent post-Kantian philosophy.

In this part of my conclusion I want then to briefly lay out some of the relations of adjacency – the distances and proximity – between some of the key thinkers associated with what has also become known as 'Speculative Realism' (although not all would now so associate themselves with this name) and the thinkers I have been looking at in the preceding chapters, especially around the finite–infinite relation, or simply the relation we might maintain to an outside of ourselves.[2] For many, although not all, of the thinkers associated with Speculative Realism, this involves, as with Badiou, recourse to a form of thought (often science), which operates, as it were, indifferent to a specifically human consciousness and experience. Indeed, Speculative Realism might be characterized as precisely anti-phenomenological when the latter names the experience of the typical subject in a world.[3]

In many ways my own book has been about attempting to define a subject beyond a certain kind of phenomenological account, at least when this remains tied to a centred subject that, ultimately, limits this experience. Nevertheless, I maintain the category of experience, but only if it is untethered from what I have been calling the subject-as-is. We might then call such a non-subject-subject specifically non-human insofar as the human is perhaps the founding name for the subject-as-is. (Indeed, looking back, Chapter 1 in its turn to Spinoza might be said to have concerned itself specifically with a kind of pre-human state; and, in the turn to Nietzsche, with a post-human one). This, in fact, sets up what seems to be the two non-anthropomorphic ideas of the subject at work in this book: the formal matheme and the passive synthesis.

As far as the first of these goes it is structure – we might even say science insofar as it is mathematical structure that is privileged – that characterizes the atypical subject. For the second of these two categories,

a kind of science, although perhaps not in the same sense, might well play a role, but other forms of thought also play their part. These other forms of thought, as Nietzsche shows us, are themselves determined by a body that goes far beyond our consciousness (or the subject-as-is). Indeed, this body and the thought of which it is capable are inextricably linked. Perhaps this is the most important lesson Spinoza's *Ethics* teaches us, echoed in Foucault's work, insofar as it implies that philosophy, to say it once more, is a way of life – a transformative practice – and, as such, that the subject's *modus operandi* cannot but be experimentation in the world (what am 'I' capable of becoming? What kinds of thought can 'I' think?). A crucial question here is whether Speculative Realism can itself produce this transformation in subjectivity given that its terrain of operation is, generally speaking, the object as thought precisely 'outside' of any subject.

C.2.1 Quentin Meillassoux and the correlation

Quentin Meillassoux's definition of what we might call the circle of correlationism – 'that there are no objects, events, no laws, no beings which are not always-already correlated with a point of view, with a subjective access' – might be refigured, in the terms of the preceding chapters, as implying a gap between the finite (the subject and its point of view on the world) and the infinite (the world – or object – outside of this 'subjective access') (Meillassoux 2008a, p. 1). As such, rather than locating a crack, or break, in the logic of the correlation, I have been interested in those philosophies and practices that refuse the gap (the correlation), positing instead a continuum between the finite and the infinite, or subject and world.

In fact, this is not just an abstract philosophical decision – and task – but has implications for, and indeed might be said to be tested in, practice. As Foucault perhaps most directly demonstrates, the accessing of the infinite (truth) by a finite subject involves a prior preparation by that subject who is then transformed through that very access. The transformation of the subject-as-is is then both the means and the ends of Foucault's technologies of the self. In a sense Meillassoux's account and critique of the correlation ignores this mutability of the subject, the way in which the latter might approximate further and further to the 'great outdoors'. We might go further than this and suggest that Meillassoux, despite his critique, remains a correlationist insofar as he holds to the subject-object split as the determining problem of philosophy. He remains Kantian. For myself, following Deleuze and Guattari, subject and object are not necessarily 'fixed' in this sense.

Indeed, to repeat the quote from Chapter 5: 'Subject and object give a poor approximation of thought. Thinking is neither a line drawn between subject and object nor a revolving of one around the other' (*WP*, p. 85).

The medium, as it were, of this continuum is the body – Spinoza's body which, as yet, we have not fully fathomed. Indeed, this is a body that extends far beyond our conception of it. A body that is more intelligent than an 'I' that only apparently governs it, and which is very much part of the world (after all, what else could it be?). On one level then we might say that the intensities – or affects – of the body *are* the world, or the 'great outdoors', to the extent that they are of 'us' but also not of us. Following Deleuze and Guattari, we might say that the body without organs names this strange intensive other body that accompanies our typical sense of self and subjectivity but that cannot be reduced to it. The subject then, insofar as they have a body (in this expanded sense), is, we might say, already object. Again, this experience is not available to the subject-as-is but must necessarily involve a practice and a transformation. It is then only the subject-as-is that is caught in the correlationist circle, or, following Bergson, caught in certain illusions about themselves and their world – but, and this has been the stake of this book, this does not preclude the possibility of the production of different kinds of subjectivity that are not so constrained and contained.

For Meillassoux, precisely, it is not possible for any kind of subject to experience the 'great outdoors' (anything that a subject experiences, in Meillassoux's terms is always already indoors as it were), *but* it can be thought, ultimately, as with Badiou, through mathematics, which can think this outside independently of the correlation itself. Indeed, this, for Meillassoux in *After Finitude*, is the 'Gallilean–Copernican decentring wrought by science': 'what is mathematizable cannot be reduced to a correlate of thought' (Meillassoux 2008b, p. 117). For Meillassoux this Copernican revolution – and the concomitant radical decentring of 'man' that it implies – was then subject to a counter-revolution with Kant (the 'Kantian catastrophe') – with the instalment of the correlation:

> Even as thought realized for the first time that it possessed in modern science the capacity to actually uncover knowledge of a world that is indifferent to any relation to the world, transcendental philosophy insisted that the condition for the conceivability of physical science consisted in revoking all non-correlational knowledge of this same world. (Meillasoux 2008b, p. 118)

But, we might ask, are these the only two options: a truly scientific, mathematizaeble 'knowledge' of the object (speculative), or a knowledge that is always determined by the subject (the correlation)? Indeed, we might ask, is knowledge really the best way to think our relation or access to an outside (insofar as knowledge itself presumes the correlation – the subject–object split – insofar as it is a knowledge 'of')? Along side Meillassoux's speculative materialism we might then posit a speculative subjectivity that does not 'access' the outside through knowledge, mathematics or otherwise, but, again, through practice. We might think here of Bergson's mystic who foregrounds this practice – as transformative – over and above an intelligence, that, in fact, stymies this transformative potential. For Bergson, prior to this action it is intuition that accesses this larger experience of the world. But, in fact, we make a mistake if we presume this is a purely subjective technology, still part, as it were, of the correlation, insofar as intuition might also be thought of as the world *devoid* of a subjective perspective (which is to say, intelligence). We might say something similar in relation to Spinoza and the intuitive third kind of Knowledge. It is not a knowledge that 'I' have 'about' the world, but, as it were, a state of being in which the distinction between myself and the world no longer holds. A veritable becoming-world of the subject (or, a becoming-subject of the world). In fact, following these extremes, we might ask where, exactly, thought itself takes place? For, as Bergson demonstrates, and Deleuze pushes to the extreme, thought might itself be said to take place in the world and not 'within' a subject that is barred from the latter (thought, for this latter subject is simply *doxa* or opinion). In fact, as both Bergson and Deleuze suggest, a certain kind of thought – contemplation and contraction (passive synthesis) – takes place in the world independent of a subject that only comes after, as a retroactive cohering mechanism (and a limiting one at that).

Indeed, the question of our relation to an outside, in this sense, is less one of access as it were, than one of opening up to an outside that is paradoxically also an inside. This, what we might call the infinite nature of the subject, is folded into the very body – it is the body's virtual aspect. Here, Deleuze's reciprocal determination of the actual and virtual can be pitched against any mathematic formalism which the body might support, as it were, but from which it is ultimately independent – and against the bar between the finite and the infinite that is thus instantiated by this very formalism.

Meillassoux's properly philosophical project is then to demonstrate a kind of thought that 'can access reality as it is in itself, independently

of any act of subjectivity' (Meillassoux 2008a, p. 2). As Meillassoux continues in the essay 'Time Without Becoming': 'In other words, I maintain the absolute – i.e. a reality absolutely separate *from* the subject – can be thought *by* the subject' (Meillasoux 2008a, p. 2). The key term here, once more, is thought. Thought, for Meillassoux, can access that which lies beyond the subject. Thought is, in this sense, inhuman and a-subjective, but it is also, again, specifically incorporeal and mathematic (as we shall see in a moment, Ray Brassier's anti-correlationist project follows similar lines).

Meillassoux begins his own assault on correlationism by foregrounding what he sees as an aporia for the correlation: the arche-fossil, and more specifically, scientific statements about the latter. This arche-fossil is an object which, as it were, evidences a time before man, and thus also before any human subject that might witness it. As such, the 'distance' which the arche-fossil evidences is, in fact, a more profound 'anteriority in time' since the arche-fossil 'designates an event *anterior* to terrestrial life and hence *anterior to giveness itself*' (Meillassoux 2008b, p. 20). Because this event is nevertheless thinkable by science, it produces a problem for the correlation, for, in order that scientific statements are to have meaning the arche-fossil must have a certain truth to it outside the correlation (the alternative is an extreme relativism that empties science out of any truthful content).

We might say that the arche-fossil operates a little like Badiou's forcing (albeit to an extreme past rather than to a future): from within a given world determined by a given set of knowledges (the encyclopaedia/the correlation) it demonstrates that there is something outside the given, or, in Meillassoux's terms, it allows us 'to know what there is when we are not' (Meillassoux 2008a, p. 7).[4]

The arche-fossil, as a problem for the correlation is, however, also one that instates a certain line of demarcation between the living and the non-living. It disrupts one binary – between subject and object – but only through setting up another. In fact, contrary to the logic of the arche-fossil, and following Deleuze–Bergson, we might claim that the non-living object, to the extent that it is still in the universe, continues to interact – to 'contemplate and contract' – other elements of that universe. From another perspective, this time Deleuze–Nietzsche, we might say that life itself, insofar as it is made up of these passive syntheses, already contains within it a myriad of molecular deaths. Meillassoux's argument about the non-living (and, indeed non-dead) matter of the universe demonstrating a non-human outdoors misses the point about this inorganic life that permeates the universe.[5] Another way of putting

this is that, in a sense, the body *is* the arche-fossil insofar, as the cliché has it, we are made of the same stuff as stars. In a sense then the correlationist problem – that is, knowledge 'of' this outside – becomes a mind-body issue. As far as this goes it is Spinoza who most directly answers Meillassoux insofar as the body determines the mind, but is, in turn, determined by the idea that the mind has of it, and, in the third kind of knowledge, it is, we might say, the world as body–mind thinking *through* us.

Meillassoux's own argument for a 'break' in the correlationist circle involves a series of conceptual manoeuvres in which Meillassoux demonstrates that the not knowing what, if anything, lies outside the correlationist circle – once it has been absolutized – suggests, in fact, a break in the correlation itself insofar as it demonstrates that there is a radical contingency outside the circle, that is, a-maybe-something-a maybe-nothing. The 'we do not know what lies outside the circle' is less a question of ignorance and more a question of the 'nature' of what, actually, 'is' outside.

In this sense Meillassoux has found the secret of the outside hidden in the very lack of certainty about an outside. In *After Finitude* Meillassoux puts his rationale thus:

> For if we can succeed in demonstrating that the capacity-to-be-other of everything is the absolute presupposed by the circle itself, then we will have succeeded in demonstrating that one cannot de-absolutize contingency without incurring the self-destruction of the circle – which is another way of saying that contingency will turn out to have been immunized against the operation whereby correlationism relativizes the *in-itself* to the *for-us*. (Meillassoux 2008b, pp. 54–5)

This 'capacity-to-be-other' is indeed presupposed by correlationism as a way of defending the integrity of its own thesis. If this outside is, in fact, posited as non-contingent (that is, we affirm or indeed deny the existence of an outside) then we will, as the quote above suggests, have destroyed 'our' own correlationist thesis (simply put, that we cannot know an outside to the correlation).

A kind of radical undecideability is then 'the absolute whose reality is thinkable as that of the in-itself as such in its indifference to thought' (Meillasoux 2008b, p. 257). Or, the absolute is '*the absolute necessity of everything's non-necessity*', or, precisely, 'the absolute necessity of the contingency of everything' (Meillassoux 2008b, p. 62). Meillassoux names this contingency, this 'unreason': hyper-chaos.

In many ways this is just the beginning of Meillassoux's larger project – incredibly ambitious and audacious – which is to attempt to articulate the properties of the figures that might inhabit this strange outdoors (and, especially to know the properties of our world that is produced in and by hyper-chaos independent of our own subjectivity). In the essay mentioned above, for example, Meillassoux demonstrates that such a figure must obey the law of non-contradiction, for otherwise it would both be what it is and what it is not, thus denying the possibility of change, and thus denying the 'rule' of the absolute contingency of hyper-chaos.

In a sense then Meillassoux's difficult and philosophically demanding project is to construct and launch a conceptual probe into hyper-chaos that will allow a thinking of the absolute – and the *properties* of the absolute – independent of the subject (the world when we are not). The operating protocols of such a probe is thought, but in fact a specific type of rational, conceptual – mathematizeable – thought. In fact, it is the contention of my own book that a probe of sorts has already been sent in to the absolute and that the name of this probe is the subject when this is understood as specifically not the subject-as-is, but a speculative subject that is always in process, always, as it were, becoming-world.

C.2.2 Reza Negarestani and affordance

In *Cyclonopedia*, the theory-fiction of Reza Negarestani, the correlation becomes affordance, with the subject caught in the same circle in which the world is only accessible if it affords the organism's survival. Negarestani's radical openness – making oneself a meal for the universe as he puts it in *Cyclonopedia* – is then a way of breaking this particular circle that in many senses determines all life.

There is then an interesting, and important, issue here in relation to Foucault, and indeed Spinoza, or in fact any account of an ethical programme for and of the subject – namely, are such 'programmes' themselves caught within a circle of affordance, to the extent that they can take the form of an openness to the other, or even to the outside: 'Affordance presents itself as preprogrammed openness, particularly on the inevitably secured plane of *being open* (as opposed to *being opened*)' (Negarestani 2008, p. 197). Ultimately, for Negarestani, this 'being open' to the world is about the organism's survival. In our terms we might say it is the survival of the subject-as-is through a kind of appropriation of the outside. For Negarestani, crucially, affirmation itself can be part of this affordability, or economics of survival.

Going further, and pre-empting some of my comments on Graham Harman below, we might ask to what extent Bergson's thesis – of contemplation and contraction – and Deleuze and Guattari's theory of becoming are not likewise caught in the circle of affordance insofar as becoming might be seen as a form of appropriation, a 'capture of codes': 'Participations, becomings, lines of tactics and communications must all be based on the meso-sphere of affordance and its survival mechanisms' (Negarestani 2008, p. 198). Negarestani instead suggests that:

> Radical openness ... subverts the logic of capacity from within. Frequently referred to as sorcerous lines, awakenings, summonings, xeno-attractions, and triggers, strategic approaches unfold radical openness as an internal cut – gaseous, odorless, with the metallic wisdom of a scalpel. Openness emerges as radical butchery from within and without. (Negarestani 2008, p. 199)

We have here something akin to Badiou's thesis of the radical exteriority of the event. But we also have an anti-ethics of sorts if ethics is seen, via Spinoza and Foucault, as a programme – or practice – to access an outside (truth). For Negarestani, as with Badiou, there really is nothing a subject can do – intentionally as it were – to access the outside in this radical sense:

> To become open or to experience the chemistry of openness is not possible through 'opening yourself' (a desire associated with boundary, capacity and survival economy which covers both you and your environment); but it can be affirmed by entrapping yourself within a strategic alignment with the outside, becoming a lure for its exterior forces. Radical openness can be invoked by becoming more of a target for the outside. (Negarestani 2008, 199)

Despite this stymieing of subjective intentionality there is then here still an idea of preparation in Negarestani, though needs be it is a preparation that is done in disguise as it were, a feint, as with the cult of *Druj* that produces ultra-hygienic bodies as a lure for the pestilence of the outside: 'Through this excessive paranoia, rigorous closure and survivalist vigilance, one becomes an ideal prey for the radical outside and its forces' (Negarestani 2008, p. 199). As the *Druj* suggest, one must make oneself into a 'Good meal' (Negarestani 2008, p. 200). With the notion of 'being opened' by the outside Negarestani follows Bataille's own dark ethics of sacrifice. A 'project against project' as it were, or what Negarestani calls a 'schizotrategy'.[6]

The question is then whether the strategies of opening to the outside that I have been laying out in the present book are indeed forms of 'being open' rather than 'being opened'. On the one hand, to take Foucault as example, there does seem to be what Negarestani calls 'subjectively affirmed modes of openness' at stake (Negarestani 2008, p. 201). *However*, technologies of the self often, in fact, involve a form of closure and withdrawal (meditation for example). Indeed, they are precisely not about being 'open to the other' as it were, that is to say about 'typical' human interaction – or, we might say, communication.

Furthermore such technologies aim less at the survival of the subject-as-is, but rather at the transformation of the latter. We might even say its death. In this sense it is not as if the truth – as radical outside – is appropriated, attached to the subject-as-is – that is, affordance – but rather that the subject becomes other in its exposure to this truth. Indeed, Negarestani's definition of the radical outside as a 'beyond all external environments which the subject can latch on to' (Negarestani 2008, p. 206), might well serve as a definition of Foucault's (and Deleuze's) outside, since some kind of surrender by the subject is required to 'access' it. This is also the case with Spinoza where the labour of the second kind of knowledge, the labour of the subject as it were, is ultimately replaced by a leap, which might also be figured as a form of grace insofar as, paradoxically, it is not a leap the subject-as-is can make, or, at least, not on their own. It requires help from outside of the subject.[7]

Negarestani's radical butchery, and with it the summoning of the Lovecraftian pestilence of the outside, might be seen then as a form of black or anti-grace. Here it is not the universe reaching down to the subject, but something coming from below, a beyond that is deep within the recesses of the earth, and, we might say, the corporeal body itself: 'a descent or dive into the subterranean realm, affirmation of what lies beyond is supplanted by the affirmation of what lies within' (Negarestani 2008, p. 204). Is this perhaps a Lacanian moment in Negarestani? Following the discussion of the *Ethics of Psychoanalysis* in Chaspter 2 it is *das Ding*, the void, that lies at the very heart of this subject: a black infinity at the very centre of finitude. There is then, in fact, an affirmationism of sorts in Negarestini, but it is not an affirmation of life, when the latter is tied to the needs and survival of a particular being. Rather, following Chapter 1, we might say that it is a Nietzschean affirmation since it necessarily involves the death of the subject-as-is and a properly inhuman joy at this dissolution.

C.2.3 Graham Harman and vicarious causation

For Graham Harman, in his essay on 'Vicarious Causation', it is less a question of breaking the correlation than of proliferating it, especially beyond the human subject. Objects do not just withdraw from the latter, but indeed, from each other also. There is, following Derrida's own reading of Heidegger, a kind of *différance* at work here: objects differ from one another but also differ/defer what might be called their true Being – their real presence. As such, Harman's object-orientated ontology has much in common with Badiou's own Greater logic in *Logics of Worlds* (see Chapter 4) insofar as both construct a transcendental logic of appearing indexically linked to an ontology of Being (although, crucially, for Badiou, such an account of objects is merely the stage set for the real business of the event and the concomitant production of the subject).

In Harman's ontology then objects are only in vicarious contact with one another:[8]

> Dogs do not make contact with the full reality of bones, and neither do locusts with cornstalks, viruses with cells, rocks with windows, nor planets with moons. It is not human consciousness that distorts the reality of things, but relationality *per se*. (Harman 2007, p. 193)

We might turn back to Bergson here and to his account of contemplation: a plant contemplates air, water, sunlight – and then contracts these elements into its being. All else, we might say, remains hidden – withdrawn – from that plant (although, it must be said, this does not mean there is a mysterious thing-in-itself 'behind', or withdrawn, from these relations, only that the relations thus effectuated do not exhaust the relations *per se*). For Bergson this is not just the case with living things, for chemical processes are likewise involved in this contraction of elements (again, this is what Deleuze calls passive synthesis). When Harman claims then that: 'No one sees any way to speak about the interaction of fire and cotton, since philosophy remains preoccupied with the sole relational gap between humans and the world – even if only to deny such a gap' (Harman 2007, p. 188). We might answer that, in fact, Bergson has discussed this inorganic life of objects and the universe (although we would have to concur that our own project is involved in the gap Harman identifies, albeit in order to deny it).[9]

We might also note the connections with Guattari here: Harman's objects, strange agents in and of themselves, are animist – like the strange 'objectities–subjectities' of the first Assemblage we looked at in Chapter 3 (the voodoo 'object' legba for example). Indeed, it seems

to me that Bruno Latour, Harman's other philosophical touchstone (besides Heidegger), has much in common with Guattari in the notion of non-human networks, although it is less clear whether there is a theory of the production of subjectivity therein. Indeed, this seems also to be the key issue, at least from my own perspective, in Harman's particular philosophical vision of reality: what is it that differentiates the subject as a 'special' kind of object among others?

In order to answer this question one might turn to Badiou and to the account of an event that disrupts an objective world via the calling forth of such a subject, but one might also remain with objects and follow Bergson: the subject is in many ways a more stupid object, less open to that contact and communication in which all objects of the universe participate, at least to some degree. The subject is, as we have seen, a subtraction from the world in this sense (a centre of indetermination). We might make a claim then: in Harman's particular world of vicarious causation the subject is, in one sense, that which withdraws even further than the objects that surround it; but in another sense it is also, crucially, an object that can increase its realm of contact, or, following Spinoza, increase its capacity to affect and be affected. Indeed, it is this, it seems to me, that defines the strange object that the subject is: the possibility of its ongoing intentional transformation.

C.2.4 Ray Brassier and the manifest image

Alongside Meillassoux's critique of correlationism and Negarestani's critique of affordance we might place Ray Brassier's critique of the manifest image, understood as the self as it is presented to consciousness (again, what I have been calling the subject-as-is). Here Meillassoux's 'great outdoors' is also the 'great indoors' when this is thought as the reality of the organism and its 'sub-symbolic processes' outside of consciousness.

In the first chapter of his book *Nihil Unbound* Brassier suggests that it is possible to access this 'other place' (again, it is not some mysterious thing-in-itself inaccessible to thought). However, the means of access cannot be consciousness. Indeed, it is precisely the latter that prevents access through its assumption of the manifest image of the self. Science, instead, becomes the non-human probe insofar as the 'sub-symbolic reality of phenomenal consciousness' is, according to Brassier, amenable to mathematics. Indeed, this is Brassier's attraction to the radical and audacious project – what Brassier suggests is 'nothing short of a cultural revolution' – of Paul Churchland: 'the reconstruction of our manifest self-image in the light of a new scientific discourse' (Brassier 2007, p. 10). Brassier has his issues with Churchland (that amount to the latter

not being radical enough) but is clear in his support of Churchland's speculative materialism capable of accessing the 'sub-personal but perfectly objectifiable neurobiological processes' (Brassier 2007, p. 31).

As with Meillassoux then, it is science/mathematics that provides the tools of access to an outside that is barred from the subject insofar as they are the subject of typical consciousness. Indeed, these forms of thought, since they do not rely on first or second person accounts of the world, allow a different kind of knowledge to be produced (and, in this respect, we might say that Churchland, and Brassier himself, are very much part of the scientific revolution of the Enlightenment):

> the primitive data of phenomenal consciousness are often epistemically and phenomenologically unavailable to the subject of consciousness. But this is precisely why the only hope for investigating sub-symbolic reality of phenomenal consciousness lies in using the formal and mathematical resources available to the third-person perspective. (Brassier 2007, p. 29)

However, we might want to ask whether the only alternative to this scientific enquiry is either the subject of 'manifest consciousness', as determinate of all possible knowledge, or obscurantist mysticism – a religiosity? What I have tried to show in the preceding chapters is that consciousness, the subject *per se*, is mutable and that, in fact, the breaking of the manifest image is not really a question of knowledge, scientific or otherwise, but, again, of practice (even when this might also be thought of as psychoanalytic practice).

In relation to this we might turn from philosophy to non-philosophy and specifically the tradition of introspection. For the biologist and meditator Francisco Varela – whose own work was picked up by Guattari – these subjective technologies can themselves 'access' the sub-symbolic realm. Introspection has the ability to 'isolate little patterns of experience' as demonstrated particularly in the Buddhist tradition of meditation understood as a 'pragmatic of human learning based on introspection' (Varela 2001, p. 67). In the interview from where these comments are taken Varela also refers to psychoanalysis as following a similar analytical thrust, and of the couch being 'another portable laboratory' of the self (Varela 2001, p. 67). In the interview Varela also questions the founding gesture of a science that lays claim to an objective purview at odds with subjective mutability: 'the whole point [of introspection] is in some sense to see that to set the experiential of the subjective in contrast to something where the real knowledge is, which

is the objective, is already a gesture, it's already having decided what you can do' (Varela 2001, p. 69)

For Varela, then, different forms of introspection are 'a pragmatic to have access to the mental processes, to a level of experience that normally is in the pre-reflective area', that in itself implies moving 'what is pre-reflective ... into the reflective' (Varela 2001, p. 73). This is especially the case in relation to developing an awareness of one's unconscious habits that precisely operate 'below' typical consciousness (indeed, following Buddhist ideas, the self is, for Varela, precisely a bundle of these habits).[10] For Varela this questioning of basic beliefs, and especially of a fixed self view (what Brassier and Churchland refer to as 'folk psychology'), has much in common with Western science, albeit it is a questioning of belief that can be explored by the subject themselves – that can be tested against experience to the extent that such experience is not necessarily limited to the subject-as-is. Subjectivity is experimental in this sense; it is not a given, nor an obstacle, but the very means of exploration. This is what Guattari means when he writes of the production of subjectivity as an ethico-aesthetic pursuit.

In the chapter on 'The I of the Storm' from the book *The Embodied Mind* Varela attends specifically to the belief that we have a fixed self. In Buddhist terms this conviction, and the grasping after a self, is precisely the cause of man's suffering (insofar as such grasping after a kind of substance – and for permanence – goes against the fundamental impermanence and insubstantiality of the world). As Varela remarks, sustained introspective analysis upsets this 'folk' conviction insofar as it reveals 'only discontinuous moments of feeling, perception, motivation, and awareness' (Varela *et al.* 1993, p. 72). Introspection shows us impermanence, not as an idea about the world but as a reality that is experienced. We might say, in Guattari's terms, that Varela is offering up a different modelization in which a centred self is absent, but also something more than a modelization since introspection allows a testing of the latter against experience (a testing which, in fact, also produces a transformation of the tester). Indeed, for Varela, and following his Buddhist leanings, it is a model that also implies a set of tools for analysis and for transformation. For Varela science can begin to describe aspects of this process, but it cannot explain the transformative nature of this introspection itself:

> cognition and experience do not appear to have a truly existing self ... the habitual belief in such an egoself, the continual grasping to such a self, is the basis of the origin and continuation of human

suffering and habitual patterns. In our culture, science has contributed to the awakening of this sense of the lack of a fixed self but has only described it from afar. Science has shown us that a fixed self is not necessary for mind but has not provided any way of dealing with the basic fact that this no-longer-needed self is precisely the ego-self that everyone clings to and holds most dear. By remaining at the level of description, science has yet to awaken to the idea that the experience of mind, not merely without some impersonal, hypothetical, and theoretically construed self but without ego-self, can be profoundly transformative. (Varela 1993, pp. 80–1)

The key understanding here is that the 'great outdoors' (or, again, the 'great indoors') is accessible by the subject, not just through science, but actually through an experience that is in and of itself transformative. But, again, this is only the case if the category of subject is itself rethought – after all, it is not so much a subject-as-is that 'has' this experience, but rather, again, that the experience might afterwards be claimed by such a subject. We return here to the thesis of Deleuze and Guattari in which thought is not necessarily the thought of an already constituted subject, but is a more impersonal and specifically inhuman operation.

In fact, following Deleuze and Guattari in this sense, we might suggest that ultimately there is a limit of sorts to Varela's phenomenology – and, as such, we might also return to some of Brassier's terrain. After all, experience is limited to what we sense, but, as subjects, we can also deduce – and speculate – from that experience. As we saw in the second section of Chapter 5, access to the infinite is then also a constructive pursuit. It takes place through the concept – when this is figured as experimental, constructive *and* intensive – and through affect – understood as that virtual aspect of our individuality, but also as that which constitutes art as a composed thing in the world. Each of these, alongside science and its functives, involves the giving of consistency or shape to the infinite, allowing it to be thought (when thought itself is defined in this most decentred and abstract sense). Strictly speaking this has nothing to do with human experience when the latter remains on the level of opinion and *doxa*, but also insofar as such experience is determined by our habitual responses to the world. We have left the typical subject far behind here. The subject of this thought is these strange shapes and compositions themselves. A subject that is radically inhuman, but still coherent. Indeed, this, it seems to me, is what the production of subjectivity ultimately involves: the invention of new

compositions in and of the world. The subject-as-is is nothing more than a retroactive claiming and reduction of these prior and stranger subjectivities.

In a later chapter of *Nihil Unbound* Brassier attends to the thought of Francois Laruelle, criticizing the central claim of the latter that all philosophy is characterized by the same 'invariant', namely a certain 'decision'. Brassier points out that this criticism is in fact founded on an understanding of philosophy inherited by Heidegger and the history of being posited by the latter (the endless asking of the question: 'what is Being?'). Brassier's project is then a critique, but also a subtle re-using, of Laruelle's non-philosophy as itself a philosophical device – to pitch against certain kinds of philosophical claim. In relation to my own book, we might say that many of the thinkers I look at, not least those ancient philosophers and their 'spiritual exercises', see philosophy as less 'about' Being, but, once more, as a way of life (a practice) – but we might also go further and suggest that such philosophy as practice is also different, ultimately, to Brassier's scientific/mathematic thought that although not 'about' Being, is still a knowledge, at least of sorts, of the world.

Is this to bring my own selection of thinkers alongside non-philosophy in Laruelle's terms? For myself this question has to be deferred until I have a greater familiarity with the writings of the latter. Nevertheless, it does seem that Laruelle's non-philosophy is inevitably determined by what it differentiates itself from, namely, philosophy (it is marked, we might say, by the logic of its predecessor, deconstruction). The practices of the self – the production of subjectivity – might then be better described as what Badiou himself calls 'non-philosophy', that includes Lacan, Kierkegaard, and so on. Brassier's point, however, remains salient: the definition of any non-philosophy will always depend on a particular definition of philosophy – a particular 'reading' as it were of the history of philosophy: it is conducted, invariably, from the bias of a present view point, and ultimately ties non-philosophical thought to its philosophical other. Perhaps then the production of subjectivity might be better named as simply a pragmatics, which might use philosophical concepts, but is certainly not reducible to them.

C.2.5 Iain Hamilton Grant and nature as subject

For Iain Hamilton Grant the issue of the correlation might be said to produce a set of false problems, premised as it is, for Grant, on a misunderstanding of nature, or the 'great outdoors', itself. Indeed, for Grant, Kant – the 'author' of the correlation – erected a prison of sorts

with his Critical philosophy which has since set the parameters, and the terms, for our encounter with nature. It might be said, in fact, that such an encounter, for Kant, is always with what we already know, an object perceived and determined by a subject. Grant's project then is to excavate and develop the 'consequences of exiting the Kantian framework which has held nature in its analogical grasp for the two hundred years since its inception' (Grant 2008, p. 19).

Grant finds the tools for such an endeavour in Schelling, and specifically his 'naturephilosophy'. For Schelling, a philosopher's proper terrain of operation is the infinite, the absolute, or what he also names the unconditioned. As Grant remarks, for philosophy to begin, rather, with the conditioned (or the finite) is then to always have the unconditioned determined by the conditioned. It is to perform an inversion:

> If *what a given species thinks* or *can think* about nature were the limit of Schelling's naturephilosophy, then it would simply be a prototype of recent naturalized epistemologies. Moreover the philosophy of the unconditioned would then be conducted under the strict conditions imposed upon it by the neurophysiological constraints specific to that species, and would therefore a priori fail to be an unconditioned philosophy, forming instead just another conditioned philosophy of the unconditioned ... (Grant 2008, p. 2)

For Grant–Schelling nature, rather than the subject, must then be thought as *a priori*. We can see here how Schelling might be seen as a precursor of Deleuze and Guattari's thesis in *Anti-Oedipus*: there is a nature – a process of production – that comes before the subject and must be thought *contra* that subject. For Grant we make a grave mistake if we identify nature with what we can say about it, or, indeed, if we limit it to distinct recognizable entities: 'nature, extends beyond animality, or beyond *organized bodies in general*' (Grant 2008, p. 9). Importantly, Grant notes that this in itself disqualifies the opposition that Badiou posits between his – Badiou's – interest in formalism and Deleuze's interest in the body – namely animal versus number – insofar as nature, for Grant, might be seen to partake of both of these: 'both the formal critique of the organic and the organic critique of the formal, operate on a shared basis: the suppression of inorganic externality' (Grant 2008, p. 17).

Indeed, for Grant, the subject/object – or freedom/nature – split goes back to this splitting of nature itself, into the organic and the inorganic: 'the basis of the two-worlds metaphysics lies in a two-worlds physics: the inert, inorganic world of external nature, and the organic

world' (Grant 2008, p. 15). For Schelling, in Grant's reading, this is a false split in the sense that the inorganic is, in fact, always already organized, just as the organic is itself just a higher level of the same operation. This is not simply to project the organic on to the inorganic, that is, to posit the dominance of the organism, but rather is to suggest that nature is itself always self-organizing: 'organic matter, organism – or organization – results simply from matter acting on its self-construction, or from increasingly complex organizations of the inorganic' (Grant 2008, p. 13). We can see here a further reason why Schelling is so important to Deleuze and Guattari's own attempts at laying out a philosophy of inorganic life (especially in *A Thousand Plateaus*) insofar as he gives a non-hylomorphic account of nature's self-organization in which the organic and inorganic are on a continuum.

Schelling will instead develop a thesis of nature itself as subject, that is to say, as generative and autonomous, independent of how it might appear in the mind. As Grant remarks:

> the foundational relation, for Fichte [following Kant] of the absolute to the empirical I, is transformed in Schelling: on the one hand, the production of an empirical I is merely a conditioning of the unconditioned; on the other hand, the unconditioned I has a nature which, rather than empirical consciousness, corresponds to the self-acting of a *subjectnature*. (Grant 2008, p. 16)

In terms of my own thesis it is especially this idea of a different kind of subject, a subject of the unconditioned, or of the absolute, that is interesting. This subject is arrived at, as with Meillassoux, through philosophy – understood as a method for thinking the absolute outside of any determinant species which would only limit it. Philosophy is then intrinsically speculative, involving a 'successive unconditioning performed by thought-operations upon nature' (Grant 2008, p. 2).

This nature-as-subject, nature's own self-organization processes as it were, might be thought of as the process of desiring-production of Chapter 5, which is to say, it is not a subject in the usual sense (that is, as different to an object). Indeed, it is the subject *as* object; the subject *as* nature's own mode of self-organization: a larval subject before consciousness – and external to it. As Grant has it later on in his book:

> Schellingian subjectivity is not therefore the eliminative subjectivism of its Kantian variant, but reinstates the objectivity of the subjective ... 'nature as subjectivity' means simply nature *itself*,

nature to *auto*, that owes more to repairing the Aristotelian rift in Platonic physics than to any post-Cartesian conception of subjectivity. (Grant 2008, p. 168)

It is, I would argue, a subjectivity to come as it were (or, indeed, a subject that has always already been), radically different to the subject-as-is (the Cartesian subject) insofar as the latter is one pole of a subject–object split that it helps to maintain. Grant's thesis might then be said to move in the opposite direction to Foucault's, that is, from the object to a subject (from the infinite to the finite), rather than from the subject to the object (from the finite to the infinite). It is a physics rather than an ethics. The net result, however, is the same: a collapsing of the subject–object split, and with it the correlationist circle (and, as such, also the physics/ethics split) that hitherto, at least from one perspective, had seemed to determine thought – and subjectivity – post-Kant.

So ends this brief sampling of recent continental philosophy, and my attempt to situate my project and cast of characters among, and sometimes against, the latter. Looking back over my own book, what seems to have been at stake in my philosophical and psychoanalytical commentaries and explorations – and in my different diagrams of the finite–infinite relation – is an attempt at thinking the production of subjectivity as speculative, but also as a pragmatic and creative practice. In fact, I want to finally conclude on this latter note, for it seems to me that if philosophy is in some senses a way of life, then a book dealing with the philosophy of the production of subjectivity needs to position itself in terms of this pragmatic and creative function. This is not, however, to transpose the philosophical and speculative into something more practical, for I would argue that the preceding arguments and diagrams are themselves a kind of practice (what else could they be?). It is, however, to suggest that there are limits to what is essentially a scholarly work – and that the production of subjectivity is itself predominantly an experimental business that necessarily also occurs away from the reading of texts (though these might be an important part of it). Perhaps then my key 'relation of adjacency', once again, is to Guattari's ethico-aesthetic paradigm, that foregrounds this pragmatic and creative aspect of subjectivity (hence my book's title) and in so doing also points to the importance of our relation – or adjacency – to an 'outside', however this might be thought.

Certainly my own writing, as I suggested in my Introduction, is motivated and given direction by certain problems of my life (not least the question of finitude), but it is also inspired by an outside, whether this

be an art practice, an interest in folk culture, Buddhism or in creative and collective practice more generally. I have touched on some of these areas in my book, and elsewhere more explicitly addressed my own production of subjectivity in relation to them.[11] It seems to me that these kinds of practices – of lived life as it were – are a necessary accompaniment to any speculation about the possibilities for our processual self-creation. What I want to say here, however, is that I hope my book, even in its most abstract parts, might operate in a reverse manner to this, that is, as itself an outside – or simply one point of inspiration – for others in their own lives and in their own project of the production of subjectivity.

Notes

Introduction

1. In relation to this interest in an object devoid of a subject, I have in mind the recent philosophical 'movement' known as 'Speculative Realism' that attempts what might be called a pre-Critical and materialist speculative philosophy. I will return to this – and to some of its key exponents – in my Conclusion. As far as the interest in the subject goes, we might note the increasing amount of attention being paid to Guattari's solo works and to his ethico-aesthetic paradigm (see, for example, Gary Genosko's recent *Félix Guattari: A Critical Introduction*, Janell Watson's *Guattari's Diagrammatic Thought*, Franco Berardi's recently translated *Félix Guattari: Thought, Friendship, and Visionary Cartography* and the edited collection on *The Guattari Effect* (Alliez and Goffey). This interest, it seems to me, is part of a growing concern with the question of subjectivity, specifically as a site of struggle in relation to post-fordist modes of production (notably, flexible and immaterial labour) (witness also, for example, the relatively new interdisciplinary *Subjectivity* journal from Palgrave). A second key exemplar of this interest is the increasing turn, within the humanities, to the work of Alain Badiou and to his radical thesis of a 'subject to truth'. There is an increasing amount of secondary literature on Badiou's thought, though Peter Hallwards's *Badiou: A Subject to Truth* remains the most general, but also precise, introduction, survey and critique.
2. The beginnings of this project can be located in my essay, 'The Production of the New and the Care of the Self'. Indeed, in many ways that essay set the intention for the present book, which involves, in part at least, an extended thinking through of some of the philosophical orientations and strategies briefly sketched out in that essay. The latter also contains some preliminary thoughts about Western Buddhism/meditation and contemporary art practice in relation to the philosophical resources.
3. My encounter with Hadot's work actually occurred outside the Academy and in relation to my involvement with Buddhism (it was a text that was studied by the Padmaloka community in Norfolk). Subsequent to that an academic colleague gave me Todd May's article 'Philosophy as a Spiritual Exercise in Foucault and Deleuze', which, especially in its focus on the late writings of Michel Foucault, has some parallels with some of the work I carry out in Chapter 2. May's particular thesis is that the writings of Foucault and Deleuze might be seen as a form of spiritual exercise for the writers themselves, as well as, of course, for their intended readers. It seems to me that this cannot but be correct insofar as any writing brings one up against oneself and one's limitations, while also gesturing beyond them (this book being no exception). When the actual 'subject' of one's

writing is itself this self-knowledge and self-transformation then this is even more so the case:

> After all, when one is writing or speaking in areas where oneself is at stake, there can be a passion and commitment that may be lacking when the writing is solely for the edification of others, not to mention those cases – undoubtedly the most numerous – in which the writing is an academic exercise rather than a spiritual one. (May 2000, p. 225)

I have written an article that further explores the resonances between Buddhist practice and the writings of Deleuze and Badiou – forthcoming from *Deleuze Studies*.

4. I attempted something along similar lines just before beginning work on the present book. See 'Contours and Case Studies for a Dissenting Subjectivity (or, How to Live Creatively in a Fearful World)'. I was interested in this article in identifying certain creative moments of my own life – when I felt most alive as it were – and then reflecting on them philosophically, seeing if I could extract a diagram from them which might be mobilized elsewhere. It was important that this was done as a collaboration, with my friend, Ola Ståhl, as it was apparent to both of us that collectivity, in the different senses of the term, played a major part in these case studies. We also hoped that sharing our 'diagrams' might foster further experiments and explorations. In relation to this I should also mention another collaboration I have with David Burrows, and others, named *Plastique Fantastique*. This expanded art practice might be thought of in different ways, indeed we have often seen it as an artistic exploration of a triumvirate of the sacred, the aesthetic and the political – an exploration that takes the form of a performance *fiction* (see David Burrows' essay 'Performance Fictions' and my own reflections entitled 'Towards a Mythopoetic Art Practice', both of which are published in *Performance Fictions*). In the context of the present book however this practice might be thought as precisely an experimental production of subjectivity, a particular diagram – or 'probe-head' perhaps? Certainly it has been a crucible in which many of the ideas of the present book were developed and tested. Two further reflections on the practice, the earlier written with John Lynch, the later with David Burrows, are: 'One Day in the Life of a City (21 July 2006)' and 'The Chymical Wedding: Performance Art as Masochistic Practice (an Account, the Contracts and Further Reflections)'.

5. Here is the passage, from Guattari's interview 'A Liberation of Desire':

> Writing begins to function in something else, as for example for the Beat generation in the relation with drugs; for Kerouac in the relation with travel, or with mountains, with yoga. Then something begins to vibrate, begins to function. Rhythms appear, a need, a desire to speak. Where is it possible for a writer to start this literary machine if it isn't precisely outside of writing and of the field of literature. (Guattari 1996a, p. 209)

6. Jason Read's own writings on the production of subjectivity address precisely this area. See, as indicative, the essay: 'The Age of Cynicism: Deleuze and Guattari on the Production of Subjectivity in Capitalism'.

7. Another name for this gap is simply alienation, the condition we find ourselves in the world, whether this is figured as our existential situation as 'human', or as produced specifically by our capitalist mode of production. In fact it is a contention of my book that capitalism does indeed produce a certain alienated subject, but that the 'resources' for thinking a different kind of production of subjectivity are not necessarily to be found in the tradition of dialectic thinking that Marx inherits from Hegel and which, we might say, is continued in Frankfurt School Critical Theory.
8. In conversation with non-academics, especially those involved in a therapeutic and/or spiritual context, the idea of a continuum between the finite and the infinite tends to be assumed, after all spiritual practice often involves developing an ever greater awareness of, or access to, that which hitherto was beyond a given (finite) subject. What then can we say about the Kantian subject? Perhaps that it is less prevalent than is often declared within the discipline of philosophy itself.
9. Deleuze, and Deleuze and Guattari, also write about, and, of course, use diagrams. I will return to Deleuze and Guattari's own idea of 'diagrammatics' in the final part of my Conclusion, suffice to say here that for them it is less a formal device (although it is specifically *abstract*), than one based on experimentation. As far as Deleuze himself goes, a certain idea of the diagram is mobilized in *Francis Bacon: The Logic of Sensation* where it is figured as a painterly device – the use of asignifying marks and strokes – for undoing narrative, figuration and, ultimately, representation (see my article 'From Stuttering and Stammering to the Diagram: Deleuze, Bacon and Contemporary Art Practice'). The diagram is also an important aspect of the *Foucault* book where it becomes a way of thinking the relation of forces outside, again, of typical representation (I briefly look at Deleuze's own diagram of Foucault's methodology in Chapter 2).
10. The final chapter of John Mullarkey's compelling book, *Post-Continental Philosophy: An Outline*, calls for, and gives examples of, what the author calls 'diagrammatology' understood as a form of thought, or 'showing', that is not captured within representation, whether this be pictorial or more philosophical (in particular, and in relation to three of the philosophers discussed in Mullarkey's book (Deleuze, Michel Henry and Badiou) the diagram does not involve yet one more 'account' of immanence; it *is* immanence (and thus has something in common with the non-philosophy of the fourth figure in the book, François Laruelle)). Of particular interest, in terms of my own book, are two arguments that lead from this: 1. The diagram is 'metaphilosophical' insofar as it allows different philosophical systems to be thought together, or simply layered and overlapped (in my terms this is to bring such diagrams into encounter, thus producing a composite diagram). Mullarkey also refers to this, following others, as an 'archaeology' of diagrams or as a 'montage-collision'. Here Mullarkey conducts his own experiments in diagrammatology, for example, as with myself, bringing Bergson and Lacan together (with, also, Merleau-Ponty), and, in the book's conclusion, using a Bergsonian schema to think the reciprocal relations between Deleuze, Badiou and Henry. 2. The diagram partakes of both the matheme (Badiou) and the patheme (Henry) (the patheme here is what I have referred to above as the animal or affective). It seems to me that this bringing into encounter

of Henry's reading of Kandinsky's serpentine line with Badiou's diagrams from set and category theory is very productive, and, in fact, relates to how Deleuze and Guattari think the diagram themselves in relation to the gothic line. We might say then, following Mullarkey, that the diagram is both a cold static abstraction, but also a living and moving line, or simply a *drawing*. In relation to this I want to note a dilemma I faced with my own book: to have my drawings 'redrawn', by computer, thus making them more formal and precise (and giving them a certain objectivity, which, of course, is tempting), but in so doing freezing any processuality which is also important to them as thought-in-process (most are, in fact, originally based on blackboard drawings made in a pedagogical situation). Ultimately I have opted to keep them as drawings, even though the versions in the book are cleaner and more precise than the sketches on which they are originally based. In fact, it seems to me that the above two styles of depiction exemplifies the two ways diagrams are used within contemporary philosophy, perhaps best exemplified by Badiou's formal and mathematical diagrams (one can find hand done drawings by Badiou, but the impression is that these are always waiting to be converted to more precise, objective drawings by computer); and Deleuze's that are more processual and hand drawn (in relation to Deleuze, Mullarkey points to the reverse situation in which Deleuze's hand drawn diagrams in the French edition of *The Fold* are then technically 'redrawn' in the English edition – a certain amount of clarity is without doubt gained, but something is most certainly lost).

11. I cannot take credit for this particular insight as it was a comment made by someone in the audience after I had given a paper on *Anti-Oedipus* – with accompanying diagrams – at the *Fourth International Deleuze Studies Conference* at the Copenhagen Business School in 2011.

Chapter 1

1. In this sense Spinoza's *Ethics* harks back to the ancient tradition of understanding 'philosophy as a way of life' as Pierre Hadot has it. In fact, Spinoza's emphasis on developing knowledge, or simply a certain clarity about our being in the world, and then acting accordingly, has a precursor in Stoic philosophy. To quote Hadot:

> The Stoics ... declared explicitly that philosophy, for them, was an 'exercise'. In their view, philosophy did not consist in teaching abstract theory – much less in the exegesis of texts – but rather in the art of living. It is a concrete attitude and determinate lifestyle, which engages the whole of existence. The philosophical act is not situated merely on the cognitive level, but on that of the self and of being. It is a progress which causes us to *be* more fully, and makes us better. It is a conversion which turns our entire life upside down, changing the life of the person who goes through it. It raises the individual from an inauthentic condition of life, darkened by unconsciousness and harassed by worry, to an authentic state of life, in which he attains self-consciousness, an exact vision of the world, inner peace, and freedom. (Hadot 1995, pp. 82–3)

For the stoics this involves an analysis and ongoing enquiry in to what depends on us and what does not:

> all mankind's woes derive from the fact that he seeks to acquire or to keep possessions that he may either lose or fail to obtain, and from the fact that he tries to avoid misfortunes which are often inevitable. The task of philosophy, then, is to educate so that they seek only the goods they are able to obtain, and try to avoid only those evils which it is possible to avoid. In order for something good to be always obtainable, or an evil always avoidable, they must depend exclusively on man's freedom ... (Hadot 1995, p. 83)

It is this that dictates the famous Stoic 'indifference' to nature, or to that which is necessary. For the Epicureans, on the other hand, it is a focus on the joys of life that can alleviate man's condition of suffering:

> People's unhappiness, for the Epicureans, comes from the fact that they are afraid of things which are not to be feared, and desire things which it is not necessary to desire, and which are beyond their control. Consequently, their life is consumed in worries over unjustified fears and unsatisfied desires. As a result they are deprived of the only genuine pleasure there is: the pleasure of existing. (Hadot 1995, p. 87)

To a certain extent Spinoza's own ethics tacks a course between these two traditions insofar as it attends to freedom and necessity, but also to joy as a key technology in the assumption of knowledge (although the actual mechanism of the latter, that is, the common notions, is specific to Spinoza). I will have more to say about Hadot, in relation to Foucault, in note 14 of Chapter 2.

2. My synopsis follows Deleuze's own reading of Spinoza (see *Spinoza: Practical Philosophy*, especially the last chapter, 'Spinoza and Us', pp. 122–30; *Expressionism in Philosophy: Spinoza*, especially the last two chapters, 'Toward the Third Kind of Knowledge' and 'Beatitude', pp. 289–302 and 303–20; and, in particular, the 'Lecture on Spinoza' and a further lecture published as 'The Three Kinds of Knowledge'.

3. We might remark on the resonances with Leibniz's monadology here, especially as Deleuze reads the latter and in so doing develops his own thesis on the relation between the dominata and the dominated:

> as far as variable terms are concerned, monads are what enter in to the relation as 'Objects', even if for brief moments. They can exist without the relation, and the relation can exist without them. The relation is exterior to variables, as it is the outside of the constant. It is especially complex since it acquires an infinity of variables. The latter are said to be dominated, specifically insofar as they enter into the relation attached to the dominant or constant. When they cease being submitted to this relation, they enter under another, into another vinculum attached to another dominant (unless they are freed from every vinculum). (Deleuze 1993, p. 112)

Deleuze diagrams this capture of variables as in Figure 1.14.

Figure 1.14 Deleuze's diagram of the viniculum (from 'The Two Floors', *The Fold*)

4. This thesis on the kinetic and the dynamic aspects of the Spinozist body is developed in the Becoming plateau of *A Thousand Plateaus*, in the two sections on 'Memories of a Spinozist' (pp. 253–6 and 256–60), where it is specifically linked to the concept of the plane of immanence and to a becoming-animal.
5. In terms of this affective landscape Deleuze, following von Uexküll, offers the image of the tick – and its world – as defined by only three affects:

> the first has to do with light (climb to the top of the branch), the second is olfactive (let yourself fall on to the mammal that passes beneath the branch); and the third is thermal (seek the area without fur, the warmest spot). A world with only three affects, in the midst of all that goes on in the immense forest. (Deleuze 1988a, 125)

6. As Deleuze and Guattari say in the section 'Memories of a Spinozist, I' of the Becoming plateau:

> there is a pure plane of immanence, univocality, composition, upon which everything is given, upon which unformed elements and materials dance that are distinguished from one another only by their speed and that enter into this or that individuated assemblage depending on their connections, their relations of movement. A fixed plane of life upon which everything stirs, slows down or accelerates. A single abstract Animal for all the assemblages that effectuate it. (*ATP*, p. 255)

7. As Deleuze remarks: 'signs appear to tell us what we *must* do to obtain a given result, achieve a given end: this is knowledge by *hearsay*' (Deleuze 1992, p. 289).
8. To quote Deleuze:

> Signs *do not have objects as their direct referents*. They are states of bodies (affections) and variations of power (affects), each of which refers to the other. Signs refer to signs. They have as their referent confused mixtures

of bodies ... Effects or signs are *shadows* that play on the surface of bodies, always between two bodies. (Deleuze 1998, p. 141)

9. In fact, Deleuze, in his 'Lecture on Spinoza', admits that the second kind of knowledge *might* involve speculative abstraction, mentioning mathematics and the formal 'theory of relations' as a 'special case' of the second kind of knowledge. As we shall see, this non-corporeal and mathematical understanding of knowledge characterizes Badiou's interest in Spinoza.
10. The critique of 'affirmationism' in terms of its politics (as, for example, when the neo-liberal injunction to 'be happy' is rightly figured as a device for maintaining a certain status quo of capitalist relations), does not, it seems to me, attend to affirmation as an ethical principle in Spinoza's sense. Once more, it is not as if critique and negation do not have a place, but simply, in terms of this ethics, that they do not provide knowledge (of true causality) in Spinoza's sense.
11. As Deleuze remarks:

> If we consider the second aspect of the *Ethics*, we see a determining opposition to signs emerge: *common notions are concepts of objects*, and objects are causes. Light is no longer reflected or absorbed by bodies that produce shadows, it makes bodies transparent by revealing their intimate 'structure' *(fabrica)*. This is the second aspect of light; and the intellect is the true apprehension of the structures of the body, whereas the imagination merely grasped the shadow of one body upon another. (Deleuze 1998, pp. 141–2)

12. Deleuze: 'the true Christ does not proceed through common notions. He adapts or conforms what he teaches us to common notions, but his own knowledge is directly of the third kind...' (Deleuze 1992, p. 301).
13. In anticipation of Chapter 4, we might note here another of the attractions of Spinoza for Badiou insofar as this infinity of modes correlates well with Badiou's idea of 'inconsistent multiplicity'. Badiou, however, disavows any Univocity, for example of 'substance', hence his polemic against Deleuze and the turn to set theory that, for Badiou, is able to 'figure' this bounded infinity without recourse to the One.
14. Although, of course, the *promise* of such a state can be commodified and has been; witness the New Age publishing phenomena that trades on this very promise.
15. We might jump ahead a little here and note Deleuze and Guattari's own take on capitalism – in *Anti-Oedipus* – as itself schizophrenic, meaning nothing, least of all that desire is *outside* of it, but that nevertheless the schizophrenic production remains in some way prior to its instrumentalization and reterritorialization – its capture – by capitalist production in subjectivity (Oedipus) and representation (money and the signifier). It might be said, in this sense, that capitalism has both an active and passive phase.
16. In fact, we might also say that Spinoza's thought in general, although in one sense determined by capitalism – after all he writes the *Ethics* at the time of its inception and it bears the marks of a rationality and scientific world view that follows from this – nevertheless goes well beyond the reductive logics

and operations of capitalism as it existed in Spinoza's time, and, indeed, in our own. Antonio Negri is especially attuned to this idea of two Spinozas:

> The first expresses the highest consciousness that the scientific revolution and the civilisation of the Renaissance have produced; the second produces a philosophy of the future. The first is the product of the highest and most extensive development of cultural history of its time; the second accomplishes a dislocation and projection of the ideas of crisis and revolution. The first is the author of the capitalist order, the second is perhaps the author of a future constitution. The first is the highest development of idealism; the second participates in the foundation of revolutionary materialism and in its beauty. (Negri 1991, p. 4)

I will be looking at Negri's particular kind of Spinozism in Chapter 3.

17. One might note an apparent caveat to this point: speculative finance, or precisely the market in *Futures*. To pre-empt some of the material to come – on Bergson and Deleuze – we might point out that this particular future-orientation, it seems to me, works through a logic of the possible rather than the virtual insofar as, precisely, it is predictive. A further question arises here insofar as capitalism is not a uniform system and, as such, one might argue that certain aspects of it – education, medical care and so forth – increase our capacity to act, which means, on the face of it, the second kind of knowledge could arise from capitalist relations. So the question becomes: what prevents them from entering the third kind of knowledge? Indeed, the imaginary of contemporary capitalism, particularly with new information and communication technologies, has become increasingly Spinozist in the sense of promoting a global vision of immediate inter-connectivity. This is a complex area in which philosophy bleeds into Science Fiction (and where the mystics are also technologists). What might be said, however, following my comments in note 15, is that capitalism has two tendencies, deterritorialization and then a reterritorialization on the latter. As far as this goes, again to pre-empt some of the work of Chapter 5, we might say that the third kind of knowledge will always be prior to a capitalism that, in fact, seeks to profit from it (or, more specifically, from the promise of it). (I want to thank Stephen Zepke for alerting me to the issues addressed in this note).

18. As Deleuze remarks in that essay:

> This is the third element of Spinoza's logic: no longer signs or affects, nor concepts, but Essences or Singularities, Percepts. It is the third state of light: no longer signs of shadow, nor of light as colour, but light in itself and for itself ... *pure figures of light* produced by a substantial Luminosity (and no longer geometrical figures revealed by light). (Deleuze 1998, p. 148)

19. Affirmation, in this sense, is an ethics – or even a style of life. To quote Deleuze from the interview 'Life as a Work of Art (Deleuze 1995a, pp. 94–101)':

> We say this, do that: what way of existing does it involve? There are things one can only do or say through mean-spiritedness, a life based on hatred, or bitterness towards life. Sometimes it takes just one gesture

or word. It's the styles of life in everything that makes us this or that. (Deleuze 1995a, p. 100)

For Deleuze this idea of style is there in Spinoza's modes, in the late writings of Foucault, and also, as Deleuze remarks earlier in the same interview, in Nietzsche's thought insofar as the latter involved 'rules at once ethical and aesthetic that constitute ways of existing or styles of life' (Deleuze 1995a, p. 98).

20. Contrary to what has sometimes been said in relation to affirmation as the dominant affective tonality of contemporary culture, according to Nietzsche it is negativity and resentment that dominates *even though* this might appear as the injunction to 'be happy' and so forth. This is to point out, again, that one must not confuse the injunction to 'be happy' with what Nietzsche (and Spinoza) see as affirmation. Indeed, one might affirm that which contemporary culture sees as negative – this, in fact, being Nietzsche's method, for example when the anti-Christ is affirmed against Christ. Affirmation then is not ultimately a human emotion at all, but the arising of something inhuman within the human.
21. Nick Land, in his book on Bataille, is especially attentive to and critical of the temptation of reading Nietzsche as an 'all too human' thinker, a 'project' that is allowed to take place, so Land argues, because of an ignorance of Schopenhauer:

Schopenhauer is the great well-spring of the impersonal in post-Kantian thought; the sole member of the immediately succeeding generation to begin vomiting monotheism out of their cosmology in order to attack the superstition of the self. The repression of Schopenhauer's thinking is continuous with the co-option of Nietzsche back into the monotheistic/humanist fold of ontologically grounded subjects, real choices, existential individuation, irreducible persons, ethical norms, and suchlike garbage. (Land 1992, p. 138)

22. Or, as Nietzsche puts it – bluntly and succinctly – in Book Two: 'Only as creators can we destroy!' (*GS* 58, p. 70).
23. For Nietzsche, this contemplative life is however not a final state, but, indeed, might be counterpoised (in a dovetailing, as we shall see, with Bergson's thesis on the mystic) with a more active participation in life that follows from it. Here one is not merely a spectator of life, however attentive, nor, in fact simply an actor in the drama of life, but rather, is the author of this drama: 'As the poet, he certainly possesses *vis contemplativa* and a retrospective view of his work; but at the same time and above all *vis creative*, which the man of action lacks, whatever universal belief may say' (*GS* 301, p. 171). Nietzsche continues: 'It is we, the thinking-sensing ones, who really and continually *make* something that is not yet there: the whole perpetually growing world of valuations, colours, weights, perspectives, scales, affirmations and negations' (*GS* 301, p. 171).
24. Klossowski's reading of Nietzsche foregrounds this intelligence of the body:

Since the body is the *Self* [*Soi*], the *Self* resides in the midst of the body and expresses itself through the body – for Nietzsche, this was already a

fundamental position. Everything his brain had refused him lay hidden in his corporeal life, this intelligence that was larger than the *seat* of the intelligence. All evil and suffering are the result of the quarrel between the body's multiplicity, with its millions of vague impulses, and the interpretive stubbornness of the meaning bestowed on it by the brain. (Klossowski 1998, p. 33)

25. Ray Brassier in *Nihil Unbound* is especially attuned to this understanding of the Enlightenment project as that which privileges the search for knowledge over any reified ideas of 'man'. I will be looking briefly at Brassier's thesis in my Conclusion.
26. As Deleuze remarks in his essay on 'Nietzsche' (*I*, pp. 53–99): 'Modes of life inspire ways of thinking; modes of thinking create ways of living' (*I*, p. 66). Nietzsche's philosophical insights were, for Deleuze, in part determined by his illness. Nietzsche 'saw in illness a *point of view* on health; and in health, a *point of view* on illness' (*I*, p. 58). Again, it is this ability to shift perspective that is the 'Great Health'. Nietzsche himself lived these different perspectives and their accompanying intensive states:

 Nietzsche didn't believe in the unity of a self and didn't experience it. Subtle relations of power and of evaluation between different 'selves' that conceal but also express other kinds of forces – forces of life, forces of thought – such is Nietzsche's conception, his way of living. (*I*, p. 59)

27. As Nietzsche remarks in Book 3: 'Thoughts are the shadows of our sensations – always darker, emptier, simpler' (*GS* 179, p. 137) and, again, in Book 5:

 For ... man, like every living creature, is constantly thinking but does not know it; the thinking which becomes *conscious* is only the smallest part of it, lets say the shallowest, worst part – for only that conscious thinking *takes place in words, that is, in communication symbols*; and this fact discloses the origin of consciousness. (*GS* 354, p. 213)

28. The foreshadowing of Lacan continues in the next aphorism with a statement about the oft-time *necessity* of suffering, and against the moral injunction to 'love one's neighbour', which Lacan also rails against: 'the moral teacher of compassion even goes so far as to hold that this and only this is moral – to lose one's own way like this in order to help a neighbour' (*GS* 338, p. 192).
29. In the essay on 'Nietzsche' in *Immanence ... A Life* (*I*, pp. 53–99) Deleuze suggests that: '[i]n the affirmation of the multiple lies the practical joy of the diverse', and that, as such, '[j]oy emerges as the sole motive for philosophizing. To valorize negative sentiments or sad passions – that is the mystification on which nihilism bases its power' (*I*, p. 84). Deleuze also remarks at this point in his essay that Spinoza 'already wrote decisive passages on this subject', conceiving 'philosophy as the power to affirm, as the practical struggle against mystifications, as the expulsion of the negative' (*I*, p. 84).

30. For Deleuze's Nietzsche it is the Overman who lives this inhuman state insofar as the eternal return itself:

> implies and produces the Overman. In his human essence, man is a reactive being who combines his forces with nihilism. The eternal return repels and expels him. The transmutation involves an essential, radical conversion that is produced in man but that produces the Overman. The Overman refers specifically to the gathering of all that can be affirmed, the superior form of what is, the figure that represents selective being, its offspring and subjectivity. He is thus at the intersection of two genealogies. On the one hand, he is produced in man, through the intermediary of the last man and the man who wants to die, but beyond them, through a sort of wrenching apart and transformation of human essence. (*I*, p. 91)

Keith Ansell-Pearson is also especially attentive to this inhuman character of the eternal return, understood as the death of the 'I', and the concomitant release of non-human becomings. In Ansell-Pearson's telling (backed up by recourse to the *Nachlass*) Nietzsche, in fact, invents the Overman *after* the thought of the eternal return as a form of life that is capable of thinking it:

> Nietzsche formulated the teaching of return first and was led to positioning a notion of the overman as a result of his inability to conceive of its affirmation by man: the thought of eternal return is not human at all, hence its 'undecideable' and uncanny quality. Only the overman is able to endure that thought of eternal return, to dance and play with it, and then deploy it 'as a means of discipline and training'. It is only the prospect of the overman which can make the thought of return conceivable (an immaculate conception). Once possible, however, the overman then becomes the progenitor of the thought of the eternal return as an affirmative *über-menschliche* thought. (Ansell-Pearson 1997, p. 78)

Ansell-Pearson points out that the 'flame death' that the human subject must undergo in order to allow this other state is different to the 'heat death' that Freud sees as characteristic of the death drive of the organism (the return to inorganic matter). Again, it is an irruption of life as becoming when this must involve the death of the subject-as-is. Helpfully, Ansell-Pearson puts this in terms of the 'contemporary science of complexity':

> the eternal return is a thought of non-linear becoming in which the stress is on non-equilibrium and positive feedback as the conditions of possibility for a truly 'creative' and complex (involuted) mapping of 'evolution' ... This is to posit the world as a '*monster of energy*' without beginning and without end, a Dionysian world of 'eternal' self-creation and 'eternal' self-destruction, moving from the simple to the complex and then back again to the simple out of abundance: cold/hot/hot/cold, 'beyond' satiety, disgust, and weariness, a world of becoming that never 'attains' being, never reaching a *final* death. (Ansell-Pearson 1997, p. 62)

31. For a discussion of Deleuze's take on literature in precisely these terms see Dan Smith's 'Introduction' to Deleuze's collection of essays on literary works, *Essays Critical and Clinical*.
32. As with the question of capitalism and Spinoza's third kind of knowledge there might equally be a question here as to whether capitalism has now colonized this virtual. My own take on this is that certain technologies, for example the mapping of the human genome, do indeed partake of a kind of future-within-the-present, but that this is a logic of the possible, tied as it is, to a certain linear temporality and to already existing knowledges and procedures. I will be returning to this terrain in Chapter 4.
33. In *Adventures of Ideas* Alfred North Whitehead makes a similar argument as regards our experience being of the present but also of the immediate past which determines that present, 'a doctrine of the immanence of the past energizing in the present' as Whitehead has it (Whitehead 1967, p. 188). In fact for Whitehead, as for Bergson, this 'vector-structure' applies not just to human experience but to nature more generally (the former being merely a special case of the latter). All of nature, we might say, is involved in non-sensuous perception, or, in Bergson's terms, 'contemplation' (see note 39 below and also the section on 'The brain' in the second part of my Conclusion). More obscure is Whitehead's argument for prehension, or for an immanence of the future in the present. Such a future, for Whitehead, cannot have an objective existence as it were, but is nevertheless determined by the present insofar as the latter 'bears in its own essence the relationships which it will have to the future. It thereby includes in its essence the necessities to which the future must conform' (Whitehead 1967, p. 194). Put simply the present prehends, or, we might say, calls forth a future that is there, germinally speaking, within it. To a certain extent this parallels Bergson's own account of a future determined by a past, although, as we shall see, there is a further notion in Bergson of a future that is aligned to a 'pure past' that is not determined by an organism understood as a sensori-motor schema. Although I will be exploring this further in Chapter 4 in relation to Deleuze's syntheses of time, we might say here that Whitehead operates, like Bergson, as a precursor of the first passive synthesis, which, again, in Whitehead's terms, is 'the doctrine of the immanence of the past energizing the present' (Whitehead 1967, p. 188). In relation to my own thesis it is perhaps enough to end this long digression with the remark that prehension is certainly not a knowledge, unless the later is thought in terms of a feeling-knowledge (what Whitehead, in Quaker terminology, names 'concern'). It is a contention of my book that this – feeling, or intensity – increasingly determines both the operating terrain of contemporary capitalism and any possibilities of resistance to it.
34. Or, as Bergson puts it: 'in that continuity of becoming which is reality itself, the present moment is constituted by the quasi-instantaneous section effected by our perception in the flowing mass, and this section is precisely that which we call the material world' (*MM*, p. 139).
35. In Deleuze's essay 'Michel Tournier and the World without Others' we have a compelling account of what happens when this dark background 'invades' our existing perceptual world (Deleuze 1990, pp. 301–20). The 'structure-Other' that surrounds and reassures us, that demarcates and protects the

'margins and transitions' of our world, also constitutes our particular space–time delimiting:

> a complete margin where I had already felt the preexistence of objects yet to come, and of an entire field of virtualities and potentialities which I already knew were capable of being actualized. Now, such a knowledge or sentiment of marginal existence is possible only through other people. (Deleuze 1990, p. 305)

When the 'benevolent murmuring' of this world with Others, our human world, has ceased we encounter a different place:

> A harsh and black world, without potentialities or virtualities: the category of the possible has collapsed. Instead of relatively harmonious forms surging forth from, and going back to, a background in accordance with an order of space and time, only abstract lines now exist, luminous and harmful – only a groundless abyss, rebellious and devouring. Nothing but elements. (Deleuze 1990, p. 306)

For Deleuze, following Nietzsche, the end of the possible is the liberation of the 'Great Health' and with it a kind of inhuman desire: 'the sign of a death instinct – an instinct which has become solar' (Deleuze 1990, p. 318). Here a perverse structure replaces the 'structure-Other', and, as a consequence, consciousness is no longer separated from its object. In relation to the production of subjectivity, this particular essay by Deleuze lays out an experimental programme for the production of a state 'beyond' the subject as given, that is, as constituted by and through Others. The programme is also specifically performative: it is through a series of rituals that Robinson, finally, becomes island.

36. One need only think of cinema, as indeed Deleuze himself famously does, or indeed other new technologies that open up these virtual worlds by altering the spatial and temporal registers of human perception (cinema, in this sense, continues the task of philosophy – or 'transcendental empiricism' – ultimately moving towards an imaging of the pure past itself in the time-image).

37. In terms, however, of the relative 'reality' of the future as opposed to the past, Bergson outlines the reasons for, and implications of, this necessary focus and blindness – and with it the illusion that produces metaphysics:

> First, the objects ranged along the line AB represent to our eyes what we are going to perceive, while the line CI contains only that which has already been perceived. Now the past has no longer any interest for us: it has exhausted its possible action or will only recover an influence by borrowing the vitality of the present perception. The immediate future, on the contrary, consists in an impending action, in an energy not yet spent. The unperceived part of the material universe, big with promises and threats [we might say, following Spinoza, big with possible encounters] has then for us a reality which the actually unperceived periods of our past experience cannot and should not possess. But this distinction, which is entirely relative to practical utility and to the material needs of

life, takes in our minds the more and more marked form of a metaphysical distinction. (*MM*, p. 144)

A difference determined purely by utility becomes hypostasized as a no longer existing past versus an actually existing present (the illusion we have of 'time passing'), but also of a world available to the senses (phenomena) and of a world beyond them (noumena). As Bergson remarks a little later, it is our misrecognition of this difference between conscious and unconscious states that produces the illusions of dualism. To quote Bergson, again at some length:

> here we come to the capital problem of *existence*, a problem we can only glance at, for otherwise it would lead us step by step into the heart of metaphysics. We will merely say that with regard to matters of experience – which alone concern us here – existence appears to imply two conditions taken together: (1) presentation in consciousness and (2) the logical or causal connection of that which is so presented with what precedes and with what follows ... We ought to say, then, that existence, in the empirical sense of the word, always implies conscious apprehension and regular connection; both at the same time, although in different degrees ... But our intellect, of which the function is to establish clear-cut distinctions, does not so understand things. Rather than admit the presence in all cases of the two elements mingled in varying proportions, it prefers to disassociate them, and thus attribute to external objects, on the one hand, and to internal states, on the other hand, two radically different modes of existence, each characterized by the exclusive presence of the condition which should be regarded as merely preponderating. (*MM*, pp. 147–8)

Indeed, this is our fundamental human misrecognition, which 'consists in transferring to duration itself in its continuous flow, the form of instantaneous sections we make in it.' (*MM*, p. 149) We project our *view* of reality onto reality itself – and in so doing separate ourselves from this reality.
38. I will be returning to this particular oscillation, and the intensive states – or singular personae – that are 'produced' by it, in the first part of my final chapter.
39. With this first kind of memory – habit – we only see 'that aspect in which it practically *resembles* former situations' (*MM*, p. 155). In the second kind of memory we see only differences – 'leaving to each image its peculiar specificity' (*MM*, p. 155). In relation to the former, more utilitarian memory Bergson remarks at a later point:

> That which interests us in a given situation, that which we are likely to grasp in it first, is the side by which it can respond to a tendency or a need ... a need goes straight to the resemblance or quality; it cares little for individual differences. (*MM*, p. 158)

Bergson gives us here the example of animals for which it is 'grass *in general*' which attracts them ('the color and the smell of grass, felt and experienced

as forces' (*MM*, p. 161)). We have here, again, a resonance with Spinoza's affective mapping of the world. In fact, Bergson applies the latter to inorganic life too in a remarkable passage that prefigures Deleuze's own theory of inorganic life. The passage is worth quoting in its entirety:

> Hydrochloric acid always acts the same way upon carbonate of lime whether in the form of marble or of chalk, yet we do not say that the acid perceives in the various species the characteristic features of the genus. Now there is no essential difference between the process by which this acid picks out from the salt its base and the act of the plant which invariably extracts from the most diverse soils those elements that serve to nourish it. Make one more step; imagine a rudimentary consciousness such as that of an amoeba in a drop of water: it will be sensible of the resemblances, and not of the difference, in the various organic substances which it can assimilate. In short, we can follow from the mineral to the plant, from the plant to the simplest conscious beings, from the animal to man, the progress of the operation by which things and beings seize from their surroundings that which attracts them, that which interests them practically, without needing any effort of abstraction, simply because the rest of their surroundings takes no hold upon them: this similarity of reaction following actions superficially different is the germ which the human consciousness develops into general ideas. (*MM*, p. 158)

Indeed, general ideas here have much in common with Spinoza's own 'common notions' insofar as they are an 'understanding' of similarity that arises from an encounter. As Bergson remarks: 'Generalization can only be effected by extracting common qualities', and further: 'It would seem, then, that we neither start from the perception of the individual nor from the conception of the genus, but from an intermediate knowledge, from a confused sense of the *striking quality* or of resemblance' (*MM*, p. 158). This is 'a similarity felt and lived, or, if you prefer, the expression, a similarity which is automatically acted' (*MM*, p. 160). But, this 'similarity, from which the mind begins its work of abstraction ... it is not the similarity at which the mind arrives when it consciously generalizes' (*MM*, p. 160). The first is simply habit, the second, intellectual work – the production of general ideas or concepts. The 'general idea', or what we might call the concept, but also language, is then the result of 'reflective analysis' on this '*striking quality*'. Bergson is not writing an *Ethics* so there is less here about how the general idea involves a working on nature, although insofar as the general idea, ultimately, can be traced back to the 'utilitarian origin of our perception of things' (*MM*, p. 158), which is itself determined by our bodies as centres of action ('that which interests us in a given situation, that which we are likely to grasp in it first, is the side by which it can respond to a tendency or need' (*MM*, p. 158)), then we can say that the general idea, although more sophisticated, is still a response to being in the world. In this sense, the general idea is also ultimately tied to typical and habitual tendencies – themselves determined by our desire to continue to exist. This would be to bring Bergson's general ideas more in line with Badiou's encyclopaedia or Lacan's symbolic.

40. It is the summoning up of an incorporeal universe. Guattari will say something similar about Duchamp's Readymades, specifically the *Bottlerack*, and the universes of reference opened up by this trigger point, in his essay 'Ritornellos and Existential Affects':

> Marcel Duchamp's *Bottlerack* functions as the trigger for a constellation of referential universes engaging both intimate reminiscences (the cellar of the house, a certain winter, the rays of light upon spider's webs, adolescent solitude) and connotations of a cultural or economic order – the time when bottles were still washed with the aid of a bottle wash ... (Guattari 1996b, p. 164)

For a compelling discussion of Guattari's take on the Readymade – understood as an 'expressive mechanism capable of creating a people yet to come' see Stephen Zepke's essay 'The Readymade: Art as the Refrain of Life' (Zepke 2008, p. 39).

41. See note 39 for a discussion of Bergson's account of language – or, the 'general idea' – as it appears in *Matter and Memory*.
42. Deleuze writes about this first – and typical – idea of history in his essay 'Control and Becoming' (Deleuze 1995a, pp. 169–76):

> What history grasps in an event is the way it's actualized in particular circumstances; the event's becoming is beyond the scope of history. History isn't experimental, its just the set of more or less negative preconditions that make it possible to experiment with something beyond history ... Becoming isn't part of history; history amounts only the set of preconditions, however recent, that one leaves behind in order to 'become', that is, to create something new. This is precisely what Nietzsche calls the Untimely. (Deleuze 1995a, pp. 170–1)

43. We might go further than this and suggest that if the plane of matter constitutes our 'reality' and those aspects from the cone that are actualized are our 'history' then the actualization of other aspects of the cone (or, indeed, other aspects of the plane of matter) that were hitherto 'invisible' might be thought of as a 'fictioning'. It seems to me that this is fertile territory for thinking art practice, but also a militant subjectivity that is intent on living a life that is not already proscribed by dominant narratives of 'reality'.
44. Bergson gives us the example here of hearing a word spoken in another language. It might summon up the memory of an individual that once spoke that word, in which case the memory is located closer to the base. It might also however make one think of the language itself, in which case the memory is located towards the summit, which is to say is more 'disposed towards immediate response' (*MM*, p. 169).
45. It might be countered that the 'creativity' produced through 'dreaming' is precisely that element that contemporary capitalism is most eager to both generate and exploit, but crucially, I would argue, it is only a certain kind of creativity, one that can be instrumentalized, that is encouraged. Can this difference be sustained, or does cognitive capitalism, in fact, describe a general

exploitation of the human faculty for dreaming/creativity, or actualizing the virtual in new ways? The question here would be whether pinning capitalism to the world of the sensori-motor schema runs into difficulty in relation to cognitive capitalism, which exploits the *intense* aspects of production – affect and creativity. My argument, following Bergson–Deleuze, would be that it is not the virtual that is here being colonized, but simply the possible, or, we might say – at a stretch – a specific set of virtualities, or even a certain actual–virtual circuit. (Once again I want to thank Stephen Zepke for discussions related to this particular note.)

46. I will be returning in my Conclusion to this question of strategy – of how we might, as it were, invite the outside in – specifically in relation to Reza Negarestani's *Cyclonopedia*.

47. In a footnote Pierre Hadot briefly attends to this kind of practice that he sees as a precursor to the 'spiritual exercises' of the Ancients:

> The prehistory of spiritual exercises is to be sought, first of all, in traditional rules of life and popular exhortation. Must we go back further still, and look for it first of all in Pythogoreanism, and then, beyond, Pythagoras, in magico-religious/shamanistic traditions of respiratory techniques and mnemonic exercises? This theory ... is entirely plausible. (Hadot 1995, p. 116)

Hadot gives his reasons for not following this particular line of enquiry as his own unfamiliarity with this area, the complexity of the latter, especially in terms of sources, but also, most tellingly, the following:

> the spiritual exercises under discussion here are mental processes which have nothing in common with cataleptic trances, but, on the contrary, respond to a rigorous demand for rational control which, as far as we are concerned, emerges with the figure of Socrates. (Hadot 1995, p. 116)

This is then, from a certain perspective, a Spinozist understanding of the ancients insofar as it involves the privileging of reason. It is not, however, the only way of understanding Spinoza, as we saw in the first section of this chapter with Deleuze who foregrounds, rather, experimentation over reason. Indeed, returning to the Bergson quote that instantiated this footnote we might note Deleuze and Guattari's own thesis on 'losing it' in the remarkable passage in *What is Philosophy?* about all philosophy having a non-philosophical moment:

> Precisely because the plane of immanence is prephilosophical and does not immediately take effect with concepts, it implies a sort of groping experimentation and its layout resorts to measures that are not very respectable, rational, or reasonable. These measures belong to the order of dreams, of pathological processes, esoteric experiences, drunkenness, and excess. We head for the horizon, on the plane of immanence, and we return with bloodshot eyes, yet they are the eyes of the mind. (*WP*, p. 41)

In a final turn let us quote Lacan's own take on this matter, which, again, differs from Deleuze's in somewhat following Hadot. I quote him here from 'The Subversion of the Subject and the Dialectic of Desire':

> Whether we're dealing with the states of enthusiasm described by Plato, the degrees of Samadhi in Buddhism, or the experience (*Erlebnis*) one has under the influence of hallucinogens, it is important to know how much of this is authenticated by any theory ... I assume you are sufficiently informed about Freudian practice to realize that such states play no part in it ... (Lacan 2002b, p. 673)

For Lacan, discourse, even if it be that of the hysteric, is preferable to any 'hypnoid state'. Indeed, Lacan has very little time for what might be called 'mystical experience':

> a strain of psychoanalysis that is sustained by its allegiance to Freud cannot under any circumstances pass itself off as a rite of passage to some archetypal, or in any sense ineffable, experience. The day someone who is not simply a moron obtains a hearing for a view of this kind will be the day all limits will have been abolished. We are still a long way from that. (Lacan 2002b, p. 674)

This pitching of discourse – and ultimately formal structure – against bodily experience will be addressed, at least to a certain extent, in Chapter 2 (see especially note 30 to that chapter where Lacan, in fact, seems to contradict his position on the value of these experiences).

48. Walter Benjamin also gives an account of what he calls this 'now time' in thesis XIV of his 'Thesis on the Philosophy of History':

> History is the subject of a structure whose site is not homogenous, empty time, but time filled by the presence of the now [*Jetzeit*]. Thus, to Robespierre ancient Rome was a past charged with the time of the now which he blasted out of the continuum of history. The French Revolution viewed itself as Rome incarnate. It evoked ancient Rome the way fashion evokes costumes of the past. Fashion has a flair for the topical, no matter where it stirs in the thickets of long ago; it is a tiger's leap into the past. This jump, however, takes place in an arena where the ruling class gives the commands. The same leap in the open air of history is the dialectical one, which is how Marx understood the revolution. (Benjamin 1999b, pp. 252–3)

As we shall see in Chapter 3, this *Jetzeit* might be thought as a specifically generative time or the time of *kairos*. In terms of Chapter 5, it might also be thought as a form of disjunctive synthesis. As we shall also see in Chapter 4, St Paul is an important figure for Badiou for reasons that also follow from this notion of time: Paul's radical conversion, and the concomitant militant subjectivity that is produced, proceeds from this 'understanding' of the past and especially of its relation to the now. To end this digression it is worth

briefly quoting Georgio Agamben who is also especially attentive to this hidden but intrinsic relation of the past to the contemporary:

> If ... it is the contemporary who has broken the vertebrae of his time (or, at any rate, who has perceived in it a fault line or a breaking point), then he also makes of this fracture a meeting place, or an encounter between times and generations. There is nothing more exemplary, in this sense, than Paul's gesture at the point in which he experiences and announces to his brothers the contemporariness par excellence that is messianic time, the being-contemporary with the Messiah, which he calls precisely 'time of now' (*ho n yn kairos*). (Agamben 2009, p. 52)

Chapter 2

1. This discovery – or invention – of the psychoanalytic unconscious might be said to have had a parallel artistic 'origin' with Surrealism and Dada, especially with its 'technologies' of automatic writing and the like.
2. As John Rajchman notes in his own reading of Lacan's *Ethics* this inversion of the ethical position is performed via an analysis of the three great ethical thinkers pre Freud: Aristotle, Kant and Bentham. Rajchman succinctly summarizes Lacan's portrayal of these three moral giants as, respectively, 'a wise friend who knows the good in which one flourishes', 'a supersensible ego who presents to one the imperative of one's obligations' and 'an efficient mental hygienist who knows how to rehabilitate one's unproductive or dysfunctional behaviour' (Rajchman 1991, p. 70). Each of these thinkers makes a decisive move on the previous definition of ethical behaviour, defining the good in their own way, but in so defining it they keep to the basic schema (that there is a good to be worked towards as it were) that Lacan's *Ethics*, following Freud, will undermine. To quote Rajchman: 'Thus unlike the ethical ideals that would "centre us" by making us wise, autonomous or productive, psychoanalysis places at the heart of experience something that "decentres us", submitting us to the singularity of our desire, the unpredictable fortune of our *amours*' (Rajchman 1991, p. 70). In relation to the previous chapter, we might also note that Nietzsche is a precursor, at least of an implicit kind, to Lacan (and, indeed, to Freud) insofar as he identifies a wider field of forces (active and reactive) that are prior to morality, or, precisely 'beyond good and evil'.
3. I want to thank Jean Mathee for introducing Lacan's *The Ethics of Psychoanalysis* to me – and to the MA Contemporary Art Theory students of 2007–8 – in a workshop she gave on the latter at Goldsmiths College, London in that year. Some of my thinking in this chapter – around the Lacanian subject – was directly inspired by the rigorous and committed approached to the *Ethics* displayed in that seminar and, indeed, to Mathee's very particular reading of Lacan (and where I reference Jean Mathee in what follows it is to the work of that seminar that I am referring). I am also indebted to Jean more directly for the figuring of Lacan's *Ethics* as a torus and for the diagram of the latter in Figure 2.4.
4. Although I do not reference it in what follows, Bruce Fink's compelling book, *The Lacanian Subject: Between Language and Jouissance*, was invaluable in helping me think through the complexities of the Lacanian subject.

5. I have already mentioned John Rajchman whose book length study similarly – and masterfully – tracks the resonances and differences between Lacan and Foucault's ethics, and which, as such, has informed parts of what follows (especially around the understanding of freedom as a practice). Indeed, Rajchman demonstrates a profound resonance around the meaning of ethics in general in both writers as that which is irreducible to whatever constituted ethics before – a suspicion, as Rajchman has it, about any 'received values' (Rajchman 1991, p. 145). 'Thus, there is Lacan's "realism" of what must always be left out in our self-idealization, and Foucault's "pragmatism" concerning what is yet free in our historical determinations' (Rajchman 1991, pp. 143–4). On the other hand, for Rajchman, Foucault was explicitly concerned with historicizing the Freudian-Lacanian revolution in ethics and in demonstrating how the latter was less a universal aspect of humanity than an invention, one with a historical moment of production, and, as such, Rajchman figures Foucault's ethical project as a grand genealogy of 'desiring man' (Rajchman 1991, p. 88). For Rajchman's Foucault then, 'our own ethical predicament would be to rid ourselves of this long internalisation through which we came to think of ourselves as "subjects of desire"', an internalization, it has to be said, premised on a certain heterosexuality (Rajchman 1991, p. 88). The 'new' ethics, following Foucault, would be one that learnt from homosexuality and the new kinds of relationships being experimented therewith, and one that thus owed very little to Lacanian models that Foucault saw as dangerously ahistorical and universalist. This would also be to privilege questions of pleasure over desire. As Foucault himself remarks in the interview 'On the Genealogy of Ethics' (*EST*, pp. 253–80):

> I think there is no exemplary value in a period that is not our period ... it is not anything to go back to. But we do have an example of an ethical experience which implied a very strong connection between pleasure and desire. If we compare that to our experience now, where everybody – the philosopher or the psychoanalyst – explains that what is important is desire, and pleasure is nothing at all, we can wonder whether this disconnection wasn't a historical event, one that was not at all necessary, not linked to human nature, or to any anthropological necessity. (*EST*, p. 259)

6. For an extensive discussion of these various practices and technologies see the interview 'Technologies of the Self' in *Ethics: Subjectivity and Truth* (*EST*, pp. 223–52). For an alternative account see Pierre Hadot's chapter on 'Spiritual Exercises' in his *Philosophy as a Way of Life* (Hadot 1995, pp. 81–125).
7. In passing we might return to Nietzsche and note here the resonances with the eternal return understood as a *test* of experience. The demon that 'steals into your loneliest loneliness' poses the question of desire that is at the heart of Lacan's Last Judgement (and, indeed, his *Ethics* in general), namely: 'Is this what you *really* want?'
8. As we shall see in Chapter 3, Guattari addresses the crucial role of asignification in relation to the production of subjectivity throughout his writing. See, as indicative, pp. 4–5 of the essay 'On the Production of Subjectivity' (*C*, p. 1–32).

9. To quote Spinoza:

> To make use of things and take delight in them as much as possible (not indeed to satiety, for that is not to take delight) is the part of a wise man. It is, I say, the part of a wise man to feed himself with moderate pleasant food and drink ... (*E* Book IV, Prop. 45, Corollary 2, note, p. 173).

10. This connection is also evidenced biographically, and somewhat anecdotally, by the adolescent Lacan having 'a diagram on the wall of his bedroom that depicted the structure of [Spinoza's] *Ethics* with the aid of coloured arrows' (Roudinesco 1997, p. 11).
11. This question of the nature of the ethical destination seems to me an important one, especially in terms of whether the latter is 'reachable' or not. Put bluntly, is it the case that one can reach beatitude – as in Spinoza's account – or, as it were, only approximate it – as in certain accounts given by ancient philosophy? In Lacan's *Ethics*, as we shall see, this is given a further twist insofar as finally arriving at the ethical destination would amount to the undoing – or death – of the subject-as-is (hence, the movement towards, but also the constant deferral of, the ethical destination in Lacan).
12. A further connection here between Foucault and Spinoza is that such a refusal of transcendent operators, and the 'work' of the subject that follows from this, takes the body as its medium insofar as the actions and practices of the latter, in their very materiality, are the site of ethics for both these thinkers. We might also note here that for Lacan it is less the body than speech (as it makes manifest the unconscious) that is the ethical site since Lacan's ethics is not about 'well being', but, as Lacan remarks in *Television*, about '*bien-dire*' (speaking-well) (Lacan 1990, p. 41).
13. See Quentin Meillassoux, *After Finitude: An Essay on the Necessity of Contingency*. I will be returning to Meillassoux, and to his critique of correlationism, in my Conclusion.
14. Pierre Hadot likewise uses the term 'spiritual' when writing of these ancient exercises, foregrounding, in resonance with Bergson (the mystic) and Spinoza (the third kind of knowledge), what might be called the *telos* of 'spiritual exercises':

> The word 'spiritual' is quite apt to make us understand that these exercises are the result, not merely of thought, but of the individual's entire psychism. Above all, the word 'spiritual' reveals the true dimension of these exercises. By means of them the individual raises himself up to the life of the objective spirit; that is to say, he re-places himself within the perspective of the Whole ('Become eternal by transcending yourself'). (Hadot 1995, p. 82)

> For Hadot, in fact, the term ethics, although relevant in that it names a 'therapeutics of the passions' and is to do with 'the conduct of life', is limited insofar as it does not attend to what we might call this properly *trans*-human and necessarily transformative moment (the same is true for the intellect which, although useful in terms of some 'spiritual exercises' does not cover the breadth of practices or their intended destination).

In many ways Hadot's account of 'spiritual exercises' is a parallel account to Foucault's 'Care of the Self' insofar as both authors list the actual practices of the ancients while also emphasizing the idea of self-knowledge and self-determination. For Hadot it is especially attention to the present moment that characterizes such practices insofar as the cause of man's unhappiness is precisely the passions, or simply anxiety about the future and remorse for the past. There are however differences between Hadot and Foucault, not least around the meaning attributed to the phrase 'know thyself', which, for Hadot, is less the precursor of the Cartesian moment than a call to self-knowledge ('it invites us to establish a relation of the self to the self, which constitutes the foundation of every spiritual exercise' (Hadot 1995, p. 90)). One area that Hadot is especially eloquent on is 'learning how to die' understood as a further key philosophical trope of ancient thought. Hadot's exemplar here is Socrates and the idea that: 'Training for death is training to die *to one's individuality and passions*, in order to look at things from the perspective of universality and objectivity' (Hadot 1995, p. 95). In the terms of the present chapter one might say that this particular death is the death of the subject-as-is. As we shall see this is also what constitutes the interest of Socrates/Plato for Badiou: the positing of a certain objective existence (in eternity) for the subject that is not reducible to a given identity, or, indeed, a biological body. In psychoanalytical terms this 'learning how to die' might also be seen as having resonances with what Lacan says about the thought experiment/test of the 'Last Judgement'.

15. Foucault goes on to describe the movement of truth (as love (or *Eros*)) as either 'an ascending movement of the subject himself, or else a movement by which the truth comes to him and enlightens him' (*H*, pp. 15–16). The parallels with Badiou are striking. Unlike Badiou, however, Foucault writes of 'another major form through which the subject can and must transform himself in order to have access to the truth' (*H*, p. 16). This is a form of work that is a 'long labour of ascesis (*askesis*)' (*H*, p. 16). It is a preparation made by the subject – 'a work of the self on the self' – that in and of itself enables the subject to have access to truth (*H*, p. 16).

16. In fact Foucault himself references Spinoza's *Treatise on the Correction of the Understanding* in the second of the year's opening lectures. To quote Foucault:

> in formulating the problem of access to the truth Spinoza linked the problem to a series of requirements concerning the subject's very being: In what aspects and how must I transform my being as subject? What conditions must I impose on my being as subject so as to have access to the truth, and to what extent will this access to the truth give me what I seek, that is to say the highest good, the sovereign good. This is a properly spiritual question ... (*H*, pp. 27–8)

17. In a nod to Bergson (and to pre-empt some discussion to come) we might map the difference between the infinite field of knowledge and the infinite nature of truth onto Bergson's cone (see Figure 2.2). In this case, P is the plane of knowledge that carries on in every direction *but remains on that plane*. A–B represents the realm of truth that likewise has an infinite

character, *but that is not unidirectional*. The question of access to this truth is then the question of point S as the intersection of the two realms. It is the point at which the finite subject might access the infinite, understood, in Spinoza's terms, as the eternal.
18. Hadot likewise names Nietzsche – and also Bergson – as figures that resonate with an older tradition of philosophy: 'Not until Nietzsche, Bergson, and existentialism does philosophy consciously return to being a concrete attitude, a way of life and of seeing the world' (Hadot 1995, p. 108). For Hadot the turn from the ancients comes about through a certain medieval understanding of philosophy as 'abstract-theoretical activity' that then becomes aligned with our modern understanding (and reaches its apotheosis in structuralism). For Hadot, as for Foucault, this is itself caused by 'the absorption of *philosophia* by Christianity' that then absorbs the other tradition – of spiritual exercises – into theology, thus consigning philosophy itself to be a kind of poor cousin of the latter (Hadot 1995, p. 107).
19. See also the essay on 'The Mirror Phase as Formative of the *I* Function as Revealed in Psychoanalytic Experience' where Lacan introduces his thesis on the latter for the 'light it sheds on the *I* function in the experience psychoanalysis provides us of it', and, crucially, that 'this experience sets us at odds with any philosophy directly stemming from the *cogito*' (Lacan 2002a, p. 75). For Lacan the ego – or conscious subject – is in fact the result of a mis-recognition and an identification with ideal images. Later in the same essay Lacan is even more pointed in his critique of such philosophy, in this case existentialism, that maintains a sovereignty of consciousness: '[u]nfortunately, this philosophy grasps that negativity only within the limits of a self-sufficiency of consciousness, which, being one of its premises, ties the illusion of autonomy in which it puts its faith to the ego's constitutive misrecognitions' (Lacan 2002a, p. 80).
20. It is worth noting here that other spiritual traditions such as Buddhism also emphasize a life of the 'middle way', which is to say, *not* one of extreme asceticism, but one that would allow a body the greatest capacity to affect and to be affected. This is the production of a body best capable of knowledge in Spinoza's sense. To return to – and extend – the passage quoted from Spinoza's *Ethics* in note 9, such 'new and varied nourishment' of the body means that 'the body as a whole may be equally apt for performing those things which can follow from its nature, and consequently so that the mind also may be equally apt for understanding many things at the same time' (*E* Book IV, Prop. 45, Corollary 2, note, p. 173).
21. I want to thank Emily Sharp for this particular diagram.
22. See Deleuze's essay 'To Have Done with Judgement' in *Essays Critical and Clinical* (Deleuze 1998, pp. 126–35). Thanks to Leon Cooley for this reference. In relation to Lacan's image of the 'Great Book' Deleuze remarks: 'In the doctrine of judgement ... our debts are inscribed in an autonomous book without our ever realising it, so that we are no longer able to pay off an account that has become infinite' (Deleuze 1998, p. 128).
23. This might be illustrated by the Möbius strip (a twisted torus) that diagrams this irreducible, but always local, difference between subject and object, the finite and infinite (Figure 2.6). However far we travel along there is always another side.

246 *Notes*

Figure 2.6 Möbius strip

24. A third Lacanian topology – or impossible object – would seem to follow this logic of folding: the Klein bottle, that diagrams the folding of the outside in (and is in fact produced by the cutting, twisting and rejoining of the Möbius strip) (Figure 2.7). My own composite diagram, although not itself a Klein bottle, might be said to foreground certain operations, or logics, that inhere in the latter.

Figure 2.7 Klein bottle

25. Here, we might say, the hero is not the one who sacrifices themselves, and their desire, for the other (the typical, we might even say Hollywood, understanding of the hero), but precisely an individual who sacrifices the other, and the other's desire, for themselves.
26. See *A Thousand Plateaus*, pp. 17–18.
27. Or, as Guattari tells it in the interview 'Liberation of Desire':

> We opted for an unconscious of superimposed, multiple strata of subjectivations, heterogeneous strata of development with greater and lesser consistency. An unconscious, thus, that is more 'schizo', liberated from familialist yokes, and turned more toward current praxis than toward fixations and regressions on the past. An unconscious of flux and abstract machines, more than an unconscious of structure and language. (Guattari 1996a, pp. 193–4)

28. Indeed, it might be said that in its focus on the analyst–analysand relation, almost despite itself, Lacanian modelizations produce atomized neurotic subjects; hence, precisely, the turn to group work with schizoanalysis. As we

have seen it is also the case that Lacan disregards the body, at least to a certain extent, which for Guattari, as it is for Spinoza and Foucault, is precisely the site of ethical work, or, again, schizoanalysis. We might note here, as a preview of the next chapter, Guattari's comment in his essay 'Subjectivities: for Better and for Worse' that links his ethico-aesthetic paradigm directly to Foucault's 'Care of the Self':

> To each of these components of the institution of care corresponds a necessary *practice*. That is, one is not before a subjectivity that is given such as the *en soi*, but rather facing a process of assuming autonomy, or of autopoiesis, in the sense given the term by Francisco Varela. (Guattari 1996c, p. 195).

29. Although Lacan, like Foucault, is specifically critical of this subject of science, in Lacan's case this is only insofar as such a subject is a subject of already assumed scientific knowledge – a subject of information as it were. Indeed, elsewhere Lacan has a notion of science that brings it more in line with what he calls the 'Hysteric's Discourse' – rather than with the typical notion of science that is the 'University Discourse' *par excellence*. At stake in the 'Hysteric's Discourse' (and indeed the 'Analyst's Discourse') is a kind of knowledge that has something in common with Spinoza and Nietzsche's own definitions of 'knowledge' as that which is precisely experimental and ultimately transformative (albeit Lacan certainly sees any philosophical discourse as a variant on the Master's Discourse). In Lacan's mathemes of the four discourses, knowledge is in the position of truth in the 'Analyst's Discourse' (emphasizing truth as transformative), whereas in the 'University Discourse' it is in the position of agent (this being scientific knowledge as a discourse of power). The 'Hysteric's Discourse' 'opposes' the 'Master's Discourse' insofar as for the former, knowledge is in the position of production (emphasizing the 'true' scientist as hysteric), whereas in the latter it is in the position of the other (knowledge, in the sense of that which might transform a subject, being what the Master defines himself against). See *Encore* (Lacan 1999, p. 16).
30. As I noted in Chapter 1 (see end of note 47), Lacan has very little time for those experiences that are, strictly speaking, ineffable. However, in the seminar on *The Ethics of Psychoanalysis*, which in fact dates from the same time as 'The Subversion of the Subject and the Dialectics of Desire' (from where Lacan's previous comments were extracted), we find a more generous and open attitude towards this 'other' tradition:

> Of course, not every catharsis can be reduced to something as external as a topological demonstration. When it is a matter of the practices of those whom the Greeks called μαινομενοι, those who go crazy through a trance, through religious experience, through passion or through anything else, the value of catharsis presupposes that, in a way that is either more-or-less directed or wild, the subject enters into the zone described here, and that his return involves some gain that will be called possession or whatever – Plato doesn't hesitate to point this out in the cathartic procedures. There is a whole range there, a spectrum of possibilities, that it would take a whole year to catalogue. (Lacan 2002b, pp. 323–4)

The path of the mystic that we traced in the last chapter might be seen to follow precisely this return journey.
31. For a discussion of the *hypomnēmata* see Foucault's essay 'Self Writing' (*EST*, pp. 207–21), specifically pp. 209–14. *Parrhēsia* is addressed at different moments in *The Hermeneutics of the Subject*; see, for example, p. 366.
32. For an extended discussion of the master see pp. 246–7 in Foucault's 'Technologies of the Self' in *Ethics: Subjectivity and Truth*, pp. 223–52.
33. Might it also be said that Lacan looked to these new ways of folding – especially of the Real – in his own late work? This would be the place to consider the seminars on the RSI and *Le Sinthome* understood as particular artistic technologies of the production of subjectivity. This is a project I leave to a later date, although it is worth suggesting here that with the positing of knots between the three realms of the Real, Symbolic and Imaginary Lacan moves away from the symbolic/real bar, and, as such, moves closer to a position such as Deleuze and Guattari's.

Chapter 3

1. As Guattari remarks in an earlier interview ('A Liberation of Desire'):

 For Gilles Deleuze and me desire is everything that exists *before* the opposition between subject and object, *before* representation and production. It's everything whereby the world and affects constitute us outside of ourselves, in spite of ourselves. It's everything that overflows from us. That's why we define it as flow [*flux*]. (Guattari 1996a, p. 205)

 Guattari is talking specifically about *Anti-Oedipus* and the refiguring of desire as plenitude (rather than lack) that takes place in that book, but replace desire with chaosmosis and we have a statement about his own solo writings (indeed, perhaps the most notable change in the ten or so years between this interview and *Chaosmosis* is Guattari's reframing of the question of desire and desiring-machines in terms of chaos and complexity). In the interview Guattari is interested especially in the repression of this desire – or what he calls micro-fascisms. In the terms of *Chaosmosis* micro-fascisms might be understood as those models of subjectivity that are hierarchized, organized around transcendence – and, crucially, have become petrified.
2. We might compare this with the account of art that Guattari and Deleuze give in *What is Philosophy?*: 'Art wants to create the finite that restores the infinite: it lays out a plane of composition that, in turn, through the action of aesthetic figures, bears monuments or composite sensations' (*WP*, p. 197).
3. And in 'Machinic Orality and Virtual Ecology' (*C*, pp. 88–97), an essay concerned with mapping the resonances between psychosis and creativity, we are given another 'definition' of such practices that might in fact also be part of the aesthetic paradigm:

 Strange contraptions ... these machines of virtuality, these blocks of mutant percepts and affects, half-object half-subject, already here in sensation and outside themselves in fields of the possible. They are not usually found at

the usual marketplace for subjectivity and maybe even less at that for art; yet they haunt everything concerned with creation, the desire for becoming-other, as well as mental disorder or the passion for power. (C, p. 92)

4. See especially pp. 34–5 of *Anti-Oedipus* for an account of capitalism in these terms.
5. This 'effacement of polysemy' might be seen in the standardizing individuating mechanisms of web 2.0 that masquerade as interactive and participatory (for example Facebook). Indeed, Guattari is prescient here, as elsewhere, as regards the dangers (as well as the hopes) of new media, referring to a language 'rigorously subjected to scriptural machines and their mass media avatars. In its extreme contemporary forms it amounts to an exchange of information tokens calculable as bits and reducible on computers' (C, p. 104).
6. I will be exploring some of this terrain in the third section of Chapter 5.
7. Duchamp is the privileged exemplar of the aesthetic paradigm, as evidenced also in Guattari's definition of the readymade (in this case the *Bottlerack*) in the essay 'Ritornellos and Refrains' as a 'trigger for a constellation of referential universes' (Guattari 1996b, p. 164). Although Guattari is increasingly seen as providing the theoretical model for expanded practices beyond the object – as in relational aesthetics (see Bourriaud 1998) – we can see in the three Assemblages, or at least in the third, the importance of an object of sorts, or rather an intentional point, around which a subjectivity might cohere. This point of self-assertion or autonomy will necessarily involve a break with typical transcendent schema and signifying regimes, and, as such, art once more points the way. As Guattari remarks in 'On the Production of Subjectivity' (C, pp. 1–32): '[a] singularity, a rupture of sense, a cut, a fragmentation, the detachment of a semiotic content – in a Dadaist or surrealist manner – can originate nuclei of subjectivity' (C, p. 18). In that essay Guattari turns to Mikhail Bahktin for whom it is 'the event of striving, the axiological tension' that operates as this point, and 'that "takes possession of the author" to engender a certain mode of aesthetic enunciation' (Guattari quotes Bahktin, C, p. 14). For a more thorough account of Guattari's relation to Bahktin see Stephen Zepke's essay 'From Aesthetic Autonomy to Autonomist Aesthetics: Art and Life in Guattari' in the recent collection *The Guattari Effect*.
8. Indeed, in Lacanian terms we might say that the second Assemblage involves an imposition of the Symbolic 'over' the Real; in the third Assemblage this Symbolic is then folded-in, brought 'down' to the Real, where it becomes a singular point – a name – around which a subjectivity might crystallize. In terms of Lacan's *The Ethics of Psychoanalysis* we might say that the difference between the first and second Assemblages, in this specific sense, is that in the first, one 'eats the book', which is to say, takes up a position within a symbolic which, by definition, predetermines the positions available, whereas in the second, the book is itself re-written, which is to say the symbolic is made over in the subject's own image.
9. Is it a coincidence that the third Assemblage (as I have drawn it), again resembles the Klein bottle used by Lacan as a model of the psyche (see Figure 2.7 in footnote 25 of Chapter 2). Following the work of Chapter 2, this is a model in which transcendence has been 'folded-in' and the subject has thus

become a cause of him or herself (the goal of analysis). As we saw in Chapter 1, a similar 'manoeuvre' – the folding-in of transcendence – is at stake in both Spinoza's third kind of knowledge (no longer being subject *to* a world) and Nietzsche's eternal return (the affirmation of which enables a mastery of one's own destiny).

10. The notion of machinic being is developed in the essay 'Machinic Heterogenesis' (C, pp. 33–57) where the 'entities' are defined as 'abstract machines' that traverse chaos and complexity, giving the different levels of being 'an efficiency, a power of ontological auto-affirmation' (C, p. 35). In that essay Guattari extends his machinic ontology out to the universe, positing the existence 'of other autopoietic machines at the heart of other bio-mecanospheres scattered throughout the cosmos' (C, p. 51), while at the same time, following the new aesthetic paradigm, foregrounding the importance of 'machines of desire and aesthetic creation' in today's 'assemblages of subjectivation' (C, p. 54).

11. In 'Machinic Orality and Virtual Ecology' (C, pp. 88–97) these pre-objectal 'entities' are defined in psycho/schizoanalytic terms: 'In the wake of Freud, Kleinian and Lacanian psychoanalysts apprehended, each in their own way, this type of entity in their fields of investigation. They christened it the "part object", the "transitional object", situating it at the junction of a subjectivity and alterity which are themselves partial and transitional' (C, p. 94). This notion of part objects is part of the genesis of Deleuze and Guattari's 'desiring-machines' that further 'rupture with Freudian determinism', situating the latter in more expanded and incorporeal 'fields of virtuality' (C, p. 95).

12. In 'Machinic Orality and Virtual Ecology' (C, pp. 88–97) Guattari would seem to have Spinoza in mind when he describes new practices of orality – such as performance art – as involving 'a search for enunciative nuclei which would institute new cleavages between other insides and other outsides and which would offer a different metabolism of past-future where *eternity will coexist with the present moment* [my italics]' (C, p. 90).

13. See also *What is Philosophy?* where the three great forms of thought – art, philosophy, science – are characterized as *chaoids*: 'compositions' or 'daughters' of chaos *(WP*, p. 204). I will be returning to this in Chapter 5.

14. Or as Guattari has it in 'Schizo Chaosmosis' (C, pp. 77–87): '[a]nd chaos is not pure indifferentiation; it possesses a specific ontological texture. It is inhabited by virtual entities and modalities of alterity' (C, p. 81).

15. In Guattari's essay 'On the Production of Subjectivity' (C, pp. 1–32) these entities are defined as 'existential refrains' to draw attention to this temporal aspect. Here is the paragraph in full where Guattari articulates the refrain's local temporalization, or what we might call singular crystallization of time:

> What we are aiming at with this concept of the refrain aren't just massive affects, but hyper-complex refrains, catalysing the emergence of incorporeal Universes such as those of music or mathematics, and crystallising the most deterritorialised existential Territories. This type of transversalist refrain evades strict spatio-temporal delimitation. With it, time ceases to be exterior in order to become an intensive nucleus [*foyer*] of temporalisation. From this perspective, universal time appears to be no more than a hypothetical projection, a time of generalised equivalence, a 'flattened' capitalistic time; what is important are these partial modules

of temporalisation, operating in diverse domains (biological, theological, socio-cultural, machinic, cosmic ...) and out of which complex refrains constitute highly relative existential synchronies. (*C*, p. 16)

16. As Guattari remarks in 'On the Production of Subjectivity' (*C*, pp. 1–32): 'An incorporeal universe is not supported by coordinates embedded in the world, but by ordinates, by an intensive ordination coupled for better or worse to these existential territories' (*C*, p. 28). As I suggest below, these 'incorporeal universes' or actual–virtual ecologies might be productively thought as the content of Bergson's cone. The 'grasping' here then is the work of creative memory.
17. This particular 'image' of the production of subjectivity has a precursor in the looping circuits the subject traces around the desiring-machines/Body without Organs. I will return to this, and draw a diagram that might also show the operation of the transmonadic line/strange attractor, in the first section of Chapter 5.
18. Although there is not space to develop this here we might ask what ultimately determines the trans-monadic line – or the 'choice of finitude' – that begins the process of subjectivation? To a certain extent, for Guattari, this process is self-organizing, structure forming, naturally as it were, from chaos. However it seems to me, as I hope I have demonstrated, that some kind of folding-in of a transcendent point is required. Another way of thinking this is in terms of Buddhism and the idea of karmic streams. Here volitions themselves are the cohering mechanism – the 'stickiness' – insofar as they cause a re-cohesion, or rebecoming of a subject.
19. In the essay 'Schizo Chaosmosis' (*C*, pp. 77–87) this 'giving consistency' is figured as 'worlding':

 > worlding a complexion of sense always involves taking hold of a massive and immediate ensemble of contextual diversity, a fusion in an undifferentiated, or rather de-differentiated whole. A world is only constituted on the condition of being inhabited by an umbilical point ... from which a subjective positionality embodies itself. (*C*, p. 80)

 Again, this 'worlding' takes place 'before space and time, before spatialisation and temporalisation' (*C*, p. 81).
20. Deleuze attends similarly to a transmonadic line that produces a new kind of subjectivity in his own solo book post *What is Philosophy?*: *The Fold: Leibniz and the Baroque*. See especially the last few pages where Leibniz's monad, that 'submit[s] to two conditions, one of closure and the other of selection' is prised open 'to the degree that the world is now made up of divergent series (the chaosmos)' (Deleuze 1993, p. 137). This is the replacement of monadology with 'nomadology', defined as involving 'new ways of folding' (Deleuze 1993, p. 137). Indeed, in general, it seems to me that Deleuze's book parallels Guattari's investigations, albeit utilizing Leibniz rather than the new sciences, in mapping out the possibility of a more processual subjectivity and specifically the nature of those entities, or autopoietic points, around which a subjectivity might gather.
21. A key question here is whether capitalism also now operates through this processual immanence, and, in which case, where this leaves the

ethicoaesthetic paradigm itself. To a certain extent Guattari's collaboration with Deleuze addresses this problem insofar as in *Anti-Oedipus* it is no longer a question of resisting capitalism, but, precisely, of accelerating its generative and genuinely productive aspects. The issue here would be that capitalism is itself schizophrenic in its operation, but that this experimental and deterritorializing tendency is captured, limited by a further tendency of capitalism, intent on standardization and a concomitant siphoning of surplus value from the flows. It is this second mode of capitalism that needs combating through the affirmation of the first deterritorializing mode.

22. Guattari ends 'The New Aesthetic Paradigm' (*C*, pp. 98–118) with a consideration, and redefinition, of the body as always already a multiplicity of different bodies, different interfaces that intersect and that are 'open to the most diverse fields of alterity' (*C*, p. 118). Indeed, the body – as it is for Bergson and Spinoza – is the very name of the relation, but also the means of passage, between the actual and virtual (or the finite and infinite). This might be compared with Badiou where the body – in its biological sense – is the name for that which stymies access to the infinite.

23. In the final essay of *Chaosmosis*, 'The Ecoscopic Object' (*C*, pp. 119–35), this refrain becomes the 'ecoscopic object' of the chapter's title and the four quadrants become its four dimensions – or strata – of existence. As Guattari remarks: '[w]ithin each of these strata, each of these Becomings and Universes what is put into question is a certain metabolism of the infinite, a threat of transcendence, a politics of immanence' (*C*, p. 125).

24. We might usefully compare the diagram of the real/possible and actual/virtual in Figure 3.6 with Deleuze's own on the same from *The Fold*. Deleuze's accompanying comments are as follows:

> The world is a virtuality that is actualized in monads or souls, but also a possibility that must be realized in matter or bodies ... The process of actualization operates through distribution, while the process of realization operates by resemblance. This raises the especially delicate point. For if the world is taken as a double process – of actualization in monads and of realization in monads – then in what does itself consist? How can we define it as *what* is actualized and realized? We find ourselves before events. (Deleuze 1993, p. 105)

Although there is not space here to work out the specific resonances (and differences) between Deleuze's Leibniz and Guattari's account of subjectivity in *Chaosmosis*, it does seem to me that it is also the idea of 'subjectivity as event' (an actualization *and* a realization) that is at stake in Guattari's aesthetic paradigm.

25. This latter intention is even more explicit in other earlier diagrams, for example that in Figure 3.7 taken from Guattari's essay 'The Place of the Signifier in the Institution' (Guattari 1996d). As Janell Watson points out, this diagram – or metamodel – 'swallow[s] up Lacan's models of the linguistically-dominated psyche' (Watson 2008: n.p.). One can see this clearly in the diagram where signifying semiologies are placed in a larger context

Figure 3.6 Deleuze's diagram of the actual–virtual/real–possible (from 'The Two Floors', *The Fold*)

Figure 3.7 Guattari's diagram from 'The Place of the Signifier in the Institution', *The Guattari Reader*

of asignifying semiotics and the Hjemslevian categories of form, content, substance and matter are used to expand and complexify the dualisms of signification. Watson draws attention to the importance of 'asignifying semiotics' in this framework precisely because they bypass substance and involve form working directly on matter. This then is to avoid signifying regimes altogether (and thus, theoretically, the various capitalist subjectivities produced by them). This asignifying semiotics might also be called the aesthetic paradigm, involved as it is in the production of blocs or entities composed of sensations and intensities.

26. The notion of the 'atmospheric' is important to schizoanalysis. See David Reggio's interview with Jean Oury where the latter links this interest back to Tosquelles' earlier experiments in institutional psychotherapy: 'I've always

said, and will continue to say in drawing upon Tosquelles and others, that atmosphere, ambience, is important because today we have the grave ideologies of the pseudo neurosciences which say that atmosphere is not important' (Oury quoted in Reggio 2004, n.p.).

27. See especially the section 'Memories of a Molecule' in the Becoming plateau of *A Thousand* Plateaus, pp. 272–86.
28. In the essay on 'Schizo Chaosmosis' (*C*, pp. 77–87) Guattari calls these moments 'Z or Zen points of chaosmosis, which can only be discovered in nonsense, through the lapsus symptoms, aporias, the acting out of somatic scenes, familial theatricalism, or institutional structures' (*C*, p. 85). This implies a form of group, or institutional psychiatry insofar as it follows from the above that such points are 'not exclusive to the individuated psyche' (*C*, p. 85).
29. This is in fact to follow Deleuze and Guattari in *Anti-Oedipus*, where the subject is a kind of side effect of the oscillation between desiring-machines and the body without organs, *but also* the product of a retroactive recognition and claiming of this residuum. As Deleuze and Guattari say, a '"So it's me!"' (*AO*, p. 20). I will return to this particular quote and this retroactive claiming in my final chapter.
30. As we noted towards the end of Chapter 2, *Hupomnēmata* were notebooks – that constituted 'a material and a framework for exercises to be carried out frequently: reading, rereading, meditating, conversing with oneself and others' (*EST*, p. 210). Their purpose, as Foucault remarks, 'is nothing less than the shaping of the self' (*EST*, p. 211).
31. In passing it is worth noting that we can clearly see this co-existence of signifying and asignifying semiotics within contemporary art practice, insofar as it involves each of the three moments above. For a discussion along these lines see my essay 'From Aesthetics to the Abstract Machine: Deleuze, Guattari, and Contemporary Art Practice'.
32. This is mirrored in Jean Oury's own take on the work at *La Borde*: '[w]e work at the level of the poetic, a level infinitely more complex than the logic of computers and neuroscience ... We work at the level of gestures here at *La Borde*. This is within the domain of what is called the "deictic"' (Oury quoted in Reggio 2004, n.p.).
33. Or, in more simple terms:

> For psychoanalysis the unconscious is always *already there*, genetically programmed, structured, and finalized on objects of conformity to social norms. For schizoanalysis it's a question of constructing an unconscious not only with phrases but with all possible semiotic means, and not only with individuals or relations between individuals, but also with groups, with physiological and perceptual systems, with machines, struggles, and arrangements of every nature. (Guattari 1996a, p. 206)

34. In the earlier interview quoted above Guattari refers to this asignifying semiotics as a semiotics of the body: 'what I call the semiotics of the body, is something specifically repressed by the capitalist-socialist-bureaucratic system. So I would say that each time the body is emphasized in a situation – by dances, by homosexuals, etc. – something breaks with the dominant

semiotics that crush the semiotics of the body' (Guattari 1996a, p. 205). Such a semiotics will involve what Deleuze and Guattari call a 'becoming-woman' when this involves forms of sexuality and subjectivity that are specifically non-phallocentric and thus closer to the 'situation of desire' (Guattari 1996a, p. 205; *ATP*, pp. 275–7). In passing, it is important to note that asignification does not only work in the direction of the 'liberation of desire', but can also be part of its repression. Gary Genosko alerts us to this important point when he writes, for example, of the 'triggering action' of 'part signs' – 'PINS/passwords', 'the magistripe-reader encoding-decoding relation' that 'do without mental representation' and that allow or block access to information and the like (Genosko 2009, pp. 96–9).

35. As Guattari remarks in 'On the Production of Subjectivity' (*C*, pp. 1–32):

> I am only emphasising that the existential registers concerned here involve a dimension of autonomy of an aesthetic order. We are faced with an important ethical choice: either we objectify, reify, 'scientific' subjectivity, or, on the contrary, we try to grasp it in the dimension of its processual creativity. (*C*, p. 13)

36. As Guattari has it: 'To speak of machines rather than drives, Fluxes rather than libido, existential Territories rather than instances of the self and of transference, incorporeal Universes rather than unconscious complexions and sublimation, chaosmic entities rather than signifiers ...' (*C*, p. 126).

37. Although Guattari does not address this directly it would seem to me that metamodelization will require the development of introspective strategies to break certain modelizations (or simply habits). I have addressed this elsewhere in relation to meditation (O'Sullivan 2008, pp. 99–100). Guattari's attitude is that such breaks happen through group interaction, but, one might ask, how can one really work with collectivity on the molecular and sub-individual level without some kind of practice of introspection?

38. Guattari links his thesis of metamodelization to the practice of 'ecosophy' in the final essay of *Chaosmosis*:

> The ecological crises can be traced to a more general crisis of the social, political and existential. The problem involves a revolution of mentalities whereby they cease investing in a certain kind of development, based on a productivism that has lost all human finality. Thus the issue returns with insistence: how do we change mentalities, how do we reinvent social practices that would give back to humanity – if it ever had it – a sense of responsibility, and not only for its own survival, but equally for the future of all life on the planet, for animal and vegetable species, likewise for incorporeal species such as music, the arts, cinema, the relation with time, love and compassion for others, the feeling of fusion at the heart of the cosmos. (*C*, pp. 119–20)

This final essay draws out the political implications of the ontology and ethics, as I have called them above, of Guattari's system – a politics that would be post-human in that it attends to *other* forms of organic and

inorganic life. This 'science' of ecosophy might be said to be the extension of schizoanalysis from the institution to the world (in this respect, see also Guattari's *The Three Ecologies*). Importantly, once more, the arts and the aesthetic paradigm more generally, have a privileged place here inasmuch as art can produce the new subjectivities which Guattari's ecosophy calls for and gestures towards:

> The artist – and more generally aesthetic perception – detach and deterritorialise a segment of the real in such a way as to make it play the role of partial enunciator. Art confers a function of sense and alterity to a subset of the perceived world. The consequence of this quasi-animistic speech effect of a work of art is that the subjectivity of the artist and the 'consumer' is reshaped ... The work of art, for those who use it, is an activity of unarming, of rupturing sense, of baroque proliferation or extreme impoverishment, which leads to a recreation and reinvention of the subject itself. (C, p. 131)

39. We might note also here the resonances this has with the Bergsonian schema from *Matter and Memory*, especially as reconstructed by Meillassoux in his compelling essay 'Subtraction and Contraction'. Meillassoux identifies two kinds of death in Bergson's account: a 'reactive death': 'by narcosis, by exhaustion, by an ever-increasing indifference to the world'; and a 'creative death': 'an *infinite madness* ... a saturation, an abominable superfluity of existence' (Meillassoux 2007, pp. 103–4).

40. Virno also makes an interesting argument about how 'bad sentiments' – such as cynicism and opportunism – arise from a basically 'neutral core'. This neutral emotional tonality is connected to the way in which our emotional life is almost directly connected to the relations of production, a state of precarious labour that actually exists beyond (and before) a generalized nihilism that itself arises from an increasing lack of foundations, or reference. The key point here is that the very thing that produces certain bad sentiments might produce something different. As Virno remarks 'the antidote, so to speak, can be tracked down only in what for the moment appears to be poison' (Virno 2004, p. 10). Virno illustrates this idea in reference to what he calls 'idle talk': speech that happens without any clear referent; and curiosity: a kind of intoxication with the new. For Virno, following Heidegger, both exemplify an 'inauthentic life' in which the 'world workshop' has become a 'world spectacle'. Indeed, again following Heidegger, it is practice, or what Virno calls labour, that constitutes a genuine interaction with, and thus a 'belonging' to, the world:

> to belong to the world does not mean contemplating it in a disinterested fashion. Rather, this belonging indicates a pragmatic involvement. The relation with my vital context does not consist, above all, of acts of comprehension and representation, but of an adaptive practice, in the search for protection, of a practical orientation, of a manipulative intervention upon surrounding objects. (Virno 2004, p. 15)

We might note here the connections with my remarks about Bergson in Chapter 1 as regards the idea of action taking precedence over contemplation.

We might also note the resonances with Badiou, where, as we shall see, life, when it is truly lived, is always active and generative. Importantly for Virno, however, these negative aspects of capitalism contain within them the germ of something different. Idle talk, for example, is a kind of murmuring that is also the crucible for new uses of language, new modes of expression. Curiosity – or simply the endless reproducibility of all aspects of life – might also, following Benjamin, bring about a democratization of art.

41. See especially 'The Poisoned Soul' in the latter book (Berardi 2010, pp. 106–83), and in direct relation to Guattari, the chapter on 'The Happy Depression' in the book on Guattari (Berardi 2008, pp. 9–15).
42. In Hardt and Negri's *Empire*, *kairos* is figured as the productive capacity of the multitude – understood as precisely a collective of such bodies. This productive capacity is beyond measure: virtual and infinite in nature, it exists prior to an Empire that is essentially parasitic on it. Put simply, the multitude is generative and constitutive, while Empire is merely regulative. For Hardt and Negri the key question is how this virtual might become possible and then real. The terms are used differently to Deleuze, with an emphasis more on the possible than the virtual, but nevertheless the ontological coordinates are similar: 'We are situated precisely at the hinge of infinite finitude that links together the virtual and the possible, engaged in the passage from desire to a coming future' (Hardt and Negri 2000, p. 361). Empire attempts to hold this gap open, living labour, or the multitude, attempts to close it. This then is the terrain of capitalism *and* its counter-movement that attempts to establish a relationship between the finite and the infinite in a situation in which, at least in part, a non-relation is maintained.
43. 'As Burroughs says, language is not a cannon that fires missiles, but a spaceship in which we live and with which we construct trajectories of truth in the void' (*TR*, p. 180).
44. Or, as Nietzsche has it in *The Gay Science*: 'But let us also not forget that in the long run it is enough to create new names and valuations and appearances of truth in order to create new "things"' (*GS* 58, p. 70).
45. Can in fact something be called forth by another method that is not a naming? For example by an artwork, or, in Deleuzian terms, a 'bloc of sensations'? Here art would operate as a technology of *kairos*, calling forth a world, and, following Deleuze, a people adequate to it. A second question also arises here: what is the connection between this future-orientation and the actual production of subjectivity in the present? Or, put differently, what is the connection between art and life? This, it seems to me, is Guattari's particular contribution to this area insofar as he foregrounds aesthetics as a specifically constructive discipline. I will return to this in the final part of Chapter 5.

Chapter 4

1. In the terms of Chapter 2 the encyclopaedia is Lacan's symbolic. We might also say – thinking back to Guattari and Chapter 3 – that the encyclopaedia operates as a transcendent enunciator insofar as it demarcates what counts as knowledge and thus what determines value.

2. As an addendum here (and as a delayed continuation to some of the discussion of Chapter 2 (see note 19 to that chapter)) it is worth noting Badiou's view that despite Lacan's own critique of the *cogito* he – Lacan – nevertheless remains within the Cartesian tradition insofar as Lacan's act of subversion (of the subject) implies a kind of fidelity to Descartes' founding gesture of 'centring' such a subject. As Badiou remarks in the final meditation of *Being and Event*: 'What localizes the subject is the point at which Freud can only be understood within the heritage of the Cartesian gesture, and at which he subverts, via dislocation, the latter's pure coincidence with the self, its reflexive transparency' (*BE*, p. 432). Badiou's summing up of his own philosophical project involves the claim that he has moved beyond this 'positioning' of the subject – even if it has been inverted, as with Lacan – insofar as he, Badiou, locates the void 'as generic hole in knowledge' not within the 'being-in-situation' but as precisely radically separate to this (hence his theory of an extra-ontological event that alone can call a subject into being – and that puts him more radically at odds with the Cartesian tradition) (*BE*, pp. 432–4). It seems to me that Badiou somewhat overstates the case, perhaps to differentiate his own system of thought from his Master's, nevertheless the idea of a 're-positioning of the "void"' does allow us to think further the differences and resonances between Badiou, or indeed the Foucault of Chapter 2, and Lacan. Indeed, on the face of it, Foucault would seem to have more in common with Badiou than Lacan insofar as the former's notion of spirituality involves accessing a radical outside to the subject – 'truth' – that then transforms that subject. However, as I hope I have demonstrated in Chapter 2, this outside might itself be thought as an outside that is folded inside. Truth, or the void, relocated by Badiou contra Lacan as outside the subject (and the situation) is folded back into the deepest interiority of the subject by Foucault (especially in Deleuze's reading). The location of this void has implications for the practices of transformation that follow from it. Thus, with Lacan it is the 'speaking cure', or simply the subject overhearing themselves speaking; with Badiou it is fidelity to an event that comes from outside of the subject that it has nevertheless called into being; and with Foucault it is the processual deployment of technologies of the self that allow a kind of side stepping of the subject as constituted.
3. See also note 16 below where I survey a number of accounts of Deleuze's Univocity.
4. The third section of Chapter 5 involves a more sustained look at this idea of practices that dismantle subjectivity (in this case, through the concept of 'probe-head' from *A Thousand Plateaus*).
5. See Badiou's chapter on 'The Virtual' in *Deleuze: The Clamor of Being* (pp. 43–54)
6. I will be looking at Deleuze's collaboration with Guattari in Chapter 5. It is worth noting here, however, that in contradistinction to Badiou's subject-to-truth, and Deleuze's scepticism of, and, indeed, occasional all out assault on, subjectivity, Guattari in his own writings – as we saw in Chapter 3 – maintains a politics of the subject that follows from a definition of subjectivity that is constructive, materialist, and, insofar as it is pitched against Lacan, not reducible to the signifier, or we mighty say, contra Badiou, the matheme. Indeed, subjectivity, for Guattari, is collective and specifically relational.

Guattari gives a succinct definition of this subjectivity in the essay 'On the Production of Subjectivity' (*C*, pp. 1–32): 'The ensemble of conditions which render possible the emergence of individual and/or collective instances as self-referential existential Territories, adjacent, or in a delimiting relation, to an alterity that is itself subjective' (*C*, p. 9). It follows directly from this that the operating terrain of subjectivity, for Guattari, is not fidelity, but – as it is for Foucault – aesthetic production, albeit, for Guattari, this is what we might call a 'chemo-aesthetics':

> Just as chemistry has to purify complex mixtures to extract atomic and homogenous molecular matter, thus creating an infinite scale of chemical entities that have no prior existence, the same is true in the 'extraction' and 'separation' of aesthetic subjectivities or partial objects, in the psychoanalytic sense, that make an immense complexification of subjectivity possible – harmonies, polyphonies, counterpoints, rhythms and existential orchestration, until now unheard and unknown. (*C*, pp. 18–19)

My suspicion is that Badiou would read Guattari's particular definition of subjectivity as being synonymous with the 'bodies and languages' of democratic materialism. However, again as we saw in Chapter 3, Guattari's idea of a body is that it has actual and virtual aspects (it has a non-corporeal existence). It is also constituted as much by pre-verbal intensities as by language. As such, it cannot be reduced to Badiou's definition of the subject of democratic materialism (and has more in common, as we shall see, with Deleuze's idea of an 'individual').

Guattari's own definition of the production of subjectivity – in which we interact with each other and with the materials of the world – might be seen to have its origins in the experimental pragmatics of *La Borde*. Badiou's theory of the subject – with its fidelity to an otherworldly event – is certainly the result of his own experiencing of the revolutionary moment of 1968 (and a concomitant faith in what that event promised). Is there any intersection of these two diagrams (beyond the obvious importance of 1968 for both)? In fact, we might say that the event – understood as a creative moment of rupture – is common to both Badiou and Guattari, as is, indeed, the idea that subjectivity or the subject is a result of this event. As we saw in Chapter 3, for Guattari, it is 'around' an event that a given subjectivity coheres; but this is not an event that is extra-ontological. Indeed, it is an event that is very much in and of the world. For Deleuze there is no production of a subject in the sense that both Guattari and Badiou, in their different ways, posit it (although, for Deleuze the event is likewise a crucial concept). Might there however be a third intersection between all three in the Spinozist idea, echoed also by Lacan, of an individual becoming a cause of itself?

7. The subject is somewhat like a tuning fork in this sense, testing the different elements of the situation for any resonances they might have with the event that has itself set the fork vibrating.
8. In another essay, 'The Ethic of Truths: Construction and Potency', this technology of forcing is re-named, by Badiou, 'fictioning':

> What happens is that we can always *anticipate* the idea of a completed generic truth. The generic being of a truth is never presented. A truth is

uncompleteable. But we can know, formally, that a truth will always have taken place as a generic infinity. Thus the possible fictioning of the effects of its having-taken-place. The subject can hypothesize a universe wherein this truth, of which the subject is a local point, will have completed its generic totalization. I call the anticipating hypothesis for the generic being of truth, a *forcing*. Forcing is the powerful fiction of a *completed* truth. (2001, p. 252)

Without doubt this formulation of forcing is particularly useful in thinking especially about art practice. What the above quote highlights, however, is the same paradox of *Being and Event*, namely that the very truth which is fictioned can never, of itself be presented within a situation or a world (that is, it cannot be 'completed').

9. This might also be defined as the coming into form of that which was hitherto formless. This passage *is* the event, with the 'subject of art' maintaining a fidelity to it. We might, following this definition, map out various events and their subjects in the history of art. Two immediately spring to mind in the modern era: the Duchamp event and the Pollock event. In each, it was the coming to be considered art of that which was hitherto considered non-art that characterizes the event. Duchamp placing a Readymade in a gallery; Pollock's experimentations with non-figuration and especially the drip technique that involved laying the pictures on the ground (denying pictorial illusion). In each case the artwork operates as a forcing statement: its existence *as* art will only have been verified once the situation that the work helps bring about comes into being (the situation of painting post Pollock; the situation of (contemporary) art post Duchamp). Although there is not the space to do this here, one might follow the logics of *Logics of Worlds* and identify the body and trace, as well as subject and event, within these moments, as well as, crucially, the question of what, in each case, fidelity might involve – especially in terms of the production of further works (and this might well involve a practice that appears to be an act of infidelity, indeed, ultimately, how could a genuine fidelity to the event of art appear otherwise?).

10. In his essay on 'The Subject and the Infinite' (from the collection *Conditions*, that contains essays written post-*Being and Event*, but pre-*Logics of Worlds*) Badiou differentiates his own philosophical attitude from Lacan's non-philosophy specifically on what he sees as their two different understandings of the infinite. According to Badiou, for Lacan, despite his invocation of Cantor, the infinite remains an 'operational fiction', a cipher for that which is inaccessible to the subject (following Lacan's seminar *Encore* this infinite is feminine jouissance that, ultimately, is determined by, and as the negative to, the phallic function). For Badiou, on the other hand, the infinite (as Cantor had shown) is real. In fact, for Badiou, Cantor's revolution means that the infinite cannot be thought as merely being determined by the finite (feminine jouissance is not solely determined by the phallic function). Indeed, this is what defines a generic truth: it is not determined by any one worldly – or finite – situation. Badiou draws a second consequence from Lacan's error in locating the infinite between 1 and 2, namely that, in fact, the 2 is 'reachable' through the 1 (there is not a break, or crack as it were between them). If for Lacan there can be no sexual relation precisely because of this infinite

figured as gap, for Badiou, with love, the infinite – as generic truth – allows the 2 to arise and move towards the infinite. For Lacan the infinite is within the gap of the split subject; for Badiou the infinite is the very atmosphere in which subjects are produced and, crucially, is instrumental in how they are produced. If for Lacan the 2 is a tragedy; for Badiou it is consummation when this is understood as 'disjunctive truth' (Badiou 2008, p. 227).

For Badiou then, Lacan's thought is tied to a finitude that although invoking it, actually disavows the infinite. But, to jump ahead to an argument I make later in this chapter, we might ask what the subject's relation to this infinity can be in Badiou's system if not precisely a non-relation? Badiou might want to claim a more privileged access to the Real (than Lacan), but it seems to me that in the detail of his account of the subject (including the subject of love) the infinite cannot but be a cipher for that which is inaccessible, and cannot but, as Badiou admits, be the product of an axiomatic decision (certainly the knowledge of this infinite is restricted to the mathematician, and, by extension, the philosopher, *but* the question remains as to a finite subject's relation to this real infinite. It seems to me that despite Cantor's proof of the existence of the infinite, as far as the subject goes, within Badiou's system, it remains precisely an object of faith, or, precisely, an 'operational fiction' of that which is inaccessible). Would this not be Lacan's rejoinder? Indeed, the question for Badiou is whether, essentially, there is a difference between an 'operational fiction' and an axiom. As I hope I have demonstrated the doctrine of the event is Badiou's attempt to cross this finite–infinite gulf, but, it seems to me, the notion of the event itself implies and maintains this gap.

The problem arises, in both Lacan and Badiou, when the subject is defined as either being of the signifier or of the matheme. In each case a rift is produced between this subject-of-representation and the world, the body, and so forth. For Badiou this rift actually gives the subject an existence within infinity insofar as such a subject is irreducible to the finite body. But the same move also means that this infinite is always abstract and ideal, divorced from the circumstances of a living body, that from a different perspective in fact always already partakes of the infinite (this being the virtual of Bergson and Deleuze). Whereas for Badiou the existence of the infinite, insofar as it is inaccessible, can only be the result of a decision, that is, an axiom; for Deleuze, following Spinoza, the infinite is in a liveable relation – a continuum – with the finite.

11. As the final diagram of the first part of Chapter 1 shows (see Figure 1.5), ultimately this is to depart even further from the Bergsonian schema of a virtual and actual that differ in kind, and, instead, to place both on the same plane of life as it were. This, it seems to me, being the move that Guattari's influence, and practical experience, allowed Deleuze to make in their collaboration (as we saw in the previous chapter, Guattari also – more theoretically – figures the chaos-complexity relation as reciprocal and, as it were, existing on the same plane). In their collaboration, *A Thousand Plateaus*, an individual is defined precisely in these more horizontal, and, we might say, Spinozist terms of different capacities to affect (and to be affected) themselves arising from different relations of speeds and slownesses (see the discussion in section 1.2.2 of Chapter 1).

12. This is also echoed in Deleuze's study of his fourth great philosophical precursor, Leibniz:

> Now what makes an organic, specific, or generic body? It is probably made of infinities of present material parts, in conformity with the nature of masses or collections. But these infinities in turn would not comprise organs if they were not inseparable from crowds of little monads, monads of heart, liver, knee, eyes, hands ... animal monads that themselves belong to material parts of 'my' body, and that are not confused with the monad to which my body belongs. (Deleuze 1993, p. 108)

Indeed, '[m]y unique monad has a body; the parts of this body have crowds of monads; each one of these monads has a body ...' (Deleuze 1993, p. 108). In relation to Deleuze's Leibniz we might also note the thesis of the two floors of the 'baroque house': '[t]he great equation, the world thus has two levels, two moments, two halves, one by which it is enveloped or folded in the monads, and the other, set or creased in matter' (Deleuze 1993, p. 102). The two floors are separate, operating according to their own laws, *but* they both express the same world. Between them is what Deleuze calls an 'ideal action': 'as when I assign something bodily to be the cause of what happens in a soul (a suffering) or when I assign to a soul the cause of what happens to a body (a movement taken as voluntary)' (Deleuze 1993, p. 119). We can map this on to our Bergsonian cone (see Figure 1.9): This time P is matter, AB the monad, and point S, the 'ideal action' or fold between the two realms.
13. It is in this sense that the Bergson-Deleuze gap allows a movement off the plane of matter, insofar as a hesitation in the sensori-motor schema allows passage to the virtual. Badiou's gap on the other hand (what I have also been calling a bar), keeps the subject on the plane of matter insofar as it opens a rift between the actual (the subject) and the virtual (the void) (this is a gap that is traversed by an event, but precisely *not* by a given body-subject). Might Bergson–Deleuze's difference in kind between the virtual and actual also be articulated as a gap? Perhaps, but only if it is understood to be endlessly crossed – traversed – by the process of reciprocal determination outlined above (whose medium is the body).
14. Tamsin Lorraine attends to this Nietzschean moment of the third synthesis in her 'Living a Time Out of Joint', where she also follows Deleuze's *Logic of Sense*, and thinks the time of Aion as 'an achronological time where everything has already happened and is yet to come', that is to say the stoic incorporeal regime of events (or becomings) that are actualized in states of affairs, but are separate to them (Lorraine 2003, p. 32). 'They are no longer states of affairs – mixtures deep inside bodies – but incorporeal events at the surface which are the results of these mixtures' (Lorraine 2003, p. 6). Once more, we might diagram this using our cone (see Figure 1.9). Here, P is the realm of mixed bodies/states of affairs, or the time of Chronos (sense); AB is the realm of incorporeal events, or the time of Aion (non-sense); point S remains the subject. Lorraine is also especially astute on how 'good sense' operates to pin us on the plane of matter: '[g]ood sense entails a socially sanctioned chronology according to a shared time-line by which what happens is unambiguously marked as before or after other occurrences' (Lorraine

2003, p. 33). Alice enters a nonsensical world where, among other things, this straightforward chronology is mixed up; however, it is Hamlet that acutely faces this strangeness as a problem insofar as events put his time 'out of joint', forcing him, ultimately, to 'become a self that would make no sense to the self of the old order ...' (Lorraine 2003, p. 38). Finally, it is Nietzsche who points to a mastery of sorts of this realm: 'It is the overman who is able to break free from representations of a chronological past in order to draw upon the virtual past as a durational whole in resolving the problem of living' (Lorraine 2003, p. 34). Indeed, for Lorraine (following Deleuze), 'Nietzsche's discovery was that of a world of nomadic singularities, no longer imprisoned in God or the finite subject' (Lorraine 2003, p. 38).

15. As we saw in the previous chapter it is to Deleuze's other key precursor, Spinoza, that we can look for just such a programme (precisely the *Ethics*). It is perhaps worth noting two important differences here to Badiou. First, with Spinoza, the infinite can indeed be prepared for (the conditions of its arising can be put in place albeit the arising itself is fundamentally 'other' to any efforts of the subject), this preparation, the second kind of knowledge, being the key material of the *Ethics*. Second, the infinite can itself be experienced directly, this being Spinoza's third kind of knowledge – an experience of beatitude, of 'becoming-world', that takes place outside space-time, *sub species aeterni*. It seems to me that Badiou misses both these points in his reading of Spinoza in *Being and Event*. We might also look once more to Bergson here, and to his account of mystical experience, for although in *Matter and Memory* Bergson only posits, as a demonstrative technique, the existence of a someone who 'experiences' the pure image and the pure past (that is, a pure virtuality), in *The Two Sources of Religion and Magic*, again as we saw in the previous chapter, he describes the mystic as precisely someone who inhabits the gap (in this case in-between the fixed rituals of society) and thus accesses the infinite. This insight might only be temporary, but nevertheless it can transform the subject who experiences it and indeed the world in which such a mystic actualizes. The important point here – as it is with Spinoza – is that the subject, as finite being, can experience the infinite *directly* even if only temporarily. Finally, in relation to the notion of preparation or a programme of ethics, as we saw in Chapter 2, we might also look to the late writings of Foucault on the 'Care of the Self' in which truth is only accessible to a subject who has worked on and transformed themselves – which is to say truth must very definitely be prepared for.

16. This is Deleuze and Guattari's own critique of Badiou's system, simply that it holds to just one multiplicity rather than two. As they point out in *What is Philosophy?*: 'There must be at least two multiplicit*ies*, two types, from the outset. This is not because dualism is better than unity but because the multiplicity is precisely what happens between the two' (*WP*, p. 152). For Deleuze and Guattari this is not to posit any kind of transcendence because there is no sense in which either of the two is 'above' the other, rather, they are 'one beside the other, against the other, face to face, or back to back' (*WP*, p. 152).

In his book on Deleuze, as I have already suggested, Badiou himself differentiates his own philosophy from Deleuze's specifically on the issue of the virtual, which, Badiou argues, determines Deleuze's philosophy as a vitalist ontology of the 'One' – in contrast to his own subtractive ontology of the 'not-One' (see

especially Badiou 2000, p. 42). Deleuze's actual/virtual dyad, for Badiou, thus, in fact, introduces a certain transcendence, a 'Two', into Deleuze's system with one term operating as prior and primary – as ground. For Badiou, Deleuze is then a philosopher of the One that then implies a Two (the virtual determining an actual). For Deleuze on the other hand, as I just mentioned, Badiou might also be said to be a philosopher of the One, in the sense that there is just one multiplicity, and yet, in the doubling of this to both consistent and inconsistent he becomes a philosopher of the Two. Each philosopher then accuses the other of the arch evil: of smuggling in transcendence.

A variety of commentators have taken Badiou to task for what they see as his reductive and somewhat misleading reading of Deleuze. Jeffrey Bell, for example, turns back to Spinoza and makes the argument that just as Spinoza's attributes are a condition of the modes, but only 'identifiable' through them, so Deleuze's virtual is less a separate realm to the actual, than the condition of it (see Bell 2006). Bell suggests that, in fact, Badiou's issue about how we can 'know' this indiscernible virtual reveals a certain misunderstanding about Deleuze's thought insofar as the virtual is not to do with knowledge at all (this, in fact, being, Badiou's own operating logic), but rather with the conditions of a problem that is, in this sense, inseparable, though different, from its solution. For Bell, we might say, the actual/virtual is not a 'two' at all.

Morgens Laerke calls attention, again, to each thinker's profound debt to Spinoza (see Laerke 1999). For Laerke, the philosophical *contretemps* rests on two different readings of the *Ethics*: Deleuze's, which concentrates on affect and the encounter (reading especially, Books IV and V), leading, as Laerke suggests, to a philosophy of the animal with its focus on the event as intensive variation; and Badiou's, which focuses on the geometrical method of Spinoza, and, indeed, on the various axiomatic choices that take place before, as it were, the *Ethics* is actually written. The event here is both a decision and beginning – in place of the animal, we have the matheme. Although Laerke sees each philosopher as making only a partial reading of their forebearer, he is especially critical of Badiou's reading of Spinoza, and subsequent reading of Deleuze, insofar as it 'names' being (as the 'One'). For Laerke, precisely, there is always a self-masking of Being, through the modes. Hence the 'passional geometry' or ethology of Deleuze that attends specifically to the latter. Deleuze's Univocity is then an affirmation of the voice of Being, but not necessarily of what is said. For both Bell and Laerke it is this 'making Spinoza turn on the modes' that is crucial in understanding Deleuze's Univocity (and with this, an understanding of the reciprocal determination of the actual/virtual).

Keith Ansell-Pearson likewise critiques Badiou for his reductionist account of Deleuze's Univocity, which, again, Ansell-Pearson claims, Badiou has not properly understood in that it necessarily involves both a One and a Many (see Ansell-Pearson 2001). Ansell-Pearson looks not to Spinoza, but to Bergson, excavating Bergson's idea of the virtual as a One that already holds within it a pluralism (this being the sections of the virtual cone). For Ansell-Pearson, Badiou's chief error – and it is the same error as pointed out by the Spinozists – is that he has an idea of Deleuze's Being as eminative rather than expressive, thus leading to a wrongly founded argument about Deleuze's philosophy being one of transcendence. In fact, for Deleuze–Bergson, in Ansell-Pearson's

reading, the virtual is not transcendent to an actual that it differs from but, indeed, already 'contains' the difference that is actualized in matter.

For John Mullarkey the difference between Badiou and Deleuze is again number versus animal, or, mathematics versus affect (see Mullarkey 2010). In his commentary Mullarkey relates this to each thinker's notion of abstraction: whereas for Badiou abstraction constitutes a formal (or empty) thinking, for Deleuze it involves the capture of larger and larger processes – the abstract machine grasping an ever larger content as it were. For Badiou then, Deleuze's theory of multiplicities is vitalist; whereas his own is purely mathematic and abstract. For Deleuze, on the other hand (following the quote above from *What is Philosophy?*), Badiou's theory of multiplicity is lacking insofor as it consists of only one multiplicity, rather than two types. For Mullarkey, the opposition between Badiou and Deleuze can also be seen explicitly in each author's attitude, again, towards the event: for Deleuze an event is 'from' the virtual, or, in Mullarkey's terms, a fold of being; for Badiou, the event is from the void, which implies a more radical cut (and a more radical new beginning).

To finish this sampling of the Deleuzian riposte to Badiou's reading of Deleuze we might turn to Dan Smith who thinks the opposition between these two thinkers on what he sees as their real ground of difference, that is, the mathematics that underlines their respective theory of multiplicity (see Smith 2003). According to Smith, Deleuze's multiplicity must be thought in terms of calculus and problematics; on the ground problems and their solutions as it were, or, in the terms of *A Thousand Plateaus*, as a nomadic science. In Smith's reading, Badiou's multiplicity, is, in fact, abstracted from this prior one. It is axiomatic, a royal science that explains from above. In fact, it is not as if Deleuze does not think this latter category of 'extensive multiplicity' but rather that he thinks it alongside his own intensive differential multiplicity. Indeed, again, it is what happens between the two – the reduction of one to the other – that interests Deleuze (Smith tracks through this process of capture in the history of mathematics). Although Badiou claims his axiomatic set theory as beginning decision, in Smith's reading, for Deleuze, the latter is, in fact, always secondary, parasitical on the intensive form of multiplicity that precedes it. Problematics, in this sense, is the multiplicity of life. Again, in Smith's reading this difference is exemplified in two notions of the event: they are evacuated from Badiou's set-theory ontology (hence the positing of them as extra-ontological), whereas they are common in Deleuze. For Smith, the statement that Badiou bases his reading of Deleuze on 'Being is Univocity', in fact, amounts to saying that Being *is* difference. Indeed, Smith demonstrates that Badiou's own idea of the One really operates as a marker for any philosophy that is not his own – based on set theory. Deleuze's philosophy is then, we might say, about biology *and* also maths (both the animal and the matheme). It is about the comprehension of existence, an existence that Badiou, in his cold abstract set theory, eliminates. For Smith this refusal to engage with problematics/life is indicative of the way in which Badiou does not engage with the *Capitalism and Schizophrenia* project which, we might say, is concerned precisely with the latter. In relation to our own Deleuzian critique of Badiou, Smith likewise follows the digression in *What is Philosophy?*: in making all life reducible to the set/inconsistent multiplicity – a making discrete – all is made the same, laid out on one plane

(even though, as I hope to demonstrate, the event is made to appear to come from elsewhere). The difference then, really, comes down to ontology. For Deleuze this is the horizon, as it were, of thought. For Badiou there is an extra-ontological, inconsistent multiplicity. Smith's take on this then is that for Badiou there is a supplementary dimension – the void – from where this extra-ontological event originates.

To balance out this critique and end this very lengthy note, we might make a couple of observations. The first is that Badiou, presumably, would maintain that with his own mathematics he has found a way out of vitalism without recourse to a transcendence, but rather to a more radical immanence (this being the discovery of nested infinities by Cantor). Indeed, Ray Brassier, perhaps Badiou's most rigorous Anglophone champion in this particular philosophical contretemps makes the case, again, that Deleuze's Univocity invariably has two faces, or needs two names; for the numerically different modes of being *and* then their 'unity' as expression of the same Being (see Brassier 2000). This, for Badiou and for Brassier, cannot but introduce a form of transcendence. Interestingly, Brassier's critique, though pitched on ontological grounds, is especially concerned with the political implications of the two systems, at least as he reads them, and, in Deleuze's case, in the figuring of Capital as being in a 'covenant' with the virtual One-all (Brassier 2000, p. 209). Deleuze is then taken to task for his punitive *'ascesis* of the One-all' in which any subject is effectively abnegated (Brassier 2000, p. 204): the spiritual automaton becomes a conduit for the virtual One-all, but is also, in Brassier's terms, a passive figure of machinc enslavement to Capital (Brassier 2000, pp. 213–14). For Brassier, the power of Badiou's system on the other hand is, rather, in the constitution of the subjective as 'militant fidelity to the dispersive void', an active decision maker that operates subtractively to counter-act this One-all. In fact, Brassier then turns his own cold nihilistic gaze to Badiou himself and discerns there a similar problem, simply that the void in Badiou's system is in danger of becoming another kind of 'consistent multiplicity', the 'virtual unity' of a ground of formally distinct events. For Brassier, this danger is summed up in Badiou's odd claim about the 'Chance of chances', or, as Brassier has it, in the fact that: 'although all events remain mathematically distinct, the *matheme* of the event is an invariant' (Brassier 2000, p. 215). I detect a similar aporia in Badiou's *Logics of Worlds* in the strange and strained relationship between truths and Truth, in which the former seem to rely on the smuggling in of a concept of the latter. This last criticism aside, Brassier ultimately champions the subtractive logic of what he calls the stellar matheme (Badiou) as that which, ultimately, is able to puncture the vitalist cosmic animal (Deleuze). We might ask further, whether Badiou's 'Theory of the Subject' as I have laid it out is an answer of sorts to the question that Smith raises about problematics versus axiomatics. After all, the subject lives a problem of sorts and, in the testing of elements of a situation post-event, is involved in precisely an immanent field of life (both problematics (in Smith's definition) and Badiou's trajectory of the subject, are experimental and aleatory). Might we say then, that the subject is Badiou's own 'nomadic science' that accompanies the royal science of the philosopher? And, in this sense, might the argument be made, contra Smith, and perhaps contra Badiou also, that Badiou, too, holds to two different multiplicities?

17. We might further contrast St Paul – Badiou's model of the militant subject – with a further Christian saint, St Francis who, at the end of Hardt and Negri's *Empire* makes an entrance as 'the future life of communist militancy' (Hardt and Negri 2000, p. 413). St Francis, by adopting the common condition – of the multitude – 'discovered there the ontological power of a new society', a joy of becoming and of endless biopolitical productivity (Hardt and Negri 2000, p. 413). St Francis identifies with all of life and in so doing orientates himself against instrumental reason, and indeed all forms of transcendent control and domination. Indeed, with these two saints (St Francis and St Paul), with their different attributes and narratives, we have encapsulated the two dominant forms of contemporary communist subjectivity: subject to truth versus becoming-world.
18. Badiou himself sees Deleuze as a kind of fellow adversary against democratic materialism – a fellow constructor of a contemporary metaphysics. In fact, for Badiou, he and Deleuze exemplify the two 'French traditions' that lead, respectively, from 'Brunschvicg (mathematizing idealism) and Bergson (vitalist mysticism), the one passing through Cavailles, Lautman, Desanti, Althusser, Lacan and myself, the other through Canguilheim, Foucault, Simondon and Deleuze' (*LW*, pp. 7–8).
19. One need only compare Lacan's key essay – and formal diagram – on the subject *as* structure, 'The Subversion of the Subject and the Dialectic of Desire in the Freudian Unconscious' with Guattari's 'Schizoanalytic Metamodelisation' with its account of 'the little opera scene' of *La Borde*: 'in it people talk, dance and play with all kinds of instruments, with water and fire, dough and dustbins, relations of prestige and submission. As a place for the preparation of food, it is the centre of exchange of material and indicative fluxes and presentations of every kind' (*C*, p. 69).
20. Jacques Rancière is perhaps the other key contemporary political thinker who also attends to the politics of what Badiou calls the transcendental of a world, or simply the laws which govern 'appearing' in a given world (although Badiou himself does not explicitly address this in the footnote in *Logics of Worlds* dedicated to Rancière, which instead concerns their differing attitudes to politics and history, and, indeed, to Mallarmé). In his book *The Aesthetics of Politics*, Rancière lays out his own transcendental thesis – as regards the different historical regimes of the seeable and the sayable – under the banner of the 'distribution of the sensible'. Rancière's interest here is in going beyond – or 'beneath' – any given forms of knowledge to examine the conditions that allow the latter to emerge. An example would be history and fiction; for Rancière it is not really their differences that is most interesting, but that the possibilities of each are determined by a prior system of what can be seen/said (history and fiction are in this sense similar – both being a material arrangement of signs). For Rancière, like almost all the thinkers in my book, there is then a profoundly aesthetic moment to all politics (and indeed to life itself) insofar as aesthetics is defined, by Rancière, as: 'the system of a priori forms which present themselves to experience' (Rancière 2004, p. 13). As opposed to Badiou however, for whom the transcendental is asubjective, Rancière's 'distribution of the sensible' is very firmly *in* the realm of politics insofar as it is determined by the mode of production, that

is capitalism, and, in turn, determines what we can see and say, and, indeed, who can speak as such (specifically, who has the *time* to speak).

There is then in Rancière an implicit call for an analysis of these different regimes, but also a call to interfere in them. In fact, for Rancière, different practices, for example art, work back on their own transcendental coordinates. Aesthetic practices, or 'ways of doing and making' can 'feedback' and modify the distribution itself (Rancière 2004, p. 10). As far as this goes art's chief *modus operandi*, as it is for Badiou, is formal:

> The important thing is that the question of the relationship between aesthetics and politics be raised ... at the level of the sensible delimitation of what is common to the community, the forms of its visibility and of its organization ... The arts only ever lend to projects of domination or emancipation what they are able to lend them, that is to say, quite simply, what they have in common with them: bodily positions and movements, functions of speech, the parcelling out of the visible and the invisible. (Rancière 2004, pp. 18–19)

However, from a perspective such as Guattari's, this means that art is not really involved in producing new subjectivities, new collectivities, or new communities – but only precisely in disrupting those already existing: the disruption of what Rancière calls the police by politics (the latter being the name for a kind of a restless antagonism). In fact, this is central to Rancière's attitude/orientation – and is what we might say differentiates him from Guattari's own aesthetic paradigm, but also from Negri and the whole Spinozist turn. For Rancière dissent always comes first; it is disagreement as primary political act (a constant agitation and intervention into the existing state of affairs). As far as this goes one might say that Rancière's politics is tied to the possible – the 'what is' – albeit it involves the refusal of the specific possibles on offer.

21. To quote Badiou: 'in a given world, what is the degree of identity of a being to another being in the same world? Furthermore, what happens in this world to the identity of a being to its own being? The transcendental organization of a world is the protocol of response to these questions' (*LW*, p. 119). We have only to replace identity with difference and we have Derrida's *différance*. And again, in the section on Hegel:

> For us, once it is posited – not only in the mathematical rigidity of its multiple-being, but also in and through its worldly location – a being is given simultaneously as that which is other than itself and as that which is other than others. Whence the necessity of a logic that integrates these differentiations and lends them consistency. (*LW*, p. 145)

Badiou himself references Derrida's work in a footnote where he admits a certain resonance between his transcendental logic and deconstruction, and especially between his notion of the inexistent and Derrida's *différance* (*LW*, p. 545).

22. We might compare this attempt to 'rescue', or rewrite, a transcendental logic, to that of Negri, who, in his own major philosophical statement,

explicitly orientates himself against any transcendental as that which has fixed being *avant la lettre* as it were. To quote Negri from the Introduction to 'Kairos, Alma Venus, Multitudo' in *Time for Revolution*:

> Materialist experience is a blade that continually slices through being and assembles it in open arrangements of communication and invention and this is the case in language in particular. In this way any conceptual form that presupposes the whole to the parts and the truth to experience dies, as does every Eleatic fixation of being, and so too every consequent transcendental duplification-mystification of the real which reveals itself to be a logical perversion – a continuous and unbearable tautology. (*TR*, p. 141)

Negri goes on immediately to remark: 'Deleuze has, in the contemporaneity that he opens to the postmodern, banished with enthusiasm and force the abomination of repetition in transcendental logic. For this reason, Foucault said, "this century will be known as Deleuzian"' (*TR*, p. 141).

23. And, indeed, independent of time itself:

 > no time is implied in the transcendental indexing of being-there. Time here is only a parasite introduced by the metaphorical or didactic use of vulgar phenomenology. Objective phenomenology comes down to suppressing this parasitism by retaining only the identitarian or differential result of the trajectory that is imputed to a consciousness. (*LW*, p. 202)

24. We might ask, as other commentators have (see note 16), whether Badiou gives an adequate account of Deleuze's Univocity insofar as the latter involves the One *and* the many, and specifically a reciprocal determination between the two. In this sense could it not been said that Deleuze holds to an ontology that is both continuous *and* discontinuous?

25. Just as the subject is not reducible to the body, so it is the conviction that the ideal of thinking is not reducible to sense (or 'communication') that Badiou responds to in Lacan. In each case it is formalism (the matheme) that is the ideal form of thought:

 > Nothing ties me more to Lacan's teaching than his conviction that the ideal of any thinking is that aspect which can be universally transmitted outside of sense. In other words, that senselessness [*l'insense*] is the primordial attribute of the true. What may be called 'Platonism' is the belief that in order to come close to this ideal, it is necessary to mathematize, by hook or by crook. (*LW*, p. 522, note p. 8)

26. We might note, for example, that with art, each new event is, in a sense, a reanimation of a previous movement/moment of formlessness becoming form; in politics each revolution looks back to, and reanimates, previous revolutionary moments, and so forth.

27. See, for example, *WP*, pp. 112–13.

28. A more accurate – flatter – 'diagram' of Badiou's system would then be to simply follow set theory's own protocols and draw a Venn diagram of a

Figure 4.6 Venn diagram: U: Universal set (inconsistent multiplicity), A: a set (situation/world), ∅: Empty set (void)

given set, its relation to the universal set, and its 'containing' of the empty set (∅) (see Figure 4.6). Although, crucially, this does not diagram the subject itself. In order to really follow this through – again, in set theory terms – we would need to be able to diagram the function of forcing (insofar as this *is* the path of the subject) – or that process by which a given set is 'converted' to a new one. We might note, once more, that this would be a picture from the outside (precisely from the perspective of the philosopher). From within the set – on the ground as it were – things look very different insofar as any element of the set itself 'sees' only the other elements. Hence, once more, that faith is the operating mode of the subject (faith that is also the idea that there is, as it were, the possibility of a different set). In fact, I think here we begin to come up against a certain limiting aspect of set theory, or at least a tension in terms of the relation between philosopher and subject, insofar as set theory contains no temporal dimension. For, it seems to me, that the faith of the subject can only but be based on history (precisely, that sets have changed in the past). Hence another key modality of Badiou's subject: it reactivates the events of history. Indeed, for Badiou, faith itself is premised on an event, that, in set theory terms, 'arrives' via the empty set – the void – that is present within any set. This is a kind of inclusion within of that which is outside, and which, for Badiou, in fact constitutes a kind of founding 'origin' of all sets insofar as they are built on this void. Hence the sequence where more and more complex sets – or 'worlds' – are built 'on' the empty set itself: {∅},{{∅}∅}, {{{∅}∅}∅}, ...

29. Once again, this attitude towards life and the present also necessarily involves a different attitude to the past: 'one reconstitutes a different past, a history of achievements, discoveries, breakthroughs ... a legible succession of fragments of eternity' (*LW*, p. 510). As I mentioned above, and as we saw in the previous chapter, this attitude towards the past also characterizes those Spinozists that Badiou is so critical of, in particular Negri.

30. In a recent essay Badiou suggests that 'Communism' is precisely an Idea in this sense, and one that gets reactivated in each generation in accordance with the logics of that situation (but maintaining an eternal call to egalitarianism) (Badiou 2010). To turn to our cone, we might diagram it as in Figure 4.7.

Figure 4.7 Passage through history of the Idea

31. For Mullarkey's own take on Badiou and Deleuze see note 16.
32. As we saw in the previous chapter Negri likewise doubles the notion of the eternal with the idea of *kairos* as that which creates 'within' the eternal. Is Negri then also erecting a bar between the subject, or, in this case, between the body *and* the eternal? Not if we are to follow a properly Spinozist understanding of this, which would suggest that the body is a mode of the eternal, and, indeed, is in a constant and reciprocal relation with it.
33. It is this that characterizes truth procedures as specifically political enterprises irrespective of the worlds they are carried out within. Another way of saying this is that truth is always a series, or, in Badiou's terms, a process (Badiou himself addresses this question – of how he figures the relation between his philosophy and his political commitments in a long footnote in *Logics of Worlds*, from where this is taken: 'in the materialist dialectic, what secures the eternity of truths is *precisely* the fact that they result from a singular process, in a world disjoined from every other' (*LW*, p. 520)).

Chapter 5

1. Can *Anti-Oedipus* be called an ethics? Certainly there is, in Spinoza's terms, a call to experiment – and to find out what a body (that is, the three syntheses) is capable of, but there is no rational programme, in fact, far from it – one need only think of Judge Schreber. Indeed, this is the style of *Anti-Oedipus*, that it pulls in different literary and other references, almost as though replacing the programme – that to some extent returns in *A Thousand Plateaus* – is a list of characters or conceptual personae, who, like Schreber, or Beckett's Malone, dramatize different and singular cases of desiring-production.
2. As Deleuze and Guattari remark (in relation to Proust) in the section on 'The Whole and its Parts':

 the whole itself is a product, produced as nothing more than a part alongside other parts, which it neither unifies nor totalizes, though it has an

> effect on these other parts simply because it establishes aberrant paths of communication between noncommunicating vessels, transverse unities between elements that retain all their differences within their own particular boundaries. (*AO*, p. 43)

The One is produced 'on the way', as a component of the process, and not as transcendent to (or before or after) it. It is Melanie Klein who opens the door to this conception with the notion of partial objects, though Deleuze and Guattari see her as also reinstating a regime of the One insofar as these partial objects are related back to the body (of the mother). Later in this paticular section of *Anti-Oedipus* we find a further comment that operates as a prophetic riposte to Badiou's reduction of Deleuze to a philosopher of the One and a pigeonholing of his philosophy as simply vitalist:

> As a general rule, the problem of the relationships between parts and the whole continues to be rather awkwardly formulated by classic mechanism and vitalism, so long as the whole is considered as a totality derived from the parts, or as an original totality from which the parts emanate, or as a dialectical totalization. Neither mechanism nor vitalism has really understood the nature of desiring-machines ... (*AO*, p. 44)

Desiring-production is then precisely a multiplicity when the latter is thought as a 'substantive' that goes 'beyond both the One and the many, beyond the predicative relation of the One and the many' (*AO*, p. 42). In the terms of *A Thousand Plateaus* desiring-production is rhizomatic.

3. Hence, piety: a strange but necessary affective aspect of an otherwise cold axiomatic working of capitalism (piety being the belief in a ground from which all emanates). In passing we might note the resonances the full body with organs has with Badiou's 'obscure subject', which, as we saw in the previous chapter, operates as a 'pure transcendent body, an ahistorical or anti-evental body' (*LW*, p. 59).
4. In the section on 'A Materialist Psychiatry' this idea of social production as a form of desiring-production (and vice versa) is expanded into a consideration of the massive deterritorializing power of capitalism understood as desiring-production. Here capitalism itself tends toward the production of the schizo as the 'subject of the decoded flows on the body without organs – more capitalist than the capitalist and more proletarian than the proletariat' (*AO*, p. 34):

> what we are really trying to say is that capitalism, through its process of production, produces an awesome schizophrenic accumulation of energy or charge, against which it brings all its vast powers of repression to bear, but which nonetheless continues to act as capitalism's limit. For capitalism constantly counteracts, constantly inhibits this inherent tendency while at the same time allowing it free rein; it continually seeks to avoid reaching its limit while simultaneously tending toward that limit. (*AO*, p. 34)

As Deleuze and Guattari remark, in an affirmation of this accelerating aspect of capitalism: 'we really haven't seen anything yet!' (*AO*, p. 34). I will return, briefly, to this notion of 'accelerationism' below. Deleuze and Guattari continue:

> As for the schizo, continually wandering about, migrating here, there, and everywhere as best he can, he plunges further and further into the realm of deterritorialization, reaching the furthest limits of the decomposition of the socius on the surface of his own body without organs. It may well be that these peregrinations are the schizo's own particular way of rediscovering the earth. The schizophrenic deliberately seeks out the very limit of capitalism: he is its inherent tendency brought to fulfillment, its surplus product, its proletariat, and its exterminating angel. He scrambles all the codes and is the transmitter of the decoded flows of desire. (*AO*, p. 35)

Art practice might also be understood as the irruption of desiring-production into social production. I will return to this in the third section of the present chapter.

5. Deleuze and Guattari later refer to a code that every machine has built in to it, and that determines the relation of different organs to different flows (insofar as there may be more than one flow for any one organ, and more than one organ for any one flow). This, again, is the disjunctive synthesis in which '[t]he data, the bits of information recorded, and their transmission form a grid of disjunctions ...' (*AO*, p. 38). It is here, as elsewhere in *Anti-Oedipus*, that Deleuze and Guattari pay a debt, albeit a qualified one, to Lacan:

> We owe to Jacques Lacan the discovery of this fertile domain of a code of the unconscious, incorporating the entire chain – or several chains – of meaning: a discovery thus totally transforming analysis ... But how very strange this domain seems, simply because of its multiplicity – a multiplicity so complex that we can hardly speak of *one* chain or even *one* code of desire. The chains are called 'signifying chains' (*chaînes signifiantes*) because they are made up of signs, but these signs are not themselves signifying. The code resembles not so much a language as a jargon, an open-ended, polyvocal formation. (*AO*, p. 38)

Such a characterization of codes and coding prefigures the asignifying semiotics of Guattari that we examined in Chapter 4. In fact, we have a succinct definition of the latter – in relation to desiring-production in general – more or less immediately after the above distancing from Lacan:

> No chain is homogenous; all of them resemble, rather, a succession of characters from different alphabets in which an ideogram, a pictogram, a tiny image of an elephant passing by, or a rising sun may suddenly make its appearance. In a chain that mixes together phonemes, morphemes, etc., without combining them, papa's moustache, mama's upraised arm, a ribbon, a little girl, a cop, a shoe suddenly turn up. Each chain captures fragments of other chains from which it 'extracts' a surplus value, just as the orchid code 'attracts' the figure of a wasp: both phenomena demonstrate the surplus value of a code. It is an entire system of shunting along certain

tracks, and of selection by lot, that bring about partially dependent, aleatory phenomena bearing a close resemblance to a Markov chain. (*AO*, p, 39)

6. In a return to the material of Chapter 1 we might note that the body without organs as described here has much in common with the body without organs described in *A Thousand Plateaus* where it is explicitly labelled as Spinozist (see the quote on p. 26). There are however differences between the two uses made of Artaud's formulation that are both technical and to do with intention. Insofar as the former goes, the body without organs of *A Thousand Plateaus* names what we might call the whole process of desiring-production, at least insofar as this is an experimental and constructive project. In terms of the latter, this second volume of *Capitalism and Schizophrenia* emphasizes the programmatic nature of the body without organs (precisely: 'How Do You Make Yourself a Body Without Organs?'). My previous monograph looked briefly at this particular plateau in relation to art practice (and, specifically the artist Robert Smithson, see Chapter 4, 'From Geophilosophy to Geoaesthetics: The Virtual and the Plane of Immanence vs. Mirror Travel and *Spiral Jetty*', of my *Art Encounters Deleuze and Guattari*, pp. 98–120). The third section of the present chapter might also be said to be concerned with this more programmatic and constructive take on desiring-production.

7. Both Eugene Holland and Ian Buchanan draw attention to the passive syntheses, as mapped out in *Difference and Repetition*, as key precursors to the three syntheses of the unconscious as they are mapped out in *Anti-Oedipus*. Buchanan goes on to explain the latter in relation to Marx's theory of Capital; Holland attends more to the Nietszchean/Freudian conjunction that informs Deleuze and Guattari's framing of desiring-production. Both are very useful in unpacking the complexities of *Anti-Oedipus*, though from my own perspective, and on the particular theme of the production of subjectivity, Holland provides more detail, and examples of, the three syntheses. Holland also makes some thought provoking comments – themselves provoked by Norman O. Brown's *Life Against Death* – about how our fear of death represses the death instinct (Thanatos) and:

> leaves humans fixated on all the impossible infantile projects they refused to let die in the past, thereby leaving them unable to live in the present and giving motive force to an obsessive orientation toward the future – to restless historical development and eventually to the unavailing 'progress' of consumerism and technologism afforded by capitalism. (Holland 1999, p. 9)

It seems to me that Holland has identified a key problem here. In the terms of my book we might say that fear of death pins us to the plane of matter, or, more simply, what bars us from the infinite is our fear of it. It follows that it is only through facing one's finitude – or death – that a certain 'freedom' from the latter becomes possible. In a sense Deleuze's blurring of the distinction between the organic and inorganic – in a larger understanding of 'life' – circumnavigates this issue insofar as death might strike living beings but cannot strike life itself. We might connect all this to the Lacanian torus of Chapter 2. What keeps us on the torus, and on a certain path, is fear. It is then not simply

a matter of choosing to leave a particular pathway, nor is it merely the result of an event, but must come from a prior preparation in terms of facing this fear. Another name for this – which Badiou does attend to – is courage.

8. We might note here how things appear to the subject themselves as they are positioned at the periphery of the process of desiring-production: they perceive an immanent horizon towards which they progress, and experience desire as a lack insofar as this appears, to them, to be the motor of their trajectory. Indeed, for the subject as residuum of a process, they are lacking – the process itself, however, is lacking nothing.

9. We might note also Laruelle's recent comments about the subject of non-philosophy that has many resonances with the various conceptual personae in my book, especially Badiou's militant, Lacan/Guattari's analyst, Bergson's mystic and Foucault's spiritual practitioner:

> Ultimately, I see non-philosophers in several different ways. I see them, inevitably, as subjects of the university, as is required by worldly life, but above all as related to three fundamental human types. They are related to the analyst and the political militant, obviously, since non-philosophy is close to psychoanalysis and Marxism – it transforms the subject by transforming instances of philosophy. But they are also related to what I would call the 'spiritual' type – which it is imperative not to confuse with 'spiritualist'. The spiritual are not spiritualists. They are the great destroyers of the forces of philosophy and the state, which band together in the name of order and conformity. The spiritual haunt the margins of philosophy, gnosticism, mysticism, and even of institutional religion and politics. The spiritual are not just abstract, quietist mystics; they are for the world.

10. From the perspective of desiring-production desire is not characterized by lack, but by plenitude. From the perspective of a neurotic subject however, one oblivious to the latter process and instead 'caught' on a loop – on the torus – desire might well be experienced as lack, and, such lack then produces another world (see also note 8 above).

11. David Deamer pointed out to me, when I presented a paper on this material, that the concentric circles might also be the cone seen from above, that is, from a *different* perspective (down from the base as it were). It would seem to me that this would, however, maintain a certain implied depth, or virtuality, which the collapsing of the cone does not. That said it does lead on to the intriguing idea of different perspectives on the same process. For example, for the subject 'on' the lines of desire, as opposed to the abstract perspective of the philosopher who diagrams the process. We might say that here we have an echo of the problem we identified with Badiou in the previous chapter as regards the ontologist who can see the whole picture versus the subject who, insofar as they 'live' the process, has only a partial view. Insofar as this goes the diagram is itself a view from 'outside' the process. As I indicated in my Introduction, diagrams might also be seen, ultimately, as fictions that allow a subject to speculate beyond the situation they find themselves within. (I want to thank Jacopo Nouvalari for initiating my thoughts on *Anti-Oedipus'* rejection of the Bergsonial virtual).

12. We might also note that in a strange twist this is to bring Deleuze (and Guattari) closer to Badiou's own system in which, as we saw in Chapter 4,

everything is laid out on the same plane. Indeed, it might be said that Badiou does not read *Capitalism and Schizophrenia* in his own account of Deleuze's Univocity precisely because it 'solves' a certain issue of the actual/virtual dyad (and, as I suggested in note 3 above, explicitly deals with the question of vitalism and the One), *but also* because, to a certain extent – at least diagrammatically – the body without organs, or what becomes, in *A Thousand Plateaus*, the plane of immanence, is closer to his own inconsistent multiplicity than the Bergsonian actual–virtual.

13. See note 26 of Chapter 1.
14. In Chapter 3 I suggested that Guattari's chaotic entities are the inhabitants – the virtual ecology – of the cone, traversing as it were the different levels depending on their particular make up. I suggested there that this is to bring a certain Bergsonian duration to psychoanalysis. We might now reverse this, and, in flattening the cone, diagram these entities as loops that link the different intensive lines together (Figure 5.7). Would it be too much to say that these loops constitute knots, the knots of a subject when they have constituted themselves (rather than being 'subject to' the desiring lines which they traverse); which is to say, in Lacanian terms, a sinthome?

Figure 5.7 Deleuze/Guattari–Lacan sinthome

15. For an account of the body without organs – and desiring-production more generally – along these lines see Nick Land's incendiary reading of *Anti-Oedipus* in 'Making it with Death: Remarks on Thanatos and Desiring Production'.
16. For Éric Alliez, in his own extraordinary commentary on Deleuze and Guattari's final book, the work of philosophy itself (the construction of concepts or 'presentation of the infinite in the finitude of the here-and-now' (Alliez 2004, p. 29)) cannot but involve an ethics insofar as it relies on a certain perspective, and, we might say (following Spinoza) a certain mode of life:

> By operating a section of chaos, the plane of immanence calls on concepts, but these concepts in turn *cannot be deduced* from the absolute

directions of the plane ... the creation of concepts, like the tracing of the plane, is the work of conceptual persona, through which speculation becomes *ethos* ... (Alliez 2004, p. 15)

In relation to this, we might say that the subject as explored throughout my own book is both a diagram of a life that might be lived *and* a conceptual persona: 'the becoming or the subject of a philosophy' (Deleuze and Guattari, quoted in Alliez 2004, p. 10). This is a figure that takes on different components and a different 'character' depending on the philosophical terrain, or plane of immanence, they move across.

17. See note 39 to Chapter 1.
18. Following my own book's trajectory, Franco Berardi is the one author that has attended to a notion of a production of subjectivity implicit in *What is Philosophy?* I have discussed Berardi in Chapter 3, but it is worth repeating here that for Berardi subjectivity is itself a kind of chaoid, and, as such, schizoanalysis – or the production of subjectivity – is added by him to the three great forms of thought.
19. I have written about my encounter with *A Thousand Plateaus* in my previous monograph, which, although ranging across Deleuze's and Deleuze and Guattari's work, certainly began with the latter – and is marked throughout by that encounter. I have also listed there the various important secondary sources and other points of inspiration that have contributed to my understanding of Deleuze and Guattari, and especially of *A Thousand Plateaus*.
20. See Hallward 2006.
21. Although what follows in this final section of the chapter does not specifically address the finite–infinite relation as it occurs in *A Thousand Plateaus*, I would argue that the whole of the latter book evidences the move made in *Anti-Oedipus* away from the actual-virtual dyad and the topological model it implies, to a flatter system. Insofar as this goes the many couplets within *A Thousand Plateaus* are, as it were, all laid out on the same plane, and might, following Guattari, be figured as finite–infinite weavings. So, for example, we have the root (finite) and the rhizome (infinite); or the molar (finite) and the molecular (infinite); or striated space (finite) and smooth space (infinite). The point here is that the one is in the other, or, to take the last pairing as example, a striated space will 'contain' within it smooth space (that is a bounded infinity), just as a smooth space itself might become striated, and so forth.
22. This final part of my final chapter was the first part of my book to be written, directly after I had completed a draft of my previous monograph (and the reader of both will notice some repetition of themes and phrases in what follows, especially as regards the discussion of art (some of the arguments also appear in my essay 'From Aesthetics to the Abstract Machine: Deleuze, Guattari, and Contemporary Art Practice')). Perhaps because of the date of writing this section seems to me to offer a different perspective on my book's subject matter insofar as the previous chapters, although they have addressed other areas such as psychoanalysis and what we might call therapeutics more generally, have, nonetheless been involved in often quite philosophical – and technical – discussion.

23. The mass media presents events in such a way as to produce a landscape of anxiety (always the fear of rupture, of interruption, of 'death' (however this latter is figured)). This is particularly the case with so-called news programmes, which select, isolate and exaggerate apparent threats and in so doing contribute to the alienation of contemporary life (we become spectators on a fearful world). A case study of this, especially today, would be the 'terrorist threat'. As regards the mass media, little attention is given to the complexities of any given geopolitical situation, or indeed the different 'terrorisms' that are invariably grouped together (in legal and popular terms), and instead 'terrorists' are presented as personifications – faces – of evil that may strike anyone in any place at any time. The enemy is among us in this sense; anyone and everyone might be the potential suicide bomber. It is the apparently arbitrary nature of this threat that constitutes its force. Paradoxically these faces of evil operate to reassure a public that evil does indeed have a face, although it is not the white man's face, hence the emphasis on 'terrorist' 'leaders', the obsession with the face of Saddam Hussein or Osama Bin Laden for example. In fact the real threat (but also the hope of a kind of liberation) is of the faceless, of that which might disrupt the face, and with it the typical norms and procedures of subject-production (that is, the faciality machine).
24. Buddhism might be seen as a diagnosis of this situation produced by the faciality machine, and as a series of strategies for living 'against' it. It is in this sense that practices of Western Buddhism in particular might be said to operate as probe-heads.
25. The plateau, 'November 28, 1947: How Do You Make Yourself a Body Without Organs?' (*ATP*, pp. 149–66), offers a series of case studies of just such a programme in *A Thousand Plateaus*. The body without organs (BwO), in that book, is a parallel concept to probe-heads, both being names for those constructive and experimental practices that involve living against that stratum that binds us and constitutes us as human:

> Let us consider the three great strata concerning us, in other words, the ones that most directly bind us: the organism, signifiance, and subjectification. The surface of the organism, the angle of signifiance and interpretation, and the point of subjectification or subjection. You will be organised, you will be an organism, you will articulate your body – otherwise you're just depraved. You will be signifier and signified, interpreter and interpreted – otherwise you're just a deviant. You will be a subject, nailed down as one, a subject of the enunciation recoiled into a subject of the statement – otherwise you're just a tramp. To the strata as a whole, the BwO opposes disarticulation (or *n* articulations) as the property of the plane of consistency, experimentation as the operation on that plane (no signifier, never interpret!), and nomadism as the movement (keep moving even in place, never stop moving, motionless voyage, desubjectification). (*ATP*, p. 159)

Importantly, the body without organs plateau also alerts us to the need for caution in such experimental practices. Building yourself a body without organs, and we might say the same about constructing probe-heads, is an art

of dosages. As Deleuze and Guattari suggest: 'Staying stratified – organized, signified, subjected – is not the worst that can happen; the worse that can happen is if you throw the strata into demented or suicidal collapse, which brings them back down on us heavier than ever' (*ATP*, p. 161). We might note here that this is an important difference to *Anti-Oedipus* in which the injunction is always to *go further*.

26. As Deleuze remarks:

> As a portraitist, Bacon is a painter of heads, not faces, and there is a great difference between the two. For the face is a structured, spatial organization that conceals the head, whereas the head is dependent on the body, even if it is the point of the body, its culmination ... Bacon thus pursues a very peculiar project as a portrait painter: *to dismantle the face*, to rediscover the head or make it emerge from beneath the face. (Deleuze 2003b, pp. 20–1)

27. Jason Read's essay 'The Age of Cynicism: Deleuze and Guattari on the Production of Subjectivity in Capitalism' draws attention to the complexity of the relations between old and new forms of coding and recoding (reterritorialization), but also between the latter and the cold axiomatic functioning of capitalism in its deterritorializing character, hence Read's thesis of cynicism (the axiomatic aspect in which there is a 'breakdown of codes and traditions by the abstract quantities of labour and desire') and his particular take on piety (the reterritorialization aspect in which 'old beliefs and traditions' are resuscitated). Read quotes a long passage from the third chapter of *Anti-Oedipus* that is worth re-quoting here for the resonances it has with William's framing of the archaic and the residual:

> Civilised modern societies are defined by processes of decoding and deterritorialization. But *what they deterritorialize with one hand, they reterritorialize with the other*. These neoterritorializations are often artificial, residual, archaic; but they are archaisms having a perfectly current function, our modern way of 'imbricating', of sectioning off, of reintroducing code fragments, resuscitating old codes, inventing pseudo codes or jargons ... These modern archaisms are extremely complex and varied. Some are mainly folkloric, but they nonetheless represent social and potentially political forces ... Others are enclaves whose archaism is just as capable of nourishing a modern fascism as of freeing a revolutionary charge ... some of these archaisms take form as if spontaneously in the current of the movement of deterritorialization – Others are organized and promoted by the state, even though they might turn against the state and cause it serious problems (regionalism, nationalism). (Deleuze and Guattari quoted in Read 2008, p. 155)

28. Deleuze and Guattari note a further '*countersignifying* semiotic' of 'a nomad war-machine directed against the state apparatus' that proceeds by an asignifying numeration: 'breaks, transitions, migration and accumulation' (*ATP*, p. 118). See Chapter 3, 'Art and the Political: Minor Literature, The War

Machine and the Production of Subjectivity', of my *Art Encounters Deleuze and Guattari* (O'Sullivan 2005, pp. 69–97) for an exploration of this semiotic in relation to the Red Army Faction guerrilla formation and the particular production of subjectivity found therein.

29. Deleuze's account of the fold of modern subjectivity can be found in his book on *Foucault*, specifically the chapter 'Foldings, or the Inside of Thought (Subjectivation)' (Deleuze 1988c, pp. 94–123). I attend to parts of this in Chapter 2. See also Deleuze's *The Fold: Leibniz and the Baroque*, and especially 'The Two Floors' (Deleuze 1993, pp. 100–21), for a more complex account of the baroque fold of subjectivity.

30. See the discussion of the films of Glauber Rocha in *Cinema 2* (Deleuze 1989, pp. 218–22). As Deleuze remarks in relation to these: 'it is not a matter of analyzing myth in order to discover its archaic meaning or structure, but of connecting archaic myth to the state of the drives in an absolutely contemporary society, hunger, thirst, sexuality, power, death, worship' (Deleuze 1989, p. 219). For a brief discussion of Deleuze's argument, and of the 'use' of myth – or mythopoesis – within contemporary art, see the first part of my Conclusion to *Art Encounters Deleuze and Guattari*, 'Fabulation: Myth-Science' (O'Sullivan 2005, pp. 144–53).

31. We might note here Guattari's own understanding of subjectivity as including various archaisms, including myth. Indeed, we might suggest, following Guattari, that myth can undo typical subject-object reifications. See my discussion of Guattari's third Assemblage in Chapter 3, and specifically the example of the voodoo practice/object 'Legba' that Guattari borrows from Marc Augé, and which, in the terms of this section of my chapter, might also be seen as a point of subjectification (*C*, p. 46).

32. We might understand this affirmation as a celebration and activation of immanence understood as that inorganic life that Deleuze was so attuned to. I discuss this briefly at the end of the first section of Chapter 1.

33. In relation to this we might note Bergson's notion of fabulation: the telling of stories about the world which in itself allows for a general slowing down – the opening of a gap between action and reaction – in which genuine creativity, or what Bergson calls 'creative emotion', can arise. See Deleuze 1998b, pp. 108–13, and my discussion of the latter on p. 53 of Chapter 1.

34. We see a similar ambivalence towards modernity in Walter Benjamin's writings, with the oft-quoted loss of aura and replacement of the sorcerer by the surgeon (Benjamin 1999c, pp. 226–7). Again, there is no call for a return here; indeed Benjamin's essay precisely affirms, at least in one sense, the technological developments of modernity and the subsequent democratization of art. There is however a call to the past as a corrective to a simple celebration of the regime of the present. Guattari himself references the loss of aura in modernity in relation to Duchamp's *Bottlerack* in the essay 'Ritornellos and Existential Affects' (see pp. 158–71).

35. See Deleuze and Guattari 1986, especially pp. 16–19.

36. For a more extensive discussion of the glitch – and of the stuttering and stammering of a minor literature – in relation to contemporary art, see my article: 'From Stuttering and Stammering to the Diagram: Deleuze, Bacon and Contemporary Art Practice'.

37. This is also to bring art practice and the therapeutic together, or, to see art practice as a form of schizoanalysis. In relation to a case study of this – that foregrounds my own particular production of subjectivity – I would point the reader to my collaboration with David Burrows and others: *Plastique Fantastique*. I have, at least to a certain extent, written about how this practice operates as a kind of 'mixed semiotic' or 'probe-head'. See the various articles mentioned in note 4 of my Introduction. An archive of the practice can be found at www.plastiquefantastique.org.
38. See Deleuze and Parnet 1977, pp. 36–76, for a discussion of the traitor in this sense.
39. See 'Beatitude,' the final section of *Expressionism in Philosophy: Spinoza* (Deleuze 1992, pp. 303–20), for an account of this third kind of knowledge and what can only be described as the *trans*-human state it produces.
40. See also footnote 35 of Chapter 1.

Conclusion

1. Žižek declares that such a theory must be 'neither that of transcendental subjectivity nor that of reducing the subject to a part of objective reality' (Žižek 2011, p. 415). For Žižek it is Hegel – and we might also say Badiou – who provides such a theory. As I hope I have demonstrated in my own book a further theory of the subject – or, of the production of subjectivity – might be developed from an alternative philosophical archive that includes Spinoza, Nietzsche and Bergson – and then Deleuze, Guattari and Foucault (and, indeed, Lacan in some of his writings).
2. What follows is a brief sampling of the writings of the four philosophers originally associated with Speculative Realism and who gave presentations at the symposium of the same name at Goldsmiths College, London in 2007. I also include a fifth, Reza Negarestani, whose own *Cyclonopedia* was published in 2008. As has been widely commented upon, this philosophical movement, if it can be called one, originates to a certain extent in the exponential growth of philosophy blogs and para-academic publishers. For a sampling of other thinkers associated with Speculative Realism see *The Speculative Turn: Continental Materialism and Realism* (Bryant, L., N. Srnicek and G. Harman). For an indication of books published, blogs and other Internet resources as well as a selection of published and unpublished essays see http://speculativeheresy.wordpress.com/.
3. This anti-phenomenological aspect of Speculative Realism might be said to have at least one of its determinations in the writings of Nick Land, and, indeed, the operations of CCRU (Centre for Cybernetic Research Unit) in the 1990s in, and outside of, the Philosophy Department at the University of Warwick. Both Negarestani and Brassier have critiqued Land's particular brand of technological 'accelerationism', but are both also clear that Land's writings opened the way for speculative projects such as their own (see Brassier and Robin McKay's 'Editor's Introduction' to Land's *Collected Writings* and Negarestani's contribution to *The Speculative Turn*). In my previous monograph I have referred to my own indebtedness to the Virtual Futures conferences at Warwick in the mid 1990s, but, here, two things are worth

remarking on in direct relation to Land, who was, at least in terms of the academic disciplines of philosophy – and the humanities more generally – about 15 years ahead of his time: 1. For Land, capitalism is in and of itself a speculative project, uninterested as it is, ultimately, in the human – and mapping out a reality that has increasingly little to do with the latter. It is in this sense that Speculative Realism, in a very real sense, is determined by our latest form of technological capitalism (see, as indicative of this general position, Land's essay: 'Critique of Transcendental Miserabilism'). 2. Land cannot be said to have been an individual who thought certain things but did not live them, that is to say, the problem of the body, within CCRU – this precursor to Speculative Realism – was, it seems to me, a problem that was lived on the basis of the production of certain affects and speeds of the body, that is to say, the body was a site of experimentation.
4. In relation to this, contemporary art practice is an interesting case study. In a sense, art might be thought of as an arche-fossil of sorts: not so much evidence of a world pre-existing the correlation, but often the production of something – an object – that is ultimately irreducible to that correlation. An object that 'speaks back' to its producer as it were. In this sense the artist blindly produces a proxy from a world hitherto unknown. Indeed, one wonders whether correlationism has ever been the problem for artists as it has been for philosophers, after all has not art always been involved in accessing something 'beyond' the artist, not least in the utilization of contingency? Another way of saying this is that art, when it really is art, tends to operate against representation.
5. A counter claim might be that Deleuze's contemplation–contraction is in fact just another kind of inhuman correlation – a correlation that is multiplied and expanded out to plants and rocks. To return to the quote in Chapter 5: 'The plant contemplates by contracting the elements from which it originates – light, carbon, and the salts – and it fills itself with colors and odors that in each case qualify its variety, its composition: it is *sensation* in itself' (*WP*, p. 212). As we shall see, this seems to be the position of Graham Harman, following Heidegger's tool-being and the thesis of the essential withdrawal of the thing itself from its relations. However, it seems to me that Deleuze could only be considered correlationist if it is maintained that there is something 'outside' or 'beyond' this contemplation–contraction (again, the thing in itself). As, for example, in Harman's Heideggerianism. For Deleuze, it seems to me, there is no deeper 'reality' beyond the relations, only, as it were, further relations all the way to infinity.
6. For another image of a subject-not-of-affordability we can look to Deleuze's account of Tournier's Robinson on his island and in a world without others (see note 35 of Chapter 1). We might say, in Meillassoux's terms, that the correlation – understood here as the 'structural-other' – itself breaks down given certain conditions. Robinson's adventures are then, to a certain extent, an adventure in and with hyper-chaos, or radical contingency, insofar as the island becomes totally unpredictable (and unknowable). Deleuze, via Tournier, then offers us a narrative of a breakdown of the correlation, or its continuing dissolution, ending in the subject, that is Robinson, 'becoming-island'.

7. And might there even be – despite itself – a Kantian moment in this being radically opened by the outside? To quote Jean-François Lyotard:

> If we are in a state of possibility, it's that something is happening to us, and when this possibility has a fundamental status, the donation itself is something fundamental, originary. What happens to us is not at all something we have first controlled, programmed, grasped by a concept [*Begriff*]. Or else, if what we are possible to has first been plotted conceptually, how can it *seize us*? How can it test us if we already know, or if we can know – of what, with what, for what, it is done? Or else, if such a feeling, in the very radical sense that Kant tries to give the term, takes place, it must be admitted that what happens to us disconcerts us. (Lyotard 1991, p. 111)

Lyotard's thesis is one of a radical 'passibility' and a certain feeling-sense that in itself implies a critique of the Cartesian subject with its emphasis on communication, mastery – and on following that which is always already predetermined:

> We are thus still derivatives from the Cartesian model of 'making oneself master and professor ...'. It implies the retreat of the passibility by which alone we are fit to receive and, as a result, to modify and do, and perhaps even to enjoy. This passibility as *jouissance* and obligatory belonging to an immediate community is repressed nowadays in the general problematic of communication, and is even taken as shameful. (Lyotard 1991, p. 117)

Elsewhere Lyotard suggests that a certain attitude is required to access this non-communication, or logic of the event:

> you have to impoverish your mind, clean it out as much as possible, so that you become incapable of anticipating the meaning, the 'What' of the 'It happens...' The secret of such ascesis lies in the power to be able to endure occurrences as 'directly' as possible without mediation or protection of a 'pre-text'. (Lyotard 1988, p. 18)

Again, this is a felt sense, an intensity, or what Lyotard, again in another text, calls a tensor ('a region in flames' (Lyotard 1993, p. 56)). We might note here the resonances with Nietzsche's comments on idleness (see p. 30), and, indeed, Bataille's idea of 'project' (from *Inner Experience*):

> 'Action' is utterly dependent upon project. And what is serious, is that discursive thought is itself engaged in the mode of existence of project. Discursive thought is evinced by an individual engaged in action: it takes place with him beginning with his projects, on the level of reflection on projects. Project is not only the mode of existence implied by action, necessary to action – it is a way of being in paradoxical time: *it is the putting off of existence to a later point.* (Bataille 1988, p. 76)

It is project that stymies mystical ecstasy, producing, we might say a self when this is the self of project (work). Anguish, when it is not reduced to

project (as it is with Christianity) is the voice of the human experiencing their finitude, and, as such, is a passageway of sorts to the infinite. Bataille might then be counterpoised to Spinoza insofar as the former sees negative affect – anguish – as a kind of knowledge (although, for Bataille, this knowledge is also, precisely, 'non-knowledge'). That said, for Bataille, reason is important – it is the only thing capable of dismantling reason: 'Natural exaltation or intoxication have a certain "flash in the pan" quality. Without the support of reason, we don't reach "dark incandescence"' (Bataille 1988, p. 77). Bataille's writings operate very much as the precursor to aspects of Speculative Realism in this turn to negative affect – for example, with Negarestani, where the circle of affordance replaces project as a name for the subject's typical interaction with the world. In fact, Negarestani's lure has the same paradoxical logic as Bataille's inner experience: 'Principle of inner experience: to emerge through project from the realm of project' (Bataille 1988, p. 77). (Thanks to Jon K. Shaw for directing me to Bataille's writings in this context.)
8. In passing, we might note that if we think this in relation to the subject, for example in relation to sexuation, we have something very close to Lacan's famous statement: 'there is no such thing as the sexual relation', which is to say, ultimately, the sexes are closed off, precisely withdrawn, from each other's worlds.
9. Harman would not, I suspect, go as far as Bergson insofar as the latter posits a kind of thinking for and of objects (contemplation). For Harman, on the other hand: 'The question for us is not the panpsychist query of whether these marbles have some kind of rudimentary thinking and feeling capacities, but whether they as real objects encounter the table-surface as a sensual one' (Harman 2007, p. 206).
10. Habit forms the subject insofar as it constitutes a repetition of volition/ grasping. In fact this habit also forms the object insofar as the subject necessarily perceives unity in what is in fact a field of chaos. See Brian Massumi's essay on the Ganzfield experiments, 'Chaos in the "Total Field of Vision"':

> The object 'constancy' at the basis of cognition is not so much persistence in existence of unitary things as it is a ratio between perceptual variations: the ratio between habit (pattern of reaction) and the sea of chaos in which it swims (doggedly holding onto itself, as its own lifeboat). (Massumi 2002, p. 150)

It is in this sense that '[h]abit adds to reality':

> It is really productive. That productive capacity appeared in the multisensory Ganzfield experiments as hallucination: a creative striving to recognize objects 'out there', even under the most adverse conditions (the body's slowness having been subtracted by the immobilizing experimental set up, scuttling the rationalization). (Massumi 2002, p. 151)

Massumi continues:

> Is it assuming too much to interpret the variations from which perceptual unity and constancy emerge as 'interactions' of 'a body' and 'objects',

as if their recognizable identity preexisted their chaos Objectified body, object world, and their regulated in-between – the empirical workings of experience – arise from a nonphenomenal chaos that is not what or where they are (having neither determinate form nor dimensionality) but is of them, inseparably: their incipiency. (Massumi 2002, p. 151)

In a long footnote to a passage just before the above, Massumi tellingly connects the '"formlike" or "objectlike"' emergences of Ganzfield to Deleuze's 'Leibnizian "inflections"' and also to Guattari's own theorization of the becoming autonomous of subjectivity.
11. See the articles mentioned in note 4 of my Introduction.

Bibliography

Agamben, G. (2009) 'What is Contemporary?', in *What is an Apparatus? and Other Essays*, trans. D. Kishik and S. Pedatella, Stanford: Stanford University Press, pp. 39–54.
Alliez, É. (2004) *The Signature of the World, Or, What is Deleuze and Guattari's Philosophy?*, trans. E. R. Albert and A. Toscano, London: Continuum.
Alliez, É. and A. Goffey (2011) *The Guattari Effect*, London: Continuum.
Ansell-Pearson, K. (1997) *Viroid Life: Perspectives on Nietzsche and the Transhuman Condition*, London: Routledge.
Ansell-Pearson, K. (2001) 'The Simple Virtual: Bergsonism and a Renewed Thinking of the One', *Pli: Warwick Journal of Philosophy*, no. 11, pp. 230–52.
Badiou, A. (1996) 'What is Love?', trans. J. Clemens, *Umbr(a)*, no. 1, pp. 37–53.
Badiou, A. (2000) *Deleuze: The Clamor of Being*, trans. L. Burchill, Minneapolis: University of Minnesota Press.
Badiou, A. (2001) 'The Ethic of Truths: Construction and Potency', *Pli: Warwick Journal of Philosophy*, no. 12, pp. 247–55.
Badiou, A. (2003a) 'Beyond Formalism: An Interview with P. Hallward and B. Bosteels', trans. A. Toscano and B. Bosteels, *Angelaki*, vol. 8, no. 2, pp. 11–36.
Badiou, A. (2003b) *Saint Paul: The Foundation of Universalism*, trans. R. Brassier, Stanford: Stanford University Press.
Badiou, A. (2004) 'Fifteen Theses on Contemporary Art', *Lacanian Ink*, no. 23, n.p., available at www.lacan.com/frameXXIII7.htm, accessed 10 February 2012.
Badiou, A. (2005a) *Being and Event*, trans. O. Feltham, London: Continuum.
Badiou, A. (2005b) *Handbook of Inaesthetics*, trans. A. Toscano, Stanford: Stanford University Press.
Badiou, A. (2005c) *Metapolitics*, trans. J. Barker, London: Verso.
Badiou, A. (2005d) 'The Subject of Art', trans. L. Kerr, *The Symptom*, no. 6, n.p., available at www.lacan.com/symptom6_articles/badiou.html, accessed 10 February 2012.
Badiou, A. (2008) 'The Subject and the Infinite', in *Conditions*, trans. S. Corcoran, London: Continuum.
Badiou, A. (2009) *Logics of Worlds*, trans. A. Toscano, London: Continuum.
Badiou, A. (2010) 'The Idea of Communism', in *The Idea of Communism*, ed. S. Žižek and C. Douzinas, London: Verso, pp. 1–14.
Bataille, G. (1988) *Inner Experience*, trans. L. Boldt, New York: SUNY.
Bell, J. (2006) 'Charting the Road of Inquiry: Deleuze's Humean Pragmatics and the Challenge of Badiou', *The Southern Journal of Philosophy*, vol. 44, pp. 399–425.
Benjamin, W. (1999a) 'The Storyteller: Reflections on the Work of Nikolai Leskov', in *Illuminations*, trans. H. Zorn, ed. H. Arendt, London: Pimlico, pp. 83–107.
Benjamin, W. (1999b) 'Thesis on the Philosophy of History', in *Illuminations*, trans. H. Zorn, ed. H. Arendt, London: Pimlico, pp. 245–55.

Benjamin, W. (1999c) 'The Work of Art in the Age of Mechanical Reproduction', in *Illuminations*, trans. H. Zorn, ed. H. Arendt, London: Pimlico, pp. 211–44.
Berardi, F. (2008) *Félix Guattari: Thought, Friendship, and Visionary Cartography*, trans. and ed. G. Mecchia and C. J. Stivale, London: Macmillan.
Berardi, F. (2010) *The Soul at Work: from Alienation to Autonomy*, trans. F. Cadel and G. Mecchia, Los Angeles: Semiotext(e).
Bergson, H. (1935) *The Two Sources of Morality and Religion*, trans. R. A. Audra and C. Brereton with W. Horstall-Carter, New York: Doubleday Anchor Books.
Bergson, H. (1991) *Matter and Memory*, trans. N. M. Paul and W. S. Palmer, New York: Zone Books.
Bourriaud, N. (1998) *Relational Aesthetics*, trans. S. Pleasance and F. Woods with M. Copeland, Paris: Les Presses du Réel.
Brassier, R. (2000) 'Stellar Void or Cosmic Animal? Badiou and Deleuze on the Dice-Throw', *Pli: Warwick Journal of Philosophy*, no. 10, pp. 200–16.
Brassier, R. (2007) *Nihil Unbound: Enlightenment and Extinction*, Basingstoke: Palgrave Macmillan.
Brassier, R. and R. Mackay (2011) 'Editor's Introduction', to N. Land, *Fanged Noumena: Collected Writings 1987–2007*, Falmouth: Urbanomic, pp. 1–54.
Buchanan, I. (2008) *Deleuze and Guattari's* Anti-Oedipus: *A Reader's Guide*, London: Continuum.
Burrows, D. (2011) 'Performance Fictions', in *Performance Fiction*, ed. D. Burrows, Birmingham: Article Press, pp. 47–70.
Bryant, L., N. Srnicek and G. Harman (2011) *The Speculative Turn: Continental Materialism and Realism*, Melbourne: re.press.
Deleuze, G. (1978) 'Lecture on Spinoza: *Cours Vincennes* 24 January 1978', n.p., available at www.webdeleuze.com/php/texte.php?cle=14&groupe=Spinoza&langue=2, accessed 10 February 2012.
Deleuze, G. (1988a) *Spinoza: Practical Philosophy*, trans. R. Hurley, San Francisco: City Lights Books.
Deleuze, G. (1988b) *Bergsonism*, trans. H. Tomlinson and B. Habberjam, New York: Zone Books.
Deleuze, G. (1988c) *Foucault*, trans. S. Hand, Minneapolis: University of Minnesota Press.
Deleuze, G. (1989) *Cinema 2: The Time Image*, trans. H. Tomlinson and R. Galeta, London: Athlone.
Deleuze, G. (1990) *The Logic of Sense*, trans. M. Lester with C. Stivale, ed. C. V. Boundas, New York: Columbia University Press.
Deleuze, G. (1992) *Expressionism in Philosophy: Spinoza*, trans. M. Joughin, New York: Zone Books.
Deleuze, G. (1993) *The Fold: Leibniz and the Baroque*, trans. T. Conley, Minneapolis: University of Minnesota Press.
Deleuze, G. (1995a) *Negotiations: 1972–1990*, trans. M. Joughin, New York: Columbia University Press.
Deleuze, G. (1995b) *Difference and Repetition*, trans. P. Patton, New York: Columbia University Press.
Deleuze, G. (1998) *Essays Critical and Clinical*, trans. D. W. Smith and M. A. Greco, London: Verso.
Deleuze, G. (2001) *Pure Immanence: Essays on A Life*, trans. A. Boyman, ed. J. Rajchman, New York: Zone Books.

Deleuze, G. (2003a) 'The Three Kinds of Knowledge', trans. J. Rubin, *Pli: Warwick Journal of Philosophy*, no. 14, pp. 1–20.
Deleuze, G. (2003b) *Francis Bacon: The Logic of Sensation*, trans. D. W. Smith, London: Continuum.
Deleuze, G. (2006) *Two Regimes of Madness: Texts and Interviews 1975–1995*, trans. A. Hodges and M. Taormina, ed. D. Lapoujade, New York: Semiotext(e).
Deleuze, G. and F. Guattari (1984) *Anti-Oedipus: Capitalism and Schizophrenia*, trans. R. Hurley, M. Seem and H. R. Lane, London: Athlone Press.
Deleuze, G. and F. Guattari (1986) *Kafka: Towards a Minor Literature*, trans. D. Polan, Minneapolis: University of Minnesota Press.
Deleuze, G. and F. Guattari (1988) *A Thousand Plateaus*, trans. B. Massumi, London: Athlone Press.
Deleuze, G. and F. Guattari (1994) *What is Philosophy?*, trans. H. Tomlinson and G. Burchell, London: Verso.
Deleuze, G. and C. Parnet (1977) *Dialogues*, trans. H. Tomlinson and B. Habberjam, London: Athlone.
Fink, B. (1995) *The Lacanian Subject: Between Language and Jouissance*, Princeton: Princeton University Press.
Foucault, M. (1990) 'An Aesthetics of Existence', in *Politics, Philosophy, Culture*, trans. A. Sheridan, ed. L. Kritzman, London: Routledge, pp. 47–53.
Foucault, M. (2000) *Ethics: Subjectivity and Truth (Essential Works of Foucault, 1954–1984, Volume One)*, trans. R. Hurley, ed. P. Rabinow, Harmondsworth: Penguin.
Foucault, M. (2005) *The Hermeneutics of the Subject: Lectures at the Collège de France 1981–82*, trans. G. Burchell, ed. F. Gros, London: Macmillan.
Genosko, G. (2009) *Félix Guattari: A Critical Introduction*, London: Pluto.
Grant, I. H. (2008) *Philosophies of Nature after Schelling*, London: Continuum.
Guattari, F. (1995) *Chaosmosis: An Ethico-Aesthetic Paradigm*, trans. P. Bains and J. Pefanis, Sydney: Power Publications.
Guattari, F. (1996a) 'A Liberation of Desire: An Interview by George Stambolian', in *The Guattari Reader*, trans. G. Stambolian, ed. G. Genosko, Oxford: Basil Blackwell, pp. 204–14.
Guattari, F. (1996b) 'Ritornellos and Existential Affects', in *The Guattari Reader*, trans. J. Schiesari and G. Van Den Abbeele, ed. G. Genosko, Oxford: Basil Blackwell, pp. 158–71.
Guattari, F. (1996c) 'Subjectivities: For Better or Worse', in *The Guattari Reader*, trans. S. Thomas, ed. G. Genosko, Oxford: Basil Blackwell, pp. 193–203.
Guattari, F. (1996d) 'The Place of the Signifier in the Institution', in *The Guattari Reader*, trans. G. Genosko, ed. G. Genosko, Oxford: Basil Blackwell, pp. 148–57.
Guattari, F. (2000) *The Three Ecologies*, trans. I. Pindar and P. Sutton, London: Athlone Press.
Hadot, P. (1995) 'Spiritual Exercises', in *Philosophy as a Way of Life*, trans. M. Chase, ed. A. I. Davidson, Oxford: Blackwell, pp. 81–125.
Hallward, P. (2003) *Badiou: A Subject to Truth*, Minneapolis: University of Minnesota Press.
Hallward, P. (2006) *Out of this World: Deleuze and the Philosophy of Creation*, London: Verso.
Hardt, M. and A. Negri (2000) *Empire*, Cambridge: Harvard University Press.
Harman, G. (2007) 'On Vicarious Causation', *Collapse: Philosophical Research and Development*, vol. 2, pp. 187–221.

Holland, E. (1999) *Deleuze and Guattari's* Anti-Oedipus*: Introduction to Schizoanalysis*, London: Routledge.
Klossowski, P. (1998) *Nietzsche and the Vicious Circle*, trans. D. W. Smith, Chicago: University of Chicago Press.
Lacan, J. (1990) *Television: A Challenge to the Psychoanalytic Establishment*, trans. D. Hollier, R. Krauss and A. Michelson, London: W. W. Norton & Company.
Lacan, J. (1992) *The Ethics of Psychoanalysis 1959–1960: The Seminar of Jacques Lacan, Book VII*, trans. D. Potter, ed. J.-A. Miller, London: Routledge.
Lacan, J. (1999) *On Feminine Sexuality: The Limits of Love and Knowledge 1972–1973 (Encore): The Seminar of Jacques Lacan, Book XX*, trans. B. Fink, ed. J.-A. Miller, London: W. W. Norton & Company.
Lacan, J. (2002a) 'The Mirror Phase as Formative of the *I* Function as Revealed in Psychoanalytic Experience', in *Écrits: The First Complete Edition in English*, trans. B. Fink with H. Fink and R. Grigg, London: W. W. Norton & Company, pp. 75–81.
Lacan, J. (2002b) 'The Subversion of the Subject and the Dialectics of Desire', in *Écrits: The First Complete Edition in English*, trans. B. Fink with H. Fink and R. Grigg, London: W. W. Norton & Company, pp. 671–702.
Laerke, M. (1999) 'The Voice and the Name: Spinoza in the Badiouian Critique of Deleuze', *Pli: Warwick Journal of Philosophy*, no. 8, pp. 86–99.
Land, N. (1992) *Thirst for Annihilation: Georges Bataille and Virulent Nihilism*, London: Routledge.
Land, N. (1993) 'Making it With Death: Remarks on Thanatos and Desiring-Production', *Journal of the British Society for Phenomenology*, vol. 24, no. 1, pp. 66–76.
Land, N. (2011) 'Critique of Transcendental Miserabilism', in *Fanged Noumena: Collected Writings 1987–2007*, Falmouth: Urbanomic, pp. 623–8.
Laruelle, F. (no date) 'A New Presentation of Non-Philosophy', n.p., available at www.onphi.net/texte-a-new-presentation-of-non-philosophy-32.html, accessed 5 December 2011.
Lorraine, T. (2003) 'Living a Time Out of Joint', in *Between Deleuze and Derrida*, ed. P. Patton and J. Protevi, London: Continuum, pp. 30–45.
Lyotard, J.-F. (1988) *Peregrinations: Law, Form, Event*, New York: Columbia University Press.
Lyotard, J.-F. (1991) 'Something like: Communication ... without Communication', in *The Inhuman*, trans. G. Bennington and R. Bowlby, Oxford: Polity, pp. 108–18.
Lyotard, J.-F. (1993) *Libidinal Economy*, trans. I. H. Grant, London: Athlone Press.
Massumi, B. (2002) 'Chaos in the "Total Field of Vision"', in *Parables for the Virtual: Movement, Affect, Sensation*, Durham, Duke University Press, pp. 144–61.
May, T. (2000) 'Philosophy as a Spiritual Exercise in Foucault and Deleuze', *Angelaki*, vol. 5, no. 2, pp. 223–9.
Meillassoux, Q. (2007) 'Subtraction and Contraction: Deleuze's Remarks, Matter and Memory', *Collapse: Philosophical Research and Development*, vol. 3, pp. 63–107.
Meillassoux, Q (2008a) 'Time without Becoming', unpublished paper, available at: http://speculativeheresy.files.wordpress.com/2008/07/3729-time_without_becoming.pdf, accessed 10 February 2012.
Meillassoux, Q. (2008b) *After Finitude: An Essay on the Necessity of Contingency*, trans. R. Brassier, London: Continuum.
Mullarkey, J. (2006) *Post-Continental Philosophy: An Outline*, London: Continuum.

Mullarkey, J. (2010) 'Badiou and Deleuze', in *Alain Badiou: Key Concepts*, ed. A. J. Bartlett and J. Clemens, Durham: Acumen, pp. 168–75.
Negarestani, R. (2008) *Cyclonopedia: Complicity with Anonymous Materials*, Melbourne: re.press.
Negarestani, R. (2011) 'Drafting the Inhuman: Conjectures on Capitalism and Organic Necrocracy', in *The Speculative Turn: Continental Materialism and Realism*, ed. L. Bryant, G. Harman and N. Srnicek, Melbourne: re.press, pp. 182–201.
Negri, A. (1991) *The Savage Anomaly: Power of Spinoza's Metaphysics and Politics*, trans. M. Hardt, Minneapolis: University of Minnesota Press.
Negri, A. (2003) *Time for Revolution*, trans. M. Mandarini, London: Continuum.
Negri, A (2004) *Negri on Negri: Antonio Negri in Conversation with Anne Dufourmantelle*, trans. M. B. DeBevoise, London: Routledge.
Nietzsche, F. (1969) *Thus Spake Zarathustra: A Book for Everyone and No One*, trans. R. J. Hollingdale, Harmondsworth: Penguin.
Nietzsche, F. (2001) *The Gay Science*, trans. J. Nauckhoff, Cambridge: Cambridge University Press.
O'Sullivan, S. (2005) *Art Encounters Deleuze and Guattari: Thought Beyond Representation*, London: Palgrave Macmillan.
O'Sullivan, S. (2008) 'The Production of the New and the Care of the Self', in *Deleuze, Guattari and the Production of the New*, ed. S. O'Sullivan and S. Zepke, London: Continuum, pp. 91–103.
O'Sullivan, S. (2009) 'From Stuttering and Stammering to the Diagram: Deleuze, Bacon and Contemporary Art Practice', *Journal of Deleuze Studies*, vol. 3, no. 2, pp. 247–58.
O'Sullivan, S. (2010a) 'From Aesthetics to the Abstract Machine: Deleuze, Guattari, and Contemporary Art Practice', in *Deleuze and Contemporary Art*, ed. S. Zepke and S. O'Sullivan, Edinburgh: Edinburgh University Press, pp. 189–207.
O'Sullivan, S. (2010b) 'The Chymical Wedding: Performance Art as Masochistic Practice, an Account, the Contracts and Further Reflections', *Angelaki*, vol. 15, no. 1, pp. 139–48.
O'Sullivan, S. (2011) 'Performance Fictions: Towards a Mythopoetic Art Practice', in *Performance Fictions*, ed. D. Burrows, Birmingham: Article Press, pp. 71–80.
O'Sullivan, S. and J. Lynch (2007) 'One Day in the Life of a City (July 21, 2006)', *Parallax*, vol. 13, no. 1, pp. 32–40.
O'Sullivan, S. and O. Stahl (2006) 'Contours and Case Studies for a Dissenting Subjectivity (or, How to Live Creatively in a Fearful World)', *Angelaki*, vol. 11, no. 1, pp. 147–56.
Parkinson, G. H. R. (1989) '"Introduction" to B. Spinoza', *Ethics*, London: Everyman, pp. vii–xx.
Rajchman, J. (1991) *Truth and Eros: Foucault, Lacan and the Question of Ethics*, London: Routledge.
Rancière, J. (2004) *The Politics of Aesthetics: The Distribution of the Sensible*, trans. G. Rockhill, London: Continuum.
Read, J. (2008) 'The Age of Cynicism: Deleuze and Guattari on the Production of Subjectivity in Capitalism', in *Deleuze and Politics*, ed. I. Buchanan and N. Thoburn, Edinburgh: Edinburgh University Press.
Reggio, D. (2004) 'An Interview with Jean Oury', available at www.gold.ac.uk/media/interview1-jean-oury.pdf, accessed 10 February 2012.

Roudinesco, E. (1997) *Jacques Lacan: An Outline of a Life and a History of a System of Thought*, trans. B. Bray, Cambridge: Polity Press.
Smith, D. W. (1997) 'Introduction, "A Life of Pure Immanence": Deleuze's "Critique and Clinique" Project', to G. Deleuze, *Essays Critical and Clinical*, Minneapolis: University of Minnesota Press, pp. xi–liii.
Smith, D. W. (2003) 'Mathematics and the Theory of Multiplicities: Badiou and Deleuze Revisited', *Southern Journal of Philosophy*, vol. 41, no. 3, pp. 411–49.
Spinoza, B. (1989) *Ethics*, trans. A. Boyle, London: Everyman.
Varela, F. (2001) 'Francisco J. Varela Interviewed by Hans Ulrich Obrist and Barbara Vanderlinden', in *Laboratorium*, Ostfildern: Dumont, pp. 61–77.
Varela, F. E. Thompson and E. Rosch (1993) *The Embodied Mind: Cognitive Science and Human Experience*, Cambridge, MA: MIT Press.
Virno, P. (2004) *A Grammar of the Multitude: For an Analysis of Contemporary Forms of Life*, trans. I. Bertoletti, J. Cascaito and A. Casson, London: Semiotext(e).
Warburg, A. (1998) 'Images from the Region of the Pueblo Indians of North America', in *The Art of Art History: A Critical Anthology*, ed. D. Preziosi, Oxford: Oxford University Press, pp. 127–42.
Watson, J. (2008) 'Schizoanalysis as Metamodelling', *Fibreculture*, no. 12, available at http://journal.fibreculture.org/issue12/issue12_watson.html, accessed 10 February 2012.
Watson, J. (2009) *Guattari's Diagrammatic Thought: Writing between Lacan and Deleuze*, London: Continuum.
Whitehead, A. N. (1967) *Adventures of Ideas*, New York: The Free Press.
Williams, J. (2003) *Gilles Deleuze's* Difference and Repetition*: A Critical Introduction and Guide*, Edinburgh: Edinburgh University Press.
Williams, J. (2005) *The Transversal Thought of Gilles Deleuze: Encounters and Influences*, Manchester: Clinamen.
Williams, R. (1977) *Marxism and Literature*, Oxford: Oxford University Press.
Williams, R. (1980) 'Base and Superstructure in Marxist Cultural Theory', in *Problems in Materialism and Culture*, London: Verso, pp. 31–49.
Zepke, S. (2008) 'The Readymade: Art as the Refrain of Life', in *Deleuze, Guattari and the Production of the New*, ed. S. O'Sullivan and S. Zepke, London: Continuum, pp. 33–44.
Zepke, S. (2011) 'From Aesthetic Autonomy to Autonomist Aesthetics: Art and Life in Guattari', in *The Guattari Effect*, ed. É. Alliez and A. Goffey, London: Continuum.
Žižek, S. (2011) 'Interview' with Ben Woodward, in *The Speculative Turn: Continental Materialism and Realism*, ed. L. Bryant, G. Harman and N. Srnicek, Melbourne: re:press, pp. 406–15.

Index

Note: page references given in **bold** refer to diagrams.

abstract machine (*see also* diagram), 12, 189, 198, 199, 250n.10, 265n.16
acceleration (*compare* dosage), 179, 273n.4, 200–1
actual, actualization (*see also* matter, plane of), 43, 48, 49, 46, 89, 97, 98, 99, 100, 102, **104**, 128, 129, 138, 139–40, 142, 143, 144, 145, **253**
adjacency, relations of, 178, 204, 221
aesthetics, 4, 118, 268n.20
 aesthetic paradigm, 91–3, 94–6, 96, 97, 101, 103, 106, 111
affect, 15, 17, 31, 41, 139, 146, 163, 184, 206, 214, 217
 affective labour, 22–3, 238–9n.45
affirmation, 6, 20, 28, 30–1, 33–4, 35, 36, 94, 140, 198, 210, 212, 229n.10, 230n.19, 231n.20
affordance, 210–12
Aion, 141, **143**, 262n.14
Alliez, Éric, 277n.16
allopoiesis, 96
animal, animality (*see also* becoming animal; body; *compare* matheme), 16, 45, 141, 148, 150, 160, 162, 163, 164, 175, 189, 194, 219, 264n.16, 265n.16, 266n.16
Ansell-Pearson, Keith, 233n.30
anti-production (*see also* repulsion), 171, 172
anxiety, 163
appearance, appearing, 149, 151–3, 156, 213
arche-fossil, 208–9
art, 3, 91–2, 94, 135, 137, 163, 184, 185, 187, **187**, 188, 191, 197–201, 217, 249n.7, 256n.38, 257n.45, 260n.9, 269n.26, 282n.4
Artaud, Antonin, 274n.6

ascesis, ascetic, 29, 32, 67, 68, 82, 82, 283n.7
asignification, asignifying nucleus, asignifying regime, 90, 103, 106, 108, 110, 182, 190, 194, 199, **253**, 273–4n.5
assemblage
 enunciative, 104, 253
 first kind (animist, territorialized), 94–4, 95, 96, **96**, 213
 second kind (deterritorialized, capitalist), 93–4, 95, **96**
 third kind (*see also* aesthetic paradigm; transcendence, folding-in of), 94–6, **96**, 182
attraction (*see also* miraculation), 171, 173–4, **174**, 175, 178, 179, 180
autopoiesis, autopoietic nuclei, 22, 25, **26**, 95, 96, **96**, 100, 101, 182, 199
axiom, 261n.10, 262n.10

Badiou, Alain (*see also* Deleuze, Gilles, contra Badiou), 69, 125–8, **127**, 129–38, 141, 142–4, 145–67, **161**, 170–1, 213, 214, 219, 258n.2, 260–1n.10, 263n.15, 263–6n.16
bar, 1, 14, 44, 68, 71, 72, 77, **77**, 78, **79**, 83, 89, **96**, 100, **102**, **127**, 129, 132, 134, 135, 136, 137–8, 142, 143, 145, 146, 147, 153, 157–8, 161, **161**, 163–4, 166, 167, 183, **204**, 205, 207, 208, 213, 215, **270**
Bataille, Georges, 211, 283–4n.7
Baudelaire, Charles, 83
becoming, 34, 129, 130, 147, 173–4, 183, 211
 animal, 16, 147, 189, 196, 228n.34
 child, 107

293

becoming – *continued*
 island (*see* Tournier, Michel)
 nameless, imperceptible, 183, 189
 woman, 174, 175
 world, 15, 31, 129, 202, 207, 210, 263n.15
Berardi, Franco, 113, 114–15, 116–18, 121, 277n.18
Bergson, Henri, 38–57, 75, **75**, **76**, 78, 79, **79**, 98–9, **102**, 139, 141, **142**, 160–2, **161**, 213, 214, 256n.39, 263n.15
 his style, 40
betrayal, 80
biopolitics, 113, 116, 267n.17
black hole, 189
body (*see also* animal), 3, 4, 13–14, 15–16, 17, 18, 19, 23, 24, **25**, 32, 33, 38, 41, 42, 46–7, 48–9, 53, 55, 72, 108, 116, 121–2, 137, 141, 146, 149–52, 155–60, 162, 163, 165–5, 167, 183, 205, 206, 207, 209, 219, 282n.3, 284n.10
body without organs, 25–6, **26**, 27, 103, 130, 171, 172, 173, 174, **174**, 175, 176, 177, 178, **178**, 179, 180, 181, 182, 206, 272n.3, 274n.6, 276n.12, 278–9n.25
(*La*) *Borde* clinic, 109
brain, 185–7, **187**
Brassier, Ray, 214–15, 216, 217, 218, 266n.16

Cantor, Georg, *see* set theory
capitalism, 17, 22–3, 28, 35, 42, 54, 56, 93, 113–23, 175, 200, 230n.17, 251–2n.21, 266n.16, 272–3n.4, 282n.3
 capitalist time, 90
 semio-capitalism, 113, 117
Care of the Self, *see* ethics; Foucault, Michel
causation, 16–18, 19, 20, 22, 28, 65–6, 72, 184
 cause of self (*see also* autopoiesis), 14, 18, 24, 30, 66, 85–6, 177
 vicarious causation, 213, 214

celibate, celibate machine (*see also* synthesis, conjunctive), 173, 175, **178**, 179
chaoid, 117, 183
chaos, lumpy chaos, 90, 98, 99, 100–1, 106, 108, 110, 117, 138, 169, 183–4, 185, 186–7, **187**, 284–5n.10
 hyper-chaos, 209–10, 283n.6
chaosmosis, 89, 98–9, 100, 101, 104, **104**, 106, 110, 144, 248n.1
choice, *see* decision
chronos, 263n.14
Churchland, Paul, 214–15, 216
cliché, *see* doxa
Cohen, Paul, *see* set theory
coherence, coherence mechanism, cohesion, *see* consistency
common notions (*see also* joy), 19, 20, 21, **21**, 22, 23, 25, 27, 123, 227n.1, 237n.39
complexity, 90, 98, 99, 100, 110, 138, 183
concepts, *see* common notions
cone (*see also* spiral), 25, **25**, **26**, 36, **36**, 40, 45, 46–7, **46**, 49–51, **50**, **52**, **54**, 56, 75–6, **75**, **76**, 78, **79**, 96, **102**, 120, 141, **142**, **143**, 161, **161**, 174, **178**, 179, 180, **181**, 204, 244–5n.17, 262n.12, 262n.14, **271**, 275n.11, **276**
 double cone, *see* transcendent enunciator
 flattened, 178, 179, 181, 204, 276
 as fold, 75, 76, 78, 79
 as spiral, *see* spiral
confidence (*see also* fidelity), 132
consequence, 157
consistency, 182, 183, 184, 187, **187**, 207
consumption, 171, 175, 178
contemplation, 186, 213
contempt, 81
contingency, 209–10, 282n.4
contraction, 140, **142**, 213
Copernicus, 206
correlation, correlationism, 182, 186, 205–9, 210, 213, 218, 221, 282n.5
count, 126, 127, 130–1, **161**, 165–6

courage, 163, 275n.7
crystallization, 95, 97, 100, 107
culture
 emergent, 192-3
 residual, 192-3

death, being-toward-death, death drive, 59, 74, 78, 87, 110, 137, 141, 165, 172, 173, 180, 181, 208, 212, 256n.39, 274-5n.7
decision, 134, 145, 152, 155, 156, 163, 164, 166, 172, 218, 261n.10
deferral, 129, 134
Deleuze, Gilles, 2-3, 5, 6, 11-12, 15-16, 17-18, 19, 22, 25, 33-4, 37, 39, 51, 54, 73-6, **74**, **76**, 77, 78, **79**, 86, 89, 97, 98, 99, 138-48, 150, 154, 166-7, 180, 184, 194, 197, 258-9n.6, 263-6n.16
 and Félix Guattari (*see also* Guattari, Félix), 84, 90, 107, 112, 166-7, 169-91, 193-5, 196-8, 199-202, 217, 219, 220, 265n.16, 276
 contra Badiou, 16, 127-30, 229n.9, 229n.13
denial, 157, 158-9
Derrida, Jacques, 136, 210
desire, subject of desire, 63, 65, 73, 78, 80, 81, 89, 93, 158, 169, 170, **181**, 242n.5, 248n.1
 desiring machine, 110, 167, 171, 173, 174, 176, 177, 179, 180, 181, 182, 250n.11
 desiring-production (*see also* attraction; repulsion), 170, 171-2, 173-6, **174**, 177-81, **178**, **181**, 220, 272n.2, 272-3n.4
determination, 18, 19, 23, 24, 38, 57, 79, 143, 144, 161, 166, 167, 170, 177, 182, 189, 219
 reciprocal determination, 11, 18, 25, 89, 93, 99, 114, 128, 129, 138-40, 146, 147, 153, 180, 183, 207
diagram, diagramming (*see also* list of figures pp. viii-x), 8-9, 83, 103, 105, 198, 199, 225n.9, 225-6n.10, 275n.11

difference, 33, 127, 128, 144
 originary difference (*see also* multiplicity, inconsistent), 152
(*das*) *Ding* (*see also* the Real; torus; void), 77, 78, **79**, 127, **127**, 180, 181, 182
disinterest, 198
disjunction (*see also* synthesis, disjunctive), 177
doxa, urdoxa, 169, 182, 184, 207
dreamer, *see* mystic
duration, 15, 23, 24, 37, 40, 50, 78, 99

ecology, ecosophy, 111, 255-6n.38
 actual-virtual ecology, 52, 100, 101, 102, 251n.16, 276
elements, *see* count
Empire (*see also* capitalism; Negri, Antonio), 113
encyclopaedia, 69, 126, 130, 131, 132, 161
enjoyment, self-enjoyment, 175, 186
Enlightenment (*see also* science), 31, 69, 81-2, 215
essence (*see also* autopoietic nuclei), 16, 24, **25**
eternal, eternity, 20, 23, 24, 27
eternal return, 7, 28, 33-4, 35-6, **36**, 37, **56**, 141, 144, 174, **174**, 179, 250n.9, 233n.30
 as cone (*see also* cone), 36
ethico-aesthetics, ethico-aesthetic paradigm, 82, 83, 84, 139, 200, 201, 216, 221
ethics, ethical subject, 3-4, 21, 22, 31, 34, 39, 59-66, 67, 72, 72-3, 76-7, **76**, 82, 85, 170, 205, 210, 211, 218, 221, 242n.5, 263n.15, 276-7n.16
event, 61-2, 79, 92, 112, 119, 126-7, 128, 129, 130-2, 133, 134, 137, 138, 143, 149, 152, 153, 154, 155, 156, 157, 158, 159, 160, **161**, 164, 166, 176, 198, 211, 214, 252n.24, 265n.16
exchange principle (*see also* capitalism), 93

experimentation, 16, 31–2, 39, 52, 65, 84, 96, 139, 146, 170, 201, 202, 205, 207, 216, 217, 221, 238n.42, 247n.29, 282n.3
expression (*see also* actual, actualization), 25, **104**, 253
extension, 14, 15, 20

fabulation (*see also* fictioning; forcing), 280n.33
face, faciality, faciality machine, 169, 189–91, 194, 196, 198, 202
facelessness, 278n.23
faith, faithful subject (*see also* fiction, operating; *compare* fidelity), 129, 132, 133, 134, 136, 148, 155, 158–9, 163, 164, 166, 176
fear, 190, 278n.23
fictioning (*see also* forcing), 108, 238n.43, 259–60n.8, 275n.11
operating fiction, 9, 95, 182, 261n.10
fidelity (*compare* faith), 81, 126, 129, 131, 133, 134, 147, 148, 166, 176
finite–infinite relation, 14, 23, **25**, **26**, **36**, **46**, **50**, **52**, **54**, 56, 71, **74**, 75, **75**, **76**, 77, 78, **79**, 83, 87, 91, 92, 96, **96**, 98, 99, **102**, 108, 110, 112, 113, 114, 116, **120**, 125, 129, 135, 137, 141, **142**, **143**, 147, 149, **161**, 163–4, 166, 170, **174**, **178**, **181**, 183, 184, **204**, 221 227–8n.21, **276**
as non-relation, *see* bar
fold (*see also* cone, as fold; finite–infinite relation; transcendence, folding of), 73–6, **74**, **76**, 78, **79**, 93, **96**, **102**, 183, 194, **204**, 207, 248n.33
super-fold, 86
forcing (*see also* fictioning), 132–4, 136, 145, 146, 154, 208, 270n.28
Foucault, Michel, 60–2, 63–5, 66–8, 69–71, 72, 73–5, **74**, **76**, 78, **79**, 81–6, 87, 95, 205, 221, 258n.2
Freud, Sigmund, Freudianism, 59, 62, 105–6, 109–10, 170
future, future-orientated, **120**, 197, 198

gap (temporal) (*for* gap (ontological) *see* bar), 41, 48–9, 53, 55, 79, 127, 141, 160, 174, **174**, 196, 257n.42, 262n.13
glitch, 199
good, service of goods, 59, 60, 62–3, 64, 65, 71, 73, 78, 79, 80, 81, 158, 241n.2
grace, 69, 165, 212
Grant, Iain Hamilton, 218–21
Guattari, Félix (*see also* Deleuze; Deleuze and Guattari), 2, 89–114, **102**, **104**, 115, 117, 123, 127, 138–9, 150, 182, 188, 194, 198–9, 201, 213–14, 216, 248–9n.1, 258–9n.6
guilt, 80

habit (*see also* knowledge, first kind; sensori-motor schema), 38, 43, 47, 52, **54**, 56, 57, 78, 79, **142**, 174, 216, 284n.10
Hadot, Pierre, 3, 226–7n.1, 239n.47, 243–4n.14
Harman, Graham, 211, 213–14
Hegel, G.W.F., 152, 167, 268n.21
Heidegger, Martin, 197, 213
hero, **77**, 81, 83, 167, 246n.25
hesitation, *see* gap
Hjelmslev, Louis, 104
Holland, Eugene, 274–5n.7
Hume, David, 140, **142**, 184

Idea, 164, 165, 166, 167, **271**
immanence, 77–8, 148, 182
plane of, 16, 21, 25, 31, 96, 128, 228n.4, 276n.12
immortal, immortality, 162, 164, 167
imperceptibility (*see also* becoming imperceptible), 147
indeterminate, 143, 145
indiscernibility, 132, 133, 134, 137
individual, individuation, 115, 138, 139, 145, 177
infinite (*see also* finite–infinite relation), 23, 75, 135, 138, 260–1n.10
inhuman, non-human, 31, 35–6, 43, 71, 78, 86, 87, 147, 170, 184, 186,

188, 190, 191, 204, 208, 212, 214, 217, 231n.20, 282n.5
inject, 186
inorganic life, 97, 208, 219–20
intentional object, 197
introspection, 215–16
intuition, 22, 23, 25, **26**, 38–9, 43, 52, 53, **54**, 207

jouissance, 261n.10
joy, joyful encounters, 17, 19–20, 21, **21**, 23, 24, 25, **26**, 27–8, 30–1, 36, 53, 164, 175, 212
judgement, 62, 63, 77, 245n.22
 last judgement, 62
justice, 163

kairos, 113, 118–20, **120**, 121–3
Kant, Immanuel, 5–6, 14, 33, 76–7, 206, 219
Kierkegaard, Søren, 155, 167
Klein bottle, 246n.24, **246**, 249n.9
Klein, Melanie, 272
knot, 276n.14, **276**
knowledge (*see also* encyclopaedia), 28, 31–2, 67, 68, 69, 70–1, 79, 131, 132
 first kind (*see also* habit; sensori-motor schema), 15–18, **18**, 19, 21, 25, **26**, 29, 41, 45
 second kind (*see also* common notions), 18–21, **21**, 22, 25, **26**, 68, 212, 263n.15
 third kind (*see also* mystic), 21–7, 25, **26**, 31, 33, 36, 53, 68–9, 97, 207, 209, 250n.9, 263n.15

Lacan, Jacques, 49, 59–63, 64–7, 70–3, 76, 77–8, **77**, 79–82, **79**, 83–6, 87, 109–10, 127, **127**, 150, 156, 158, 161, 171, 249n.8, 258n.2, 260–1n.10, 273n.5, **276**
lack, 78, 275n.8, 275n.10
Land, Nick, 281–2n.3
Laruelle, François, 218
larval, larval subjectivities, 3, 11, 128, 140–1, 167, 186, 220
Latour, Bruno, 214

Leibniz, Gottfried, 43, 153, 227–8n.3, 262n.12
Lenz, Jakob, 171
love, 135
Lyotard, Jean-François, 283n.7

manifest image, 214, 215
Marx, Karl, marxism, 170
master, mastery, 73, **77**, 85–6
 self-mastery, *see* autopoiesis; causation, of self; subjectivation
Mathee, Jean, 66, 74, 76, 241n.3
mathematics, *see* matheme; science; set theory
matheme (*compare* animal), 3, 150, 157–9, 162, 183, 184, 185, 204, 225–6n.10, 247n.29, 266n.16
matter, **253**
 line of, **44**
 plane of (*see also* actual), 40–5, **43**, **44**, 46–7, **46**, 49, **50**, 52–3, **52**, 54, **54**, 56, **56**, 57, **75**, **76**, 78, 98, 141, 143–4, 160, 174, 253, 262n.14
Meillassoux, Quentin, 205–10, 215, 220, 256n.39
memory, 74–5, 141, **142**
 bodily, *see* habit
 line of, **44**
 plane of (*see also* virtual), 42–7, **44**, **46**, 49–51, **50**, **52**, **75**, **142**
 true memory, *see* pure past; virtual
metamodelization, 95, 103, 104–5, **104**, 106, 109, 110
militant, militant subject, 56–7, **56**, 121, 126, 129, 131, 132, 148, 155, 156, 160, **161**, 164
minor, minor literature, 196–7
miraculation, miraculating machine, 172, 173, 178
Möbius strip, 245n.23, 246n.24, **246**
monad (*see also* transmonadism), 75, 96, 115, 252n.24
multiplicity, 127
 inconsistent, 127, 129, 136, 138, 143–4, 145, 146, 152, 153, 160–2, **161**, 165, 166, 203, 265n.16, **270**, 276n.12

mystic, 47–8, 53, 54–7, **54**, **56**, 79, 160, 207, 215, 230n.17, 239–40n.47, 263n.15
myth, mythopoesis, 52, 53, 105, 106, 192, 196, 280n.30, 280n.31

name, naming, nomination (*see also* sinthome), 122, 131, 132, 133, 146, 147, 166, 179
nature, 21, 22, 218–20
Negarestani, Reza, 210–12, 284n.7
negation, 28, 30, 157, 158
Negri, Antonio, 113, 118–23, 192, 230n.16
neurosis, neurotic, 115, 146, 171
Nietzsche, Friedrich, 27–37, 142, **143**, 148, 174, 178–9, 263n.14
his style, 28
nomadism, 176
non-art (*see also* art), 186
non-human, *see* inhuman
non-philosophy, 167, 177, 186, 215, 218, 275n.9
nonsense (*see also* asignification), 107

object, 152–3, 155, 156
obscure, obscure subject, 159, 272n.3
occultation, 157, 159, 164
openness, 210–12, 283n.7
opinion, subject of opinion, *see* doxa
organs (*see also* body without organs), 156, 157, 159
Oury, Jean (*see also La Borde* clinic), 253–4n.26, 254n.32

paganism, 195–6
paranoia, paranoiac machine (*see also* repulsion), 173, 178, 211
parrhēsia, 70, 85
partial object, 198, 202
Pascal, Blaise, 97
passivity (*see also* synthesis, passive), 17, 20, 22, 23, 27, 28, 35, 44, 54–5, 186, 229n.15
past (*see also* memory; virtual), **120**
pure past (*see also* virtual), 38, 43, 45–6, 50, 75, 78, 79, 87, 140, 141, 160–1, 179
patheme, *see* animal

percepts, 26–7
personae, conceptual personae, 28, 148, 179, 184, 272n.1, 277n.16
philosophy, 184, 185, 187, **187**
piety, 272n.3
pleasure, pleasure principle, 65, 71, 72, 140, 173
points (*see also* decision), 154–5
possible, **104**, 123, 143–5, 189, **253**, 257n.42
post-human, *see* inhuman
potential, potentiality, 113, 128
pre-human, *see* inhuman
present (*see also* matter, plane of), **120**
presubjective, 37, 114, 116, 177
probe-head (*compare* face), 189, 190–1, 192, 200, 202
procedure, 130, 131, 134
production (*see also* anti-production; desiring-production), 157
of production, 171, 175
psychosis, psychotic, 106, 108–9, 115

Rancière, Jacques, 267–8n.20
Read, Jason, 279n.27
real, realization, **104**, 132, 143, 144, 145, **253**, 257n.42
Real, the (*see also das Ding*; torus; void), 71, 76, 77, **77**, 78, **79**, 138, **127**, 204
reciprocity, *see* determination, reciprocal
recording (*see also* synthesis, disjunctive), recording surface (*see also* body without organs), 170, 171, 173, 175, **178**
refrain, 105, 106
religion
dynamic (*see also* intuition), 53, **54**
static (*see also* habit), 52, 53, **54**
repetition, 128
representation (*see also* face, faciality), 170
repulsion (*see also* anti-production), 173–4, **174**, 175, 178, 179, 180
resemblance, 184
resurrection, 157, 159

retroaction, 27, 108, 131, 153, 166, 176–7, 179, 207, 260n.9
rhythm, 206

St Francis, 267n.17
St Paul, 148, 267n.17
Schelling, F.W.J., 219, 220–1
schizoanalysis, 84, 95, 103, **104**, 106, 107, 108, 110, 116, 118, 130, 170, 171, 177, 199
 schizoanalytic metamodelization, see metamodelization
schizophrenia, schizophrenic, 171, 172–3, 175
Schreber, Judge Daniel Paul, 173–4
science (see also Enlightenment; matheme; set theory), 184, 185, 187, **187**, 204–5, 206–7, 208, 214–7
sensation, 186
sensori-motor schema (see also habit; knowledge, first kind; *compare* gap), 41, 47, 48, 49, 54, 140, 160, 174, 239n.45
set theory, 127, 134, 135, 136, 265n.16, 269–70n.28
signifiance, signification, 189–90
Simondon, Gilbert, 114, 115
singularity, 22
sinthome, 147, 276n.14, **276**
situation (see also world), 56, 126–7, 130, 131, 132–3, 134, 136, 138, 143, 145, 149, **161**, 163, 165–6, **270**
slowness, see speed (see also gap)
socius, 172
soul, 52, 92, 117, 186, 252n.24, 262n.12
Spartacus, 158–9
speculation, 1, 19, 32, 38–9, 42, 170, 177, 187, 221
 finance (see also capitalism), 230n.17
 Speculative Realism, Speculative Turn, 203–21, 281–2n.3
speed, relative speed, 24, 30, 97, 99, 100, 101, 102, 103
Spinoza, Baruch, 13–27, 28, 29, 31–33, 64–6, 68–9, 72–3, 139, 146, 149, 150, 167, 171, 205, 209, 212, 263n.15, 264–5n.16
spiral, 180, 181, **181**, 204
striation, 173
subject (see also doxa; militant), **77**, **79**, 125, 126–7, **127**, 129, 130–4, 135, 136, 137, 138, 145, 146, 147, 149, 151, 155, 156, 157, 158–9, 160, **161**, 163, 164, 166, 167, 169–70, 173, 175, 176, 177–83, **178**, 184, 185, 186, 189, 190, 203–4, 205–7, 208, 210–12, 213, 214–18, 219–22, 270n.28, 277n.16
subjectification, 189, 193–4
subjection, 63, 79
subjectivation, 73–4, **74**, 75, 95, 101, 190
subjectivity, production of subjectivity, 1, 7, 27, 29, 35, 37, **52**, 54, 73, 89, 103, 188–9, **204**, 218, 221, 222, 258–9n.6
subjectivization, 130–2, 135
substance, 14, **253**
subtraction, 44, 135, 143, 145, 214
symbolic, 49, 71, 72, 85, 237n.39, 248n.33, 249n.8
 sub-symbolic, 214, 215
symptom, 107–8
synthesis
 conjunctive (see also celibate), 171, 175, 176, 180
 connective, 171–2, 173, **173**, 174, 176, 179, 180
 disjunctive (see also gap; paranoia; recording), 119, 172, 173, **173**, 174–5, **174**, 176, **178**, 180, **181**
 passive synthesis, 204–5, 207, 208, 213
 first, 140–1, **142**, 175
 second, 140, 141, **142**
 third, 141–2, **143**, 172, 180, 204
 of the unconscious, 170

techno-science paradigm (see also science), 92
temporality, temporalities, 113, 118–22, 123, 131
terror, 163

Thanatos, *see* death
torus, 66, 76, **77**, 78, 79, **79**, 81, 83, **127**, 176, 180–1, **204**, 274n.7
Tournier, Michel, 202, 234–5n.35, 282n.6
trace (of an event) (*see also* event), 137, 149, 156, 157, 158, 159, 163, 164
traitor, traitor prophet, 200
transcendence, transcendent enunciator (*see also* judgement), 29, 63, 77, 80, 84, 85, 93, **96, 102**, 119, 128, 137, 144, 148, 152, 153, 155, 159, 160, 164, 171, 182, **204**, 206, 213, 264–5n.16, 266n.16
 folding-in of (*see also* autopoiesis), 95, 96, 101, 182, 249–50n.9
transcendental empiricism, 184–5
translation, 194, 199
transmonadism (*see also* monad), 100–1
Truth, truth, truth procedure, truths, 60, 61, 67–8, 69–71, 78, 82, 83, 84, 122, 126–7, 129, 131–3, 134, 135, 136, 144, 149, 150, 151, 155–6, 159, 162, 163, 165, 166, 167, 205, 261n.10, **271**

unconscious (*see also* synthesis, of the unconscious), 32–3, 59
unground, 144
univocity, 128, 139–40, 154, 180
untimely, 159
utility, 39, 48, 49, 54

Varela, Francisco, 215–17
vinculum, **228**
Virno, Paolo, 113, 114–16, 117, 121, 256–7n.40
virtual, virtualization (*see also* cone; memory; past), 44, 46–7, **46, 50, 52, 54, 56**, 75, 76, 79, 89, 97, 98, 99, 100, **104**, 123, 128–9, 138, 139, 141, 142, 143, 144, 145, 160, 161, 167, 179–80, **253**, 257n.42, 263–4n.16, 266n.16
void, void point (*see also das Ding*; the Real; torus), 71, 76, **77**, 78, **79, 127**, 130, 130, 154, 160, 212, 258n.2, 270n.28

war machine, 118
Warburg, Aby, 196, 199
weave, *see* finite–infinite relation
web 2.0, 249n.5
white wall, 189
Whitehead, Alfred North, 140, 234n.33
Williams, James, 139
Williams, Raymond, 192–3, 194–5
world, worlds (*see also* situation), 136–7, 148, 149, 151, 152, 153, 155, 157, **161**, 163, 164, 165, **270**

Žižek, Slavoj, 203, 281n.1